Silencing Cinema

GLOBAL CINEMA

Edited by Katarzyna Marciniak, Anikó Imre, and Áine O'Healy

The **Global Cinema** series publishes innovative scholarship on the transnational themes, industries, economies, and aesthetic elements that increasingly connect cinemas around the world. It promotes theoretically transformative and politically challenging projects that rethink film studies from cross-cultural, comparative perspectives, bringing into focus forms of cinematic production that resist nationalist or hegemonic frameworks. Rather than aiming at comprehensive geographical coverage, it foregrounds transnational interconnections in the production, distribution, exhibition, study, and teaching of film. Dedicated to the global aspects of cinema, this pioneering series combines original perspectives and new methodological paths with accessibility and coverage. Both "global" and "cinema" remain open to a range of approaches and interpretations, new and traditional. Books published in the series sustain a specific concern with the medium of cinema but do not defensively protect the boundaries of film studies, recognizing that film exists in a converging media environment. The series emphasizes a historically expanded rather than an exclusively presentist notion of globalization; it is mindful of repositioning "the global" away from a US-centric/Eurocentric grid, and remains critical of celebratory notions of "globalizing film studies."

Katarzyna Marciniak is a professor of Transnational Studies in the English Department at Ohio University.

Anikó Imre is an associate professor of Critical Studies in the School of Cinematic Arts at the University of Southern California.

Áine O'Healy is a professor of Modern Languages and Literatures at Loyola Marymount University.

Published by Palgrave Macmillan:

Prismatic Media, Transnational Circuits: Feminism in a Globalized Present
By Krista Geneviève Lynes

Transnational Stardom: International Celebrity in Film and Popular Culture
Edited by Russell Meeuf and Raphael Raphael

Silencing Cinema: Film Censorship around the World
Edited by Daniel Biltereyst and Roel Vande Winkel

Silencing Cinema

Film Censorship around the World

Edited by Daniel Biltereyst
and Roel Vande Winkel

palgrave
macmillan

First published in 2013 by
PALGRAVE MACMILLAN®
in the United States—a division of St. Martin's Press LLC,
175 Fifth Avenue, New York, NY 10010.

Where this book is distributed in the UK, Europe and the rest of the World,
this is by Palgrave Macmillan, a division of Macmillan Publishers Limited,
registered in England, company number 785998, of Houndmills,
Basingstoke, Hampshire RG21 6XS.

Palgrave Macmillan is the global academic imprint of the above
companies and has companies and representatives throughout the world.

Palgrave® and Macmillan® are registered trademarks in the United
States, the United Kingdom, Europe and other countries.

ISBN: 978–0–230–34081–7 (PB)
ISBN: 978–0–230–34080–0 (HC)

Library of Congress Cataloging-in-Publication Data

Silencing cinema : film censorship around the world / edited by
 Daniel Biltereyst and Roel Vande Winkel.
 pages cm. — (Global cinema series)
 Includes index.
 ISBN 978–0–230–34080–0 (alk. paper) —
 ISBN 978–0–230–34081–7 (alk. paper)
 1. Motion pictures—Censorship. I. Biltereyst, Daniel, 1962–
 editor of compilation. II. Vande Winkel, Roel editor of compilation.
 PN1995.6.S53 2013
 363.31—dc23 2012046505

A catalogue record of the book is available from the British Library.

Design by Integra Software Services

First edition: March 2013

10 9 8 7 6 5 4 3 2 1

Contents

Part III Colonialism, Legacy, and Policies

Part IV Censorship Multiplicity, Moral Regulation, and Experiences

List of Illustrations

Graph

Images

Tables

Acknowledgments

Editing this volume has been a slow but rewarding exercise. We are very proud that some of the key authors in the field of film history and censorship research were willing to share their work with us. As editors, we should offer our thanks to all our contributors, not only for their generosity but also for their patience. At Palgrave Macmillan, we would like to thank Richard Bellis, Robyn Curtis, Flora Kenson, Michael Strang, and Samantha Hasey, as well as Palgrave's Global Cinema series editors Anikó Imre, Katarzyna Marciniak, and Áine O'Healy. We are also very much indebted to colleagues and friends at our respective home universities, in particular the members of the Centre for Cinema and Media Studies at Ghent University and the Visual Studies and Media Culture research group at the University of Antwerp. Thanks, for a variety of reasons, also to the following people who have helped this volume to come to fruition: Nico Carpentier, Nicholas Cull, Jean-Paul Dorchain, Liesbet Depauw, JeanPaul Goergen, Joke Goovaerts, Andrew Grossman, Paul Lesch, Veerle Leus, José Carlos Lozano, Richard Maltby, Ernest Mathijs, Philippe Meers, Lies Van de Vijver, Luiz Nazario, Maurice Vambe, Thunnis Van Oort, Khaël Velders, Koen Vlassenroot, and Janet Wasko.

Silencing Cinema:
An Introduction

Daniel Biltereyst and Roel Vande Winkel

It seems to be generally agreed that Hollywood, without the Code, just could not exist. [...] With an occasional exception, no motion pictures made anywhere can begin to compare in artistry, in entertainment, and in beauty with the films which are created in Hollywood and which have brought happiness and immeasurable joy to untold millions throughout the world.

—Joseph I. Breen[1]

In his vibrant cultural biography on Joseph I. Breen, the man who from 1934 to 1954 was in charge of the Production Code Administration (PCA) in Hollywood, Thomas Doherty reminds us how difficult it is to judge the legacy of the American film industry's internal censorship system. While "Hollywood's censor" Breen saw his work as a positive mission, most film scholars and people working in the industry are much more critical. "Hollywood under the Code," Doherty reminds us, "was variously, cumulatively, and intractably racist, patriarchal, misogynistic, homophobic, capitalistic, and colonialist," along with promoting "bourgeois, heteronormative, American-centric values upheld and celebrated from genre to genre, studio to studio."[2] The PCA, which operated under Hollywood's powerful film trade organization—the Motion Picture Producers and Distributors of America, Inc. (MPPDA)—served until the end of the 1960s as the central regulatory institution in the creation, production, and distribution of motion pictures in the United States. Using the Production Code (also known as the Hays or Breen Code)[3] as its bible, the administration systematically intervened in the writing of script drafts, the shooting and editing of major Hollywood studios' motion pictures, and finally decided about the MPPDA seal of approval for distribution and exhibition.

The operations of the PCA have been among the most widely studied topics within the field of (film) censorship research, and the literature on this industrial form of self-regulation within one of the most powerful creative industries

in the world serves as an example of the different possible approaches and the difficulties related to examining film censorship.[4] One of these difficulties is, obviously, the one of defining it. Looking back at his first years in Hollywood and discussing the issue of censorship and the Production Code, MPPDA's President Will H. Hays wrote about his "disagreement with the whole principle of censorship" and he reconfirmed his "faith in the more manly and democratic process of *self-control* and *self-regulation*."[5] This view is in stark contrast with work on the PCA's day-to-day control and attempts to limit the free expression, production, and distribution of films, operated by, as Doherty wrote, "an over-arching, billowing, metastasizing 'superstructure' and the exegetic action [. . .] in detecting subversive impulses and transgressive undercurrents."[6] In this contrasting view, the PCA's self-regulatory and internal censorship practices incorporated an asymmetrical power relation, an internalization of the Production Code in the minds of those working in the film industry, and a voluntary subordination of those individuals and groups to the observer's potential gaze.[7] These critical ideas very much fit into the Panopticism model of hierarchical control and discipline,[8] and they reflect usual criticism against conventional conceptions of censorship that focus upon external, top-down institutional acts of prohibition and repression of free speech and free media.[9]

Some of the most interesting research on the PCA and, by extension, film censorship at large, however, underline that quasi-claustrophobic views upon power, discipline, and control, however theoretically stimulating they might be, are not so productive as to understand the nuances and complexities of censorship. In the American film historiography, the opening of the PCA archives in 1983[10] and the subsequent intensive research on Hollywood's self-regulatory apparatus have been crucial in triggering a much more sophisticated view on film censorship and Hollywood cinema at large. Emphasizing the various roles and the multifaceted character of censorship, studies on the PCA's operations indicate that censorship has been (and in many instances still is) a key mediating factor in discourses that govern American film industry and film culture. They underline that censorship is linked to and helps to revisit key issues of policy, political economy, and industry–public relations,[11] next to, obviously, questions of the representation of class, gender, religion, and ideology.[12] The immensely rich PCA archive material on individual films, which contains a considerable amount of correspondence, meeting memos, and other memoranda, indicates that censorship is a key factor also for reexamining issues of authorship, genre, narration, aesthetics, and audiences.[13]

Witnessing the numerous studies on individual films,[14] genres, cycles, or series of films,[15] and particular filmmakers, there is also a growing understanding that PCA operations mostly encompassed negotiations over story lines, characters, visual material, and other kinds of often minor details, all questioning conventional conceptions of an institutionalized, interventionist, and Panoptic kind of censorship. A censorship institution like the PCA did not

work in isolation, as well as it changed over time and reacted upon wider social, ethical, or political transformations. The files emphasize that the administrators were flesh-and-blood people who were not disconnected from society, and that they were willing to negotiate with filmmakers, scriptwriters, and other representatives of the creative industry. The Code was not carved in stone, but open for interpretation. Within specific hegemonic boundaries, it also left some room for sophisticated narratives and moral ambiguities.[16] Particularly interesting are the many censorship battles,[17] which, as Francis G. Couvares claimed, helped to "mark out the terrain of conflict over discursive practices" and they reveal "the boundaries of what may be said, or shown and seen." Arguing for research that connects more fully aspects of institutional policies, production, text, and consumption, Couvares contended that "those negotiations over the boundaries of acceptable representation [are] at the heart of recent studies of censorship."[18]

More generally it is clear that this view on film censorship as a significant site of struggle leaves behind conceptions of a top-down repressive apparatus—what Annette Kuhn has called the "prohibition/institutions" model—[19] and that these culturalist and post-structuralist notions emphasize productive aspects of censorship as well.[20] Within this "eventualization/diagnosis" model, concrete practices of negotiation, intervention, and even banning by a censorship board become manifestations of hegemonic views on social matters.[21] This shift in film censorship research indicates that censorship is a form of social disciplining that, as Janet Staiger argues, can be seen as a "significant social response to representations,"[22] rather than as an imposed decision of an alienated institution. As a consequence of these shifts, film censorship research has evolved and expanded into a field that not only deals with the study of the legal basis (or the "social contract"),[23] the modalities, and concrete practices of censorship boards, but also encompasses close textual analyses and other work on contextual and intertextual determinants of cinema.

The PCA type of self-regulatory and industry-based control of cinema is, of course, of a completely different nature than the ones operated, for instance, by state film censorship boards in other liberal democracies or those operating in totalitarian regimes. One of the aims of this volume is to look at those differences, both in the "social contract" or the legal basis of censorial control over cinema, and in the concrete workings, implications, and discourses surrounding it. In recent years, the revival of film censorship research, which to a large extent revised key issues in the historiography of American cinema, also took place in other countries and regions. This renewed scholarly interest in film censorship,[24] which went hand in hand with new theoretical underpinnings and an enlargement of research approaches to it, also occurred in the UK (see Chapter 9),[25] France,[26] and some major Western European countries, especially those that experienced dictatorial regimes such as Germany (Chapter 5), Russia (or the former Soviet Union, Chapter 6), and Italy (Chapter 15). In many more countries, though, including small western

European countries (chapters 12 and 16)[27] and those with a newly advanced economic development such as Mexico (Chapter 4), China (Chapter 7), and India (Chapter 11), scholars have conducted groundbreaking research on film censorship. Unfortunately, access to most of these publications is restricted to those who read the local language.

The case studies in this volume, which concentrate on a selection of national or regional film censorship cultures, highlight the amazingly wide variety of censorship systems, modalities, and practices, as well as illustrate how these mostly radically changed over time. The history of film censorship, which was and is influenced by moral panics and challenged by the arrival of "new" genres[28] and release formats (television, analogue video tapes, digital video discs, video on demand, online viewing, etc.),[29] also encompasses new concepts and labels like "classification," "governmentality," "silencing," "policing," and other words referring to various forms of regulation and control.[30] The case of the BBFC, which changed its name in 1984 from British Board of Film Censors to British Board of Film Classification, illustrates that these shifting labels are more than just strategy and discourse, because, as the organization argued, it reflects "the fact that classification plays a far larger part in the Board's work than censorship."[31]

In her groundbreaking book on the history and theories of censorship, *Censorship: The Knot That Binds Power and Knowledge*, Sue Curry Jansen, basically illustrates the different concepts' contingency, and she argues for a broad definition in which both official, overt and "regulative" forms of censorship are looked at, as well as forms of diffuse or "constituent censorship."[32] In this volume, by and large, we treat film censorship as the attempt to hinder or limit the free expression, creation, production, distribution, exhibition, and reception of films. We avoid a narrow prescription in favor of a view that recognizes various forces from a wide range of influences. This means, as the chapters in this book illustrate, that film censorship is a much wider phenomenon than the one linked to the workings of state, private, or industry-related institutions whose prime task it is to look over film content and morality (like the PCA, the BBFC, or the German *Freiwillige Selbstkontrolle der Filmwirtschaft*/FSK). This idea of the "multiplicity" of censorship includes the entrance of many more institutions, which for a variety of reasons have worked (and in some cases still work) upon cinema. The chapters in this volume illustrate that next to film censorship boards, other organizations and their representatives such as criminal courts and other juridical institutions, governments, diplomats and embassies, police forces, local states, municipal and city councils, the press, religious organizations and other pressure groups, along with market mechanisms, restricted the free production, distribution, and consumption of cinema.[33]

This situation, in which multiple actors and institutions coexist and interact, might look like a suffocating environment of surveillance and struggle for control, or what Mark Poster has called a decentralized Superpanopticon.[34] Case studies like those on Italy and Belgium (chapters 15 and 16), however,

illustrate that cinema was indeed an important battlefield, in which opponents did not only struggle but also invested in film culture in order to control people's minds and leisure. In both cases, the Roman Catholic Church first opposed cinema as a modern "school of paganism" and "immorality," but later promoted cinema, more in particular "morally healthy" film production, distribution, and exhibition.

Next to this attempt to expand the scope and to include more institutions in the analysis of film censorship, this volume also tries to foster comparative research. There is nothing wrong with focusing upon the censorship culture within nations, regions, or even cities, but a cross-cultural or -national view upon film control might offer new, fresh insights. Control boards like the BBFC and the PCA regularly exchanged information about their respective censorship decisions, using this information for cautioning producers about potential problems with specific (foreign and other US state) boards. An interesting cross-national case, linking various chapters in this volume, deals with the BBFC and its legacy in terms of what happened in Hong Kong and other British colonies (Chapter 10), India (Chapter 11), and Ireland (Chapter 12). In these studies, questions of influence and colonialism are countered by local cultural practices, interests, and power struggles. Another cross-link in a variety of studies deals with the role of religion, like in the case of Nigeria where cultural and religious diversity very much influences local film cultures, including the one on censoring cinema. Various chapters also deal with the activities of Catholic film organizations in the field of censorship or classification (what might be understood here as a form of "enforced information"). Although they were to some extent linked to the Vatican, where some issues in relation to the question of cinema were coordinated, powerful Catholic organizations like the US Legion of Decency in the United States (Chapter 14), the Italian *Centro Cattolico Cinematografico* (Catholic Cinema Centre, CCC) and similar actors in Ireland, Mexico, or Belgium mostly developed their own policies according to local needs and interests.

Next to raising questions about differences in the *censorship systems* and *institutions*, this volume also puts into perspective other levels of comparison. One deals with the *modalities* that are available to censoring institutions, at least those allocated to them by the state or some other powers (procedures like age restrictions, cuts, bans, financial repercussions, control over film criticism). While the chapters in this volume highlight modalities, they also discuss to what degree different cultures were developed in terms of the day-to-day *practices* of censorship (e.g., negotiations with producers or distributors, forms of preventive or prior censorship, financial controls over production budgets). These practices also included secretive acts of censorship that often remained invisible to the public, the press, and society at large (e.g., censorship boards or governments approaching filmmakers and distributors to withdraw their movie from public exhibition). Another level in the analysis includes *censorship discourses* or the public interventions and arguments used (or not) to legitimate

censorial acts. Finally, and returning to the opening question of this Intro-
duction, one might look at the varying *implications* of censorship practices
and discourses, not only for the industry and other institutional stakeholders,
but also for the *audiences* and their experiences and eventual resistance to
censorial acts.

Even though we include chapters describing film censorship within
particular geographical boundaries, many cross-links can be found between
the chapters in this volume. Part I consists of chapters on the North American
hemisphere, with Hollywood's hegemonic position. The first chapter by Laura
Wittern-Keller, dealing with censorship in the United States until the end of the
PCA in 1968, explicitly argues that the Administration and its predecessor were
not the only ones determining film control. In her well-researched contribu-
tion Wittern-Keller emphasizes the importance of governmental censorship,
along with the role played by state and local censors. Jon Lewis's chapter
on the post-PCA period offers a lively and highly provocative analysis of the
PCA's successor, the Motion Picture Association of America's (MPAA)'s Code
and Rating Administration (CARA, later named the Classification and Rating
Administration). Lewis's critical analysis argues that this voluntary rating uses
a moralizing discourse, but in the end mainly serves a political-economic
purpose, namely the maintenance of the larger power network of relation-
ships that compose the new Hollywood. Although Canada is often considered
Hollywood's 51st market, it has developed a film policy that in many instances
strongly defers from what happened over the border. In his historical overview,
Pierre Véronneau argues that, apart from federal government initiatives, a
wide range of provinces and territories, along with municipalities and pres-
sure groups were important in defining film control. In his chapter, Véronneau
also focuses upon the role of religious authorities like Catholic film organi-
zations in Quebec. Religion and Hollywood also very much determined local
film culture and censorship in Mexico. Next to writing about the various forms
of state, local, and religious initiatives in order to discipline cinema, Francisco
Peredo-Castro also deals with the role of international diplomacy, especially in
relation to Hollywood's negative representation of Mexico.

The contributions in Part II concentrate on the development of film
censorship in four other major film-producing countries, all of which were
at some time governed by totalitarian regimes. The first chapter, by Martin
Loiperdinger, succeeds in drawing lines of continuities and change in film
censorship and control in Germany. In this reference work on German film
censorship Loiperdinger comes to the conclusion that, notwithstanding its
turbulent history, film censorship in Germany today continues to address
quite the same concerns that preoccupied the first police censors during the
Wilhelmine period. In the next chapter on political control in the Soviet
Union, Richard Taylor brings another original analysis of developments from
the tsarist era until June 1990, when the USSR Supreme Soviet passed a law
that stated unambiguously that the censorship of mass information was not

permitted. In his contribution Taylor examines the different types of censor-
ship and controls over film and film culture in the Soviet era, ranging from
the censorship of film subject-matter to financial controls over production
budgets and control over film criticism. However, Taylor also illustrates how
in the Soviet Union film censorship was not always the well-oiled, Panoptic
machinery, and that to some extent counter-hegemonic or counter-censorial
acts were possible. In the next chapter, Zhiwei Xiao makes another daring anal-
ysis of what happened in China. His analysis illustrates how, on the one hand,
the social contract, modalities, and practices of film censorship intensively
changed as a result of political and economic transformations. But, on the
other hand, Xiao illustrates the importance of continuity, again, for instance in
terms of a strong nationalistic dimension of censorship by functioning against
Western cinema, especially Hollywood's domination. The final chapter in this
part, by Dilek Kaya Mutlu, is a critical evaluation of Turkish film censorship
during the 1960s and the early 1970s, a period not only marked by two military
interventions, but also considered the golden era of Turkish film production.
As many of the chapters in this book, Mutlu uses original archival material in
order to indicate how film and film censorship were a tool for the authoritarian
military regime to suppress freedom of speech. At the same time she illustrates
how the state struggled to maintain its fragile hegemony by intervening in the
processes of producing and circulating meaning in the cultural domain.

Part III of the volume, also consisting of four contributions, concentrates
on another type of cross-national relations, centered mainly on the oldest,
still-existing film censorship board, the BBFC. The first chapter here, writ-
ten by Julian Petley, offers a critical retrospective view of the BBFC, which is
officially an independent, non-governmental body, but in practice has a his-
tory of a tough film censor that played a significant part in a wider process
of governmentality. Petley's analysis brings into perspective historical insights
as well as very recent developments such as the video-nasties and extreme
pornography phenomena, which for the BBFC constituted major challenges.
The next three chapters deal with film censorship in three countries with very
close historical and/or colonial ties with Britain. The first is on the history of
film regulation and control in Hong Kong, the Straits Settlements, and the
Shanghai International Settlement. In his contribution David Newman argues
that whereas the BBFC had a more direct impact through the content and form
of censorship in the different colonies and dominions, the PCA potentially had
an indirect impact through the pre-production vetting of scripts in the United
States, contributing to the decrease in the level of offensive scenes in films arriv-
ing in Asia during the 1930s. In her chapter Nandana Bose first writes about
the British colonial legacy in terms of film policy in postcolonial India. She
then goes into recent developments when Indian cinema grew into a major
force in the global entertainment scene. Bose emphasizes the struggle around
cinema, leading to what she calls "supercensorship." The final contribution in
this part, by Kevin Rockett, deals with censorship of movies in Ireland since

its independence in 1922. Besides emphasizing the role played by Hollywood movies, Rockett also stresses the power of the Catholic church and the moral values associated with it, at least until the 1970s, when a new generation that had experienced 1960s youth culture came to the fore, leading to a relaxation of film censorship.

Part IV continues this focus upon the importance of religious organizations in their struggle around cinema. The first chapter here is by Carmen McCain, who uses ethnographic methods in her analysis of film censorship mechanisms in one of the most productive film and video markets in the world: Nigeria. In her lively analysis of the official censorship in Nigeria, McCain focuses on censorship of the Hausa film industry, popularly called Kannywood, from 2001 until 2011. She thereby explores political discourses in which Muslim identity is employed to both suppress and defend the Nigerian "video film" industry. The next and last chapters all pay a significant amount of attention to the role played by Roman Catholic organizations, respectively in the United States, Italy, and Belgium. Gregory Black, who has written extensively on the powerful American organization Legion of Decency, tells the rise-and-fall story of the Legion, which was not only a crucial factor in the establishment of the PCA, but through the PCA and Breen also influenced the popular family entertainment that was universally enjoyed. The next chapter concentrates on postwar Italian cinema, which in most film histories is often linked to neorealism. In her chapter Daniela Treveri Gennari explores the relationships between the powers of the Italian state and the Roman Catholic Church in order to understand the shifts in the legal and ethical underpinnings of film censorship. Apart from indicating how Catholic film leaders had close ties to some key players in the neorealist movement, Treveri Gennari illustrates how state and Catholic censorial practices profoundly affected modes of consumption of film, although on the other hand several loopholes were found by the industry to reduce film control and allow controversial films to be produced and distributed. The final chapter too focuses upon a country with (for long) a Catholic hegemony, but one that in many overviews of film censorship around the world is considered to be quite unique because it did not have a compulsory film censorship system. In his historical analysis of film censorship in Belgium, Daniel Biltereyst first concentrates on the modalities, practices, and discourses of the institution that operated a voluntary state film control board, next to looking at the role played by other organizations such as those associated with the Catholic Church. Using oral history methods, the second part of his chapter looks at the audience's experiences and at the effectiveness of these strategies of control on audiences and their cinema-going habits. Without providing definitive answers on issues such as the impact of censorship or the possible forms of resistance, the author comes to the conclusion that cinema-goers were very much aware of censorial forces and that they admitted their power.

Looking back at these contributions, we should recognize that the renewed interest in film censorship is only part of a wider awareness of the importance

of different types of control and surveillance in the field of media and com-
munication. This is closely related to a wider set of transformations such as
the growth of the internet and the availability of new sophisticated surveillance
technologies, along with the continued importance given to societal control
within the new geopolitical world order. These constraints to the free produc-
tion, distribution, exhibition, and consumption of media and communication
fuelled interesting new concepts and theories on the continuing importance
of control mechanisms, leading to a rethinking of the Panopticon metaphor
into directions like the Post-Panopticon, the postdisciplinary logic, or a refor-
mulation of the surveillance concept (e.g., sousveillance).[35] Future research on
the history of cinema and film censorship, we believe, might offer interest-
ing insights and knowledge to this growing field.[36] One might remember that
few modern mass media were subjected more vigorously to censorship than
cinema, even so that most countries still have, in some form or another, film
censorship, classification, or control boards.

Notes

1. Breen quoted in Doherty, Th. (2007) *Hollywood's Censor: Joseph I. Breen & The Production Code Administration.* New York: Columbia University Press, p. 340.
2. Doherty (2007) *Hollywood's Censor*, pp. 340–341.
3. There were different versions of the Code. On the origin and the different ver-
sions of the Code, see Gardner, G. (1987) *The Censorship Papers.* New York: Dodd,
Meat & Company, pp. 207–212; Leff, L. J. and Simmons, J. (1990) *The Dame in
the Kimono: Hollywood, Censorship, and the Production Code from the 1920s to the
1960s.* New York: Grove Wiedenfeld, pp. 283–286; Maltby, R. (1993) The Produc-
tion Code and the Hays Office, pp. 37–72 in T. Balio (ed) *Grand Design: Hollywood
as a Modern Business Enterprise, 1930–1939.* Berkeley: University of California Press;
Lewis, J. (2000) *Hollywood v. Hard Core. How the Struggle over Censorship Saved the
Modern Film Industry.* New York: New York University Press, pp. 301–307.
4. The literature on the PCA includes testimonies from key players such as
MPPDA president Will H. Hays (Hays, W. H. (1955) *The Memoirs of Will H. Hays.*
Garden City, New York: Doubleday & Company); testimonies and publications of
documents from within the administration (e.g., Gardner, *The Censorship Papers;*
Vizzard, J. (1970) *See No Evil: Life Inside a Hollywood Censor.* New York: Simon
and Schuster); various biographies on key players such as Breen (e.g., Doherty,
Hollywood's Censor); "official" histories about the PCA (e.g., Moley, R. (1945) *The
Hays Code.* Indianapolis: The Bobbs-Merrill Company); an anthropologist view on
Hollywood and the Code (Powdermaker, H. (1951) *Hollywood, the Dream Factory.
An Anthropologist Looks at the Movie-Makers.* London: Secker & Warburg).
5. Hays, *The Memoirs of Will H. Hays*, p. 347.
6. Doherty, *Hollywood's Censor*, p. 341.
7. See, for instance, de Grazia, E. and Newman, R. K. (1982) *Banned Films:
Movies, Censors and the First Amendment.* New York: R. B. Bowker Company;
Leff and Simmons (1990) *The Dame in the Kimono*; Jacobs, L. (1991) *The
Wages of Sin, 1928–1942.* Madison: University of Wisconsin Press; Miller, F.

(1994) *Censored Hollywood: Sex, Sin and Violence in Hollywood*. Atlanta: Turner; Black, G. (1994) *Hollywood Censored: Morality Codes, Catholics and the Movies*. Cambridge: Cambridge University Press; Couvares, F. G. (eds) (1996) *Movie Censorship and American Culture*. Washington, DC/London: Smithsonian Institution Press; Bernstein, M. (ed) (1999) *Controlling Hollywood: Censorship and Regulation in the Studio Era*. New Brunswick: Rutgers University Press.

8. Foucault, M. (1977) *Discipline and Punish: The Birth of the Prison*. New York: Vintage.

9. Curry Jansen, S. (1988) *Censorship: The Knot That Binds Power and Knowledge*. New York/Oxford: Oxford University Press; Post, R. C. (ed) (1998) *Censorship and Silencing. Practices of Cultural Regulation*. Los Angeles: Getty Research Institute; Müller, B. (ed) (2004) *Censorship & Cultural Regulation in the Modern Age*. Amsterdam: Rodopi.

10. Mehr, L. H. (1996) Center for Motion Picture Study, *Historical Journal of Film, Radio and Television*, 16 (1): 19–25.

11. See for instance on the PCA and the MPPDA's foreign policy, Vasey, Ruth (1997) *The World According to Hollywood: 1918–1939*. Exeter: University of Exeter Press.

12. Couvares, F. G. (1992) Introduction: Hollywood, Censorship, and American Culture, *American Quarterly*, 44 (4): 509–524, 515.

13. On censorship and author theory, see Chapter 15 in Doherty, *Hollywood's Censor*. On censorship, narration, aesthetics and audiences, see Chapter 16 in Maltby, R. (2003) *Hollywood Cinema* (second edition). Malden: Blackwell. On censorship and discourses on audiences, see Grieveson, L. (2004) *Policing Cinema: Movies and Censorship in Early-Twentieth-Century America*. Berkeley: University of California Press.

14. See, for instance, the recent *Controversies* series, published by Palgrave-Macmillan.

15. See, for instance, work on film noir: Naremore, J. (1998) *More than Night: Film Noir in Its Contexts*. Berkeley: University of California Press; Biesen, S. C. (2005) *Blackout: World War II and the Origins of Film Noir*. Baltimore: John Hopkins University Press. On violence in Hollywood cinema, see Prince, S. (2003) *Classical Film Violence: Designing and Regulating Brutality in Hollywood Cinema, 1930–1968*. New Brunswick: Rutgers University Press. On the gangster in Hollywood cinema, see Munby, J. (1999) *Public Enemies, Public Heroes. Screening the Gangster from Little Caesar to Touch of Evil*. Chicago: The University of Chicago Press.

16. Maltby, *Hollywood Cinema*, Chapter 16.

17. Among the many case studies, see for instance literature on Roberto Rossellini's *The Miracle:* Johnson, W. (2008) *Miracles and Sacrilege: Robert Rossellini, the Church, and Film Censorship in Hollywood*. Toronto: University of Toronto Press; Wittern-Keller, L. and R. Haberski (2008) *The Miracle Case: Film Censorship and the Supreme Court*. Lexington, Kentucky: University Press of Kentucky.

18. Couvares, *American Quarterly*, p. 515.

19. Kuhn, A. (1988) *Cinema, Censorship and Sexuality, 1909–1925*. London: Routledge, pp. 2–6, 108.

20. See also Staiger, J. (1992) *Interpreting Films. Studies in the Historical Reception of American Cinema*. Princeton: PUP. Staiger, J. (1995) *Bad Women. Regulating Sexuality in Early American Cinema*. Minneapolis: University of Minnesota Press.

21. Kuhn, *Cinema, Censorship and Sexuality*, p. 8.

22. Staiger, *Bad Women*, pp. 15–16.

23. Carmen, I. H. (1966) *Movies, Censorship, and the Law*. Ann Arbor: The University of Michigan Press. March Hunnings, N. (1967) *Film Censors and the Law*. Liverpool: Allen & Unwin. de Grazia and Newman (1982) *Banned Films*.

24. See, for instance, the Spring 2009 theme issue "Censorship, Regulation, and Media Policy in the Twenty-First Century: A Roundtable on Critical Approaches," *The Velvet Light Trap*, 63 (1): 58–71.

25. See, for instance, work on film censorship in Britain and on the British Board of Film Classification (BBFC): Johnson, T. (1997) *Censored Screams. The British Ban on Hollywood Horror in the Thirties*. Jefferson: MacFarland. Barker, M. et al. (2001) *The Crash Controversy. Censorship Campaigns and Film Reception*. London: Wallflower. Kuhn, A. (2002) Children, "Horrific" Films, and Censorship in 1930s Britain, *Historical Journal of Film, Radio and Television*, 22 (2): 197–202. Aldgate, A. and J. C. Robertson (2005) *Censorship in Theatre and Cinema*. Edinburgh: Edinburgh University Press. Barker, M., Mathijs, E., Sexton, J. Egan, K. et al. (2007) *Audiences and Receptions of Sexual Violence in Contemporary Cinema. Report for the BBFC*. London: BBFC. Petley, J. (2011) *Film and Video Censorship in Modern Britain*. Edinburgh: Edinburgh University Press. Lamberti, E. (ed) (2012) *Inside the BBFC: Film Censorship from the Silver Screen to the Digital Age*. London: BFI/Palgrave.

26. See, for instance, Douin, J. L. (1998) *Dictionnaire de la censure au cinéma*. Paris: PUF. Hervé, F. (2001) *La Censure du Cinéma en France à la Libération*. Paris: ADHE. Montagne, A. (2007) *Histoire juridique des interdits cinématographiques en France*. Paris: L'Harmattan.

27. See also, for instance, on Belgium: Biltereyst, D., Depauw, L. and Desmet, L. (2008) *Forbidden Images a Longitudinal Research Project on the History of the Belgian Board of Film Classification (1920–2003)*. Gent: Academia Press. On Ireland: Rockett, K. (2004) *Irish Film Censorship*. Dublin: Four Courts Press. Martin, P. (2006) *Censorship in the Two Irelands*. Dublin: Irish Academic Press. On Luxemburg: Lesch, P. (2005) *In the Name of Public Order and Morality: Cinema Control and Film Censorship in Luxembourg, 1895–2005*. Luxemburg: CAN.

28. Springhall, J. (1998) *Youth, Popular Culture and Moral Panics: Penny Gaffs to Gangsta-rap, 1830–1996*. Houndmills: Macmillan.

29. On television and the Code, see Doherty, *Hollywood's Censor*, pp. 342–344.

30. See on these concepts: Guins, R. (2008) *Edited Clean Versions: Technology and the Culture of Control*. Minneapolis: University of Minnesota Press. On some of these concepts and media, see McGuigan, J. (1996) *Culture and the Public Sphere*. London/New York: Routledge. On cinema and the concept of "policing," Chapter 1 in Grieveson, *Policing Cinema*.

31. Quoted by Caughie, J. and Rockett, K. (1996) *The Companion to British and Irish Cinema*. London: Cassell/BFI, p. 35.

32. Curry Jansen, *Censorship*.

33. On the role of the press as a "censor," see Petley, *Film and Video Censorship in Modern Britain*, pp. 5–7. On film censorship in different US states, see Chapter 2 and: Butters, G. (2007) *Banned in Kansas: Motion Picture Censorship, 1915–1966*. University of Missouri Press; Wittern-Keller, L. (2008) *Freedom of the Screen: Legal Challenges to State Film Censorship, 1915–1981*. Lexington: University of Kentucky Press.

34. Poster, M. (1990) *The Mode of Information: Poststructuralism and Social Context.* Chicago: University of Chicago Press.
35. For the debate on new technologies and new concepts of control, surveillance, and discipline, see, among others: Guins, *Edited Clean Versions;* McGuigan, *Culture and the Public Sphere;* Müller, *Censorship & Cultural Regulation in the Modern Age;* Craviolini, C., Van Wezemael, J. and Wirth, F. (2011) The Spatiality of Control, *Journal of Critical Studies in Business & Society*, 2 (1–2): 95–115.
36. See, for instance, the growing field of surveillance studies: Lyon, D. (2007) *Surveillance Studies: An Overview.* London: Polity. Ball, K., Haggerty, K. and Lyon, D. (eds) (2012) *Routledge Handbook of Surveillance Studies.* New York: Routledge.

Part I

Censorship, Regulation, and Hegemony

I

All the Power of the Law: Governmental Film Censorship in the United States

Laura Wittern-Keller

As this book makes clear, cinema has been stifled in many ways—some subtle, some blatant. But there can be little doubt that the most obvious and intrusive interference with what filmmakers could produce—and what audiences could see—has come from governmental film censorship agencies. As we will see in this chapter, in their ability to keep things from the screen, American governmental censors not only carried the force of law and the power of the state, but also influenced motion picture production companies to censor themselves. Without the state and local censor boards that sprang up during the Progressive Era, the Motion Picture Producers and Distributors Association (MPPDA, later known as the MPAA) would not likely have tried to police its own member studios. As state censorship continued through the 1930s and as other voices joined the states' demand for cleaner movies, Hollywood's censorship regime grew ever more entrenched.

Hollywood first tried to clean up its image and its content with "Thirteen Points" in 1921, then with "Don'ts and Be Carefuls" five years later, and finally with the Production Code in 1930 and the Production Code Administration (PCA) in 1934. This is the American movie censorship that most people know about.[1] What is not so well known is that the real reason for these regulations was not just to mollify critics but also to conciliate state and local censors and to stave off any possibility of federal film censorship. Hollywood's censors kept track of the type of content that irritated state censors so they could warn their producers about potentially problematic content.[2] The sanitized American motion pictures from the mid-1930s through the demise of the Production Code in the 1960s, then, is actually the product of a symbiotic relationship

between governmental censors and Hollywood's internal censors at the PCA. Put to a chicken-and-egg question, there is no doubt the governmental censors came first. But once the movie industry began policing movie morals in 1934, the PCA took over, leaving the governmental censors with little to do until the end of World War II, when cultural changes shifted the action back toward the state censors—this time, though, with most of the action coming in American courts.[3]

Origins of American Governmental Censorship

When movies burst onto the cultural scene at the turn of the twentieth century, they became immensely popular amazingly quickly. Such popularity, though, unnerved society's moral guardians—those concerned about public propriety and moral order. They were concerned—and not without justification—at the immense social implications of what they perceived as commercialized voyeurism. Previously, communal filters of clergy, teachers, and family determined what people could see, read, or hear. But with movies, those filters disappeared—bypassed in favor of profit-driven moviemakers far away from and unaccountable to the community.[4]

The turn of the twentieth century was also a time of societal turmoil, moving away from cultural commandments that strictly separated private from public.[5] Movies were seen by the guardians of the old order as accelerating that trend, not just because of questionable content, but because the new movie theaters indiscriminately mixed male and female, immigrant and native, degenerate and innocent—all in close proximity and in the dark. These rapid changes led to what sociologists call a "moral panic," a time when fear causes a disproportionate reaction.[6] So much was changing that defied regulation; movies, however, were a hittable target. Fearing that movies were a bad influence on the nation's youth and immigrants, moral guardians wanted some sort of filter that could weed out the bad in movies and then attach a label of purity to what remained.

The drive for some sort of control was so strong that it overcame Americans' long distaste for any law placing a prior restraint on publication. The First Amendment to the US Constitution protects Americans from violation of their right to freedom of speech, freedom of the press, freedom of religion, and the right to gather peaceably and to petition the government. While all of these rights seem straightforward enough, their legal definitions have been much argued over, evolving greatly over the second half of the twentieth century. For example, before World War II, freedom of speech was generally taken to mean the right to express only those opinions that most people found non-threatening. Few would have argued that advocacy of troublesome ideas like anarchism was protected speech. In such a legal culture, movie censorship was welcomed as protection from potentially vile expression that might harm the most vulnerable members of society.

Only later in the twentieth century, after many legal challenges, did the First Amendment come to protect the nearly absolute freedom of expression that Americans have today. Moreover, since the language of the First Amendment restricts only Congress's ability to limit freedoms of speech, press, and religion, it was long assumed that state and local governments were not similarly restrained. So, even if New York State passed a law that expressly violated free speech rights, the First Amendment could offer no protection.

Since the US Congress never passed a federal censorship law, the First Amendment could not have been used to stop early censorship. Moreover, because movies were not seen as legitimate vehicles of expression during the Progressive Era, most people did not see that free speech guarantees in state constitutions applied to movie control. Nor were most Progressives interested in individual rights. Assertion of an individual right to exhibit movies would fail to garner much support since most Progressives blamed society's ills—low workers' wages, unsafe workplaces, poor housing conditions, for example—on the assertion of individual rights in business and financial affairs.[7] Individualism was the problem, they believed; communitarian values were the answer. In such an atmosphere, many Progressives favored censorship as a way to maintain societal harmony and moral order.

Chicago became the first to legally censor movies when in 1907 it empowered its police chief to decide what could be seen on the city's screens. The movie industry grew worried not just about Chicago's censorship, but that this type of governmental interference would spread. They were not alone: a group of social activists who agreed that movies should be controlled for the greater good was nevertheless concerned that more governmental censorship would harm the new art form. So, they decided to take preemptive action, creating the National Board of Censorship (later called the National Board of Review). Preferring that any movie control come from them rather than from a governmental agency, their volunteer reviewers began making recommendations and encouraging elimination of questionable content in 1909. While this board sounds like something moviemakers would hate, they actually favored it. Both the National Board of Censorship and the moviemakers wanted to show that government intervention—particularly federal intervention—would not be necessary, that the industry and the board could manage to keep movie content wholesome. Although much heralded at the beginning, the board quickly disappointed many moral guardians, though, when it approved films they did not like.[8]

It was becoming clear that there was little agreement about movie content. Even those who favored controlling movies disagreed on how to do it. Some, like the National Board, favored the enlightened censoring of a sophisticated elite; others, fearful that the elite were allowing too much dangerous content, favored the creation of professional censor boards working under state and local governments. As the voices of this second group became more insistent, and as moviemakers continued to create films that shocked moral guardians,[9]

state legislatures and city councils began to take action. Then, when that first censorship ordinance in Chicago successfully withstood legal attack in 1909, it seemed inevitable that more would follow.[10] And follow they did: Pennsylvania became the first state to adopt a censorship statute in 1911 (its board began work in 1914), soon followed by Ohio (1913), Kansas (1913), and Maryland (1916). In the meantime, dozens of cities and towns had set up their own boards. The movie industry was becoming increasingly worried about possible federal censorship or, even worse, a more likely and necessarily chaotic city-by-city crazy quilt of control.

Worried about New York and its enormous New York City market in 1916, the movie men formed a trade group called the National Association of the Motion Picture Industry (NAMPI), vowing to police themselves by adopting a list of proscriptions called the Thirteen Points. Actually a laundry list of what had bothered the censors, this list pledged to keep from the screen subjects like white slavery, bloodshed, violence, illicit love, and disrespect for the law. But neither New York's legislature nor its governor believed NAMPI's promises, and New York State went under a censorship regime in 1922, followed by Virginia the same year.[11]

The language of each state's censorship statute was remarkably similar: all (with the exception of Ohio) used negative language—films would be approved if they did *not* contain anything "indecent," "immoral," "inhuman," "obscene," "sacrilegious," or would be likely to "incite to crime."[12] Ohio's law called for all movies to be approved provided they were "of a moral, educational, or amusing and harmless character."[13]

Whatever the language, what the states were looking to prohibit was the same; how they went about it was remarkably different. Because the censors had no guidelines to explain what the statutory language meant in the early years, they were free to interpret it in highly personal ways. Terminology that today seems hopelessly vague and imprecise was accepted by judges as perfectly clear. This was an age that venerated the governmental expert, and so courts were willing to accept the idea that a censor could be asked to apply a word like "immoral" without a statutory definition or regulatory clarification. In fact, in that first court challenge of censorship in Chicago in 1909, the judge dismissed the idea that vagueness could be an issue in censoring, noting that "the average person of healthy and wholesome mind knows well enough what the words 'immoral' and 'obscene' mean and can intelligently apply the test to any picture presented to him."[14] This legal philosophy, that definition was not necessary, leaving censors nearly free rein, prevailed in American courts for 44 years. But censors differed from state to state, and even from administration to administration. The state and municipal censors were usually political appointees—political party bigwigs (or their wives) who got their jobs not because they had any specialized knowledge of movies or of public morals, but because they had supported the right candidate for governor or mayor. In Pennsylvania, for example, the lead censor during that board's formative

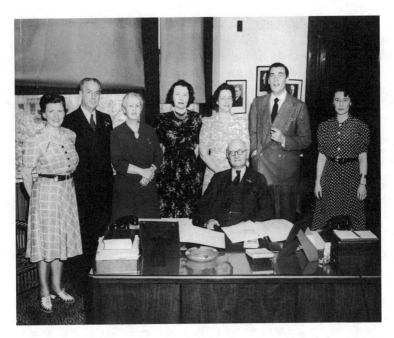

Image 1.1 Irwin Esmond, chief censor for the State of New York from 1932 to 1945, surrounded by his staff and a visitor (Canadian actor Walter Pidgeon, second from the right)
Source and permission: John Crysler and the Esmond family.

years was Ellis Oberholtzer, a neighbor of the governor. When asked about his qualifications to censor movies, Oberholtzer openly admitted that he "knew little indeed about the motion picture."[15] Only the state censors of New York and Ohio were civil servants with some minimal credentials for their work.[16]

Censors had three options when reviewing a film: they could approve it, require certain cuts to be made before approval (the cuts were called "eliminations"), or ban the film entirely ("banned *in toto*"). Censors did not make such decisions at taxpayer expense. In fact, fees for review (paid by the distributor) ranged from $1 to $3 per original reel. This was generous enough that all state boards returned handsome profits to their states' coffers. New York's profit in 1939, for example, was $200,000. If a board banned a film, the distributor could bring suit. However, since the censorship was a prior restraint—a restriction on communication *before* anyone other than the censors had seen it—the burden of proof fell on the challenger. Thus it was the distributor who had to prove that his movie was not harmful rather than, as is customary in the American legal tradition, the government proving its case against the distributor. This made governmental censorship different from other laws and would work against movie distributors.

What specifically did the censors look for? That clearly changed over time with governmental censors becoming far more active in the early period before Hollywood became adept at patrolling itself in the late 1930s. In most state records, only the category of objection—*obscene, indecent, inhuman, sacrilegious, likely to incite to crime*—was recorded. And because in most cases we do not have the original films, only their scripts, it is nearly impossible to know for sure just what the censors were cutting.[17] But film historian Gerald Butters has been able to unearth evidence of what concerned the Kansas censors. In 1915, Kansas nixed scenes of alcohol consumption, women smoking, sexual suggestion, white slavery, violence, death, provocative dancing, gambling, and worrisome political messages (they banned a 1915 newsreel about the explosive Leo Frank murder case). By the 1920s, they were also banning slapstick comedy, depictions of striking workers, and films about racial problems. In the 1930s they added ridicule of religious sects or races or public officials and any scenes dealing with pregnancy, childbirth, and sex education. Most of these concerns continued through World War II, when the focus shifted, as in all the censoring states, to foreign films.[18]

Not only were the censors unhampered in their work, but because of the way movies were distributed, their influence went far beyond their state's or city's borders. Theaters did not buy the movies they showed; they rented them from distributors called exchanges. Some exchanges covered multiple states. So, a distributor who cut a film to satisfy the censors in New York was not likely to put the objectionable content back in when the movie finished its run in Manhattan and moved across the river to Hoboken, New Jersey. In this way, although only 31 percent of Americans lived directly within censoring states, at least 10 percent more experienced indirect censoring of their movie content. In cities, the saturation of censorship was even higher: many cities in the non-censoring states had set up their own municipal boards as Chicago had done. More than 50 percent of the movie audience was under some form of governmental censorship and 60 percent of Hollywood's revenues came from censoring locales.[19] Putting the two types of governmental censorship together—direct and indirect—it becomes clear that movies were not free of review in much of the United States.

Some within the movie industry were happy to allow censorship. Theater owners and managers found that they suffered much less criticism from the community and could easily deflect criticism by pointing to the censor board if customers objected to movie content. But while exhibitors welcomed the protection, moviemakers and distributors were not happy with governmental censorship. Distributors bore the burden. They not only had to endure the inherent delays involved in submitting a film for review, but also had to pay for the privilege. Moreover, if scenes were ordered removed or a film was banned entirely, it was the distributor who bore the financial loss. So we see a variety of reactions to governmental censorship within the movie industry: relief from the exhibitors, self-regulation attempts from the

moviemaking companies (the Thirteen Points and the Don'ts and Be Carefuls), and consternation from distributors who were ultimately left holding the bag. Hollywood would soon have another reaction.

Hollywood's Own Censorship

During World War I, the moguls of the American film industry, largely immigrants, hoped to prove their Americanism to audiences and politicians. No censorship was necessary when the industry eagerly abetted the federal government's war messages by making inspirational movies.[20] But, when neither Thirteen Points nor Don'ts and Be Carefuls and not even the governmental censors succeeded in quelling all criticism of movie content, the industry came under immense pressure to clean up its act. Much of the pressure, originally from Protestant groups, by the late 1920s was coming from the Catholic Church. Father Daniel Lord, an advisor to Cecil B. DeMille's *King of Kings* (1927), offered to write a better regulation, and the moguls eagerly accepted. Lord produced what came to be called the Production Code in 1930. Unlike the open-ended statutes the state censors worked under, this Code was a specific list of what producers could no longer show. With great fanfare, MPAA introduced the new Code, pledging to provide more wholesome entertainment. But, pressured by declining revenues during the early years of the Great Depression, studios ignored the Code. Catholic leaders became so incensed over racy film content (and much of what was produced between 1930 and 1934 was quite suggestive)[21] that they created a new mass-membership organization, the Legion of Decency, and threatened a nationwide boycott unless the moguls produced more family-friendly content.

In 1934, terrified of losing the largely Catholic urban audiences and to stave off the threatened federal censorship (several bills had been introduced in Congress), MPAA created an enforcement arm, the PCA, and named a Catholic, Joseph Breen, to be its head enforcer. Breen was serious about administering the Code, Catholics were serious about influencing movie content through their box-office clout, and since MPAA controlled most of the first-run theaters through its membership, the industry finally had the clout it needed to control content, deflect criticism, and protect profits.[22] The change in movies from the pre-PCA 1930s to the post-PCA late 1930s is clear. In pre-PCA 1932, Tarzan's Jane wore a scanty costume, revealing much of her torso and legs, but in a 1939 sequel, she was covered nearly neck to knee.[23]

Between the late 1930s and World War II, the period when the Hollywood PCA effectively purified American movies before they got to the governmental censors, the state censors were mostly concerned with fly-by-night operators making exploitation films, other independently made productions, and a few foreign films. Most studio-made movies had little trouble in getting through the state offices.

The American Movie, World War II, and the Cold War

American moviemakers were eager to support the war effort after the 1941 Pearl Harbor attack, and knowing the immense influence of movies, the federal government was only too happy to have their help. But filmmakers were also leery of having to answer to several government agencies, so they requested the creation of one coordinating bureau.[24] The answer was the Bureau of Motion Pictures (BMP), a division of the Office of War Information (OWI). BMP had two goals: it encouraged Hollywood to pursue morale-boosting messages and it also made its own movies, submitting them to Hollywood for their approval and then distributing them to mainstream theaters.[25] Knowing that movies could both further the war effort and foster a more peaceful and cooperative postwar world, the BMP created a code of questions to guide moviemaking capped off with, "will this picture help win the war?"[26] And between 1943 and 1944, Hollywood complied with 71 percent of BMP's requests.[27]

In addition to following the dictates of the PCA, then, America's moviemakers willingly cooperated with official government positions during World War II, abiding (for the most part) by the BMP code. As Clayton Koppes and Gregory Black explain in their 1990 study, " . . . Hollywood became a compliant part of the American war machine . . . when OWI, like PCA, showed that censorship would be smart showmanship, the industry was only too eager to cooperate."[28] Hollywood's compliance included positive treatment of the wartime allies—the Soviet Union, Great Britain, and China—as well as attempts clearly focused on the war's end to show the Axis enemies not as evil incarnate, but as temporarily misguided.

How effective was this cooperative control? Koppes and Black see it as truly effective. Indeed, in telling moviemakers both what should be excluded and what should be included, the BMP effected "the most comprehensive and sustained government attempt to change the content of a mass medium in American history."[29] Garth Jowett in 1976 deemed it both effective and necessary, noting that under BMP, the American movie "essentially did what was asked of it during World War II. It furthered the military effort by disseminating information about the war to the public; it helped to explain the enemy and his ideology; it emotionalized the American public as no other medium was capable of doing; it told Americans about their allies and what they were fighting for; and last, and most important, it continued to entertain millions."[30] Was it censorship? Not in the same sense as the state censors: BMP had no legal enforcement authority over films shown in the United States, but it did significantly affect movie content.

Nor was the BMP the only governmental agency trying to affect the content of movies before production. Another agency had been at such work for decades. J. Edgar Hoover's Federal Bureau of Investigation (FBI) joined forces with an anti-communist industry group called the Motion Picture Alliance (MPA) and the House Committee on Un-American Activities (HUAC) and

together the three succeeded in chasing most political and social message films from American theaters by the late 1940s and early 1950s. As John Sbardellati has recently revealed, this troika dedicated to rousting communists from Hollywood was able to "dramatically alter film content."[31] Although effective in restraining content through persuasion or intimidation, like their counterparts in the BMP, the anti-communist groups differed from the state and local film censors. The BMP and J. Edgar Hoover's allies were limited to bullying the industry into going along with their ideas of what was good entertainment and what was subversive, but the state censors had the final say, with the legal authority of the state behind them, and all the benefits of a reversed burden of proof that not only helped the censors in their work, but was also judicially blessed.

Judicial Approval/Judicial Indifference

Between the first legal challenge in 1909 and the end of World War II, moviemakers generally went along with censorship, but some movie distributors were so concerned about censorship interference with their business freedom that they brought legal challenges. None was, however, successful in making any meaningful dents in the censors' clout. And only one distributor argued that movie censorship violated the First Amendment's free speech protection. This 1915 case (*Mutual Film v. Ohio*) resulted in a resounding defeat for film freedom. Facing the technology of moving pictures for the first time, the Supreme Court found they were "a business pure and simple" and therefore deserved no free speech rights.[32] For the next four decades after this validation of state censorship from America's highest court, judges routinely accepted the idea that the governmentally empowered bureaucrats in the state and local censor boards knew best.

A friendly legal culture for censors meant a hostile legal culture for any who would challenge them. Throughout the 1920s and 1930s, some distributors did fight government censors but none dared argue that such censorship was a prior restraint or that the First Amendment's free speech or free press guarantees had been violated.[33] In the 1940s, however, World War II caused shifts in both film culture and legal culture. Change came slowly, however, especially for those growing restive under the restrictions of the Production Code and the governmental censors. Foreign films—many made without the need for any trade group approval in their home counties—returned to the American market in 1946, and American moviegoers saw something quite different from the happy-ending melodrama or quaint comedy that comprised the bulk of the output from American studios.[34]

Sensing a new mood among sophisticated moviegoers, distributors began to import much more daring and controversial European movies such as *Roma città aperta* (*Open City*, 1945), *Ladri di biciclette* (*Bicycle Thieves*, 1948),

and *Riso amaro* (*Bitter Rice*, 1949). And increasingly, when the PCA denied approval for such movies to be shown in their member theaters or when governmental censors banned their films outright, distributors sued.

These distributors were not what we might expect. They were not the Paramounts, MGMs, or Universals. They were independents—small businessmen with little money and a great deal to lose when censors messed with their product. When filmgoers started to thirst for less bland, more sophisticated, more realistic fare in the 1940s, these distributors filled the demand, protesting legally when their films were cut. In all the 45 years of censoring movies before World War II, there had only been 18 challenges in state courts with only one making it to the United States' highest court. There were more challenges than that 45-year accumulation in just the first ten years after the war, with five making it to the Supreme Court and many more to come. And while courts had upheld the censors in all the censor challenges save one before the war, with each new challenge after the war, judges began to doubt the invincibility of those censor edicts, and the tide began to turn away from those who protect Americans from immoral content and toward those who value movies for the communication of ideas.

The First Amendment to the Rescue

The First Amendment to the US Constitution reads in part, "*Congress* shall make no law . . . abridging the freedom of speech, or of the press." But state and local governments were not so restricted: they could pass laws restricting free speech, like censorship of movies. Courts did not consider that a violation of the US Constitution. This only started to change in 1925. How the change came about requires a bit of explanation. In 1867, US Congress passed and the states ratified the 14th Amendment. This was intended to keep state governments from infringing the rights of the newly freed slaves, so it prohibited states from passing laws that deprived people of liberties without due process of law. However, it did not spell out what those "liberties" were. In 1925, the Supreme Court decided that free speech was so basic a right that it should be a protected "liberty."[35] Thus began a major shift in constitutional interpretation, and gradually over the course of the mid-twentieth century the Court used the same reasoning to bring nearly all of the freedoms protected by the Bill of Rights—free press, freedom of religion, criminal procedures—into the list of "liberties" that states could no longer legislate away. This 1925 shift would eventually help movie distributors challenge censorship in federal courts, but it would take another 25 years. In the *Mutual* case, the Supreme Court had definitively dismissed movie rights 10 years earlier and would not hear another film censorship challenge until 1952. In those intervening years, the state and local censors, still seen as protecting society from evil influences, reigned nearly supreme in their determinations of what could and could not be seen on their screens.

While the process of appreciating movies as art and as speech worthy of protection would take time to give results, it ramped up after World War II, and both PCA and governmental movie censors found themselves repeatedly challenged. As both American movie studios and distributors of foreign films began to answer audience demand for greater realism, censors faced a major dilemma. Their job was to hold the line on cultural change—to block threatening ideas and questionable content. While most censors did adapt somewhat to the changing circumstances, the manifestation of such reform was too slow for their critics—free speech advocates, film critics, movie aficionados, independent producers, and distributors.

A resolution would have to come from the courts, a fact realized by the distributors who began to sue. The first postwar challenges came up on two fronts: one from independents challenging the governmental censors and the other from an MPAA member challenging PCA. The insider confrontation came from Howard Hughes—legendary pilot, businessman, and part-time film producer who loved to buck the system. Hughes had made a movie during the war called *The Outlaw* (1943). The female lead, Jane Russell, had clearly been chosen not for her acting ability but for her dazzling physique. The movie's plot was thin, Russell's blouses were low-cut, her skirts were short, the entendres were double, the ads were blatantly sexy, and *The Outlaw* lost its exhibition seal. Hughes was the first member producer to openly challenge PCA when he unsuccessfully sued, but he would not be the last. He bucked the state censors, too. Maryland, Pennsylvania, Ohio, and New York had all ordered extensive eliminations or banned the film outright. Hughes sued the New York censors in 1948 and became the first to base his argument against censorship as a violation of free speech rights since the *Mutual* case of 1915. Mutual had lost and Hughes too lost: the time was not yet ripe for such an argument.

Independent distributors fared better than Hughes, but they too had a long way to go before they were able to end governmental censorship. In the late 1940s, three cases challenged the censors, for the first time claiming not that the censors were wrong about a film (as had the pre-war challengers) but that the censor statutes under which they worked were unconstitutional. Two were serious films about race relations: *Lost Boundaries* (1949) and *Pinky* (1949). The other was a 40-minute Italian film titled *Il miracolo* (*The Miracle*, 1948).[36] In each case, the first and second rounds in state court went to the censors, as had been the case for four decades.

Each film's distributor then petitioned the Supreme Court for hearing, sensing that the time was ripe for that restrictive 1915 *Mutual* decision to be reconsidered. After all, the art of motion picture had changed substantially since then. Moreover, the US legal culture was entering an era in which the rights of the individual were displacing the collectivist ideals that undergirded censorship, and some of the Supreme Court justices were starting to sound sympathetic to calls for freedom of the screen. In an unrelated 1948 antitrust case, Justice William O. Douglas remarked, "We have no doubt that moving

pictures, like newspapers and radio, are included in the press whose freedom is guaranteed by the First Amendment."[37] Since this case involved monopolistic movie business practices and censorship was not at issue, the words did not threaten state censors, but they did hold much promise for disgruntled distributors.

The Supreme Court declined to hear the *Lost Boundaries* case but it did agree to hear *The Miracle* and later, *Pinky*. *The Miracle* was promising as a test case: it was neither obscene nor indecent. It told the story of a deranged Italian peasant woman who believes that she has been visited by St. Joseph and that the child in her womb is divine. When her neighbors learn this, they taunt her mercilessly, forcing her to leave her village and wander homeless, giving birth to her child in an abandoned church. Although director Roberto Rossellini claimed that he intended to portray "man's inhumanity to man" rather than any commentary on religion, and although Italian Catholics seemed unconcerned, American Catholics took umbrage, particularly New York City's Archbishop, Francis Cardinal Spellman. *The Miracle* had been duly licensed by the New York State censors (officially known as the Motion Picture Division), but the Archbishop orchestrated so much pressure on New York state authorities that they revoked its license, agreeing belatedly with the Archbishop that it was indeed sacrilegious.

Joseph Burstyn, owner of the American distribution rights to *The Miracle*, would prove a worthy adversary to both the State of New York and the archdiocese. Burstyn was a highly principled businessman who loved both foreign films and American freedoms, so he sued to get the license back. The case came up through three layers of New York State courts, based at each turn on the First Amendment rights to free speech, free press, and freedom of religion, and each time Burstyn lost.

When the case reached the Supreme Court in 1952, its prospects looked grim. Between the governmental censors and the PCA, movie content had been controlled for four decades with American moviegoers voicing no great concern. Judges had also repeatedly added their endorsements. The American Civil Liberties Union (ACLU) was interested but it had other issues taking up its time and resources and could offer only limited help. Even American moviemakers, who had been willing to go along with censorship, were facing declining revenues after the war and increasing competition from television and foreign films. By 1952 the MPAA was starting to realize that censorship—neither the state variety nor its own—was such a good idea. The independent distributors, who had been the only legal challenges to movie censorship, would henceforth have a new, although hesitant, ally.

Film critics also became an ally. Once they saw censorship's effect on some foreign films in the 1930s, critics used their reviews to rail against bureaucrats cutting the work of film directors.[38] Still, Joseph Burstyn faced the Supreme Court alone with only an amicus brief from the ACLU and a few other organizations. Nevertheless, he was able to convince all the Supreme Court justices

that movies deserved the free speech and free press protections of the First Amendment and that censoring for sacrilege was simply too vague.

And so, in 1952 the Supreme Court overturned the 1915 *Mutual* decision. However, there was little time for dancing in the street for the justices had stopped short of declaring statutory motion picture censorship unconstitutional. Writing for the unanimous Court, Justice Tom Clark wrote that censoring under a "narrowly drawn statute" would still be allowed. This meant that the determination of what was obscene would still be left to the state censors. But henceforth, their work would be scrutinized by the courts. No longer would the censors be the only deciders of how their statutory language should be interpreted.

A concurring opinion written by Justice Stanley Reed proved prescient: Reed was concerned that the Court was setting itself up to become a sort of super-censor.[39] And, indeed, over the next 13 years, the Court would be called upon to settle recurring questions of what was and what was not censorable. It would take five more cases for the Supreme Court to settle the controversy over whether films should be controlled by statute.[40]

Meanwhile, producers and distributors were beginning to challenge the PCA. A few American studios, suffering from lower revenues early in the war period and facing increased competition from foreign films after the war, decided to buck the Code.[41] In 1953, Otto Preminger went public with an attack when he opened *The Moon is Blue* without the PCA's seal and proved that even without the first-run theaters, a film could make money. This was bad news for the PCA censors indeed. *The Man with the Golden Arm* (1955), *Tea and Sympathy* (1956), and *Baby Doll* (1956) further tested the limits of the PCA. In response, the PCA made several revisions to its regulations. State censors, however, continued using the same statutory language (minus sacrilege) they had started with back in the 1920s. Their interpretation of the language changed somewhat with the times, but legally their mandate remained the same.[42]

Hard Times for the Censors

Starting with *The Miracle* case, the state censors began to lose their aura of invincibility in court. Within a few weeks, the Supreme Court overturned a small Texas town's ban of *Pinky*, and the following year, the Court struck down New York's ability to censor on the basis of a film's "immoral" content (in the 1950 French film, Max Ophüls's *La Ronde*) and Ohio's authority to censor a film for being "harmful" (in the 1951 American film, Joseph Losey's *M*).[43] Two years later proved to be a very bad year for censors: Kansas lost the ability to censor *The Moon is Blue* as obscene, an Ohio court tossed out its censor board entirely calling its statute "repugnant to the sacred Bill of Rights," and the Massachusetts Supreme Court overturned its censoring scheme as an unconstitutional prior restraint.[44] The next year, 1956, saw the demise of the nation's

first state censor statute when the authority of the Pennsylvania board was axed by its state supreme court. Legislators re-enacted the law in 1959 only to have it struck down a second time. Pennsylvania was done censoring for good in 1961.

Between 1954 and 1961, four of the seven censoring states had had their statutes struck down by their state courts yet the Supreme Court, which had led the way with the *The Miracle* decision in 1952, was still reluctant to declare all censorship unconstitutional. In a series of decisions, it found in favor of the distributors and against the censors each time, but did so in the most cryptic of terms and without confronting the issue of prior restraint versus free speech head on. By 1961, these accumulated decisions left only New York, Kansas, Virginia, and Maryland and a few cities like Chicago and Atlanta, and their legality was far from sure. Both the governmental censors and the Production Code administrators henceforth faced unrelenting attack. In the next five years, New York squared off against seven challengers, Maryland against six, Kansas and Virginia each had only one but for each, that one would prove deadly.

One distributor, tired of the Supreme Court ducking the issue, decided in 1961 to force the question by refusing to submit a film for licensing in Chicago. Since there was no censor judgment in question, the only issue was the constitutionality of the law. Anti-censoring forces held their breath to see what the Supreme Court would do. It was a gamble, and it did not play out well for anti-censorites. In a 5–4 decision—the only post-*Burstyn* decision to go against the distributors—the Court refused to strike down Chicago's ordinance, arguing that local governments should be free to police movie morals as they saw fit.[45]

By 1961, then, movie censors were wounded but hanging on. The Supreme Court justices had put them on a short leash, first denying the right to censor for sacrilege, then immorality, finally leaving only obscenity censored under a "narrowly drawn statute." In Hollywood, the Production Code administrators were also working from a shortened list of excisions. The Code had been revised several times, each time to reflect public taste and the realities of censoring in an age of expanding individual rights.

Kicking the state censors while they were down seemed a good idea to one frustrated Maryland exhibitor. To test the constitutionality of censorship at its most basic level, Ronald Freedman decided to openly show a nonsubmitted film to his patrons in 1962. When the police came to arrest Freedman, he instructed his employees to re-sign the theater's marquee to read "Fight for Freedom of the Screen." Losing every round in the Maryland courts, three years later Freedman got the Supreme Court justices to agree to hear his case (since *Burstyn*, the Court had not turned down a single movie censorship case). This time the justices decided to end movie censorship, but they did so in a roundabout way. They stopped short of declaring all prior censorship unconstitutional but did reverse the burden of proof. Previously, the burden was on the distributor to prove that his movie was not obscene. But with the *Freedman* decision, the Supreme Court placed the burden on the censors: if they did not

want a movie shown, they had to institute legal proceedings and prove to a judge that it would be harmful. Failing to do that, any movie would have to be released.[46] It was, said Maryland's attorney general, "the Armageddon of motion picture censorship."[47]

Freedman's case meant that any state that wanted to continue censoring after 1965 had to redraw its statute to remove all vestiges of prior restraint. New York made a half-hearted attempt that was promptly ruled unconstitutional by its state court. Virginia and Kansas were each undone by state court action in 1966, leaving, ironically, only Maryland. Its legislators breathed new life into its censoring bureaucracy, and Maryland continued to be the only state with motion picture censorship.

So, by 1966, all that was left was Maryland and the enfeebled PCA: that year fully 41 percent of all American-made films had not bothered to get a seal. Two years later, the PCA was dead, replaced by a rating system (see Chapter 2). Maryland's censors hobbled on until 1981 when its legislature finally grew tired of paying the legal fees from continuing challenges and shut the board down.

Conclusion

What killed governmental movie censorship? It was a combination of factors. As we have seen, censorship was born of a society that thought in terms of rights as belonging to the community, not the individual. As that idea morphed during and after World War II and the United States entered what has been called the "rights revolution," communitarian ideals gave way. An individual-oriented society is not likely to accept governmental interference with entertainment, art, and other intellectual activities.

In the 1950s, the maturation of movie as an art form—as a legitimate medium of expression—coupled with the industry's self-control in the PCA also made it easier for the judiciary to listen receptively to arguments about free speech and free press rights. The result was the series of Supreme Court decisions expanding movies' First Amendment rights. Film critics drew attention to the arbitrariness of governmental censorship, and the ACLU contributed legal expertise and moral support. But, in the end, the credit should go to the film producers who, emboldened by the Supreme Court decisions, later bucked the PCA and to the independent distributors and exhibitors who sued the censors. Because the MPAA is a voluntary association, its members can only whittle away from within, which producers like Otto Preminger did when they released films without a Code seal. By doing so, they forced change. The independent distributors who faced the state censors did not wait for legislators to catch up with society; they demanded that governmental interference with what they could produce and what audiences could see be stopped in the only way they could—through the courts.

It took 20 years, but, in the end the major players in the demise of governmental censorship were a few intrepid distributorsand a receptive judiciary.

The Code was crippled by a few independent producers demanding creative freedom. In the background was a changing society, activist film critics, and a sophisticated audience craving new art.

Notes

1. See Black, G. (1994) *Hollywood Censored: Morality Codes, Catholics and the Movies*. Cambridge: Cambridge University Press; Black, G. (1997) *The Catholic Crusade against the Movies 1940–1975*. New York: Cambridge University Press. Other studies of the Production Code era include Leff, L. and J. Simmons (1990) *The Dame in the Kimono: Hollywood, Censorship, and the Production Code Administration from the 1920s to the 1960s*. New York: Grove Weidenfeld; Jacobs, L. (1991) *The Wages of Sin, 1928–1942*. Madison: University of Wisconsin Press; Miller, F. (1994) *Censored Hollywood: Sex, Sin and Violence in Hollywood*. Atlanta: Turner; Walsh, F. (1996) *Sin and Censorship: The Catholic Church and the Motion Picture Industry*. New Haven: Yale University Press.
2. Leff and Simmons (1990), p. 7.
3. There are several sources on governmental censors. See Carmen, I. (1966) *Movies, Censorship and the Law*. Ann Arbor: University of Michigan Press; Randall, R. (1968) *Censorship of the Movies: The Social and Political Control of a Mass Medium*. Madison: University of Wisconsin Press; Butters, G. (2007) *Banned in Kansas: Motion Picture Censorship, 1915–1966*. Columbia: University of Missouri Press; Wittern-Keller, L. and R. Haberski (2008) *The Miracle Case: Film Censorship and the Supreme Court*. Lexington, Kentucky: University Press of Kentucky; Wittern-Keller, L. (2008) *Freedom of the Screen: Legal Challenges to State Film Censorship, 1915–1981*. Lexington: University of Kentucky Press.
4. Jowett, G. (1976) *Film: The Democratic Art*. Boston: Little, Brown and Company, p. 12.
5. For more, see Gurstein, R. (1996) *The Repeal of Reticence: A History of America's Cultural and Legal Struggles over Free Speech, Obscenity, Sexual Liberation, and Modern Art*. New York: Hill and Wang; Grieveson, L. (2004) *Policing Cinema: Movies and Censorship in Early Twentieth Century America*. Berkeley: University of California Press.
6. See Springhall, J. (1998) Censoring Hollywood: youth, moral panic and crime/gangster movies of the 1930s, pp. 135–154 in *Journal of Popular Culture* 32 (3).
7. Rabban, D. (1997) *Free Speech in Its Forgotten Years*. Cambridge: Cambridge University Press.
8. For more, see Rosenbloom, N. (1987) Between reform and regulation: the struggle over film censorship in progressive America, pp. 307–325 in *Film History* 1; and Rosenbloom (2004) From regulation to censorship: film and political culture in the early twentieth century, pp. 369–406 in *Journal of the Gilded Age and the Progressive Era* 3 (4).
9. For more on the films produced in this era, see Brownlow, K. (1990) *Behind the Mask of Innocence: Sex, Violence, Prejudice, Crime: Films of Social Conscience in the Silent Era*. Los Angeles: University of California Press.
10. *Block v. Chicago*, 239 Ill. 251, 87 N.E. 1011 (1909).

11. Florida and Louisiana also adopted censoring statutes but Florida's statute required only New York State approved movies to be shown and Louisiana's 1935 law was never enforced. See Carmen (1966), pp. 126–129. After defeating a censorship statute like those in the other states, Massachusetts started using a colonial-era statute in 1926 to empower local officials to decide if a movie was fit to be shown on Sundays.
12. Records of the New York censors, the Motion Picture Division of the Department of Education, are housed at the New York State Archives in Albany. This archive contains the largest collection of American film scripts. Other censor board records can be found in the state archives of Virginia, Maryland, Kansas, Ohio, and Pennsylvania.
13. Carmen (1966), p. 11.
14. For more on the legal culture of the Progressive Era and how it viewed movies, see Wittern-Keller (2008) pp. 31, 39.
15. Oberholtzer quoted in Saylor, R. (1999) Banned in Pennsylvania!, p. 15 in *Pennsylvania Heritage* (Summer).
16. For more on the censor qualifications, see Wittern-Keller (2008), pp. 29–36.
17. For an example of how difficult it can be to find original versions of censored films, see the story of the original *Baby Face* (1933) in Kerr, D. (January 9, 2005) A wanton woman's ways revealed, 71 years later, *New York Times* [available at: http://www.nytimes.com/2005/01/09/movies/09kehr.html?pagewanted= print&position=]
18. See Butters (2007), chapters 3, 7, 8, and 9.
19. Leff and Simmons (1990), p. 8. The number of municipal censor boards varied over time and has been estimated to be as high as 300 in 1929 and as low as 90 in 1957. See Black (1997) and Walsh (1996), p. 57. For the operation of municipal boards, see Randall (1968) and Carmen (1970).
20. For a book-length treatment of the movie industry during World War I, see DeBauche, L. (1997) *Reel Patriotism: The Movies and World War I.* Madison: The University of Wisconsin Press.
21. See Doherty, T. (1990) *Pre-Code Hollywood: Sex, Immorality, and Insurrection in American Cinema, 1930–1934.* New York: Columbia University Press. See also Vieria, M. (1999) *Sin in Soft Focus: Pre-Code Hollywood.* New York: Abrams.
22. See Doherty, T. (2009) *Hollywood's Censor: Joseph I. Breen & the Production Code Administration.* New York: Columbia University Press. See also Leff and Simmons (1990).
23. *Tarzan and His Mate* (1934) and *Tarzan Finds a Son* (1939). To see the differences in costuming, see http://www.pictureshowman.com/articles_genhist_censorship.cfm, accessed on June 22, 2012.
24. For the most complete treatment of WWII governmental relations with Hollywood, see Koppes, C. and G. Black (1990) *Hollywood Goes to War: How Politics, Profits and Propaganda Shaped World War II Movies.* New York: University of California Press. For a near-contemporaneous view, see Larson, C. (1948) The domestic motion picture work of the Office of War Information, pp. 434–443 in *Hollywood Quarterly* 3 (4). Interestingly, Larson maintains that the work of the BMP effectively ended in the summer of 1943 when Congress drastically cut its budget, leaving the Hollywood producers relatively free to create morale-boosting messages as they saw fit for the remainder of the war. Koppes and Black (1990, p. 139) argue that the governmental interference with movies went on, indeed even strengthened, as the

work of control merely shifted from the wing-clipped BMP to the Overseas Branch whose reviewers used both the "club of censorship" and the "carrot of reconquered markets."

25. Larson (1948), p. 438.
26. Koppes and Black (1990), pp. 66–67.
27. Ibid., p. 323.
28. Ibid., p. 141.
29. Ibid., p. 324.
30. Jowett (1976), p. 327.
31. Sbardellati, J. (2012) *J. Edgar Hoover Goes to the Movies: The FBI and the Origins of Hollywood's Cold War.* Ithaca: Cornell University Press, p. 185.
32. *Mutual Film Corp. v. Industrial Commission of Ohio,* 236 U.S. 230 (1915).
33. For a discussion of each of these cases, see Wittern-Keller (2008), Chapter 4.
34. See Balio, T. (2010) *The Foreign Film Renaissance on American Screens, 1946–1973.* Madison: University of Wisconsin Press.
35. *Gitlow v. New York,* 268 U.S. 652 (1925).
36. For more on *The Miracle* and its director, Roberto Rossellini, see Johnson, W. (2008) *Miracles and Sacrilege: Robert Rossellini, the Church, and Film Censorship in Hollywood.* Toronto: University of Toronto Press. For the cultural context of *The Miracle* before, during, and after the Supreme Court decision, see Wittern-Keller and Haberski (2008).
37. *United States v. Paramount, Inc.,* 334 U.S. 131 (1948).
38. For more on the role of film critics, see Haberski, R. (2001) *It's Only a Movie! Films and Critics in American Culture.* Lexington: The University Press of Kentucky.
39. *Joseph Burstyn, Inc. v. Wilson,* 343 U.S. 495 (1952).
40. For a detailed discussion of the case and its effect on the Constitution, see Wittern-Keller and Haberski (2008).
41. Leff and Simmons (1990), pp. 114–116, 130–131.
42. It is impossible to determine how the censors were applying the statutory language at any given time since in most cases we do not have access to original films. We have the original scripts in the New York State Archives, but a script does not tell the whole story—facial expressions, costumes, and nuances that censors might have cut. The only real way to track the changes in censoring over time would be to have the original film, the script, and the censored film for comparison.
43. *Gelling v. Texas;* 343 U.S. 960 (1952); *Superior Films v. Department of Education of Ohio,* 346 U.S. 587 (1953).
44. *Holmby Productions v. Vaughn,* 350 U.S. 870 (1955); *RKO Radio Pictures, Inc. v. Board of Education,* 130 N.E. 2d 845 (1955); *Brattle Films, Inc. v. Commissioner of Public Safety,* 333 Mass. 58,127 N.E.2d 891 (1955).
45. *Times Film Corp. v. City of Chicago,* 365 U.S. 43 (1961).
46. *Freedman v. Maryland,* 380 U.S. 51 (1965).
47. Thomas J. Finan as quoted in the *Baltimore Sun,* March 2, 1965.

2

"American morality is not to be trifled with": Content Regulation in Hollywood after 1968

Jon Lewis

In 1968, the American film industry was in its second decade of a box office slump. Many Hollywood executives and filmmakers put the blame on the Production Code, a strict regime of censorship authored by a Jesuit priest (Daniel Lord) and a Catholic pro-censorship activist (Martin Quigley).[1] The Code had hamstrung production since 1930 and American filmmakers and filmgoers seemed primed for a change (see Chapter 1).

To replace the PCA (the Production Code Administration, which enforced the old Code), the Motion Picture Association of America (MPAA) introduced CARA, the Code and Rating Administration, later renamed the Classification and Rating Administration. CARA's mandate was to classify films according to a "Voluntary Movie Rating System." This new system was built upon the notion of variable obscenity: that all movies need not be suitable for all audiences, that what might be suitable for adults might not be suitable for children (but might be worth making and viewing anyway). The legal basis for variable obscenity hearkened back to Justice Learned Hand's landmark opinion in a 1913 federal court case, *U.S. v. Kennerly*, the first in a series of breaks with the so-called *Hicklin* standard that called for the ban of "obscene" works that might "deprave and corrupt those whose minds are open to such immoral influences, and into whose hands a publication of this sort might fall."[2] Hand proposed a break with such a rigid standard as follows: "it seems hardly that we are even to-day so lukewarm in our interest in letters or serious discussion as to be content to

reduce our treatment of sex to the standard of a child's library in the supposed interest of a salacious few, or that shame will for long prevent us from adequate portrayal of some of the most serious and beautiful sides of human nature."[3]

Both regimes of censorship—the PCA and CARA—regulated entry into the marketplace. Success (of each regime) thus hinged on corporate relationships between one studio and another, and between the studios and the National Association of Theater Owners (the other NATO) who, absent any obvious financial advantage with regard to either system, voluntarily complied. Both the Production Code and the new rating system regarded content censorship as a matter of industrial policy and public relations, the consequence of studio politics and not, as advertised, public morality. Both reflected the industry's cynicism about public opinion and about film content, both of which the studios have historically regarded as malleable and temporary.[4]

The Commission on Obscenity and Pornography

While it is axiomatic that a sea-change in sexual culture and attitudes toward sexuality took shape in the 1960s in the United States, and that that change is what urged the studios to replace the Code with the rating system, the story is more complicated than that. Indeed, just as the so-called Age of Aquarius had seemingly dawned, a very different America loomed: Richard Nixon's America, in which a not-so "silent majority" would control public opinion.

America was at a cultural crossroads in 1968, but the direction for the foreseeable future was not so easy to determine. So when MPAA president Jack Valenti proposed a new movie rating system, one that (in his words) promised to "free the screen," industry-wide adoption was accompanied by rhetoric celebrating the virtues of self-censorship, parental guidance, and industry responsibility.

A key here as well was President Lyndon Johnson's "Great Society" outlined in his 1965 State of the Union address. The Great Society was as ambitious a social program as President Franklin D. Roosevelt's New Deal, just as progressive and just as dependent on so-called "big government." The legacy of the "Great Society" includes Medicaid and Medicare (enabling health care for the poor and elderly); VISTA (a sort of Peace Corps for America's inner cities); the food stamp program (introduced by Johnson as part of his War on Poverty); the creation of new cabinet offices (the Departments of Transportation and of Housing and Urban Development); progressive federal agencies including the Equal Employment Opportunity Commission, the National Endowments for the Humanities and the Arts, and the federally funded Public Broadcasting System (PBS); and a comprehensive social study, the Commission on Obscenity and Pornography.

The Commission was formed in 1967 in what turned out to be Johnson's last full year in office. So when the Commission's findings were published in the fall of 1970, Nixon reacted swiftly with a torrid press release: "I have evaluated that report and categorically reject its morally bankrupt conclusions." Warning that "American morality is not to be trifled with," Nixon remarked bluntly: "Smut should not be simply contained at its present level; it should be outlawed in every state in the union."[5]

What the report signaled all too clearly was the emerging division in American society between secular humanists on the Left and a religious, conservative contingent on the Right, between an educated professional class ("the nattering nabobs of negativism," the "effete corps of impudent snobs" so dubbed by Nixon's vice president Spiro Agnew) and the working class in the South, Mid- and South-west. In miniature, it foreshadowed the culture wars of the subsequent 40 years. Nixon repudiated the Commission's report but could do nothing to prevent its publication or limit its play in the popular press during his tenure as president. But the Right would get the final word on the subject 16 years later with the publication of *The Final Report of the Attorney General's Commission on Pornography*, the so-called Meese Report, published at President Ronald Reagan's behest in 1986.[6] The 1970 commission report focused on scientific studies and used selected findings to support an absolute civil libertarianism. The 1986 Meese Report eschewed science in favor of the personal anecdote; hour after hour, page after page of testimonial and confessional from victims of pornography. And if the procession of ruined lives was not enough, the new Commission focused on the role of organized crime in the distribution of pornography.

Even if the Mafia scenario was in fact accurate, the Commission begged a question they had no intention of answering: if pornography was deregulated and decriminalized, would not a more legitimate, transparent business model become the norm? The 1986 study regarded the notion of decriminalization as "starkly obsolete." On that score, at least, they were right. By then the silent majority had met the enemy and they had won.

Movies and the First Amendment

Jack Valenti had one eye on the courts when he devised the rating system, and he arguably had his other eye on the box office. What Valenti seemed to intuit was that the two were inextricably connected, that progressive public sentiment and a uniquely free market between 1968 and 1973 (supported whole-heartedly by the first Commission report) seemed less a precedent than a problem waiting to be solved, that "freeing the screen" was one thing, a completely unregulated marketplace quite another.

The culture war set in motion by the Commission on Obscenity and Pornography in which a politically progressive current of popular thought was

JACK VALENTI *founder, MPAA ratings system*

Image 2.1 Jack Valenti discussing the voluntary movie rating system in *This Film Is Not Yet Rated* (Kirby Dick, 2006)

eventually contained and then reversed by a trenchant (and familiar) American Puritanism found a parallel in the United States Supreme Court's 15-year struggle with what Justice John Harlan called "the intractable obscenity problem." Especially relevant to Valenti was Justice William Brennan's attempt to posit a commonsensical legal definition of obscenity beginning with a 1957 case, *Roth v. United States:* "The test for obscenity is whether to the average person, applying contemporary community standards, the dominant theme of the material, taken as a whole, appeals to prurient interest."[7] In the so-called *Memoirs* case nine years later, Brennan added four significant clarifications: (a) a work cannot be proscribed unless it is "utterly without redeeming social importance," and hence material that deals with sex in a manner that advocates ideas, or has literary or scientific or artistic value or any other form of social importance, may not be held obscene and denied constitutional protection, (b) "the constitutional status of allegedly obscene material does not turn on a 'weighing' of its social importance against its prurient appeal, for a work may not be proscribed unless it is 'utterly' without social importance," (c) "Before material can be proscribed as obscene under this test, it must be found to go substantially beyond customary limits of candor in description or representation," and (d) "The 'contemporary community standards' by which obscenity is to be determined are not those of the particular

local community from which the case arises, but those of the Nation as a whole."[8]

Valenti adopted Brennan's 1966 definition for his 1968 movie ratings system and in doing so rejected the strict civil libertarian argument staked out by Justice William O. Douglas, who viewed any and all attempts to qualify the First Amendment as something akin to thought control. (Importantly, Douglas's position was clearly influential to the authors of the Commission's report, published two years after the ratings system went into effect.) Douglas argued that if one followed Brennan's obscenity standard (outlined above), "punishment is inflicted for thoughts provoked, not for overt acts or anti-social conduct." As to the issue of "community standards"—even when those standards were, in Brennan's odd logic, synonymous with national standards—Douglas bristled: "Any test (for obscenity) that turns on what is offensive to community standards, is too loose, too capricious, too destructive of freedom of expression to be squared with the First Amendment . . . This is community censorship in one of its worst forms. It creates a regime where, in the battle between the literati and the Philistines, the Philistines are sure to win."[9]

Valenti was not an attorney. He was an advertising man and a savvy political player. The rating system after all was something the MPAA would have to *sell* to its members, to the exhibitors who would have to enforce it, and to the American filmgoer. In his effort to work in concert with the Court, Valenti turned to his second-in-command, Louis Nizer, a Hollywood attorney (whose client list included: Johnny Carson and Charlie Chaplin) who ably built the new rating system upon a series of Court precedents, including many First Amendment cases that did not involve movies per se, like *Redrup v. New York*, a case that imposed practices and procedures at the Court that in retrospect reveals the folly of content censorship.[10] Robert Redrup was a *clerk* at a New York City newsstand. He was arrested after selling two paperbacks, *Lust Pool* and *Shame Agent*, to an undercover policeman for $1.65. After considering *Redrup*, the justices determined that obscenity must be decided on a case by case—novel by novel, film by film, basis. It thus required the Justices to view a wealth of exhibits—films, books, and photographs—before they could render decisions in obscenity cases.

From 1967 to 1973, the screening of relevant exhibits in film—obscenity cases—collectively referred to as "movie day" at the Court—offered the jurists a strange, sometimes surreal diversion. Convened in a basement storeroom, seated on folding chairs in the dark, six Supreme Court Justices and all of the clerks did their civic duty and watched dirty movies. By the late 1960s, Justice Harlan had such bad eyesight he had to sit just a few feet from the screen. Even up so close to the action Harlan could only make out shadows and outlines. Inevitably, a fellow Justice or clerk would sit next to him in order to provide a running commentary. Prompted during appropriate scenes, Harlan was reputed to exclaim: "By Jove" or "Extraordinary." Clerks openly made light of movie day. At appropriate and sometimes inappropriate points in a given film,

under cover of darkness, clerks were wont to call out, poking fun at Justice Potter Stewart: "That's it, that's it! I know it when I see it!"[11] Justice Thurgood Marshall's quips were often more entertaining than the film under review. During the screening of a picture in a 1970 case, one of a number of hard-core films framed by pseudo-scientific discourse so as not to appear "*utterly* without redeeming social importance," an actor posing as a psychologist concluded the hard-core action by observing: "And so our nymphomaniac subject was never cured." To which Marshall added: "Yeah, but I am." During the last few minutes of a screening of Russ Meyer's *Vixen!* (1968), a soft-core feature that ends as an Irish-communist-terrorist hijacker bound for Cuba offers a treatise on the relative merits of communist and capitalist societies, Marshall ironically quipped: "Ah the redeeming social value."[12]

The case that finally resolved the intractable obscenity problem at the Court was *Miller v. California*, a 1973 case that concerned the mass mailing of an advertisement circular by an erotic bookseller named Marvin Miller. The circular touted four books: *Intercourse, Man-Woman, Sex Orgies Illustrated*, and *An Illustrated History of Pornography*, and one film, *Marital Intercourse*. When the circular arrived, unsolicited, at a Newport Beach restaurant, the manager and his mother promptly called the police. They filed a complaint and Miller was arrested for violating the California state criminal obscenity statute. Miller was tried and convicted and his appeals were all denied. By the time the US Supreme Court agreed to hear the case, at stake was not only or not really the fate of one pornographer but also the state's right to adopt and enforce an obscenity statute stricter than the one elaborated by the federal judiciary.

The US Supreme Court, with four new Nixon appointees, was finally configured in a way that might finally resolve the intractable obscenity problem.[13] Writing for the 5–4 majority in July 1973, Chief Justice Warren Burger used the *Miller* case to establish a new standard as well as a new procedure strictly limiting federal oversight. The new standard explicitly targeted hard-core—which again was assumed to be something prosecutors would *know when they saw it*—and effectively left the dirty work of content censorship to ambitious local prosecutors and antiporn activists.

Douglas, in a dissent joined by Brennan, Stewart, and Marshall, bristled at the so-called Nixon Court's decision to hold Miller accountable to what amounted to a new state procedure for applying and enforcing a strict(er) obscenity standard: "Today we leave open the way for California to send a man to prison for distributing brochures that advertise books and a movie under freshly written standards defining obscenity which until today's decision were never part of any law." Conflating his due process argument with a defense of the First Amendment, Douglas added: "Obscenity—which even we can't define with precision—is a hodge podge. To send men to jail for violating standards they cannot understand, construe, and apply is a monstrous thing to do in a Nation dedicated to fair trials and due process." In response to the civil libertarian position elaborated by Douglas in dissent, Burger argued that obscenity

had no place in such a lofty debate: "In our view, to equate the free and robust exchange of ideas and political debate with commercial exploitation of obscene material demeans the grand conception of the First Amendment and its high purposes in the historic struggle for freedom."[14]

After July 1973, local authorities routinely viewed porn as a breach of contemporary community standards, a threat to otherwise safe neighborhoods. As a result, hard-core films disappeared from the theatrical landscape in most every community in America. Thanks to MPAA president Jack Valenti's careful attention to the obscenity debate at the Court, his entreaties to the studios to produce and distribute films rated G, PG, PG-13, and R proved prescient.[15] When the *Miller* decision was announced the studios' film slates all fell safely within the new guidelines. The rating system became a symbol of the studios' collective restraint and as such functioned less as a regime of censorship than as a masterwork of public relations.

Movies after Miller

A little over a month after the Court announced its decision in *Miller v. California*, the *New York Times* ran an *Arts and Leisure* feature titled "Has the Supreme Court Saved Us From Obscenity?"[16] The feature included reactions from 15 interested parties: cartoonist and scenarist Jules Feiffer,[17] actress Joan Crawford, blacksploitation (and *X*-rated) moviemaker Melvin Van Peebles, *Deep Throat* (1972) auteur Gerard Damiano, conservative political commentator William Buckley, actress and author Chris Chase, writer-director Paul Mazursky, MPAA president Jack Valenti, actress Shelley Winters, *New Yorker* film critic and screenwriter Penelope Gilliatt, leading law professor Harry Kalven, Jr., the Reverend Malcolm Boyd (an Episcopal Priest), the serially banned novelist and essayist Henry Miller, attorney Ephraim London and United Artists President David Picker. *The New York Times'* selection of contributors was hardly balanced. Only Buckley seemed to have much use for the Burger Court's retrenchment.[18] The *Times* feature seems instead, especially today, the sort of thing one might find in a time capsule: what were some interesting, mostly like-minded people in the film and culture business in 1973 thinking when they were thinking about pornography?

Under the title, "Art for the Court's Sake," Feiffer glibly opined: "Movies, which in the past were made to please banks, will in the future be made to please courts." Looking to the future, Feiffer predicted that the *Miller* decision would not decrease the number of obscenity cases reaching the Court but instead would generate a new "obscenity bureaucracy" manned by "Talmudic authorities on community standards." At the end of his commentary, Feiffer seemed to speak for the majority consulted by *The New York Times*: "we claim to be committed to [liberty and freedom], but look close and you will see that the freedom to which we commit ourselves is freedom *from*, not freedom *to*.

Freedom from those guys, freedom from weird ideas, freedom from bother, freedom from thought, freedom from equality, freedom from art, freedom from sex."[19]

A similar argument regarding obscenity and larger civil libertarian concerns lay at the heart Van Peebles' entry. The director of the controversial X-rated comedy *Sweet Sweetback's Baadasssss Song* (1971) deftly conflated the censorship of art with larger and related issues regarding race, identity, and efforts to abridge or restrict civil rights.[20] "My shiftless behind must have slept through the whole thing," van Peebles wrote, "NEW OBSCENITY RULING!!!??? Lord, lord, new rulings and here me I haven't run into no relevant old obscenity laws."[21]

Writing on behalf of the MPAA, Valenti was at once sober and realistic. Beneath the misleading title, "Censorship is Deadly," he wrote: "It is plain that the Supreme Court decision is aimed at so-called hard-core pornography. The responsible motion picture companies and producers in this country who create theatrical entertainment films are not the target of the decision." Touting the value of "voluntary controls" adopted by "a free film industry," controls that allow adults "to make their own free choice of viewing, without imposing that choice on others," Valenti promised only good times to come, so long as the studios went along with the MPAA. While elaborating a personal distaste for censorship in general—"You can't put tape over the mouths of artists, handcuff them to a legal stockade, and expect creative progress to be made"—Valenti nonetheless *used* the *Miller* decision and the accompanying move to the Right at the Court as an excuse to publicly insist once again upon studio loyalty to the MPAA and its new rating system. Valenti understood that the Voluntary Movie Rating System was bottomed on industry cooperation and collusion, a willing adherence to the policies and procedures of the MPAA (which oversees CARA), and the continued willingness on the part of movie exhibitors to enforce the age-based system, which on occasion asked them to turn away paying customers.[22]

Porno-chic

From 1968 to 1973, the Voluntary Movie Rating System supported an open and free market in movies in America. The studios themselves declined to take part in aspects of this new market despite what *The New York Times'* feature writer Ralph Blumenthal called "porno-chic,"[23] the astonishing cultural phenomenon marking the mainstream popularity of hard-core movies. Under the freer production standards ushered in by the rating system, boundaries between legitimate moviemaking and hard-core pornography became, consistent with the newly expanded film marketplace, simply a matter of taste.

The rating system was designed primarily to regulate entry into the legit film market. CARA was designed as an official gatekeeper and its success

hinged rather tenuously on complex relationships not only between *rival* studios (which agreed to comply with content classification) but also between the studios and the National Association of Theater Owners, which had to enforce the new system. The X-rating, which the MPAA decided not to copy-right (because Valenti believed the studios shouldn't make X-rated movies), offered an alternative point of entry outside the purview of the MPAA. A whole lot of independent filmmakers and distributors used this alternative entry point by self-imposing an X-rating.

Legit theater owners' willingness to screen X and XXX films, the ease with which they abandoned a history of compliance with MPAA regimes of censorship, revealed just how fragile their relationship had become with the mainstream studio distributors. Many of the exhibitors were unhappy with the seeming inequities of the CARA system: they bristled at the variable obscenity guidelines, the burden it placed on theater owners to enforce unpredictable rat-ing designations (that they had no part in deciding). The exhibitors were also tired of screening old-fashioned studio films that did not fully exploit the new system and that no one wanted to see.

Working with the hard-core industry had its advantages. Distributors offered a product that didn't require much or any advertising, a product lots of people seemed to want to see. Moreover, there was no content regulation for theater owners to impose. The XXX-rating was fundamentally arbitrary, more a come-on to adult audiences and a guarantee of a certain kind of enter-tainment than a warning to parents about a certain movie's suitability for kids. All XXX-rated films were unsuitable for children and no reasonable person making or screening the films argued otherwise.

The Supreme Court's interpretation after the *Roth* case of "community standards" as a single, national definition coupled with its later decisions in *Ginsberg v. New York* and *Interstate Circuit v. Dallas*[24]—two cases that tem-porarily stalled local censorship—for the moment protected theater owners who wanted to screen hard-core.

The year 1972 proved to be pivotal for the film industry, but at the time the signs of change were difficult to read. We know now that 1972 was the begin-ning of a dramatic box-office turnaround for the studios. But back in 1972, studio executives were not so sure what to make of the end-of-the-year box office figures. The overall box office numbers were up for the first time in 25 years. But even a cursory look revealed that one film, Francis Ford Coppola's *The Godfather* (1972), not only carried the day, its record-breaking revenues skewed upward the overall industry statistics; things were indeed better at the box office, but mostly for one studio, Paramount, and at that studio things were better because of just one film. In 1972, industry players had every rea-son to believe that the blockbuster success of *The Godfather* was something of a fluke or something at the very least difficult to reproduce anytime soon. *The Godfather* was an R-rated film. But its exploitation of the new rating system— its R-rating—seemed to have little to do with its success. The formula for

success initiated by *The Godfather* was that studios could get people back into theaters if they only made better movies—a tough formula to reproduce.

If the studios looked to *The Godfather*, which by the end of 1972 became the highest grossing picture in history, for some sort of sign, then they had to also consider *Deep Throat* (1972), which at the same time set box office records for hard-core. Which film was easier to reproduce? The answer was at once obvious and disconcerting. The effect on the studio industry of *The Godfather* and *Deep Throat*—two films seldom linked in film history—was immediate. When the studios accepted Valenti's argument that the hard-core business was best left to smaller, sleazier entrepreneurs, they began courting directors who seemed capable of producing quality pictures. The studios put these directors' names above the titles of films and began exploiting a sort of auteur marketing theory. In doing so, the studios began to accept or believe the notion that good directors mostly made good movies and that good movies made more money than bad ones.

The top 20 box office films list for 1972 revealed the wisdom in such a strategy. The end-of-the-year list included nine auteur pictures: *The Godfather* (at number one); Peter Bogdanovich's *What's Up Doc?* (1972, number four) and *The Last Picture Show* (1972, number six); Stanley Kubrick's *A Clockwork Orange* (1971, number seven) and *2001: A Space Odyssey* (1968, in reissue at number 20); Woody Allen's *Everything You Wanted to Know about Sex* (1972, number ten); Franklin J. Shaffner's *Nicholas and Alexandra* (1971, a three-hour British prestige picture at number 13); and Alfred Hitchcock's last serious feature, *Frenzy* (1972, number 14).

The roots of this auteur renaissance can be attributed to not only studio anxiety over the transition into post-rating-system production and their reluctant acceptance of film-school education as a new sort of preparation in such a new Hollywood, but also to a kind of desperation to compete with America's befuddling affection for hard-core. It was the best of times in Hollywood (terrific filmmakers making terrific films with near-absolute creative freedom)—or so many of us continue to believe today—and we have the competition mounted by the hard-core to thank for it.

Regulation by Contract

The MPAA no longer worries much about censorship, mostly because they have market research that shows that 75 percent of the nation's parents are satisfied with the present system. The ratings system is an unquestioned public relations success story.

The current regime of censorship in the United States is now over 40 years old. It works because the studios realize that it is in their best interests to comply—that even when a film must be edited to suit the caprice of the CARA board, the sacrifice is worth it given the public relations function of

the rating system. Regulation today is executed by contract as the rating system is inevitably considered whenever a picture deal is signed. Directors agree to deliver their film as a G, PG, PG-13, or R and agree to do whatever CARA says they have to do to meet that contractual obligation.

The studios introduced the NC-17 rating in 1990 for adults-only films that were still somehow within the range of appropriate studio product lines—a rating designation they did copyright—but have since abandoned that designation by including in their contracts the inevitable rejoinder against producing an NC-17 film.[25] Executives do so not because they find such content offensive; that is beside the point. They do so because they can't successfully market NC-17 films: many theater chains won't show such films, many shopping malls (where many multiplexes are situated) have in their lease a provision prohibiting the screening of such films, and many DVD retailers (Wal-Mart, for example) maintain a family-friendly image by not shelving NC-17 titles.

The rating system is so central to the business of making and distributing movies today that it is now routinely considered in the development stage of a film project. It functions as a regime of censorship not because some random adults and parents who sit on the CARA board impose their peculiar likes and dislikes on an unwitting Hollywood but because everyone who works in Hollywood has agreed that whatever they produce will be classified before it enters the marketplace. And that classification is crucial to the film's definition and performance in the marketplace. The dialogue between CARA and the studios is by policy confidential. The MPAA offices in New York guard CARA transcripts. All records of the ratings board since its inception in 1968 are kept secret. Researchers are never granted access to official CARA materials because the MPAA believes that revelation, analysis, and/or discussion of how or why CARA rates a film *R* or *NC-17* might compromise the board's objectivity.[26]

The absurdity of the present system is axiomatic but moot. Case in point: *South Park: Bigger, Longer and Uncut* (1999). In what may well have been something of a publicity gimmick, a series of confidential memos exchanged between the CARA board and Trey Parker and Matt Stone, the producers of the film, were leaked to the press. In one of the memos, reprinted in part in *Entertainment Weekly*, the filmmakers were asked to change a line of dialogue from "God fucking me up the ass" to "God's the biggest bitch of them all." After some negotiation, the board finally approved the use of the word "fisting," so long as its definition was excised. One board member had trouble figuring out whether or not he/she should be offended by a scene in which a cut-out depiction of the actress Winona Ryder does something seemingly unspeakable with ping-pong balls. Subsequent correspondence from the animators pointed out that Ryder's paddle, revealed in the last shot of the sequence, was the source of her expertise. The board accepted the explanation and okayed the scene.

The source of the leak, it turned out, was the film's executive producer, Scott Rudin, whose frustration with the board no doubt speaks for a lot of creative

Image 2.2 An animated rendering of the actress Winona Ryder doing something unspeakable with ping-pong balls in *South Park: Bigger, Longer and Uncut* (Trey Parker, 1999)

people in Hollywood: "The [memos were] like *Alice in Wonderland*, it was so crazy. I realize they're good people trying to do a good job, but the MPAA's not meant to be some moral arbiter of an entire culture." Of course it's not and Rudin knows that. The squabble between the *South Park* producers and CARA made for good publicity, just the right hint of subversion for the comedy filmmakers to keep their audience interested. But the key here is that Rudin and Paramount never for a second considered releasing the film theatrically as an NC-17 ("uncut" as the film's title promises). And Parker and Stone were simply not in a position to argue. They had signed a contract with the studio to deliver an R-rated print. However irritating Parker and Stone may have seemed to Valenti and the MPAA at the time, he was no doubt happy for Paramount. *South Park* was a huge hit for the studio, even without an accurate tally of the youngsters who bought tickets at their local multiplex to the G-rated Disney film *Tarzan* (1999) and then snuck into *South Park* when the theater manager wasn't looking.

The CARA board continues to madden critics, filmgoers, occasionally even the studios. In the heat of a ratings controversy, we tend to forget that the true measure of the rating system lay not in its treatment of specific scenes in specific movies but in its maintenance of the larger network of relationships that compose the new Hollywood. In response to a press release put out by a group of well-known New York and Los Angeles movie critics protesting the MPAA's rating inconsistencies with regard to *South Park, American Pie* (1999), and *Eyes Wide Shut* (1999) in the summer of 1999, Valenti bristled: "When I invented this system, which is totally voluntary, it was not to placate critics—it was to

protect parents. I haven't heard from a single parent who said, 'Gee, I wish you'd kept that orgy in there' ... The ratings board isn't infallible, but I don't understand why a bunch of critics are so certain that an orgy is something the rest of America would find casual. I think this system is doing exactly what it was intended to do."[27]

Valenti could afford to be so glib. The system was indeed "doing exactly what it was designed to do." As we marvel at the success of the studios these days—theatrical revenues topped $10.5 billion in 2010—we need to remember that once upon a time not so very long ago the studios were not making any money. They are now. And they have Jack Valenti, the MPAA, and the film rating system to thank for it.

Notes

1. Lord, Quigley and their involvement in the Legion of Decency are discussed in Chapter 14.
2. The Hicklin standard was established in a British case, *Queen (Regina) v. Hicklin*, L. R. 3 Q. B. 360 (1868).
3. *United States v Kennerly*, 209F 119 D.C.D.S.N.Y. (1913).
4. In addition to my own work on contemporary content censorship in Hollywood— Lewis, J. (2002) *Hollywood v. Hard Core: How the Struggle over Censorship Saved the Modern Film Industry.* New York: New York University Press as well as: Lewis, J. (2009) Real sex: the aesthetics and economics of art-house porn, in *JumpCut* 51, http://www.ejumpcut.org/archive/jc51.2009/LewisRealsex/1.html; Lewis, J. (2008) Presumed effects of erotica: some notes on the *Report of the Commission on Obscenity and Pornography*, pp. 1–16 in *Film International* 6 (6); and Lewis, J. (2003) The Utah version: some notes on the relative integrity of the Hollywood product, pp. 27–29 in *Film International* 1 (4)—see: Lyons, Ch. (1997) *The New Censors: Movies and the Culture Wars.* Philadelphia: Temple University Press, pp. 146–182; "Pornography: Love or Death," *Film Comment* December 1984; Sandler, K. (2007) *The Naked Truth: Why Hollywood Doesn't Make X-Rated Movies.* New Brunswick, NJ: Rutgers University Press; Vaughan, S. (2005) *Freedom and Entertainment: Rating the Movies in an Age of New Media.* New York: Cambridge University Press; and Kirby Dick's documentary: This Film Is Not Yet Rated (2006).
5. On October 24, 1970, President Richard Nixon made clear his feelings in a written restatement released through the White House Counsel's Office. These comments are taken from the written statement. http://www.presidency.ucsb.edu/ws/index.php?pid=2759#axzz1PrPUA8TU
6. *Final Report of the Attorney General's Commission on Pornography.* New York: Rutledge Hill, 1986. The publication was dubbed the "Meese Report" conferring due credit to then Attorney General Edwin Meese.
7. *Roth v. United States*, 354 U.S. 476 (1957): http://supreme.justia.com/us/354/476/case.html
8. *A Book Named "John Cleland's Memoirs of a Woman of Pleasure" v. Attorney General of Massachusetts*,383 U.S. 413 (1966): http://supreme.justia.com/us/383/413/case.html

9. For Justice Douglas' entire opinion in *Roth v United States*, see: http://www.law. cornell.edu/supct/html/historics/USSC_CR_0354_0476_ZS.html

10. *Redrup v. New York*, 386 U.S. 767 (1967): http://supreme.justia.com/us/386/767/

11. In a 1964 obscenity case, Justice Potter Stewart included in his opinion the following: "I shall not today attempt further to define the kinds of material I understand to be embraced within the shorthand description [of hard-core pornography]; and perhaps I shall never succeed in intelligibly doing so. *But I know it when I see it.*" Though Stewart intended to juxtapose the difficulty he had in defining obscenity with the ease with which he recognized it, the statement became something of a joke inside legal circles and later in the popular culture at large. Jacobellis v. Ohio, 378 U.S. 184 (1964: http://supreme.justia.com/us/378/184/

12. Woodward, B. and S. Armstrong (1979) *The Brethren: Inside the Supreme Court.* New York: Avon, p. 234.

13. The Nixon appointees were: Chief Justice Warren E. Burger and Justices Harry Blackmun, Lewis Powell, and (future Chief Justice) William Rehnquist.

14. For Douglas's dissent and Burger's majority opinion in *Miller v California*, 413 U.S. 15 (1973) along with Brennan's separate dissent, see: http://www.law.cornell.edu/ supct/html/historics/USSC_CR_0413_0015_ZO.html

15. The PCA gave films a Production Seal (of approval) that protected studio pictures from screening bans or print seizures. The 1968 voluntary movie rating system was meant to move away from such a simple and restrictive system, but after 1973 films rated G-for General Audiences, PG and PG-13 (films for which parental guidance should guide attendance), and R (films restricted to adults and children with adult supervision) carried what amounted to an MPAA seal—a promise that the film could not under any circumstances (under the new *Miller* guidelines) be found to be legally obscene. A relevant case here is *Jenkins v. Georgia* 418 U.S. 153 (1974), in which the Nixon Court used the *Miller* decision to unanimously reverse a 1971 ban on screenings of the R-rated Hollywood film *Carnal Knowledge* (Mike Nichols, 1971). The case proved pivotal for the studios and has since insured that films rated G, PG, and R are by definition not obscene.

16. Has the supreme court saved us from obscenity? pp. 1, 11 and 16 in *The New York Times*, August 5, 1973, Section 2.

17. Though he is far better known as a cartoonist, Jules Feiffer wrote *Carnal Knowledge*, the studio film that first put the *Miller* standard to the test in *Jenkins v. Georgia*, 418 U.S. 153 (1974).

18. "I vigorously applaud the decision of the Supreme Court," "Buckley wrote in an essay focusing mostly on the Court's effort to distinguish between pornography and art." See: Buckley, W. (August 5, 1973) Obscenity is commerce, p. 11 in *The New York Times*, Section 2.

19. Feiffer, J. (August 5, 1973) Art for court's sake, p. 1 in *The New York Times*, Section 2.

20. Nixon made the connection as well. His efforts to realign the Court had less to do (directly at least) with revisiting the obscenity issue than in supporting states' rights, which in the South were being used to delay implementation of integration.

21. van Peebles, M. (August 5, 1973) Rulings? not mine, p. 11 in *The New York Times*, Section 2.

22. See: Lewis, *Hollywood v. Hard Core*, pp. 187–191 and 267–276.

23. Blumenthal, R. (January 21, 1973) Porno chic; Hard-core grows fashionable-and very profitable, in *The New York Times Magazine*.

24. *Ginsberg v. New York*, 390 U.S. 629 (1968): http://supreme.justia.com/us/390/629/. *Interstate Circuit, Inc. v. City of Dallas*, 390 U.S. 676 (1968): http://supreme.justia.com/us/390/676/

25. The NC-17 was introduced as an attempt to protect studio films with more pervasive erotic content than most R-rated films. The film that was meant to define this new adults-only designation was Philip Kaufman's 1990 feature *Henry and June*, a film with a lot of soft-core simulated action that was very much tied to its highbrow plot (it was ostensibly about the romantic entanglements of Henry Miller, Anaïs Nin, and Miller's charismatic wife June) and its high-end Hollywood production values. Unfortunately for the studios, the NC-17 rating was subsequently applied to the simply awful soft-core film *Showgirls* (Paul Verhoeven, 1995) forever identifying this new rating designation with soft-core trash.

26. Kirby Dick's 2006 documentary, *This Film Is Not Yet Rated*, "outed" several members of the CARA board. For his trouble, Dick's film got saddled with an NC-17 rating.

27. Essex, A. (August 13, 1999) NC-17 gets an F, pp. 20–21 in *Entertainment Weekly*. The orgy Valenti refers to occurs in a scene in *Eyes Wide Shut*. In order to get an R-rating, Kubrick used digital effects to obscure some of the offensive images.

3

When Cinema Faces Social Values: One Hundred Years of Film Censorship in Canada

Pierre Véronneau

Every authority develops mechanisms that allow it to exercise its power, and this power applies particularly in controlling the creation and circulation of knowledge and culture in a given society. In this sense, censorship is a social practice, in tune with its specific environment, and it reflects the tensions and differences in a society at a given time. Studying it, particularly in the case of mass popular culture, allows one to plunge into the heart of a country's social history, to understand the evolution of various concepts and ideas that compose it, the values that confront it, and to grasp the factors that influence its reception.[1] To understand the history of film censorship in Canada, one must remember that this country is a political confederation and that, by its constitution, culture and all that is related to it are a provincial responsibility. This explains the diversity of policies and practices that are implemented.[2] The length of time that some film censorship officials were on duty also explains some of the tendencies.[3] The Federal Government still has an intervention tool, the criminal code, which defines obscenity and allows legal action against works considered obscene. Municipalities can also intervene in their jurisdictions (including maintaining public order and fire prevention), although they use their power to ban a film or fine an exhibitor only on very rare occasions: above all else, the film must pass through the previous controls and interventions. Religious authorities regularly pressured the civilian authorities to prohibit film screenings on Sundays, considered a dedicated religious day, specifically, by not attending commercial entertainment.[4]

Censorship during the Silent Film Era

Because Canada was not a major film production country, censorship was rarely applied to filmmaking, but it rather targeted distribution and exhibition. In the silent era, film distribution in Canada was dominated by foreign companies, in particular by American enterprises. After the First World War, 95 percent of the films shown in Canada came from the United States. There was also a modest import of French films, mainly of movies that had been exported to the United States.[5] This explains the absence, on Canadian screens, of films that might have been controversial and therefore subjected to censorship like Soviet films, which were never shown in Canada.

Initially, the authorities preferred using the laws that controlled live entertainment. Consequently, film distributors and exhibitors faced the arbitrariness of those who applied them. Thus, in the city of Toronto, in February 1910, the police seized copies of a Hamlet film (director unknown) on the grounds of violent content. In practice, the only censorship that applied to the movies was that of the police authorities who seized and destroyed films that they found outrageous or unacceptable.[6] In the early 1910s, several provinces changed their policy. In 1911, Ontario (Image 3.1) passed a censorship law specifically for moving pictures. Also in 1911, Quebec amended its Act on Public Exhibitions to forbid (movie) theater access to unaccompanied minors (younger than 15 years) and provided for severe punishment of offending theater owners. Quebec, in 1913, created the Board of Censors of the Moving Pictures. On the other side of the country, the province of British Columbia established a position of Chief Censor along with some assistants.

Within three years, five of the nine provinces passed laws to prohibit showing films that did not correspond to the dominant values of their society. The rejection criteria were very varied: immorality, infidelity and divorce, seduction, murder and crimes, violence (including boxing matches), vulgarity, negative image of religion, inadmissible political comments, insult to the British Crown, deployment of the American flag (treated as an anti-British gesture), etc. In Quebec, for instance, D. W. Griffith's *The Birth of a Nation* (1915) and *Intolerance* (1916) were cut for a range of reasons, including immorality and race prejudice.[7] In 1918, Manitoba even prohibited comedies for a while, on the grounds that they encouraged spectator frivolity. It was not only fiction films that were an object of censorship. Occasionally newsreels and documentaries were censored too, especially when they dealt with subjects that seemed immoral, contrary to the war ban criteria, or when they were considered to inflame public passions.[8]

The provinces gradually set up censorship boards staffed by a small number of censors, generally people without previous experience in the film business. It was their primary job, whenever they felt the film's content justified so, to physically cut out frames or scenes from film prints, which distributors

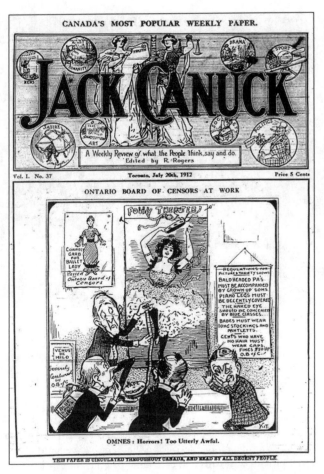

Image 3.1 One year after its creation, the Ontario Board of Censors has already a bad name for its severity. The newly founded independent newspaper *Jack Canuck* (1911–1923), in its quest for Truth and Justice, printed a biting cartoon on the censors

Source: Author's collection.

and theater owners had to submit. Films were either approved for screening (with our without cuts) or banned. Distributors were allowed to appeal and to request a review of the censor's decision. However, this was rarely granted since censors were both judge and jury. Occasionally, some boards accepted that distributors of banned films, based on the rejection criteria, re-edited their prints themselves, provided they submitted the withdrawn footage to the board along with an affidavit confirming the nature of their rework. Sometimes the boards boasted publicly to demonstrate their zeal and vigilance (see Image 3.2).

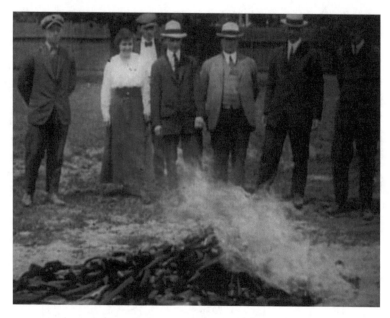

Image 3.2 A frame from 40,000 feet of rejected film destroyed by the Ontario Censor Board (1916), made by James and Sons

Source: Library and Archives Canada. The film can be seen at http://www.cinemamuetquebec.ca/content/movies/14?lang=fr.

The censorship boards sometimes operated for the Provincial Treasury, to the extent that, besides censorship, their other main function was to collect taxes on each film presented and even on advertising material.[9] If a distributor wanted to show a film in more than one province, he had to submit copies to all the required provincial boards and each time pay the appropriate fees. Some provinces, like Alberta, automatically ratified a previous decision by another board. Sometimes the distributor or theater owner decided to bypass the censorship board by showing the film. The board then had the choice to ask the police to intervene or to use their own inspectors, if indeed it was equipped with such a staff.

Certain groups found that censorship was not tough enough given that tens of thousands of spectators attended cinemas every week in each province. In Quebec, the Roman Catholic Church, through episcopal orders or pressures from Catholic associations, continued its fight to close theaters on Sunday, as well as to prohibit the admission of children (the age limit had been raised to 16 years) and to ensure moral conformity of the screened works, which were too often, in their eyes, a school for perversion and occasions of sin. For some, the movies corrupted,[10] for others, because of the predominance of films with English intertitles and the control of distribution and exhibition by foreigners,

cinema diluted national identity and pride. It is not surprising that in some cases, censors sought the opinion of Catholic or Protestant clergy if the issue was pertinent. In Ontario, the Methodist, Baptist, and Presbyterian churches led a similar fight, though less radically than the demands of the Catholic clergy in Quebec.

From the early years until the end of the silent era, censorship was consolidated and often became stricter as time went on. The institutionalization that affected the whole film industry could not exclude the censors' activities. In 1920, the Ontario Board of Censors adopted its Standards and Field of Work that systemized the censorship criteria: still mainly issues of sexuality, religion, patriotism, and violence. Comedies that addressed these issues for laughter and humor were judged more tolerantly. The following year, the Quebec Board of Censors followed by adopting its own code, which was a carbon copy of Ontario's. However, Quebec stood out by not only censoring the actual films, but also intervening in the field of the titles, intertitles, and advertising slogans. In this orgy of cuts and transformations, it was not surprising that many movies appeared incoherent and unintelligible to the audience, but this was the least concern for the censors. In 1925, Quebec revised its statutes and everything that touched cinema was included under a new Moving Pictures Act.

Quebec censors were known to be among the toughest in Canada. So much so that in 1926, American film distributors threatened to boycott the province. Catholic and nationalist elites leaped at the opportunity to denounce threats of "Jewish-American intimidation" and called for a total ban on film screenings in Quebec.[11] But the threat was never implemented, because in the United States, at the same time, film content was in dispute, forcing the industry to regulate itself (through the Production Code administered by the MPPDA, led by Will Hays, see chapters 1, 2, and 14) rather than fight against the various censorship bodies around North America.

This American pull-back did not calm down the voices demanding greater severity. A tragic incident revived their cause in Quebec. On Sunday January 9, 1927, a minor fire broke out in a Montreal theater, the Laurier Palace. Because of the panic, 78 children, many under 16 years, were killed. A Commission of Inquiry, headed by Justice Louis Boyer, was created to clarify the circumstances of the disaster and proposed new regulation. Unfortunately for advocates of tougher censorship, the judge did not meet their demands and adopted a moderate position. If he reinstated the exclusion of children under 16 years, he was against the banning of Sunday films shows, because it would punish a population that was opposed to this ban, and concluded that, generally speaking, cinema was not immoral. He did not believe that Quebec should be more puritanical than the other provinces. Among Catholics, for whom bishops were the supreme and indisputable authority, the judge's decision created consternation and motivation for new activism. In 1928, the Moving Pictures Act was

amended to strengthen provisions on the prohibition of minors and the cen-
sorship of posters and advertising.[12] It even added a provision that prohibited
outdoor screenings.

Censorship at the Time of the Talkies

The major event that influenced the censors' work was the arrival of talking
pictures. This more or less coincided with Hollywood's adoption of the Pro-
duction Code (see Chapter 1), which clearly inspired Canadian censors. Thus
in 1931, Quebec adopted new criteria that were neither more, nor less, than
a translation of the Hollywood Production Code. Assuming that Hollywood
films arriving on Canadian screens had already complied with the require-
ments of the Code, one might think that these criteria were used more to
judge films from other countries, particularly France, which in Quebec, due
to the common language, were much more important. Nevertheless, there
were always those who regretted the censors' "laxity" and wanted it strength-
ened.[13] Thus, in Canada (as in the United States or in France) the Catholic
Church used moral ratings to guide its adult followers. In the case of literary
adaptations, such ratings were taken from the Index of Banned Books pub-
lished by the Church. The 1936 publication of the encyclical *Vigilanti Cura*
(see Chapter 15) encouraged the use of this moral classification system and
established organizations to assure its dissemination. Meantime, official cen-
sorship boards went ahead with their own guidelines. So, the Ontario Board of
Censors adopted two classifications: "Suitable for All" and "Suitable for Adult
Audiences," which corresponded to those used in Alberta and Manitoba. But
there were still dissatisfied people who, when they were not directly campaign-
ing against cinema, did not hesitate to write to the political authorities to put
pressure on the censors.[14] In Quebec, from 1938 until 1952, to prevent refusals
from the Board of Censors, the largest distributor of French films, France-Film,
established its own precensorship committee, which—if necessary—reedited
its own film prints before submitting them to the censors. This committee's
reputation for severity was such that on a few occasions French producers shot
a specific Canadian ending, such as Marc Allégret's *Orage* (*Storm*, 1938) and
Julien Duvivier's *La Belle Équipe* (*They Were Five*, 1938).

The outbreak of the Second World War did not change much on the censor-
ship front except for documentary productions produced by the National Film
Board of Canada (NFB), newly created in 1939. Filmmakers were not allowed
to shoot images or provide information that would be considered strategic for
the enemy or could demoralize the Canadian population. However, censorship
was applied to some Soviet films (the Soviet Union was then a Canadian ally) or
to NFB films showing the Soviet Union. Anything too positive, such as presen-
tations of that country or any discussion of its values were defined as Bolshevik
or revolutionary propaganda, and the censorship boards intervened to limit its

impact. It produced other censorship criteria that became widespread during the Cold War and the "Red Scare," namely Communist propaganda.[15]

Until the early 1960s, Canada was marked by a period of traditionalism, with provincial governments being often more reactionary—Quebec and Alberta in particular. Thus in 1946, Ontario permitted drive-in theaters as seen in the United States, while in 1947, Quebec reinforced its law banning open-air performances, which they saw as occasions for such intimacies that would not be tolerated in the films themselves. Alberta, even in the mid-1960s, banned adult movies shown in drive-in theaters, called "passion pits." Quebec also required distributors to provide a copy of the scripts for submitted films to easily identify issues or litigious dialogues.[16] In 1953, Ontario replaced its old 1911 legislation but remained at the leading-edge of Canadian liberalism.

Censorship applied to all kinds of screenings: film exhibition in cinemas, but also 16-mm films showings (often without permits) in noncommercial venues or film clubs, or special-event screenings. These could cause surprise. For example, in 1947, the banning of Marcel Carné's *Les Enfants du paradis* (*Children of Paradise*, 1945), to be shown at the University of Montreal under the auspices of the Embassy of France, created a diplomatic incident. A few years later, such a controversy was caused by Max Ophüls' *La Ronde* (1950), which was prohibited in Manitoba. In the 1950s, it was not surprising that certain types of film were controversial. They manifested a willingness and openness for cinema that was more than just entertainment, and could only emphasize the concerns of the censors. The development of film clubs and film culture across the country echoed these issues. As these screenings often took place in private venues where churches wielded influence, it is not surprising that they could locally exercise their own censorship, in the name of morality.

The arrival of television in 1952 upset the situation because, to the great displeasure of some provincial prime ministers, as a federal institution, the Canadian Broadcasting Corporation (CBC) was not subject to provincial censorship. Quebec tried hard to treat television as a cinema theater but its law remained *ultra vires*. The audience could therefore see films that would otherwise be banned, or cut, as the CBC determined its own selection criteria, generally more liberal than those of the censors.

The Liberalization of Censorship

From the 1960s, Canada experienced a series of social, economic, and institutional reforms. This also influenced censorship. Quebec ended up leading the liberalization movement and advancing more open social standards. The creation of the Montreal International Film Festival in 1960 highlighted an openness to world cinema, and the Censorship Board demonstrated tolerance by issuing permits for a single screening of a film presented without cuts. But this tolerance did not extend to business of commercial projections.

Thus, Alain Resnais' *Hiroshima mon amour* (1959), presented uncensored at the Festival, was cut by 13 minutes when released for theaters.[17] Increasingly, in the media and elsewhere, there were calls for reform of censorship and reorganization of the Board.

In 1961, the Quebec government created a provisional committee to study film censorship; the committee examined the entire dossier and received numerous submissions on the subject. In 1962, after seven months of work, the committee, headed by Dominican father Louis-Marie Régis, published a voluminous report that acknowledged that the ways in which the situation is handled are outdated, and made several recommendations, including classification of films according to age group, end of cuts, revision of the 1931 criteria, professionalization of the Board—where the censors become examiners—and revision of the Moving Pictures Act. The situation remained uncertain for a year, although the new liberal philosophy was pursued progressively. The issuance of special limited permits, the so-called conditional approval, encouraged the unedited presentation of films that normally would have been cut. In 1963, the appointment of a new president, André Guérin, marked the beginning of a real renewal of censorship. It emphasized its education role, its mandate to protect youth and moral behavior, as well as the respect for society's pluralism and social morality. It is noticeable that from then on, religious power no longer took precedence over the civil authority.

Nevertheless, the Canadian government still intervened in the field of censorship through the Criminal Code, targeting obscenity and indecency, without defining too clearly the nature of these concepts. As the 1950–1960s ended, the Code stated that obscenity applied to a work in which one of the dominant features was the exploitation of sex, whether or not fortified by crime, horror, cruelty, or violence. It was used to ban movies from entering the country that would otherwise be subject to censorship and eventually banned or cut.[18]

The early 1960s were highlighted by many contradictions. On one side, society became more open and the censors allowed films that previously would have been cut. On the other hand, religious pressure groups were still present and attacked films that, in their eyes, were most reprehensible, even though they represented a real artistic or social interest. One needs only to think of the films of French New Wave, Japanese or Swedish cinema, or the Brigitte Bardot phenomenon. Although Roger Vadim's controversial *Et Dieu . . . créa la femme* (. . . *And God Created Woman*, 1956), featuring the young Bardot, was released in 1962 in a strongly expurgated version (80 minutes instead of its original 95 minutes), it didn't calm the Catholics who asked for a complete ban. Another notorious case was Louis Malle's *Les Amants* (*The Lovers, 1958*), which was submitted in a cut version by the distributors in 1964, but this gesture earned them a letter of reprimand from Guérin. In Quebec, the Censorship Board, composed of open-minded members and moviegoers, navigated between the religious and political pressures, the demands of distributors, and

the expectations of the majority of the population. They realized that the situation would eventually be normalized and that tolerance and freedom of conscience would prevail.

In the summer of 1967, Quebec passed a law, which transformed the Censorship Board into the *Bureau de surveillance du cinéma* (BSCQ, Cinema Supervisory Board).[19] Instead of defining criteria for refusing films, it now focused on works that could be prejudicial to public order or good morality. The BSCQ adopted a practice used in many other provinces: films were now classified into three levels ("for all till 14 years," "for teens and adults till 18," and "adults only"), and their advertising had to be approved concurrently. Special permits issued to allow the presentation of a film of special interest to a limited group of spectators were still possible; distributors benefited from this limited opportunity. Spectators were now responsible for their own choice. When distributors thought a refusal was likely, they could submit a self-modified (or self-censored) version. They were also allowed to present previously censored movies for reclassification. Many used this provision since the current practices were less restrictive and many of these works still had good market potential. Occasionally, the BSCQ reaffirmed that the issuance of a permit did not result from a particular aesthetic opinion, but from a global evaluation of a film. A similar situation occurred in Manitoba, which in 1972 adopted, after a very tight debate in Parliament, a new law abolishing censorship and replacing it with the classification of films.[20]

But everyone did not share this shift from censorship to classification, especially when so-called erotic or pornographic films were accepted. So, some municipalities wanted to ban movies under the Criminal Code, on the pretext that they were obscene, and they asked police to intervene. Canada Customs also preventively blocked the entry of a work if it thought it could be litigious. So there was a conflict between two sets of rights and two levels of legislation, and the courts were occasionally called on to decide.[21] The judges tried to define obscenity, but this was not always easy, especially when one is presented with such remarkable films as Nagisa Ōshima's *Ai no korîda* (*In the Realm of the Senses*, 1976), banned in British Columbia by the police; or Bernardo Bertolucci's *Last Tango in Paris* (*Ultimo tango a Parigi*, 1972), reviewed by the Supreme Court of Nova Scotia, then by that of Canada in 1978, which ultimately paved the way for other famous bans like those of Volker Schlöndorff's *Die Blechtrommel* (*The Tin Drum*, 1979) and Malle's *La Petite* (*Pretty Baby*, 1978), for example.

The 1967 Quebec Act did not end the fighting between conservatives and progressives, nor did it end the vision of distributors who did not like controls, of pressure groups, and of the audience who wanted to see what was happening in the world. The BSCQ, like its counterparts in other provinces, always maintained the power of refusal. Even if not abused, it was used. It affected particularly films like Tom Laughlin's *Born Losers* (1967), which was prohibited in most Canadian provinces for showing excessive and bloody violence.[22]

Censorship was not the only concern that interested the Quebec film community. A few years later, it requested a revision of the cinema law, which was eventually revised and adopted in June 1975. The Supervisory Board was not really affected by this new law and Quebec remained the most liberal province in terms of censorship and classification in Canada, while a wind of neoconservatism blew over several other provinces. As an illustration, we can refer to the cases of *The Tin Drum*, which was classified "14 years" in Quebec and "Restricted" in Ontario, while Catherine Breillat's *À ma soeur* (*Fat Girl*, 2001) was prohibited in Ontario and rates "16 +" in Quebec. Moreover, while Quebec issued special visas for festivals, Ontario continued to demand cuts, as it was the case in 1982 for two films programmed at the Festival of Festivals, in Toronto, where the festival preferred to remove the movies from the program.

In 1983, the BSCQ became the *Régie du cinéma*[23] but the organization's policies did not really change, except that it was now subjected to new pressures. On one side, some distributors and exhibitors wanted to present hard-core movies. On the other side, the growing, active feminist movement, and others, attacked the (re)presentation of women in erotic or pornographic films, and asked the authorities not to allow X-rated cinemas to open, even if films themselves were not banned. And there were those who denounced the extreme violence that was found in several films. Guérin maintained the course that he had held for 25 years. However, in 1988, when he learned that his mandate was not to be renewed, he resigned.[24] His successor was less liberal and wanted to tighten-up the classification of films, specifically in the name of youth and child protection, and denunciation of sexual violence and extreme violence. These new self-righteous "priests" no longer acted in the name of religion but wanted, almost as much, to control what the audience could see. Meanwhile, the *Régie* was trying to operate within the current social tolerance.

In 1991, the Quebec law was modified again, mainly to correct a problem resulting from the evolution of film consumption: more and more people viewed films on video. Now each cassette (later on, each DVD) had to be labeled indicating its classification. At the same time, the law exempted classification of several types of production (e.g., educational, promotional, or technical films) and those presented at special events (festivals and similar events). It established a new classification system ("general," "13 +," "16 +," "18 + years") and most importantly, the age categories were no longer just an indication of judgment left to the viewer, but a reason for banning entry into the theater. In video stores, the retailer also had to check the validity of the client's age, whereas it reserved a separate room for sexual content films classified "18 and over." In order to guide the viewer, the *Régie* supported its classification, with more, or less, elaborate descriptions also shown on television prior to the film, even if the film was scheduled after 11 pm.[25] Gradually other provinces followed a similar path and adjusted to the reality of the 1990–2000 period. So, in 1994, the Atlantic provinces (Nova Scotia, New Brunswick, and Prince Edward Island) merged their services and created

a common body, the Maritime Film Commission Board, responsible for the classification of films in six categories (three of which related to persons aged 18 and over) through the use of information statements.[26] Moreover, starting in 2005, the operations of the Ontario Film Review Board was guided by a new Film Classification Act, which restricted its power to ban films with explicit scenes of violent sexuality.

If the various boards and *Régies* were under pressure to adopt a less liberal behavior or to be more politically correct, the Criminal Code was also subject to the same thing with respect to the definition of obscenity. When the Progressive Conservative party was in power in Ottawa, a project introduced in 1987, influenced by ultraconservative members of parliament from western Canada, proposed a very detailed definition of eroticism and especially pornography. Facing the outcry that this project raised, the government preferred to let it die out. In 1992, in a case involving the sale of pornographic material, the Supreme Court of Canada ruled that the assessment of a work as obscene may not be based solely on the exploitation of sex per se as the dominant characteristic of the work, but the exploitation of sex has also to be "undue," perceived as harmful to society, especially women.[27] These guidelines applied to the cinema.

In 2006, Christian rights groups adopted a new tactic to censor Canadian productions: they asked the elected Conservative government to forbid government agencies from providing subsidies and tax credits for audiovisual productions, where these financial benefits could be used for films showing sex, pedophilia, violence, and homosexuality. The government acquiesced in a hypocritical way. Within Bill C-10, proposing to modify the income tax law, they slipped in the following text: "Public financial support of the production would not be contrary to public policy." The House of Commons approved the law and it was only at the third reading in the Senate, in 2008, that the trick was unmasked. The majority of Canadian film and television production was threatened. A huge protest movement forced the conservative government to withdraw this article. But it is a safe bet that it has not given up. Effectively, in 2012, the Minister of Canadian Heritage, James Moore, did not hesitate to intervene with CBC, the state television corporation, to ask them not to broadcast such programs and films that may offend the "public," which is in reality the puritanical, extremist, libertarian base that controls the Conservative party.

Conclusion

In 1911, censorship in Canada forced its way into the legislations affecting moving pictures. One hundred years later, it is still there, though applied differently. This century has been witness to moral and religious bans on the liberalization of values and a greater sense of public responsibility, and in the last 20 years, the return of puritan demands. If the cinema is doing well, thanks to the segmentation of the public and domestic consumption patterns,

mainstream television is more sensitive because of its wider distribution and audience. Warnings are widespread before every presentation, and what could be really litigious is shown on specialized pay channels. With internet, the situation becomes more complex because access to moving images of any kind is now relatively easy. The state can no longer intervene as before, even when it legislates. Several provincial film boards are questioning their means of action and their role in the contemporary media landscape. None has yet proposed a magic solution. The proliferation of distribution platforms complicates the task of those who monitor what the public is invited to consume. The censors' power has been eroded greatly in a century, as has been the ability of the state and government to intervene in the private lives of the public. But there still remains a fringe group ready to promote greater censorship and limit public access in the name of "noble" causes such as youth protection, the fight against pornography and obscenity, or sexual violence. The history of censorship in a society is always the reflection of current values and the wish to impose them.

Notes

1. This study will examine only the censorship of existing films arising from the application of a law, and not one happening at the script stage or set up by a government production agency as the National Film Board, or financial assistance corporation such as Telefilm Canada, the motives for which are often ideological or political. *On est au coton* (Denys Arcand, 1970) or *Octobre* (Pierre Falardeau, 1994) are good examples of films whose production or distribution was blocked by the intervention of either organization.
2. Amongst the key texts that allow to go further on the topic, let's mention: Boisvert, N. M. and Tajuelo, T. (2006) *La saga des interdits: La censure cinématographique au Québec*. Outremont: Libre Expression; Dean, M. (1981) *Censored! Only in Canada: The History of Film Censorship—The Scandal Off the Screen*. Toronto: Virgo Press; Hébert, P., Lever, Y. and Landry, K. (eds) (2006) *Dictionnaire de la censure au Québec, littérature et cinéma*. Fides: Montréal; Lever, Y. (2008) *Anastasie ou la censure du cinéma au Québec*. Quebec: Éditions du Septentrion; Moore, P. S. (2008) *Now Playing: Early Movie Going and the Regulation of Fun*. Albany: State University of New York; Skinner, J. M. (1993) *A Leap in the Dark: The Transition from Film Censorship to Classification in Manitoba*, 1970–1972, see www.mhs.mb.ca/docs/mb_history/25/filmclassification.shtml; Silent Toronto, see http://silenttoronto.com/; *Un abécédaire sur la censure du cinéma au Québec*, see http://www.rcq.gouv.qc.ca/.
3. Some examples: Col. P. J. A. Fleming (Alberta, 1946–1966, conservative), R. W. MacDonald (British-Columbia, 1954–1978, moderate), R. B. Milliken (Saskatchewan, 1944–1964, conservative), O. J. Silverthorne (Ontario, 1934–1974, liberal), A. Guérin (Québec, 1963–1988, liberal), G. S. Enos (New-Brunswick, 1929–1964, conservative).
4. In 1906, the Canadian government adopted the Lord's Day Act, followed up, in 1907, by the province of Quebec, which votes the law of Sunday observance. These are especially aimed at film showings, becoming more and more popular. Exhibitors

resist and the Supreme Court of Canada in 1912 will support them by ruling that the provinces have no right to intervene in a field of federal jurisdiction, the Criminal Code.

5. See Véronneau, P. (1989) *La présence du film français au Québec au temps du muet*, pp. 147–156 in *Le cinéma français muet dans le monde, influences réciproques*, Toulouse: Cinémathèque de Toulouse, Institut Jean Vigo.
6. See the chapter *Senseless Censors and Startling Deeds: From Police Beat to Bureaucracy*, pp. 113–152 in Moore (2008).
7. For more details, see Lever (2008).
8. For example, the films on venereal disease *Damaged Goods* (Tom Ricketts, 1914) and *The End of the Road* (Tom Ricketts, 1915).
9. For a long time, the calculation went by roll and not by title.
10. See Lefebvre, E. (1920) *Le cinéma corrupteur*. Montreal: L'oeuvre des tracts.
11. Premier Louis-Alexandre Taschereau said on that occasion: "Better to do without American films and keep our youth. (...) We have a board of censors who knows what is best for our province and our people."
12. Some cities, like Montreal, also had inspectors to enforce municipal regulations on public posting.
13. In some provinces, we find, at some point, censors that are clergymen. However, few will chair in a board of censors, as it is the case in Saskatchewan with Rev. R. B. Milliken.
14. English Canada had an organization cousin of the Legion of Decency, whereas in the French part there was the *Centrale catholique du cinéma du Canada* (Catholic Film Centre of Canada).
15. Eisenstein's *Bronenosets Potyomkin (Battleship Potemkin*, 1925) and *Oktyabr (October*, 1928), banned for sedition in British Columbia in 1929, were still banned 25 years later, as long as revision was not obtained. In Quebec, *Potemkin* was distributed only in 1961 in a 16-mm print.
16. One can imagine the utility of it when we know that *Le rouge et le noir (The Red and the Black*, Claude Autant-Lara, 1954), which was originally 185 minutes, was cut by 86 minutes.
17. In the *Dictionnaire de la censure au Québec* (pp. 311–314), one can find a complete list of the 17 cuts forced on the film by the Censor Board. Mostly, it dealt with the bed sequences and references to sex and desire.
18. For an overview of the issue, see the *Report on the Powers of the Ontario Film Review Board*, produced in 1992 by the Ontario Law Reform Commission. See (www.archive.org/stream/reportonpowersof00onta/reportonpowersof00onta_djvu.txt)
19. Gradually, the other provinces adopted a similar measure, as British Columbia in 1970 with its Film Classification Board.
20. The first president of the new Manitoba Film Classification Board was a Jesuit, Father J. Pungente, who fortunately turned out to be a rather open-minded person.
21. See the outside pressures on films as different as Mac Ahlberg's *Jeg—en kvinde (I, a Woman*, 1965); Jens Jørgen Thorsen's *Stille Dage i Clichy (Quiet Days in Clichy*, 1970); Gerard Damiano's *Deep Throat* (1972); Stan Dragoti's *Love at First Bite/Dracula Sucks* (1979); or Pier Paolo Pasolini's *Salò o le 120 Giornate di Sodoma (Salò, or the 120 Days of Sodom*, 1975); not to mention Canadian films such as Roger Cardinal's *Après-ski (Sex in the Snow*, 1970) or Roger Fournier's *Pile ou face (Heads or Tails*, 1970).

22. To guide its thinking and interventions, the BSCQ prepared in 1970 a document entitled *Violence à l'écran et impact sur les jeunes* (Violence on the Screen and Its Impact on Young People).
23. Under Canadian administrative law, a *Régie* is a more autonomous agency reporting directly to parliament. Theoretically it is less sensitive to political pressure. The *Régie du cinéma* is an administrative, quasi-judicial body.
24. He died less than a year later at the age of 61.
25. For example, "Coarse and Vulgar Language," "Explicit or Real Sexuality," "Dominant Violence," "Not Recommended for Young Children," "This Film Contains Scenes of Nudity and Eroticism Aimed at an Adult and Informed Audience," etc.
26. For example, "Not Recommended for Young Children," "Frightening Scenes," "Disturbing Content," "Gory Scenes," "Explicit Sexual Content," etc.
27. See http://publications.gc.ca/Collection-R/LoPBdP/BP/bp289-e.htm.

4

Inquisition Shadows: Politics, Religion, Diplomacy, and Ideology in Mexican Film Censorship

Francisco Peredo-Castro

Cinema arrived in Mexico in 1896. It became very popular but simultaneously attracted not only criticism but also condemnations. When *Un duelo a pistola en el bosque de Chapultepec* (*Pistol Duel in the Forest of Chapultepec*, 1896, Gabriel Veyre) was shot—to reconstruct a duel between two deputies—the press was outraged and argued that cinema should not be used for "distortions" and, especially, should not be used to "trick" audiences. This triggered a string of controversies, which eventually led to the intervention of authorities. The new medium of social entertainment was condemned not only by journalists and intellectuals, but also by other pressure groups such as the Roman Catholic Church, political elites, and bureaucracies at various occasions and in various periods heavily attacked cinema. Another aspect of Mexico's troubled film censorship history dealt with diplomatic interventions. After the prevalence of French and Italian films during the early years of film exhibition in Mexico, 1910 and onward, in addition to problems related to Hollywood's distorted representation of Mexican culture and society, diplomatic interventions were also connected with the propagandistic use of film during the two world wars.

Despite some references to "the golden age of Mexico's silent cinema, 1918–1923,"[1] Mexican film production remained insignificant during the silent era. The film market was dominated by foreign imports. Before World War I, most films were imported from Europe, notably from Italy, France, Denmark, and

Germany. After the "Great War," the Mexican film market was slowly but inevitably taken over by American films. Eventually all American major film companies established distribution agencies in Mexico.[2]

The arrival of talking cinema eventually allowed for the creation of a modest national film production sector. Fernando de Fuentes's *Allá en el Rancho Grande* (*Out on the Big Ranch*, 1936) was the first truly successful Mexican feature film. Mexican cinema then developed, mainly from the mid-1930s until the second half of the 1950s, the most blooming (in terms of film production and distribution) Spanish-language film industry in the Iberian–Latin American area. Mexico also has a long history of film censorship and film controversies aimed against, among other, (mis)representations of Mexico, other Latin countries and their citizens in American films. Nevertheless, there is neither a single-volume overview of the history of Mexican film censorship, nor a systematic body of literature and research on this topic. Film censorship in Mexico has been referred to in a few academic journals and mostly, and in general, in some newspaper articles.[3] This chapter will explore this topic by investigating the role played by the state, political elites, and the Church in establishing a firm film censorship system, as well as bringing forward the issue of diplomacy in silencing cinema in Mexico.

Morality, Religion, and Film Censorship

In Mexico, Catholic fanaticism, along with illiteracy and the abuse of political power, hindered the expansion of cinema. Religious and political elites who lived in the big cities pretended to "protect" peasants and indigenous population living largely in the countryside, by forbidding the movies. Enrique Mouliniè, a French entrepreneur living in Mexico, who was important and active in the emerging distribution of films in the country, reminisced that the main obstacle he faced was

> The religious intolerance of some people, who rejected the showing of movies, because they regarded them as evil ... in many cases, it was necessary to give private functions for civil and ecclesiastical authorities, in order to get them convinced of how harmless the cinema was. And just then they gave license and communicated to the timid people that [the films] were not in conflict with the holy principles of the Roman Catholic church.[4]

In 1899 the showing of Georges Méliès's films *L'indiscret aux bains de mer* (*The Indescreet at the Seaside*, 1897) and *Après le bal* (*After the Ball*, 1897) resulted in a consequent disapproval by the Catholic Church. By 1904 the press lamented that Ruvier, a famous thief, had become "a hero of cinema," following the release of foreign films about his robberies.[5] Although "because of protests from the press, due to constant scandals, the authorities closed

[most of] the theaters in 1900,"[6] in Mexico City and Guadalajara, some of them remained open to the public in the capital city. These could be considered aristocratic cinemas, as they were located on the Plateros Street, the jet-set zone for the bourgeoisies in those days. The screening of "pornographic views" was also condemned in several movies, and that was the case of Ferdinand Zecca's *Les sept châteaux du diable* (*The Seven Castles of the Devil*, 1904), which was strongly criticized because "among these pictures there is one in which the devil appears with seven women, depicting the seven deadly sins."[7] In addition, films that were considered to be showing graphic violence or "immorality" in marriage also caused great outrage.[8]

Such criticism was matched by the action of the authorities. According to the press, in late January 1907 a film theater was closed because "there were certain views that do not fit with the culture and morality of a city like ours."[9] Although this happened initially in Mexico City, these actions were followed in other cities like San Luis Potosí,[10] Mérida,[11] and Guadalajara, where in 1911 a newspaper alarmingly noticed, "The cinema, objective school for crime. It should be banned for children."[12]

In 1911, the same year that the British Board of Film Censors (BBFC) was created (see Chapter 9), the Mexican city of Guadalajara prohibited the exhibition of "immoral films." At the same time the press tried to prevent the showing of feature films showing bandits, by claiming that they could inspire "theft at a large scale."[13] The caution appeared to be confirmed in January 1913, when the press reported the following: "thieves apprehended by the police admitted they were inspired by a movie for their robbery, and sought to seize a safe box . . . and open it with dynamite, as they had seen in the screen."[14]

Politics, Hollywood Stereotypes, and Censorship

All those events seemed to evidence an urgent need for the regulation of film screenings, not just on moral grounds, but also for political reasons. In 1913 a new dictatorship ruled in Mexico. The revolutionaries who had overthrown Porfirio Díaz were fighting Victoriano Huerta, who had also established a harsh military dictatorship and had aimed to control film images that questioned his illegal government, which was not recognized by the United States. The images of revolutionaries generated conflicts based on the political affiliations of citizens and the groups of revolutionaries they supported. The footage shot by American cinematographers was also critical of Huerta and caused anger among the population. Documentaries such as *Barbarous Mexico* (1913), produced by the America's Feature Film Co. in Chicago were strongly censored for their unfavorable portrayal of the regime. Fritz Wagner, a Pathé cameraman who was in Mexico during Huerta's dictatorship, recalled that he was "constantly shadowed," and that Huerta himself "censored the films" and "had me cut out all the parts unfavorable to the Federals."[15] Propagandistic newsreels

against the Mexican Revolution, produced by American interests (such as those of William Randolph Hearst: *Hearst—Selig News Pictorial, Hearst Vitagraph News Pictorial, Hearst International News Pictorial,* and *Hearst Pathé News*), ended up being considered dangerous and banned because they disturbed public order.[16]

Simultaneously, the anger of the Mexican government and its citizens showed up against the stereotypes about Mexican characters, costumes, and scenes that had begun to spread through the world with early fiction films, containing a sharp negative stereotype, the criminal Mexican "greaser." This derogatory term for Mexicans, which even featured in laws such as the Greaser Act almost 50 years earlier (California, 1855),[17] was also spreading through American press and literature,[18] and its use persisted throughout the silent film era. Hollywood picked it out and defined it in a simplistic, Manichean way, as a relationship of opposites, as the antithesis of the cowboy, "the hero" of the film Westerns.

Represented as a traitor and a lewd coward, the "Mexican greaser" was portrayed as one disrespectful of the law and of a wild kind. In *The Fights of Nations* (American Mutoscope and Biograph, 1907), about the ways of fighting in different parts of the world, a knife fight between a Castilian and a Mexican was portrayed. American films eventually delved into the negative stereotype of the Mexican Revolution (viewed by Americans as a savage conflict), and gradually all these images would derive as a prejudice against all "the Latinos."

Early fiction films, such as the Kalem Company's *The Lost Mine* (1907) and *The Pony Express* (1907), or Vitagraph's *A Mexican Love Story* (1908), Fred Balshofer's *The Mexican's Crime* (1909), and Gilbert Anderson's *The Mexican's Faith* (1909), contained images of savagery, treachery, fraud, kidnapping, rape attempts, and so on—all committed by Mexican men.[19] Then appeared the negative character of the Mexican woman, represented as unreliable, flirty, prone to prostitution, in such films as D. W. Griffith's *The Mexican Sweethearts* (1909) or *Broncho Billy's Mexican Wife* (1912), in which the wife, enchanted by her "Latin lover," betrayed her cowboy and tried to get rid of him.

The First Mexican Censorship Law

The first Mexican law on film censorship was published in the *Diario Oficial de la Federación* (Mexico's Governmental Official Journal) on June 23, 1913.[20] Its Article 17 intended to safeguard the image of the police and the criminal justice system, by providing that they should be portrayed as the only administrators of punishment to criminals. Article 21, which limited the display of "immoral views," aimed at curtailing movies denigrating Mexico, as well as fictional or documentary films that defamed or ridiculed the Mexican Revolution. Article 24 forced distributors and exhibitors to get permission of public personalities that were displayed in a movie. Article 35, which allowed the Federal District

Governor to suspend the exhibition of a film that might offend an authority or prominent person, or offend particular beliefs of any religion, intended to protect the image of representatives of societal power groups such as the military, policemen, judges, politicians, clergymen, and so on.

From the point of view of the Mexican governments, legal censorship 1913 onward was considered to be a "necessary evil," an instrument to curb the distorted images of Mexico and the Mexican Revolution coming from abroad, and the risks of film war propaganda. At the end, Mexico's position led to an overall Latin American solidarity, which tried to create a common front against Hollywood. The premiere of *The Mexican's Last Raid* (Frank Lloyd, 1914); *The Mexican's Chickens* (1915), a farce about the Mexican Revolution; and *The Battle of Chili con Carne* (Louis Chaudet, 1916) led to strong conflicts. The latter film was seen as a mocking of the actual revolutionaries and a rude allusion to Venustiano Carranza's Constitutionalist army, who had overthrown Dictator Huerta. Carranza, who had become the president of Mexico, had a difficult relationship with the United States, which would explain the insulting jokes portrayed by Hollywood.

Another array of cinema conflicts dealt with war propaganda and the portrayal of Mexico's role in World War I. In the American serial *Patria* (Jaques Jaccard, Leopold Wharton and Theodore Wharton, 1917), for instance, Mexico was presented as an ally of Japan, ready to attack the United States.[21] Cecil B. DeMille's overtly anti-German propaganda movie *The Little American* (1917) caused huge protests because it affected Mexican neutrality, leading to its censorship.[22]

Hollywood producers were also attacked for their awkward portrayal of Mexican history. DeMille's *The Woman God Forgot* (1917),[23] for instance, a movie on the history of Mexico's conquest by the Spaniards (1519–1521), was heavily attacked for its distorted depiction of historical figures like Montezuma (for the Aztec emperor Moctezuma), Guatemoco (for the Aztec leader Cuauhtémoc), Taloc (for the Aztec deity Tlaloc), and Tecza (supposedly Montezuma's daughter, an anagram of Aztec). The movie tells how Tecza, in love with conquistador Alvarado, finally causes the destruction of her people and their civilization. The fury unleashed by this movie mobilized Mexican consuls and ambassadors, and the Mexican consul in Columbus issued warnings about movies demeaning Mexico.[24]

Many more censorship problems were incited by other American movies. In Guadalajara, for instance, the controversial *A Daughter of the Gods* (Herbert Brenon and J. Gordon Edwards, 1918), featuring a half-naked Annette Kellerman, upset Catholics and was heavily censored.[25] The atmosphere became almost incendiary by the release of such American films as *Mexicanos comiendo madera* (*Mexicans Eating Wood*, 1919; actually a fruit that seemed wood, but that was soft and juicy). In March 1919 the press reported that "the Treasury Department has issued orders against denigrating movies," in order to prevent their importation to Mexico.[26] Objections were also raised

against local productions confirming stereotypes, like the Mexican documentary short *El Pulque* (1922), which focused on the very popular beverage and stated "give a drink of this liquor to any Mexican and he is able to kill his own mother."[27] Mexican filmmakers were supposed to produce propaganda advertising Mexico. If films were used to build stereotypes about Mexico, it was argued, then such other films should be made as to destroy those stereotypes."[28]

The Second Censorship Law and the Continued Struggle against Hollywood

It was in this atmosphere that, in 1919, Venustiano Carranza issued a new Film Censorship Act (passed on the first of October, 1919).[29] Some days later, the *Diario Oficial de la Federación* announced the establishment of the Office of Film Censorship in the ministry of the Interior.[30] Its main purpose was to contain, by all means, films that are derogatory about Mexico, mostly coming from Hollywood but sometimes from other countries as well, including Mexico itself. In 1919, 58 percent of all films released in Mexico were American productions. Italian imports came second (almost 26 percent); only 2.2 percent of the releases were Mexican.[31] Of course, the new regulation sought again to protect "public morality": Article 4 stated that "fall within the prohibitions of this article, films that present in detail the *modus operandi* of criminals, or whose overall impression is that of their supremacy, either because of their intelligence, strength, or for any other reason, that can inspire congeniality with crime or immoral habits of the protagonists."[32]

That paragraph was the basis to censor one of the most important films in the history of Mexican silent cinema, Enrique Rosas's *El automóvil gris* (*The Grey Automobile*, 1919). Based on a true story of a gang that committed crimes in the turmoil of the Mexican Revolution, the film was controversial. Following the new law, in the film's ending the film producers tried to comply with the authorities' viewpoint by showing the actual execution of the criminals (shot by Rosas himself), and thereby leaving no doubt that "crime does not pay."[33] The footage was added as the end to the fictionalized story about the gang.

In the interwar period, the confrontation between Mexico and Hollywood continued and even caused wider diplomatic problems. In December 1918, the Mexican press published that "Colombia prohibited the screening of a film insulting Mexico."[34] Other Latin American countries such as Argentina, Brazil, and Cuba, and even Spain and Canada, followed this example.[35] Previously, countries like Argentina were vilified in World War I propaganda films, which portrayed conspiracies by all Latinos all over the world in acts of espionage and destabilization against the United States.

This would lead to more serious measures taken by the Mexican Álvaro Obregón government (1920–1924). In 1922 the Obregón Cabinet temporarily banned all Paramount, Goldwyn, and Metro movies.[36] The Mexican embargo

against the entire production of those offending companies caused a real danger for Hollywood: in case of solidarity among Iberian–Latin American countries, Hollywood's movies would be at the risk of being banned all over those markets. This embargo was probably one of the reasons why in March 1922 the Motion Pictures Producers Distributors Association (MPPDA) was created in the United States (see Chapter 1), and a year later the MPPDA's Foreign Department was set up.[37] One of the resolutions adopted in the first meeting of MPPDA was to "do everything possible to prevent the production of any new motion picture films which present the Mexican character in a derogatory or objectionable manner."[38] The dispute concluded with an agreement whereby Hollywood promised to avoid the production and distribution of more films with denigrating images against Mexico "or any other country" in the Ibero-Latin-American world.

One of the strategies deployed by the Hollywood producers was to continue to use Latin American settings (many films were actually shot in Mexico), but with often distorted names of countries, cities, and persons. Tijuana, for instance, became "Tia Juana," Honduras was "Anduras," Nicaragua "Nicrania," and Paraguay "Paragonia" (with reference to Patagonia, in Argentina). Other names were invented, among them "San Mañana," "Buenas Tierras," "Santa Dinero," "San Buenaventura," and fictitious islands such as "Caparoja" or "Paradiso." As Hollywood movies continued to exploit stereotypes, more censorship and diplomatic problems emerged. In 1923 all First National pictures were banned in Mexico, followed by a similar decision in 1927 against United Artists' movies, including *The Dove* (Roland West, 1927), in which Norma Talmadge played a Mexican singer threatened by a "dictator" too similar to the Mexican revolutionary Pancho Villa. The stereotype of the "Mexican Bad Man," typified by Ruth Vasey as "a large, raucous, mustachioed bandit who spoke semicomic pidgin English and exhibited varying degrees of barbarous behavior,"[39] had become abhorrent to Mexican audiences and, especially, became anathema to the Mexican governments.[40] By 1931 *Strangers May Kiss* (George Fitzmaurice), set in Mexico and Spain, included more negative images of both nations, leading to the seizure of all MGM's films.

Although Ruth Vasey states that in "1935 Spain and El Salvador were the first countries to agree formally not to circulate or exhibit movies disparaging to either party or to any other of the Hispanic American countries,"[41] it actually was on September 5, 1933, that Mexico and Spain established the first agreement to prevent the showing in their respective territories of denigrating films. In addition they agreed to extend their bilateral sanctions against "any movies that could be considered demeaning to any other Hispanic American country."[42] Subsequently Spain established agreements with Nicaragua, Peru, and Chile in 1936, and in 1937 emerged an agreement between Chile and Costa Rica.

During the interwar period, when cinema had become an international tool of propaganda, Latin America became an important ideological battleground.

This was also the case for Mexico, which was heavily engaged in diplomatic struggles around cinema. In 1918, at the request of the German Legation, there was an attempt to censor the American movie *Lest We Forget*, directed by Léonce Perret; this was due to the fact that the film dealt with the sinking of the Lusitania passenger ship by a German torpedo, and it included as well harsh criticism against the iniquities perpetrated by the German war machine.[43] Many examples from the 1920s and 1930s illustrate how international political considerations could lead to film censorship. On December 20, 1930, for instance, the Mexican press reported that Sergei Eisenstein and his team (who arrived to Mexico at the beginning of the month), were arrested by the police when they were planning their work on *Que Viva Mexico!* (but previously filmed the Guadalupana religious feasts on December 12). An arrest order had been issued "to investigate the allegation that they were acting as 'agents of international communism' and for their shooting of the 'lower classes' of Mexican society, 'highly derogatory' to Mexico."[44]

In the interwar period both Japan and Germany, through their embassies, protested against the showing of films they considered derogatory or propagandistic against them. However, the clearly antifascist Mexican government of Lázaro Cárdenas (1934–1940) decided to censor mostly films coming from the Axis powers.[45] Based on that provision, for example, the Italian film *Scipione l'africano* (Scipio the African, 1937) by Carmine Gallone, was censored. From the mid-1930s the Mexican government condemned fascism and Nazism and gave support to republicans in the Spanish civil war. However, Mexico remained neutral. Once World War II started, the Mexican government, headed by Manuel Ávila Camacho (1940–1946), officially took side with the Allies, by declaring war on the Axis on May 1942, and created a new legislation on cinema. As happened with the two previous laws, the practice of film censorship in Mexico was beneficial to political bureaucracies and other pressure groups to limit the production, distribution, or exhibition of films they deemed opposite to their ideological positions.

Sensitivities and Issues of Censorship

Through an overview of the history of film censorship practices in Mexico, it is possible to appreciate the strong problems originated by images of eroticism and sexuality in films. During the silent era, films that highlighted "the thoughts and acts of the spectators, who see reflected in the screen the performance of their passions" were systematically prohibited, but also after World War II, eroticism and sexuality continued to alarm the censors. One interesting case is the controversy generated by Roberto Gavaldón's *La diosa arrodillada* (*The Kneeled Goddess*, 1947), a movie attacked by the Comité Pro Dignificación del Vestuario Femenino (Committee for the Moralization of Women's Dressing). The pressure group requested the censors to eliminate the kissing scenes,

and its banning in case the producers refused.[46] In addition, members of the same group stole the naked statue of the leading female character, which had been placed in the lobby of the movie theater.[47]

A strategy used by filmmakers to avoid the risks of censorship related to images of eroticism or sexuality consisted of providing the spectators with "metaphors for overwhelming passions": these included images of thunderstorms, raging seas, overflowing rivers, impressive waterfalls, fires in forests or in chimneys, and so on. Once the passion subsided, the heavens and the waters appeared (mostly by direct cut or with a panning of the camera) calm again, and the fires extinguished. If filmmakers dare not to do so, they could be sure that the censors would cut the film in a more arbitrary manner, with a less "artistic" approach. So, the governmental censorship originated some sort of self-censorship among script writers, directors, and producers.

During the 1930s and 1940s a weekly bulletin was published, the *Apreciaciones sobre películas*, created by the Committee of the Union of Mexican Catholics and the Mexican Legion of Decency (the Mexican version of the American League of Decency, see also Chapter 14). There is no strong evidence till date that the leagues of decency in Mexico and in the United States were in contact with each other. But it is easy to suppose that there was a strong influence coming to Mexico from the United States about film censorship.[48] A close examination of these overviews in the press and magazines shows that nudes were almost always removed, as this was the case in films such as Juan Bustillo Oro's *Monja, casada, virgen y martir* (*Nun and Married, Virgin and Martyr*, 1935) and Miguel Contreras Torres's *Juárez y Maximiliano* (*Juarez and Maximilian*, 1934). Adolfo Best Maugard's *La mancha de sangre* (*The Blood Stain*, 1937) (Image 4.1), whose title was supposed to allude to the loss of virginity of a woman, remained banned for 60 years.[49] Other censored films about brothels were Gabriel Soria's *Casa de mujeres* (*House of Women*, 1942) or Julio Bracho's *Cada quien su vida* (*Each His Own Life*, 1958). In relation to the question of nudity in Mexican films, it is important to mention that by 1955 economic pressure led to a relaxation on the matter. In order to fight against television, Hollywood's superproductions, films in color, or the success of foreign films, which showed nudes and eroticism (like that of the Italian bombshells) the Mexican film producers were allowed to show some nudes. But female stars should appear motionless, and without showing genitals. Scenes of nudity had to be justified in a dull manner. So, the female characters were set in plots such that they appeared as "models" for sculptors or painters. In 1955 some films were produced with nudity scenes. However, even if naked still images were permitted, the plots continued to impose a strong moral condemnation for the female characters involved in those scenes. The following can be counted among these films: Miguel M. Delgado's *La fuerza del deseo* (*The Strength of Desire*, 1955); Chano Urueta's *El seductor* (*The Seducer*, 1955) and *La ilegítima* (*The Illegitimate*, 1956); José Díaz Morales's *Esposas infieles* (*Unfaithful Wives*, 1956) and *La virtud desnuda* (*Naked Virtue*, 1957).

Image 4.1 Still image from a brothel scene in *La mancha de sangre* (*The Blood Stain*, Adolfo Best Maugard, 1937), a controversial and heavily censored film for its references to prostitution and criminality
Photography: Agustín Jiménez, Ross Fisher, and Enrique Ortega.
Source: *Archivo Filmoteca UNAM*, Universidad Nacional Autónoma de México, Mexico City.

In the 1940s the *National Film Industry Chamber* requested producers to take care of their scripts, to keep focus on morality, and to avoid complicated negotiations with other countries' authorities, where Mexican films could be banned.[50] Movies showing nudity or sex scenes continued to have problems with the censors (e.g., Julio Bracho's *Amor de adolescente* (*Teenage Love*, 1965) even till today. This was the case with Erwin Newmaier's *Un hilito de sangre* (*A Trickle of Blood*, 1995), Alfonso Cuarón's *Y tu mama también* (2001) or Julián Hernández' *El cielo dividido* (*Heaven Split*, 2005), which openly dealt with male homosexuality and was not displayed to the broad public.[51]

Another sensitive issue was the depiction of the Mexican Revolution and its protagonists. There were significant cuts and other acts of censorship exerted on movies such as Juan Bustillo Oro's *Mexico de mis recuerdos* (*My Memories of Mexico*, 1943), Emilio Fernández' *Las abandonadas* (*The Abandoned*, 1945), and Julio Bracho's *La sombra del caudillo* (*Shadow of the Tyrant*, 1960). During the 1960s most of the 60 spaghetti Westerns dealing with Mexico, produced by Italian firms, and filmed mostly in Italy and Spain, were banned from the Mexican screens because of their incorrect depiction of the Mexican Revolution, history, and characters. Later on, a film about the most important hero of the Mexican Revolution, *Zapata* (Felipe Cazals, 1970), was also censored. In a

similar way *Lázaro Cárdenas* (Alejandro Galindo, 1985) was banned from the screens, a film related to the Mexican president, which intended to make real the original purposes of social justice derived from the Mexican Revolution.[52] Even a bland comedy like *Comando marino*, made by René Cardona III in 1990, ran into problems for allegedly denigrating the Mexican navy and its uniforms.

For the question of religion and cinema, pressure groups like the *Liga Mexicana de la Decencia* (Mexican Legion of Decency), *El Comité de la Unión de Católicos Mexicanos* (The Committee of the Union of Mexican Catholics), *Los Caballeros de Colón* (The Knights of Columbus), or *La Asociación de Abogados Católicos* (The Association of Catholic Lawyers) have always played a very strong role.[53] Their power explains many cuts, bans, and acts of self-censorship, as this was the case with Fernando de Fuentes's *Creo en Dios* (*I Believe in God*, 1940), where the end of the movie was changed. The power of these groups also became evident in the censorship to give final approval for release to films such as José Díaz Morales's *Jesús de Nazareth* (*Jesus of Nazareth*, 1942) or Julio Bracho's *San Felipe de Jesus* (1949), after cuts were made in scenes where the saint, Felipe, appeared being tempted to sin by a prostitute.[54] In 1957 the Catholic film journal *Séptimo Arte* was launched under the aegis of the Vatican *International Catholic Film Office*. The power of religious groups remained important in cinema, as this was the case with the censorship of films such as Gabriel Retes's *Nuevo Mundo* (*The New World*, 1976), a movie that demystified the "apparitions" and "miracles" of the Virgin of Guadalupe during the colonial period. Particularly problematic were those movies referring to the sexual life and crimes by members of the Roman Catholic Church, such as Arturo Ripstein's *La Viuda negra* (*The Black Widow*, 1977), Raúl Busteros's *Redondo* (1986), or Carlos Carrera's *El crimen del padre Amaro* (*Father Amaro's Crime*, 2002). Catholic pressure was also felt behind the prohibition of foreign films like Jean Luc Godard's controversial *Je vous salue, Marie* (*Hail Mary*, 1985) and Martin Scorsese's *The Last Temptation of Christ* (1988). Both were released over 10 years after their production, and in short circuits.

Another problematic theme was the issue of social exclusion and violence. A notorious case in the 1930s was the semidocumentary *Humanidad* (*Humanity*, 1933), made by Adolfo Best Maugard, because according to the press the movie "could never come to light because it attempted to portray the misery of our people."[55] The display of social decay also caused great problems to movies like Luis Buñuel's classic *Los olvidados* (*The Young and the Damned*, 1950), and years later to *Intrépidos punks* (Francisco Guerrero, 1983), *Masacre en el río Tula* (Ismael Rodríguez hijo, 1985), *La venganza de los punks* (*Vengeance of the Punks*, Damián Acosta Esparza, 1987), *La ciudad al desnudo* (*The Naked City*, Gabriel Retes, 1989), and *Bancazo en los Mochis* (Francisco Guerrero, 1989).

The portrayal of Mexican political decay in films was another possible reason to censor movies like Emilio Fernández' *El impostor* (1956), Giovanni Korporaal's *El brazo fuerte* (*The Strong Arm*, 1958), and Juan Fernando Pérez Gavilán's *¿Nos traicionará el presidente?* (1991). Sociopolitical

decline and political corruption is still a very sensitive issue in Mexican cinema, as illustrated by the censorship problems around recent movies such as Fernando Sariñana's *Todo el poder* (*Gimme the Power*, 2000), Luis Estrada's *La ley de Herodes* (*Herod's Law*, 1999), and—also by Estrada— *El infierno* (*Hell*, 2010). *La ley de Herodes* referred to political corruption of the Mexican Partido Revolucionario Institucional (PRI), which governed Mexico from 1929 until 2000. *El infierno* dealt with the extreme violence and cruelty of organized crime. After much social pressure and criticism in newspapers and in the academic world, both were released, but restricted for "adult" audiences. In both cases, the government was behind the censorship: the PRI regime in the case of *La ley de Herodes*, which led to the removal of the Director of the Mexican Film Institute; the PAN (Partido Acción Nacional) government initiated the censorship of *El infierno*.

This chapter tried to indicate how in Mexico (as elsewhere) the history of film censorship is inextricably linked to international diplomatic concerns. This was also the case after World War II, especially during the Cold War. For instance, Felix Feist's *Guilty of Treason* (1950), an American anti-Soviet film based on the life of the Hungarian cardinal József Mindszenty, was censored in Mexico because of its anticommunist message. Miguel M. Delgado's Mexican version of the same story, *El Cardenal* (*The Cardinal*, 1951), was censored for the same reasons. Roberto Gavaldón's *Rosa Blanca* (*The White Rose*, 1961) was banned for 11 years, because the movie dealt with the 1938 Mexican oil expropriation and showed how an American oil company murdered a Mexican peasant in order to obtain his oil field.

Epilogue

Mexico's troubled history of film censorship shows some peculiar paradoxes. One is related to the fact that when Mexico developed the most powerful film industry in the Spanish-speaking world, it was also accused of distorting the images and characters from other countries. This happened for instance when Mexican cinema adapted novels like those written by the famous Venezuelan writer Rómulo Gallegos (*Doña Bárbara, Canaima, La trepadora, Cantaclaro,* etc.), or when the "rumba movies" were produced and the Mexican film industry was accused of distorting the image of Caribbean peoples, folklore, and society, with films whose plot and characters were set in Cuba, for example, with female characters dancing rumba, but produced in Mexico with mostly Mexican actors, who did not speak and behave like real Caribbean persons. The Mexican film industry was not only criticized but also censored in some cases in Central and South America and the Caribbean countries, particularly when some of the "rumba films" were associated with brothel melodramas.[56]

In fact, Mexican cinema was censored for the same reasons as those used by Mexico when Hollywood was accused of distorting images of Mexico.

The other great paradox, and perhaps more significant, is the phenomenon of self-censorship. The way Mexican filmmakers avoided depicting the country's social reality is illustrated by the fact that only very few images were made of some of the most significant political and social events such as the 1906 Cananea miners' strikes, the 1907 textile workers' uproar, or the start of the Mexican Revolution in 1910. Filmmakers were enchanted making images of dictator Porfirio Díaz, who was finally overthrown in 1911. With the Revolution at its most acute point in 1916, both Mexican society and the filmmakers who registered the turmoil once it started (1910–1915), decided to ignore it, in an evasive attitude that led them to attempt to produce fiction films inspired by the European models. A journalist at the time argued that "in our films the appearance of the common people is carefully avoided."[57] That same caution, the desire not to show an ugly Mexico by the Mexicans themselves, led to strong criticism at the time of Buñuel's *Los olvidados*. This long tradition of self-censorship also explains that the tragic events of 1968, which led to the slaughter of civilians—mainly students— just before the Olympic Games in Mexico City, were only recorded by college students, in the documentary *El grito* (*The Scream*, 1968) made by Leobardo López.

After the conflictive presidential elections in 1988, with a fraud that led the PRI to remain in power for 12 more years, the strong emergence of leftist movements led to a slight relaxation of the PRI governments in matters of censorship. That is the reason why perhaps 1990 onward Mexican cinema was able to develop itself in a freer environment. Two examples of such freer environment are Jorge Fons's *Rojo amanecer* (*Red Dawn*, 1990), probably one of the first feature films about the political massacre of 1968, and the release of *La sombra del caudillo* (1960) 30 years after its production. With the final defeat of the PRI in 2000, which had been in power for more than 70 years, great possibilities emerged to challenge and denounce political corruption and social decay through cinema.

Notes

1. Diccionario Porrúa: Historia, Biografía y Geografía de México (1964) *El cine en México*. Mexico: Editorial Porrúa, p. 310. Quoted in De Usabel, G. S. (1982) *The High Noon of American Films in Latin America*. Ann Arbor, Michigan: UMI Research Press. Studies in Cinema 17, p. 7 and 259.
2. Before 1916 the share of American films released in Mexico did not reach 4 percent. But in 1916 it rose to 11.11 percent and has been increasing ever since: 29.37 percent (1917), 50.86 percent (1918), 58.07 percent (1919), 55.7 percent (1920), 63.6 percent (1921), 69.2 percent (1922), 74.2 percent (1923), 87.1 percent (1924), 87.5 percent (1925), 88.9 percent (1926), 90.5 percent (1927),

90.3 percent (1928), and so on. In a general view, the percentage of American films released in Mexico between 1912 and 1919 was 29.51 percent, when Italian films had the lion's share with 36.61 percent. In contrast, the ratio of American films released in Mexico between 1920 and 1929 increased to 78.9 percent, with Italian films pushed to the second place. Afterwards, American films always remained on top of the number of films released, with Mexican films always in the second place, once sound cinema made a national film industry possible. Between 1930 and 1939 the percentage of American films released Mexico was 76.0 percent, between 1940 and 1949 it was 69.2 percent, between 1950 and 1959 it was 50.3 percent, between 1960 and 1969 it shifted to 31.9 percent, between 1970 and 1979 it was 24.9 percent, and between 1980 and 1989 it was 34.83. See Amador, M. L. and Ayala Blanco, J. (1977–2009) *Cartelera cinematográfica 1912–1989*. Mexico: UNAM (8 volumes). Even with the apparent decrease, Mexico is currently the fifth most important market in the world for Hollywood's movies, with around 200 million tickets sold in 2010 and 205 million in 2011. See Pardinas, Juan E. (2011) Educación cinematográfica, *Reforma*, February 13, 2011, and Zazueta, Oliver (2012) ¡Estrenan aquí primero! Cobra mercado internacional importancia para Hollywood, Reforma, Septiembre 10, 2012.

3. The main works in the field are Aurelio de los Reyes's contributions, some of them quoted in this text. Among them, and not quoted here, is De los Reyes, A. (2002) *Informes de Adolfo Best Maugard al jefe del Departamento de Bellas Artes sobre su trabajo de supervision a Serguiei Eisenstein durante el rodaje de ¡Que viva México! en 1930*. Mexico: Anales del Instituto de Investigaciones Estéticas—UNAM, v. 25, n. 81, pp. 161–172. In addition we shall consider: Leal y Fernández, J. F. and Barraza, E. (2002) *Los inicios de la reglamentación cinematográfica en la ciudad de México*. Mexico: Revista Mexicana de ciencias políticas y sociales FCPyS—UNAM, v. 37, n. 150; Zermeño, G. (1997) *Cine, censura y moralidad en México. En torno al nacionalismo cultural católico (1929–1960)*. Mexico: Historia y grafía, n. 8; Vázquez Mantecón, A. (2004) *La censura en el cine mexicano de los cuarenta*. Mexico: Fuentes humanísticas, n. 28.

4. Enrique Moulinié, in Leal y Fernández, J. F. et al. (1993) *Vistas que no se ven*. Mexico: UNAM, p. 25. Our translation.

5. González Casanova, M. (1995) *Los escritores mexicanos y los inicios del cine 1896–1907*. Mexico: UNAM—El Colegio de Sinaloa, p. 33.

6. De los Reyes, A., Mexico, in Abel, R. Ed (2010) *Encyclopedia of Early Cinema*. London: Routledge, pp. 430–431.

7. Un cinematógrafo pornográfico, *El Diario del hogar*, February 10, 1905, p. 2. Quoted in De los Reyes, A. (1983) *Cine y sociedad en Mexico 1896–1930*. Mexico: IIE—UNAM, p. 61.

8. Gacetilla, *El Diario del hogar*, November 27, 1906, p. 6.

9. Clausura de un cinematógrafo, *El Imparcial*, January 30, 1907, p. 2.

10. La escuela del cinematógrafo, *El Contemporáneo*, San Luis Potosí, April 15, 1908.

11. Sicalipsis, moralidad y clausura, *El Imparcial*, July 9, 1909, p. 7.

12. El cinematógrafo, escuela objetiva del crimen, *La Libertad*, Guadalajara, January 15, 1911. Quoted in Vaidovits, G. (1989) *El cine mudo en Guadalajara*. Guadalajara: Universidad de Guadalajara, p. 58.

13. La moralidad y los cinematógrafos, *El imparcial*, February 2, 1910. Quoted by De los Reyes (1983), p. 83.

14. La moralidad del cinematógrafo, *El Intransigente*, San Luis Potosí, January 20, 1913, p. 2.
15. Fritz Wagner in Mexico, *The Moving Picture World*, July 18, 1914, p. 440.
16. De Orellana, M. (1991) *La mirada circular. El cine norteamericano de la Revolución Mexicana 1911–1917*. Mexico: Joaquín Mortiz, pp. 273–278.
17. Larralde, C. (1976) *Mexican–American. Movements and Leaders*. Los Angeles: Hwong Publishing Co., p. 222, http://www.amazon.com/Mexican-American-movements-leaders-Larralde/dp/0892600268.
18. Ruiz, R. E. (1976) *La guerra con México. Tres etapas en el pensamiento norteamericano*. Mexico: Revista de la Universidad de México, December 1976–January 1977, v. XXXI, n. 4–5, pp. 13–14.
19. Apparently, the first images of a Mexicans in American fiction films were in *A Race for Millions* (Produced by Edison, 1906) and *The Girl from Montana* (Produced by Selig Company, 1907). But in *The Lost Mine* and in *The Pony Express* (both produced by Kalem Co., 1907), they clearly appear as deceivers, kidnappers, and murders. García Riera, E. (1987) *México visto por el cine extranjero 1906–1940*, Filmografía, Mexico: Ediciones Era—Universidad de Guadalajara, v. 2, p. 13.
20. Anduiza, V. (1983) *Legislación cinematográfica mexicana*. Mexico: UNAM, pp. 16–17.
21. De los Reyes (1983), p. 213.
22. Vaidovits (1989), p. 60.
23. La pantalla agresiva, *La voz de la revolución*, Mérida, May 28, 1918. Quoted in Ramírez, G. (1980) *El cine yucateco*. Mexico: Filmoteca UNAM, p. 51.
24. Exhibición de películas de las bellezas de México, *El Universal*, July 16, 1918.
25. La hija de los dioses, *El Universal*, April 23, 1918.
26. Se impedirá que vengan ciertos filmes de cine, *El Universal*, March 19, 1919; Ibid., p. 14.
27. Almoina Fidalgo, H. (1980) *Notas para la historia del cine en Mexico*. Mexico: Filmoteca UNAM, v. 2, p. 15.
28. ¡Si el cinematógrafo nos puso plumas, que el cinematógrafo nos las quite!, *El Universal*, August 26, 1919.
29. Reglamento de censura cinematográfica, *Diario Oficial de la Federación (DOF)*, October 1, 1919, v. XIII, n. 26, pp. 449–451.
30. Aviso relativo a la instalación de la Oficina de Censura Cinematográfica, *DOF*, October 10, 1919, v. XIII, n. 31, p. 585.
31. Amador and Ayala Blanco (2009), p. 162.
32. Anduiza (1983), p. 260.
33. No se exhibirá una película, *El Universal*, December 5, 1919, p. 9. Quoted in De los Reyes (1983), pp. 258–261.
34. Colombia prohíbe la exhibición de una película denigrante para Mexico, *El Universal*, December 10, 1919. Quoted in Almoina (1980–1982), pp. 99–100.
35. De los Reyes (1983), p. 234.
36. Vaidovits (1989), p. 111.
37. Vasey, R. (1997) *The World According to Hollywood 1918–1939*. Madison: The University of Wisconsin Press, p. 38. If 1923 was not the year of the creation of MPDDA's Foreign Department, it was 1924, but not later.
38. Quoted by Vasey (1997), p. 20.
39. Vasey (1997), p. 171.

40. There were six *The Bad Man* films: 1907, 1923, 1930 (English, Spanish and French versions), and 1941.
41. Vasey (1997), p. 156.
42. Denigrating Movies Convention between Mexico and Spain, *Archivo Histórico Diplomático Genaro Estrada de la Secretaría de Relaciones Exteriores* (File Code: AHDGE/SRE/III1139-6-1933).
43. Iba a ser suspendida la exhibición de una película. La legación alemana pretendía que no se permitiera la exhibición de *La catastrophe del Lusitania, El Universal,* May 27, 1918.
44. De los Reyes, A. (1985) *Medio siglo de cine mexicano.* Mexico: Trillas, pp. 99–103.
45. Cantú Robert, R. (1936) Tirando al blanco, *Filmográfico,* December 31, 1936, p. 31.
46. Censura a La diosa arrodillada, *Cinema Reporter,* August 23, 1947, pp. 12–13.
47. Ibid., p. 36.
48. Mexican newspapers and magazines frequently referred to issues of censorship in Hollywood. Examples from the 1930s are: Cinéfilo, Las piernas de las artistas del cine, *Filmográfico,* February 1937, v. 5, n. 59, pp. 42–43, 51 and 74; La censura en yanquilandia, el más grande dolor de cabeza de los productores, *Filmográfico,* March 1938, n. 72, p. 29. Examples during the forties are: Hesiquio Aguilar, El cine y la censura, *Cinema Reporter,* October 7, n. 325, 1944, p. 5; El asunto de la censura cinematográfica desde Estados Unidos, *Cinema Reporter,* October 22, 1944, n. 327, p. 27.
49. Actually the blood stain of the title was referred to a crime committed at the beginning of the story.
50. Cantú Robert, R. (1943) *Casa de mujeres,* prohibida en Argentina, Mexico y Perú, *Cinema Reporter,* July 3, 1943, pp. 27–34.
51. *El cielo dividido* was shown in the Muestra Internacional de Cine, April 2006, the event organized by the Instituto Mexicano de Cine and the Cineteca Nacional. It was released on only ten prints on September 27, 2007.
52. *Lázaro Cárdenas* was exhibited 25 years later of its production, but just through cable television.
53. Denuncia contra un cinematógrafo, *El Independiente,* Puebla, December 1, 1913, p. 5.
54. Grandioso estreno simultáneo de Jesus de Nazareth el viernes 27 de marzo en el cine Palacio y Palacio Chino, *Cinema Reporter,* March 6, 1942, p. 4.
55. Una foto histórica de nuestro archivo, *Cinema Reporter,* July 10, 1943, p. 7.
56. See Castro, M. and MacKee Irwin, R. (2011) *El cine mexicano "se impone."* Mexico: UNAM.
57. Arkel (1917) Mexico en la pantalla, *El Universal,* July 31, 1917. Quoted in Almoina (1980–1981), p. 176.

Part II

Control, Continuity, and Change

Film Censorship in Germany: Continuity and Change through Five Political Systems

Martin Loiperdinger

As the German Reich incited two world wars that resulted in its defeats, all through the twentieth century, German history proceeded in turmoil, which did not end with the *Anschluss* of East Germany to the Federal Republic in 1990 when the Cold War saw losers and winners.[1] All the five systems of political rule in Germany were confronted with alternatives and felt a strong need to protect their principles against "the enemy" inside and outside the country. In Germany, as in many countries, film exhibition was subject to precensorship from the beginning of cinematography. Though there was no universally applicable film legislation in Wilhelmine Germany, many films were cut or completely banned in the decade before the First World War. While theater and press censorship were abolished in Germany following the dissolution of the monarchy in 1918, the new Weimar democracy introduced uniform film censorship in 1920 through the *Reichslichtspielgesetz* (Reich Motion Picture Act). The guidelines of that law were significant for film censorship up to the early 1970s: a pronounced continuity extends from imperial Germany, across the Weimar Republic and Nazi Germany, and on into the Federal Republic. The situation in the German Democratic Republic (GDR) was fundamentally different, as the state itself had a monopoly over film production.

Imperial Germany

Prior to 1920, Prussian State Law was used as a basis for censoring the so-called "living pictures." Local police were responsible for the "upholding of public peace, safety and order" and travelling showmen and owners of motion picture

theaters had to submit film programs for approval. Decisions on individual titles could differ substantially between localities, but a first step toward uniform state censorship was taken in 1906 when police ordinances were issued by various German states in response to several films, which depicted the case of the real-life fugitive murderer Rudolf Hennig, and which were seen to ridicule the police. On May 5, 1906, the Berlin police commissioner introduced preventive censorship to curtail the dissemination of such "offensive" works: from now on, films required an "exhibition certificate" for public screenings. A decree by the Prussian Interior Minister in 1910 went on to centralize censorship by allowing films passed in Berlin to be shown throughout Prussia. Official lists were published citing all titles that were either completely or partially banned in Berlin, or to which children and youth (under 16) were prohibited access.

From 1907, heated debates raged over the boundaries of acceptability in film. The *Kinoreformer* (cinema reformers), comprising teachers, judges, and clergy, mobilized against the "scourge of cinema" and demanded that the authorities implement rigorous measures against cinematic "trash and filth."[2] In principle, police censorship supported these groups' theories of influence and emulation, which maintained that cinematic representations of violence and eroticism could "incite" audiences—in particular children and young people—to criminal or morally reprehensible acts. Depictions of sex and crime became subject to stringent control, with images of death, murder, adultery, and premarital sex forbidden outright. As a result, numerous films were rendered incomprehensible by the removal of key scenes. The film industry saw its economic interests under attack, while audiences felt cheated of promised sensations.

During the First World War, responsibility for censoring films passed to the military administration. Significantly, the war allowed the state to discover cinema's "positive" aspects, including its usefulness for entertainment and propaganda both among the troops and on the home front. Through the founding of the *Bild- und Film-Amt* (Photo and Film Office, known as Bufa) in early 1917, Imperial Germany itself became a producer and distributor of films; and when the *Universum Film Aktiengesellschaft* (Ufa) was founded on December 18, 1917, the Reich itself secretly took a 7 million Mark share in the film company. This move toward state funding decisively altered the cinematic landscape.

Weimar Republic

Immediately after the German capitulation, the Council of People's Representatives explicitly outlawed censorship in its proclamation "To the German People!" on November 12, 1918[3]. However, local and regional film censorship continued to be practiced widely by way of police ordinances and

direct intervention, and was aimed especially at the so-called *Aufklärungsfilme* and *Sittenfilme* (films of manners and sexual enlightenment). Even politically engaged works such as Richard Oswald's *Anders als die Andern* (*Different from the Others*, 1919), which questioned the criminalization of homosexuality, could fall foul of such measures, and it was not long until state-sanctioned censorship was introduced. The draft version of the Weimar Constitution stated expressly: "Censorship—and in particular precensorship of theatrical performances and motion picture shows—will not take place."[4] However, the finalized text of paragraph 118 reads: "Censorship will not take place, but motion pictures may be made subject by law to special regulations." The conservative parties were by this time already drawing up the *Reichslichtspielgesetz* (Reich Motion Picture Act), which was subsequently passed in the National Assembly despite opposition from the *Unabhängige Sozialdemokratische Partei Deutschlands* (the forerunner to the German Communist Party). Reich president Friedrich Ebert of the Social Democrats approved the Act on May 12, 1920.

The *Reichslichtspielgesetz* imposed a ban in principle on all films, requiring them to be examined by a state censorship board prior to being passed for release. Paragraph 1.1 stipulated: "Motion pictures (films) may only be exhibited publicly, or put into circulation for the purposes of exhibition either domestically or overseas, if passed by official certification boards." Films were submitted by production companies to certification boards in Berlin and Munich, while a head certification office in Berlin dealt with appeals against the lower boards' rulings. All three offices fell under the jurisdiction of the Interior Minister, who appointed their chairpersons. Consultation with welfare organizations and other similar bodies helped decide the composition of the boards' panels of examiners, with the result that many cinema reformers now had a direct influence on censorship matters. Films passed for public screening were issued with a so-called "exhibition certificate" listing title and cast, as well as the text of inter-titles, the length in meters, and the number of reels. Where cuts had been ordered, these were also briefly described.[5] Alongside the films themselves, all pictorial publicity materials, posters, and lobby-cards had to be submitted to the boards for approval. In the case of banned films, the grounds for rejection generally corresponded to the "moral hygiene" arguments of Wilhelmine cinema reformers. Free speech was also substantially restricted in films that questioned the political leadership and its institutions, or public morality. Indeed, paragraph 1 of the *Reichslichtspielgesetz* protected not only state authorities, including the army, navy, police, judiciary, civil service, and members of public service professions such as teachers, doctors, and lawyers, but also the legally enshrined relations of private individuals, and in particular the institution of marriage. Nationalism or "legitimate feeling for the fatherland" also enjoyed legal protection under a passage within the *Reichslichtspielgesetz* referring to the "undermining of Germany's reputation and standing." Films

depicting social conflicts were especially susceptible to threats of a ban on these grounds.

The *Reichslichtspielgesetz* firmly protected the existing state order and institutions, and afforded censors on the certification boards sweeping discretionary powers. Indeed, film certification constituted political censorship since, strictly speaking, it was not the films submitted that were examined, but rather their presumed influence and "effects" on audiences. Under the guise of the Act's stipulation to prevent the "undermining of public safety and order," film censors thus practiced a "censorship of influences," deciding *ex ante* on the capacity of a given film to elicit audience reactions that might endanger the state.

With the *Reichslichtspielgesetz*, the Interior Ministry had gained, then, a flexible instrument for "repelling" supposed "threats to the state" from German screens—threats that were consistently located in the leftist political camp, while the certification boards remained blind to threats from the right. Arguments over Ufa's series of four *Fridericus Rex* films (1921–1923) during the crisis years of 1922 and 1923 make abundantly clear that reactionary films were not the target of the *Reichslichtspielgesetz*. The working-class press assessed the cinematic exaltations of the Prussian monarch Frederick the Great as "anti-republican provocation"; the argument swiftly spilled out onto the streets, with pamphlets condemning "Fridericus Drecks" (Frederick Trash), demonstrations and boycotts against Ufa cinemas prompting police intervention. When the Hessen Interior Minister called for the films' exhibition certificates to be revoked within his state on the grounds that they constituted a "threat to public safety and order," the head certification office rejected his appeal on the grounds that this threat was "not permanent."

By contrast, the "threat to public safety and order" ostensibly represented by pacifist and socialist films was consistently interpreted as a permanent condition that at once threatened the state and needed to be forestalled through censorial intervention. A textbook example is Sergej Eisenstein's *Bronenosets Potyomkin* (*Battleship Potemkin,* 1925), which, following massive public debate after its initial ban in Germany, ultimately gained release only in a toothless version cut by over a hundred meters.[6] The first version submitted by the German distributor Prometheus Film had already been toned down; thus the 1905 mutiny was no longer compared expressly to the Bolsheviks's October Revolution, as in Eisenstein's original editing, but instead described in intertitles as a one-off event. This version was banned by the Berlin certification board on March 24, 1926, on the grounds that it was "capable of permanently endangering public order and safety." The head certification office lifted this ban on April 10, 1926, dismissing objections from the Defense Ministry, which demanded that an outright ban be upheld "in the interests of military discipline." Nevertheless, a number of cuts were demanded: all depictions of violence by the mutinying sailors against their officers were excised, along with several shots from the celebrated Odessa steps sequence, "since the excessive

violence contained herein is likely to have a brutalizing effect." Before the day was out, Defense Minister Hans von Seeckt had already lodged a protest against the film's release and forbidden all soldiers from seeing *Battleship Potemkin*. While the daily press engaged in tendentious discussions of the film, the police had nothing extraordinary to report about its Berlin screenings, other than overcrowded auditoria and expressions of approval or condemnation by various audience members. The state government of Württemberg, which described Eisenstein's film as "a treacherous and dangerous lunge at the state's throat," petitioned, however, for its exhibition certificate to be revoked; Bavaria, Hessen, Thuringia, and Mecklenburg-Schwerin swiftly followed suit. On July 12, 1926, the head certification office banned *Battleship Potemkin*. Further appeals were no longer possible, and the only remaining option for Prometheus Film was to submit a yet shorter print for examination, this time cut by an additional hundred meters. This version was granted a certificate in late July, thereby quelling the various calls for an outright ban, although minors were prohibited from attendance. All this underlines not only the defeat of *Battleship Potemkin*'s labor movement supporters at the hands of ministerial bureaucracy and military administration, but also the directly political nature of Weimar film censorship.

Numerous German documentaries and features produced after 1928 by small production companies with links to the labor movement charted a similar course to *Battleship Potemkin*. The most famous is Bertolt Brecht and Slatan Dudow's *Kuhle Wampe* (*Whither Germany?*, 1932), which, following an outright ban and an unsuccessful appeal, was finally passed for adult audiences only after the submission of a drastically "sanitized" version.[7] However, even such sanitized versions could not be certain of release throughout the Reich. Since "public safety and order" ultimately fell under the jurisdiction of local police, individual state governments could still suppress films approved by the official censors.[8] The Munich state government, for example; was frequently dissatisfied with the Berlin censor's decisions, and its appeals to the head certification office did not always meet with success. Consequently, it installed a kind of parallel censor, using the police to withhold various films passed for the Reich as a whole from Bavarian audiences. Screenings of *Battleship Potemkin* were indeed banned in several Bavarian towns on the strength of police ordinances.

During the world economic crisis, the censors' rulings reflected nationalist public opinion: thus paragraph 1 of the *Reichslichtspielgesetz*, with its reference to the possible "undermining of Germany's reputation and standing," was increasingly invoked. Even the Oscar-winning *All Quiet on the Western Front* (1930), based on Erich Maria Remarque's novel, was not safe, since the Defense Ministry regarded it as a threat to the German army's reputation. The German press attested pacifist tendencies even to the film's abridged German release, which the distributor had taken the precaution of trimming from 140

to 85 minutes. Less than three months earlier, on September 14, 1930, the Nazi party (*Nationalsozialistische Deutsche Arbeiterpartei* or National Socialist German Workers' Party, NSDAP) had emerged as the second strongest party in the Reichstag elections. While the Berlin premiere of *All Quiet on the Western Front* passed off without incident on December 4, 1930, the following night saw Storm Troopers (members of the NSDAP's paramilitary organization, the *Sturmabteilung* or SA), throwing stink bombs, and setting loose white mice, to stop the screening. The next few evenings saw SA men again occupying the cinema and the film was withdrawn. After petitions from several state governments, the head certification office banned *All Quiet on the Western Front* on December 11, 1930. The film's producer, Carl Laemmle of Universal Pictures, had to agree to a yet more abridged version, which was approved on September 2, 1931, on the stringent condition that, in order not to undermine "Germany's reputation and standing," only the version passed by the Berlin censor be distributed *anywhere in the world*.

The banning of *All Quiet on the Western Front* was symptomatic of the political collusion between the NSDAP and conservative elites. Joseph Goebbels (at the time *Gauleiter* or regional NSDAP leader in Berlin), by arranging for massive SA disruptions at screenings, was able to contrive a "spontaneous" sense of indignation to which ministerial officials could in turn respond by stating that the Remarque adaptation was "felt by the broadest sections of the populace involved in the war—regardless of political allegiance—to be an act of derision."[9] Thus, the "voice of the people"—in the shape of the SA—served as incontrovertible evidence that Germany's reputation was being undermined.

National Socialism

Hitler's appointment as Chancellor on January 30, 1933, had immediate and far-reaching consequences for the German film industry. For years, the National Socialists had attributed Germany's "degeneration" in large part to the ostensibly corrupting decadence of Weimar cultural life, with vitriol aimed in particular at "the film-Jews of Berlin." Jewish and left-wing film artists now lived in fear of persecution, and fled the country. As Minister for Popular Enlightenment and Propaganda, Joseph Goebbels ascended to the role of "patron of German film" and set about "Aryanizing" the industry. In this context, he made use of a "Law on the Exhibition of Foreign Motion Pictures" originally introduced on July 15, 1930, as a quota regulation, which established criteria to distinguish between "German" and "foreign" films and thereby limited imports. On June 28, 1933, Goebbels passed a decree stipulating that, for a film to qualify as "German," *all* those involved in its production needed to be "German" too: holding a German passport was no longer sufficient, since "in accordance with this decree, 'German' refers to whoever is of German descent and nationality."[10] The racist criterion of "German descent"

allowed the National Socialists to single out all those Germans whom they counted as Jewish; the participation of a single "non-Aryan" was now enough for a work produced in Germany to be labeled "a foreign picture." The ability of Jewish film personnel to find work was conclusively ended by paragraph 3 of the "Law on the Foundation of an Interim Film Chamber," introduced on July 14, 1933. Membership of the Film Chamber was compulsory in order to gain employment in the industry, and those deemed "not to possess the necessary dependability for film work"[11] were no longer hired. Those without documentation proving "Aryan" descent, or without loyalty to the regime, stood no chance.

Film censorship under National Socialism was marked by its continuity from Weimar. The most senior Weimar censors had already proved their worth, and stayed in office. The revised *Lichtspielgesetz* (Motion Picture Act), which came into force in 1934, introduced no fundamental changes; numerous regulations were adopted wholesale from a 1929 parliamentary proposal. The section concerning the "undermining of Germany's reputation and standing" was extended to apply to foreign films, insofar as these addressed German issues, even in their original version, which effectively gave German censorship boards the authority to actively intervene in other national industries. This presumptive step officially enshrined what the Weimar authorities had already successfully achieved in the case of *All Quiet on the Western Front*. The addition of "violation of artistic feeling" to the act's rubric was noteworthy, since this added the political censorship of "taste" to the duties of film assessors. The new ruling powers thus distinguished themselves from their republican forerunners by defining their relationship to film not merely negatively through preventive action against perceived threats, but also by claiming the right actively to shape and (re-) configure films through reference to the new state doctrine of National Socialism. The most important revision in the 1934 *Lichtspielgesetz*, however, involved the introduction of precensorship by the *Reichsfilmdramaturg* (Reich Film Dramaturgical Office), to whom all film scripts now had to be submitted for assessment. In conjunction with the newly founded Film Credit Bank, which granted funding only against confirmation of script approval, this regulation constituted a massive act of state intervention into film production—though it also corresponded to the demands of film financers who had for years supported precensorship akin to the American Production Code on the grounds that it reduced the risk of bans for completed productions.

However, as the institutions of law and order became eroded through the establishment of a state dictatorship[12] based around the "Führer's will," so too the *Lichtspielgesetz* grew increasingly irrelevant, especially as the state itself became ever more active in film production. When he personally approved Leni Riefenstahl's Nuremberg rally film, *Triumph des Willens* (*Triumph of the Will*), in which he played the leading role, this was still an exception to the rule, in 1935.[13] By 1939, most of the German film industry was nationalized, and in

many cases decisions on film censorship were taken by the "Führer" himself, during private screenings. Feature films were safeguarded by the precensorship of scripts; thus scarcely two dozen German productions were banned during the entire 12 years of National Socialist rule.[14] From 1938 onward, Hitler frequently inspected and criticized the newsreels, which were reorganized as the German war newsreel, the *Deutsche Wochenschau*, in 1940. Though Joseph Goebbels dedicated at least two evenings of the week to the supervising process of the newsreel production, in Berlin, he carefully paid attention to Hitler's remarks and had no power to take decisions against the wishes of the *Oberstes Kommando der Wehrmacht* (OKW, Supreme Command of the Armed Forces).[15]

German Democratic Republic (GDR)

The Soviet military administration in the Russian occupied zone had fewer reservations regarding the resumption of German film production than did the Occupying Military Government in the US zone. The founding of the first German postwar film production company (*Deutsche Film-Aktiengesellschaft*, DEFA) and the premiere of the first German postwar production—Wolfgang Staudte's antifascist *Die Mörder sind unter uns* (The Murderers Are among Us)—on October 15, 1946, represented a triumphant new start for the film industry in East Germany. Over the next three years, DEFA produced more antifascist films, which found similar audience favor. DEFA's film plans were of course subject to scrutiny and censorship by the occupying Soviet forces. Representatives of the Soviet Union's state distribution company Sovexport—overseen by the Ministry of Cinematography in Moscow (see Chapter 6)—examined scripts and cast-lists, issued filming permits, and inspected completed works. After the founding of the GDR (1949), film censorship was initially carried out by the DEFA Commission within the ruling politburo of the *Sozialistische Einheitspartei Deutschlands* (Socialist Unity Party of Germany, SED).

DEFA held the monopoly over film production in the GDR, and was finally nationalized in 1953. DEFA studios' production timetables were scrutinized. Decisions were reached about the feasibility of individual scripts and finished productions thoroughly checked. While such limitations on artistic freedom are also the rule for privately financed filmmaking under capitalism,—here they stem from a desire to maximize profits—in the case of DEFA creative censorship became synonymous with state intervention. The "really existing socialism" of the GDR was steadfastly committed to ideologically irreproachable and artistically polished feature films that could bolster political conviction among Cold War audiences. State supervision of state film production aimed at keeping in check DEFA production heads and film artists—even those staunchly loyal to the state—and ensuring that they in no way undermined

the GDR's central antifascist and socialist tenets. The SED's censorship bodies thus displayed an institutionalized distrust toward film production. DEFA's intention was to unite cinematic art with political directives—especially since artistic interpretations of the SED's current party line by DEFA's directors and production heads often ran contrary to the actual thinking of those in power. Film censorship in the GDR ensued from this constant tension between filmmakers and the Party, and was shaped more or less directly by the SED's Cold War maneuvering in regard to domestic policy toward West Germany and the Soviet Union.

From 1949 to 1952, the SED committed feature production at DEFA to the Soviet doctrine of "socialist realism," an aesthetic rejection of Western "formalism" and "critical realism." Meetings of the DEFA Commission at this time were attended by Soviet advisers. In 1951, the resultant power struggle between filmmakers and the Party crystallized around *Das Beil von Wandsbek* (*The Meat Cleaver of Wandsbek*), the debut film of DEFA's artistic director Falk Harnack. Based on Arnold Zweig's 1947 novel, the film centered on the historical figure of a Hamburg butcher who beheaded four resistance fighters sentenced to death by the Nazis. The butcher was boycotted by his customers, and in the end committed suicide. The film was withdrawn after six weeks on the grounds of "political shortcomings": for the executioner of antifascist resistance fighters was presented here in an ambiguous light, as both instrument and victim of National Socialism.[16] Similar "bureaucratic hindrances"—the continual interference of the state in production—led to many film projects never reaching completion, or coming to the screen only after lengthy delays. By 1952, in contrast to the pre-GDR days of DEFA, East German films met only limited success. In September 1952, the SED's politburo organized a film conference to discuss the artistic difficulty of transferring socialist realism to films featuring convincing heroes. The Party, berating the absence of "any successful deployment of working class representatives as heroes in [DEFA] films,"[17] rushed *Ernst Thälmann* (1952) into production, a two-part color film biography of the prewar communist leader, and, in late 1952, set up the State Committee for Cinematic Affairs as a general authority overseeing all film and cinema matters. After the workers' uprising of June 17, 1953, the granting of yet greater artistic freedoms was discussed and, in an attempt to win back audiences for DEFA productions, it was agreed that more entertainment films be made.

From January 1954, the various studios and divisions of DEFA fell under the newly founded Culture Ministry, presided over by the writer Johannes R. Becher. The resultant thaw in cultural policy gave rise to a series of "local studies" influenced by Italian neorealism and depicting everyday life in a divided Berlin. However, following the suppression of the Hungarian uprising in 1956, as well as the shattering of the East German government's hopes for reunification as a result of Konrad Adenauer's policy of Western integration, the SED leadership returned to a more restrictive line, including in cultural policy. The so-called "revisionism" proclaimed by the SED leadership at the

1958 Film Conference singled out in particular two Berlin films, Wolfgang Kohlhaase's *Eine Berliner Romanze* (*A Berlin Romance,* 1956) and Gerhard Klein's *Berlin—Ecke Schönhauser* (*Berlin—Schönhauser Corner,* 1957). The Party's new watchword was "that naturalism and critical realism are wholly unsuited for depicting socialist reality"[18] and the next year saw *Sonnensucher* (*Sun Seekers,* 1959)—a socially critical work about uranium mining in the GDR by the highly regarded director Konrad Wolf—withdrawn at the last minute before its scheduled premiere.

Following the erection of the Berlin Wall in 1961, the socialist state gained an increased sense of self-assurance and, from 1963, it extended DEFA's aesthetic freedoms. Some filmmakers seized on this new liberalism to produce critical works questioning contemporary realities in the GDR; but the situation was dramatically reversed once again in 1965, when the XIth Plenum of the SED Central Committee arranged for the immediate vaulting of some 12 recently shot DEFA features. Foremost among these were Kurt Maetzig's *Das Kaninchen bin ich* (*I Am the Rabbit,* 1965), whose depiction of a judge's opportunism questioned key principles of "Party loyalty"; and Frank Beyer's *Spur der Steine* (*Traces of Stones,* 1966), in which a team of anarchic roofers on a major construction site was shown to triumph over incompetent Party bureaucracy. None of these so-called "Rabbit films" was to be shown in East Germany until 1990. DEFA itself never really recovered from this drastic censorial intervention and showed few signs of revival right up until its postunification dissolution.

Federal Republic of Germany

Immediately after the Third Reich's capitulation, the Anglo-American occupying forces prohibited all publishing activities—including the production, distribution, and exhibition of films. At the same time, the US military government confiscated all circulating prints of German films. From autumn 1945, however, around 200 features produced under National Socialism were gradually released as reruns to supply cinemas in bombed-out German cities. A further 300 titles remained subject to an outright ban. In all, more than half of the features made during the Third Reich were ultimately deemed suitable for re-release, albeit after the removal of all scenes featuring Nazi uniforms and swastikas. There was no standardized censorship in the three Western zones prior to the foundation of the Federal Republic (1949), and a film banned in the American zone could well be approved in the British and French zones, or vice versa. The Federal Republic's constitution stipulated that "censorship will not take place." In practice this meant very little, and "general laws" were employed as a means of curtailing cinema's freedom: not only were the police and public prosecutors able to take action against films, but the Bonn government too implemented measures to ensure that the free democratic order could under no circumstances be challenged on-screen.

In order for films to be accorded permission for cinema release, at least one copy had to be available for inspection within the borders of the Federal Republic. Foreign films in general and, in the Cold War climate that prevailed until the early 1970s, GDR and Eastern bloc productions in particular thus became subject to a form of politicized import control.[19] The so-called "Interministerial Committee," a nonstatutory body established in 1954 at the behest of the *Amt für Verfassungsschutz* (Office for the Defense of the Constitution), was charged with deciding for or against the import of individual titles from Eastern bloc nations. The existence of this body was only made public in 1957 in response to a question in parliament. Trade and Industry Minister Ludwig Erhard justified the Committee's mode of political censorship by analogy with the Federal Constitutional Court's outlawing of the German Communist Party in 1956. Politically motivated import controls subsequently gained a legal basis through the introduction in 1961 of the Impoundage Act, which explicitly outlawed the import of films "that might function as propaganda against the free democratic order or the spirit of international understanding."[20] The upholding of such bans fell to the Federal Office for Commercial Affairs in Frankfurt am Main; it is estimated that the Interministerial Committee impounded around 130 films in total, including most notoriously Jiří Krejčík's Czechoslovak production *Vyšší princip* (*A Higher Principle*, 1960). The film showed the SS unleashing terror on the civilian population after the 1942 assassination of Reinhard Heydrich in Prague—a representation of Nazi violence that the Interministerial Committee perceived in 1963 as "a threat to Germany's reputation and standing."

The demise of the Third Reich certainly did not signal the end of direct state intervention in film production. Through the awarding or withholding of subventions during the early 1950s, local and national government could exercise control over more than half of all West German films even before they entered production. This represented a successful attempt on the state's part to become an active film producer, and thus to bypass the effects of the break-up of Ufa—the nationalized pride and joy of the National Socialist period. An Interministerial Subventions Committee was set up to process all applications from the film industry during the first wave of awards between 1950 and 1953. This Committee in turn enlisted the services of the *Deutsche Revisions- und Treuhand AG* (German Trade and Audit Co.)—the same body that had managed the film industry's finances for the *Reichskreditgesellschaft* (Reich Credit Institution) between 1933 and 1937, and whose former head, Dr. Robert Liebig, continued to take a leading role. An additional six-member panel inspected scripts from a dramatic, economic and *political* standpoint: numerous of the examination criteria employed would later be adopted by the *Freiwillige Selbstkontrolle der Filmwirtschaft* (Voluntary Self-regulatory Body of the Film Industry, FSK—see below). Neither the grounds for a proposal's rejection nor the titles of successful applications were made public, but during this first wave of subventions some 44 applications were rejected, while 82 films

received subsidies amounting to 30 percent of their projected production costs. The various ministries involved exerted a huge influence on the content, casting, and form of subsidized productions, although there were some conflicts of interest between the Trade and Industry Ministry, which considered films primarily in terms of their commercial potential, and the Interior Ministry, which was more concerned with upholding the constitution. The latter aim led the ministry in particular to the blacklisting of film artists who had previously worked for DEFA, since this was regarded as undermining state values: *Die Czardasfürstin* (*The Csardas Princess,* 1951), for instance, with the Third Reich's most popular revue film star Marika Rökk, and made by her director-husband Georg Jacoby, was initially rejected on the basis of the couple's prior participation in DEFA's *Kind der Donau* (*Marika,* 1950).

The financial aid packages offered by the state in more recent years have likewise functioned unambiguously as a vehicle of censorship. The Film Funding Act of 1967 contains a "controlling clause" stipulating that all state funding is liable to repayment if the completed film offends moral or religious sensibilities, or contravenes the constitution or any other law. Here, then, political pressure compounds the commercial imperatives within a free market economy; the result is an absolute dearth of critical filmmaking. The various instances in which the "controlling clause" has been invoked include one spectacular example in 1983, when, following the change from liberal to conservative government, Herbert Achternbusch's *Das Gespenst* (*The Ghost,* 1982) was rejected by the FSK. The conservative Interior Minister Friedrich Zimmermann reneged on payment of 70,000 Marks previously promised to the film's producers on the grounds of the film's alleged blasphemous content.

As Film Officer for the American Military Government, former UFA production head Erich Pommer had as early as 1946 proposed a voluntary self-regulatory body taking as its model the American Production Code of 1930/1934. Since individual states of the Federal Republic retained independence in matters of cultural and educational policy, holders of film exhibition licenses feared a decentralization of censorship and petitioned state culture ministries for the establishment of a central agency for film certification. Following an agreement between the various culture ministries and the German film industry's administrative body SPIO, the FSK came into being on July 15, 1949. It was to remain West German cinema's most potent censor until the early 1970s. Despite its name, this body was clearly neither "self-regulatory" nor "voluntary"; producers, distributors, and cinema owners were prohibited from any dealings with films not previously approved by the FSK. Anyone trying to circumvent FSK approval faced action from their local SPIO branch association, could be boycotted by other industry members, and ultimately driven to financial ruin. In the face of such rigor, state censorship became effectively superfluous.[21] The FSK, moreover, was hardly independent of state control. Its internal organization bore unmistakable similarities to the Weimar certification boards; its examination panels comprised equal

numbers of industry officials and public servants, including federal and state government representatives, church leaders, and members of the Federal Youth Ring. The blueprint for the FSK's examination criteria was indeed the 1920 *Reichslichtspielgesetz*, though in a form adapted to contemporary political concerns such as the Allies' victory over National Socialism and the Cold War.

The exact nature of FSK censorship rulings is difficult to assess, since absolute secrecy surrounded all decisions: neither the number of titles that the FSK objected to, nor the grounds for objection, were ever made public. Insofar as any pattern can be discerned from the handful of leaked cases, FSK practice seems to have corresponded to the political directives of the Cold War. A remarkable disagreement rose between the federal government and the FSK concerning Gerhard Grindel's *Bis fünf nach zwölf* (*Until Five past Twelve*, 1953). The compilation film, featuring excerpts of Eva Braun's previously unknown home movies, focused on Adolf Hitler's reign and paid much attention to his economic program. The FSK requested extensive cuttings. Fearing that the film could jeopardize the planned rearmament of Germany (which the Western allies had to approve), Chancellor Konrad Adenauer personally intervened and campaigned against the film. On November 20, 1953, the German Minister of Interior Affairs, Gerhard Schröder, following a private viewing session in Adenauer's company, agreed to ban the film, on the flimsy grounds of "disturbing public safety and order." According to Stephan Buchloh, in his book on censorship during the Adenauer era, this "was the first (and only) ministerial decision to ban a film in the whole Federal Republic of Germany."[22]

After the decision to rearm West Germany, in 1954, the majority of war films no longer gave cause for complaint—although the FSK appeared remarkably sensitive about representations of Germany's National Socialist past. Its 1963 ruling on Vittorio de Sica's Jean-Paul Sartre adaptation *I Sequestrate di Altona* (*The Condemned of Altona*, 1962) provoked a particular furor. Of the four sections of dialogue objected to, the first ran as follows: "Do you think I respect the things father stood for? Or that I admire Flick, Krupp and father? Every time I see a Mercedes-Benz, I smell the stench of the gas ovens." The FSK ordered the names Flick, Krupp, and Mercedes-Benz to be removed, since "leading German companies cannot be associated with crimes whose instigators and perpetrators should be sought . . . in quite different quarters." It was also commented "that these lines are wholly indistinguishable from the meaningless rabblerousing of the Eastern zone." Another section of excised dialogue was: "We've got weapons and butter. And soldiers. And tomorrow the bomb." The FSK asserted that "these lines in principle ironize and indirectly reject the current existence of the Federal Army."[23]

In Hollywood productions, representations of the Nazi past were more inconspicuously "retouched" through alterations in the German-language version. Warner Bros., for example, altered its postwar German release of Michael Curtiz' *Casablanca* (1942) by erasing Conrad Veidt's SS Major Strasser

character entirely, while changing the figure of Paul Henreid's resistance fighter to a scientist.[24] The FSK's decisions in respect of "public morality" seem to have been less stringent—and certainly insufficient to satisfy church demands. *Die Sünderin* (*The Sinner*, 1951) passed without cuts—featuring Hildegard Knef who lived in concubinage, worked as a prostitute to buy pivotal drugs for her partner, assisted to his suicide, and then committed suicide herself. This prompted the resignations of the two church representatives on the FSK board, while outraged Catholics threw stink bombs and provoked the police into issuing local exhibition bans. A similar response greeted Ingmar Bergman's *Tystnaden* (*The Silence*, 1964), the film that initiated the foundation of a "Clean Screens Campaign" by Catholic protesters. In the end, however, such boycotts generally succeeded only in providing the films with additional publicity. From the late 1960s, moreover, the FSK's powers began to wane in the face of shifting moral attitudes and more liberal policies toward the East.

In 1972, the officially appointed members of the FSK board announced that their role would henceforth no longer involve passing films for adult audiences; instead, they would restrict their activities to the protection of minors. New laws—including paragraphs 131 and 184 of the constitution, with their references to the "glorification of violence" and "dissemination of pornography"—still afforded police and public prosecutors opportunities for action against films, and 1976 witnessed the seizure of both Pier Paolo Pasolini's *Salò o le 120 Giornate di Sodoma* (*Salò, or the 120 Days of Sodom*, 1975) and Nagisa Ōshima's *Ai no korîda* (*In the Realm of the Senses*, 1976) following tirades in the conservative press.

With the opening-up of television to both state-funded and privately funded broadcasters, FSK decisions, whose significance had been in decline since the 1960s, suddenly started to play an important role again in television rating wars. Many films originally passed for over-16s or over-18s only could not be broadcast during prime time; thus they commanded smaller audience shares and lower advertising revenues for broadcasters. These films were now resubmitted in efforts to secure a lower age certification. Thus the main duty of the FSK today is to decide on children's access to representations of violence and sexuality. Film censorship in Germany today, then, continues to address the very same concerns that preoccupied the first police censors during the Wilhelmine period.

Notes

1. This chapter is a revised and updated version of Loiperdinger, M. (2002) State Legislation, Censorship, and Funding, pp. 148–157 in Bergfelder, T., Carter, E. et al. (eds) *The German Cinema Book*. London: BFI Publishing.
2. Haake, S. (1993) *The Cinema's Third Machine. Writing on Film in Germany, 1907–1933*. Lincoln/London: University of Nebraska Press, pp. 27–60.

3. An das deutsche Volk!, *Reichs-Gesetzblatt*, 153 (1918), p. 1303.
4. §32.2 of the draft constitution of February 17, 1919.
5. The full text of the *Reichslichtspielgesetz* is reprinted in Maiwald, K. -J. (1983) *Filmzensur im NS-Staat*. Dortmund: Peter Nowotny, pp. 248–253.
6. On the censoring of *Battleship Potemkin* in Germany, see Eisenstein, S. and Tisse, E. ([1926]1973) Der Weg des Potemkin durch die deutsche Zensur, pp. 200–207 in Schlegel, H. -J. (ed) *Sergej M. Eisenstein: Schriften 2, Panzerkreuzer Potemkin*. Munich: Hanser; Kühn, G., Tümmler K. et al. (eds) (1978) *Film und revolutionäre Arbeiterbewegung in Deutschland 1918–1932*. Berlin: Henschelverlag, pp. 323–369 (including quotations from the censor's report); Seeger, E. (1932) *Reichslichtspielgesetz: Kommentar*. Berlin: Carl Heymann, p. 29. See also http://collate.deutsches-filminstitut.de/collate_sp/index.html
7. Fisch, S. (1997) *Der Weg des Films "Panzerkreuzer Potemkin" (1925) in das Kino der zwanziger Jahre*. Speyer: Hochschule für Verwaltungswissenschaften.
8. On the censorship of *Kuhle Wampe*, see Gersch, W. and Hecht W. (eds) (1973) *Bertolt Brecht—Kuhle Wampe: Protokoll des Films und Materialien*. Frankfurt am Main: Suhrkamp, pp. 62–66; Kühn et al. (1978), pp. 130–185.
9. Seeger (1932), p. 68.
10. Cited in Becker, W. (1973) *Film und Herrschaft: Organisationsprinzipien und Organisationsstrukturen der nationalsozialistischen Filmpropaganda*. Berlin: Volker Spiess, p. 70.
11. Cited in Becker (1973), p. 49.
12. Fraenkel, E. (1941) *The Dual State*. New York: Oxford University Press.
13. At the time, Leni Riefenstahl expressed pride at Adolf Hitler having personally approved *Triumph des Willens* without a single objection, just four days prior to its premiere. Cf. Loiperdinger, M. (1987) *Rituale der Mobilmachung. Der Parteitagsfilm Triumph des Willens von Leni Riefenstahl*. Opladen: Leske + Budrich, p. 161.
14. Wetzel, K. and Hagemann, P. (1978) *Zensur: Verbotene deutsche Filme 1933–1945*. Berlin: Volker Spiess.
15. Moeller, F. (2000) *The Film Minister. Goebbels and the Cinema in the "Third Reich."* Stuttgart/London: Edition Axel Menges, 2000, pp. 153–160.
16. Heimann, Th. (1994) *DEFA-Künstler und SED Kulturpolitik*. Berlin: Vistas, pp. 123–126.
17. Cited in Gersch, W. (1993) Film in der DDR: Die verlorene Alternative, p. 332 in Jacobsen, W., Kaes, A. et al. (eds) *Geschichte des deutschen Films*. Stuttgart/Weimar: Metzler.
18. "Für die Entwicklung der sozialistischen Filmkunst in der DDR." Empfehlung der Kommission für Fragen der Kultur beim Politbüro des ZK der SED. In: Deutsche Filmkunst, 9 (1958), cited by Gersch (1993), p. 334.
19. For a detailed discussion, see Wohland, W. (1967) *Informationsfreiheit und Politische Filmkontrolle: Ein Beitrag zur Konkretisierung von Art. 5 Grundgesetz*. Munich: unpublished PhD dissertation, pp. 153–189.
20. Cited in Wohland (1967), p. 154.
21. Thiel, R. E. Die geheime Filmzensur, *Das Argument*, 27 (November 1963), pp. 14–20, reprinted in Bredow, W. von, and Zurek, R. (eds) (1975) *Film und Gesellschaft in Deutschland. Dokumente und Materialien*. Hamburg: Hoffmann und Campe, pp. 327–333.

22. Author's translation. See Stephan Buchloh (2002) *"Pervers, jugendgefährdend, staatsfeindlich": Zensur in der Ära Adenauer als Spiegel des gesellschaftlichen Klimas.* Frankfurt/New York: Campus, p. 272.

23. Cited in Hack, L. (1964) Filmzensur in der Bundesrepublik, *Frankfurter Hefte,* 19 (10), pp. 706–707.

24. Garncarz, J. (1992) *Filmfassungen: Eine Theorie signifikanter Filmvariation.* Frankfurt am Main: Peter Lang.

6

Seeing Red: Political Control of Cinema in the Soviet Union

Richard Taylor

Before the so-called "Great October Socialist Revolution" of November 1917, all forms of cultural activity in the former Russian Empire were in some way controlled by the Holy Synod, the department of state that had replaced the independent Patriarchate of Moscow and been established by Peter the Great when he had integrated the Russian Orthodox Church into the imperial administrative structures in 1721.

The association of church and state in the mindset of the moderate Russian socialists (the "Mensheviks") who took power in February 1917 meant that initially censorship in any form was regarded as anathema and it was swept away briefly in a tidal wave of innocence and idealism. The Holy Synod was replaced after the February Revolution by a restored Patriarchate of Moscow, but this had reduced the powers confined solely to the administration of the Russian Orthodox Church itself, thus separating church and state for the first time in almost 300 years. The political vacuum that characterized the Provisional Government meant that the innocence and idealism did not last any longer than the Government itself. Two days after the October Revolution of 1917, the incoming Bolsheviks issued the first of many decrees that were to circumscribe cultural and media activity in the coming years. The Decree on the Press, issued on October 28, 1917 (10 November Old Style), argued that stringent measures were necessary to combat counter-revolutionary activity, a cry that was to be heard many times in the future.[1]

Despite the famous quotation attributed to Lenin that, "of all the arts, for us cinema is the most important,"[2] the chaos of the 1917–1921 Civil War, following on the deprivations of the First World War, meant that cinema as both an institution and an industry virtually ceased to exist in Soviet Russia until the introduction of the New Economic Policy (NEP) in March 1921.

Nevertheless, one of Lenin's other purported remarks, that there should be a definite ratio between documentary and fiction films,[3] points toward an important subsequent method of political control other than postcensorship, namely, forms of precensorship that included control over intended genre and content. However, stringent war censorship was introduced at least on paper, and indeed on papers, and Article 14 of the first Constitution (or Basic Law) of the Russian Soviet Federative Socialist Republic (RSFSR), promulgated on July 10, 1918, stated that "in order to guarantee the workers genuine freedom of expression for their views the RSFSR is destroying the dependence of the press on capital and transferring into the hands of the working class and poor peasantry all the technical and material means of production of newspaper, brochures..."[4] This *Weltanschauung* provided the ideological basis for the approach to all media, including cinema, and the rationale and dynamic for all subsequent restrictions on the media throughout the Soviet period. Crucially, those who did not meet the most fundamental official ideological requirements were defined, not just as "counter-revolutionaries" but also, more sinisterly, as *vragi naroda* (enemies of the people)—a phrase that still chills the blood of those who lived through the darkest years of the Soviet period.

However, such was the power vacuum at the political center after the 1917 revolutions that the first attempts at film censorship came at the local level. On July 17, 1918, the Moscow Soviet demanded to see all the advertising material used by "electro-theaters" (cinemas) in the city.[5] In August the Cinema Committee of the recently established *Narodnyi Komissariat po prosveshcheniiu* (People's Commissariat for Enlightenment, Narkompros, itself set up on November 22, 1917, almost immediately after the Bolshevik coup)[6] issued the first of many lists of films that were deemed to be unsuitable for the repertoire and therefore had to be removed from Soviet screens forthwith.[7] Some of the films on this list were pre-revolutionary home products, while some had been imported. Once victory had been secured in the Civil War in March 1921, the powers invested in the various organs of war censorship were transferred the following August to the secret police, then called the Cheka (later GPU, OGPU, NKVD, MVD, and finally the KGB),[8] while on December 21, 1921, a special Cheka department with even wider powers of political control over the media, including not just cinema, but also "electro-theaters," was set up.[9] At the same time the first steps were being taken to exclude politically undesirable people from participation in the cultural organs of the new ideological state; this was to become a crucial instrument of precensorship in later years. On May 19, 1921, Lenin wrote to the head of the Cheka, Feliks Dzerzhinskii, suggesting that a list of "writers and professors who were aiding counter-revolution" should be drawn up. In the following autumn the *professorskii parokhod* (Professors' Steamer) took many members of the Russian intelligentsia, whose continuing presence did not suit the Bolshevik authorities, to an involuntary—and usually permanent—exile.[10]

Meanwhile, back in the USSR, the organs of political control were being refined. On June 6, 1922, the *Sovet Narodnykh Komissarov* (Council of People's Commissars, Sovnarkom) established under Narkompros the *Glavnoe upravlenie po delam literatury i izdatel'stv* (Chief Directorate for Literary and Publishing Affairs, Glavlit), whose function was "to unify all forms of censorship of printed works."[11] On February 9, 1923, yet another institution was created, this time directly under Glavlit and therefore indirectly under Narkompros—*Glavnyi repertuarnyi komitet* (Chief Repertoire Committee, Glavrepertkom), and this new body was tasked with ensuring that "no single work will be passed for public performance without the appropriate permission from Glavlit's Glavrepertkom or its local organs."[12] This decree was one of the first to mention cinema—and *cinemas*—specifically and therefore suggests that it was indeed on the way to becoming "the most important of the arts."

Largely because of this, from the mid-1920s, cinema began to fall under the influence, if not actual control, not just of state organs of censorship, but also of Bolshevik party institutions. The Agitprop (acronym for agitation and propaganda) Department had been set up under the Central Committee of the Bolshevik Party in 1920 and concerned itself with direct ideological control over the media and other sociopolitical activities.[13] The precise responsibilities of each state and party institution responsible for censorship and control were frequently redefined and the frontiers between them shifted according to changes in both policy and personnel. The situation was sufficiently complex even as early as September 1925 that, when Sovkino, nominally responsible for film production, distribution, and exhibition, wished to complain that an attempt at postrelease censorship of the Douglas Fairbanks film *The Mark of Zorro* (1920) on grounds of "counter-revolution" was "contrary to common sense," it had to address its complaint to three different institutions: the Party Central Committee Cinema Commission, the Board of Narkompros, and Glavrepertkom itself.[14] Even in November 1928, Anatolii V. Lunacharskii, still then head of Narkompros, complained to Petr Bliakhin, the deputy Chairman of Glavrepertkom, that Sovkino was taking far too long to consider his script for a film entitled *Kometa* (the Comet).[15] This blurring of responsibilities and the confusion between competences were to last throughout the Soviet period and meant that censorship was, more often than not, not as "total" as it aimed or claimed to be, and certainly not as effective as the authorities desired or intended.

Censorship takes many forms. The most obvious is control over content, and the rationale behind it is often as interesting as the actual control. In 1925, under the heading *Sovershenno sekretno* (top secret), Glavlit issued a list of topics that "constituted a secret and were not appropriate for promulgation in order to preserve the political and economic interests of the USSR."[16] The list precluded any mention of suicide or mental illness caused by unemployment or starvation and forbade any reporting of the infestation of bread supplies

by ticks, weevils, or other insects "in order to avoid panic."[17] So, by the middle of the 1920s, we already have the censorship of "counter-revolutionary" activities by "enemies of the people," which was a broad enough blanket category in itself, and the withholding of information "to avoid panic." However, even here, censorship was patchy and unreliable, largely because the lines of communication between the center and the periphery were not always either very clear or very effective. In March 1930, Narkompros complained to local branches of Glavlit that they were banning films that had been explicitly passed by central Glavlit (e.g., *Krest i mauzer* [*The Cross and the Mauser*, 1925], *Miss Mend* (1926) and *Zhivoi trup* [*The Living Corpse*, 1929]) under the misconception that any film with provocative "bourgeois" words such as "cross," "miss" or "corpse" should *ipso facto* be forbidden. On the contrary, Narkompros intoned, the "purging from the screen of production that is of ideologically inappropriate quality is being conducted by Glavrepertkom in a planned manner and quite decisively."[18]

Control of content could also be achieved by broad monitoring reinforced by financial controls. From the mid-1920s also we see the development of *templany* (thematic plans) for each studio for each year of production. It was the responsibility of the *khudozhestvennyi sovet* (Artistic Council) of each studio to devise and monitor the implementation of these thematic plans, so that, in theory at least, a film project was checked for deviation at every stage of consideration and then production. Ivan Pyriev's *Konveier smerti* (*The Assembly-Line of Death*) was remade 14 times before being finally released in 1933.[19] On the other hand, Abram Room's *Strogii iunosha* (*A Severe Young Man*, 1936) was, despite revisions, banned and eventually released only in 1974. Individual studio *templany* were drawn together into an overall thematic plan for the industry as a whole.[20] Eventually, the content of these *templany* was to be influenced by state investment, so that subjects that the party and state wished to encourage (for instance, the history of the revolutionary movement) received preferential funding. This process led to the growth of a sizeable apparatus of precensorship, but again one that was not always very effective. The only studio that was exempt from this kind of control was Mezhrabpom, which was partly funded by Willi Münzenberg's International Workers' Aid (German: *Internationale Arbeiterhilfe*; Russian: *Mezdunarodnaia rabochaia pomoshch'*) movement, based in Berlin, and which was only closed down in 1936, largely because, after Hitler's rise to power, funding from Germany dried up and the studio's rationale ceased to exist.[21]

Despite the measures that had been introduced to control film output in the course of the first decade after the October 1917 Revolution, it became obvious by the time of the tenth anniversary that Soviet cinema was not producing the kind of ideologically based films that the state and party authorities required for their own political ends. In March 1928 the first All-Union Party Conference on Cinema was convened under the auspices of the

Agitprop Department. Under the slogan that cinema must be "intelligible to the millions," the conference resolution argued that

> Cinema, the "most important of the arts," can and must occupy an important place in the process of cultural revolution as a medium for broad educational work and Communist propaganda, the organization and education of the masses round the slogans and tasks of the party and their artistic education, wholesome rest and entertainment . . . Cinema, like every art, cannot be apolitical.[22]

A significant part of the conference resolution was devoted to the "problem of cadres," as the Soviet authorities called personnel. In an address in the Kremlin to graduates of the Red Army Academies in May 1935, Stalin was to produce another lasting slogan, "Cadres decide everything."[23] This was not an innovative *aperçu* on Stalin's part. As early as November 1922, the Regional Party Committee of the central district of Petrograd had instructed the local branch of Glavlit that it should replace its nonparty members with party members appointed by the party committee itself at Glavlit's "request!"[24]

The problem, as applied to Soviet cinema in 1928, allegedly, that there were not enough creative and technical people of proletarian origin working in the industry to produce the films that were needed. This perception reflected the predominance of the so-called "proletarian" cultural organizations during the Cultural Revolution that accompanied the first Five-Year Plan of 1928–1932. These, such as the writers' organization RAPP (*Rossiiskaia assotsiatsiia proletarskikh pisatelei*, Russian Association of Proletarian Writers), overplayed their hand and were abolished in May 1932, but not before the notion of a close causal connection between class origin and end product had been firmly implanted in the Soviet political consciousness.[25]

Just over two years after the dissolution of RAPP and similar organizations, the first Congress of Soviet Writers in August 1934 officially promulgated the doctrine of "socialist realism," which was to furnish the framework, or some would say straitjacket, that governed all subsequent cultural activity in the Soviet Union. Like the organizations that were responsible for enforcing it, however, socialist realism was to prove over the years to be rather more flexible than Stalin and his leading cultural officials had perhaps intended. Cadres did, indeed, decide everything!

The 1930s are the crucial decade in the history, not only of Soviet cinema, but also of the censorship of that cinema, because it was in this decade that the general structures of the industry, and of its control, were firmly established. It has to be said, however, that it was also in the 1930s that the all-important "informal" structures also came into being. It is from this period that the regular late-night screenings for Stalin that gave him the soubriquet "the Kremlin censor" date.[26] The official head of Soviet cinema for most of the 1930s (until he was arrested as a "Trotskyite-Bukharinite-Rykovite fascist cur" in January

1938 and shot in July),[27] Boris Shumiatskii, recalled in particular a screening and discussion of *Chapaev* (1934) in March 1936, by which time Stalin had already seen the film 36 times![28]

Shumiatskii's notes on his discussions with Stalin at these screenings from 1934 to 1937 have been published in Russian, but alas not yet translated into other languages.[29] There is also a possibly apocryphal story that, when the editors of Stalin's collected works came to the 13th volume, covering the war period, the only writings by Stalin that could be found for inclusion in the volume were his notes and comments scrawled across film scripts in their various drafts. Many further comments were also made in one-to-one telephone calls from the Great Leader of the World Proletariat and in asides following the Kremlin screenings. Anecdotal evidence for all this is plentiful, but scholarly sources are, alas, scarce.

By the end of the 1930s the studio structure had been radically transformed, although not, as Shumiatskii had intended, along the lines of a *sovetskii Gollivud* (Soviet Hollywood). Two enormous studios were established in the two main cities, Moscow (Mosfil'm) and Leningrad (Lenfil'm); a "national" film studio was set up in each Union Republic—Ukrainfil'm in Kiev, Armenfil'm in Erevan, and so on. The Mosfil'm studio was amongst the largest in Europe and was built on the Lenin Hills (now again the Sparrow Hills) overlooking the city from the southwest, next to where the wedding-cake Moscow State University was being erected. The main educational and training establishment, *Vesoiuznii Gosudarstvennyi Institut Kinematografii* (VGIK), which had its origins in the early 1920s, remained however in the inner northern suburbs near the All-Union Agricultural Exhibition (later the inappropriately named All-Union Exhibition of Economic Achievements of the USSR or VDNKh), which provided the background for many films of the late 1930s, as if to emphasize the location's "all-Union" significance, rather than its purely Muscovite standing.

One other element in the mixture was published film criticism. In the 1920s this had been quite varied, but in the course of the 1930s it too was brought into line. The only radical criticism allowed of completed films was that which furthered official policy as, for instance, in the case of Eisenstein's aborted project *Bezhin lug* (*Bezhin Meadow*, 1935–1937).[30] Film criticism, for the authorities, was a weapon of last resort, to be used only when all the other instruments of control had signally failed. Surprisingly, this happened to a greater extent than generally realized and the phenomenon of "shelving" films that, once completed, were deemed unsuitable or even unfit for release, dates from this time. One well-known example is Eisenstein's historical epic *Aleksandr Nevskii* (*Alexander Nevsky*, 1938), which was ideally suited to the antifascist climate of the late 1930s, until the signing of the Nazi–Soviet Non-Aggression Pact in August 1939, when the film was withdrawn overnight, only to be re-released after the launch of Nazi Germany's Operation Barbarossa against the USSR on June 22, 1941.

The rapid pace and the extent of the German invasion in the summer of 1941 meant that measures had to be taken to protect the Soviet film industry. In September 1941 the major studios were relocated to Alma-Ata, the capital of the Kazakh SSR far from the advancing German lines, and merged into TsOKS, *Tsentral'naia ob"edinennaia kinostudiia* (Central United Film Studio),[31] which remained in existence until the end of the war in May 1945 made it safe to return to European Russia. It was here that the film output for the period known in the USSR as the "Great Patriotic War" was produced, including much of the first part of Eisenstein's *Ivan Groznyi* (*Ivan the Terrible*, 1945).

The upsurge in patriotism, both national and Soviet (and the two were often cleverly combined), made the harsh external censorship of the late 1930s less necessary as much of the emphasis was on mere survival. Newsreel footage became all-important and considerable effort was made to improve resources for effective frontline newsreel footage, which did more than anything else to boost popular morale. The paranoia of the authorities, however, meant that strenuous Agitprop efforts were made to counter the perceived effects of Nazi propaganda as increasing areas of territory were liberated from the German occupation.[32] Particular attention was paid to the "Western Ukraine," which was transferred from Polish to Soviet jurisdiction as the Red Army advanced.[33] The leading Ukrainian-born director, Aleksandr Dovzhenko, made three feature-length propagandist films between 1940 and 1945, which celebrated the reincorporation of "Western Ukraine" into the Soviet Union in that period.[34]

The principal task in 1945 was the restoration and reconstruction of the film industry so that it could play the full part envisaged for it in peace-time by the Soviet authorities. Its shortcomings were identified in a government report to Stalin's "cultural commissar," Andrei Zhdanov, on March 4, 1946, the day before the first part of Eisenstein's *Ivan the Terrible* was banned.[35] Its significance was recognized on March 20, 1946, by the establishment of a separate Ministry of Cinematography, under the previous chairman, Ivan Bolshakov, who, in the previous decade would, like Shumiatskii, quite literally have lost his head.[36] Instead his ambitious plans were reported to the Party Central Committee on May 27, 1946.[37] In the meantime Zhdanov has launched a blistering attack on the current state of cinema and its failure to produce the necessary films in the necessary quantities.[38] There followed concerted criticism of the second part of the film *Bol'shaia zhizn'* (*A Great Life*, 1946), which became the focus for a campaign against "cosmopolitanism" (echoes of *vragi naroda* [enemies of the people]) and for a general clampdown on the arts, that in effect paralyzed them.[39] Because of the increasing difficulty of gaining approval for film scripts and their ensuing projects, the second half of the 1940s has become known as the *malokartin'e* (film famine). Whereas in 1941, 64 feature films had been released, in 1945 this number was down to 19, in 1948 to 17, in 1950 to 13, and in 1951 to a mere nine.[40]

Ironically, given what was then still recent history, the problem of the "film famine" was solved by the reediting and release of a number of key Nazi propaganda feature films captured as war booty by the Red Army from the former UFA studios in Neubabelsberg in 1945 and known in Russian as *trofeinye fil'my* (trophy films). The list discussed by the Central Committee on August 27, 1948, included 33 German films, 31 American, five Italian, and one Czechoslovak film. Subsequent discussion also included the British film *Chu Chin Chow* (1934), a musical version of the tale of Ali Baba and the Forty Thieves![41] Many of these films were also shown in the Soviet-controlled areas of eastern Europe in the 1950s, so that the anti-British propaganda film *Titanic* (1943), banned by Goebbels, was first shown on German soil in the German Democratic Republic (GDR) in 1950.[42] If nothing else, these imported and reedited films provided a welcome relief from the apotheosis of the cinematic cult of personality from *Kliatva* (*The Vow*, 1946) to *Padenie Berlina* (*The Fall of Berlin*, 1950). Even in August 1951 the party Agitprop Department was discussing the possible release of the US film *Meet John Doe* (1941) under the revised title *Istoriia odnogo bezrabotnogo* (*The History of an Unemployed Man*).[43]

It was really only the death of Stalin in March 1953 that released Soviet cinema from the straitjacket that had curtailed production and sapped the industry of its vitality. Nikita Khrushchev's "Secret Speech" to the delegates to the 20th Party Congress in February 1956, denouncing the excesses of the personality cult and the role of Soviet cinema in it, opened the door to the period of relative relaxation known as *ottepel'* (the Thaw). The release of films such as *Letiat zhuravli* (*The Cranes Are Flying*, 1957), *Dom v kotorom ia zhivu* (*The House I Live In*, 1957), or *Ballada o soldate* (*Ballad of a Soldier*, 1959) had as much to do with generational changes in both filmmakers and filmgoers and with a significant change in the political climate as with legislative changes at the state and party level. External and prior censorship had largely given way to a common understanding of the limitations to what could be done and thus to widespread self-censorship. This is why the relative relaxation was relatively easy to put into reverse in the 1960s, when the Thaw gave way ultimately to *zastoi* or the period of "stagnation" that characterized the cultural sclerosis of the Brezhnev era.

Almost by definition very little changed in this period of stagnation, but, underneath the surface, the ice-sheet was beginning to crack. Political and economic developments in the international area were factors promoting change. Increasing opportunities for overseas travel and increasing international media communication were others. The Soviet Union could no longer remain hermetically sealed against the outside world, as it had done during the Great Patriotic War and the Stalin era. Furthermore, in Soviet cinema, as elsewhere, decades of attempted repression fostered a tacit understanding among filmmakers and a sense of community defined increasingly against official Soviet authority.[44]

In 1985 the ice-sheet finally did crack and indeed split right open and the floodwaters of *perestroika* and *glasnost'* swept away the remnants of the Soviet Union and its censorship apparatus. On February 25, 1986, Mikhail Gorbachev, First Secretary of the Communist Party of the Soviet Union, officially promulgated the policy of *glasnost'* or "openness."[45] The seminal event in the cultural politics of this period was the Fifth Congress of Soviet Film-makers in May 1986.[46] It is of course highly significant that, whereas the cultural event that heralded the tightening of controls in the 1930s was a congress of writers, the event that heralded the loosening of the 1980s was in Lenin's "most important of all the arts," and this despite the growing importance in the late Soviet period of more directly controllable mass media such as radio and television. The Congress overturned the existing leadership of Soviet cinema. One of its most significant achievements was the establishment of a Conflict Commission, whose task was to review more than 140 films that had been left *na polku* (on the shelf) during the past decades and consider whether they should be released. In the end almost 60 of these films were allowed some form of public distribution and exhibition.[47] One of the most significant releases to result from this process was Aleksandr Askoldov's *Komissar* (*The Commissar*, completed 1967, released 1988), which alluded to the fate of the Jews in the Soviet period and to the Holocaust. Perhaps even more surprising was the Georgian film *Pokaianie* (*Repentance*, Georgian: *Monanieba*, completed 1984, released 1987), which contained a thinly disguised portrayal of Beria and the terror unleashed on Georgia during the Stalin era. Once more, the most remarkable aspect of these events was that, despite all the mechanisms of control that were in place during the period of "stagnation," these films had not only been contemplated and put into production—but had actually been completed, and only then forbidden. After almost 70 years Soviet cinema had not been "silenced."

On June 12, 1990, the USSR Supreme Soviet passed the law "On the Press and Other Media of Mass Information," which stated unambiguously that the "censorship of mass information is not permitted."[48] Censorship of Soviet cinema finally came to an end. The end of the Soviet Union itself followed only 18 months later.

Notes

1. Cited from: Goriacheva, T. M. et al. (eds) (1997) *Istoriia sovetskoi politicheskoi tsenzury. Dokumenty i kommentarii.* Moscow: ROSSPEN, pp. 27–28. The Old Style, or Gregorian, Calendar was in use in Russia until February 1918, which explains the discrepancy in dates between Russia and the West.
2. Boltianskii, G. M. (ed) (1925) *Lenin i kino.* Moscow/Leningrad: Gosizdat, pp. 16–19.
3. Lunacharskii, A. V. (1928) *Kino na zapade i u nas.* Moscow: Gosizdat, pp. 63–64.
4. Goriacheva et al. (1997), p. 31.

5. Listov, V. S. & E. S. Khokhlova (eds) (1996) *Istoriia otechestvennogo kino. Dokumenty. Memuary. Pis'ma. Vypusk I.* Moscow: Materik, p. 90.
6. Volkova, N. B., S. V. Drobashenko, & R. N. Iurenev (eds) (1979) *Sovetskoe kino 1917–1978. Resheniia partii i pravitel'stva o kino.* Moscow: NIITIK & TsGALI, vol. 1, pp. 12–13. This and the companion volume covering 1937–1961 include the texts of almost all documents governing the relationship between the Soviet authorities and the cinema, but they were not published for general circulation and I have therefore given more widely available sources where possible.
7. Listov & Khokhlova (1996), pp. 91–92.
8. Molchanov, L. A. (2002) *Gazetnaia pressa Rossii v gody revoliutsii i Grazhdanskoi voiny (okt. 1917–1920).* Moscow: Izdatpoligrafpress, ch. 3.
9. Kolpakidi, A. I. & M. Seriakov (2002) *Shchit i mech.* Moscow: Olma Media Group, pp. 357–358.
10. See http://ru.wikipedia.org/wiki/tsenzura v SSSR, accessed August 15, 2011.
11. Zhirkov, G. V. (2001) "Sistema ogranichitel'nykh mer i nadzora za pechat'iu i Glavlit," in *Istoriia tsenzury v Rossii XIX-XX vv. Uchebnoe posobie.* Moscow: Aspekt-press, p. 221.
12. Goriacheva et al. (1997), pp. 39–40. See also Listov & Khokhlova (1996), pp. 96–99.
13. There is a long history in Russian socialism of appreciating the significance of agitation and propaganda for a political minority: see, for instance, Harding, N. (ed) (1983), *Marxism in Russia. Key Documents 1879–1906,* trans. R. Taylor. Cambridge: Cambridge University Press, especially pp. 103–106, 166–168, 197–205, 324–325.
14. Goriacheva et al. (1997), pp. 444–445.
15. Goriacheva et al. (1997), pp. 455–456.
16. Zhirkov (2001), p. 358.
17. Suetnov, A. (2006) "Tur vokrug tsenzury. Nedal'niaia istoriia," *Zhurnalistika i mediarynok,* no. 9.
18. Blium, A. V. (2004) *Tsenzura v Sovetskom Soiuze 1917–1991. Dokumenty.* Moscow: ROSSPEN, p. 175.
19. Faraday, G. (2000) *Revolt of the Filmmakers. The Struggle for Artistic Autonomy and the Fall of the Soviet Film Industry.* University Park, PA: Pennsylvania State University, p. 54.
20. As late as March 1938, the new head of Soviet cinema following Shumiatskii's arrest, Semen Dukel'skii, reported on the general plan to Viacheslav Molotov, chairman of Sovnarkom: Anderson, K. M. & L. V. Maksimenkov (eds) (2005) *Kremlevskii kinoteatr, 1928–1953. Dokumenty.* Moscow: ROSSPEN, pp. 489–490.
21. Mezhrabpom's films included some of the most famous "popular" works of early Soviet cinema, such as Vsevolod Pudovkin's films *Mat'* (*The Mother,* 1926), *Konets Sankt-Peterburga* (*The End of St Petersburg,* 1927), *Potomok Chingis-khana* (*Storm over Asia,* 1929) and *Dezertir* (*The Deserter,* 1933) and films based on scripts by Lunacharskii, such as *Medvezh'ia svad'ba* (*The Bear's Wedding,* 1925) and *Salamandra* (*The Salamander,* 1928). Mezhrabpom changed its name from Mezhrabpom-Rus' to Mezhrabpomfil'm in 1928.
22. Ol'khovyi, B. S. (ed) (1929) *Puti kino. Vsesoiuznoe partiinoe soveshchanie po kinematografii.* Moscow: Gosizdat, pp. 429–444, translated by R. Taylor in: Taylor R. & I. Christie (eds) (1988) *The Film Factory. Russian & Soviet Cinema in Documents, 1896–1939.* London: Routledge & Kegan Paul, pp. 208–215; this extract from p. 208.

23. Stalin, J. V. (1976) *Problems of Leninism*. Beijing: Foreign Languages Publishing House, pp. 767–774.
24. Blium (2004), p. 35.
25. The relevant RAPP document is translated in: Taylor & Christie (1988), pp. 275–280, and the Party Central Committee decree dissolving the proletarian cultural organizations is to be found in the same source on p. 325.
26. Hence the title of: Mar'iamov, G. (1992) *Kremlevskii tsenzor. Stalin smotrit kino*. Moscow: KinoTsentr.
27. Taylor & Christie (1988), pp. 387–389.
28. Kabanov, V. T. (ed) (2008) *Vozhd' i kul'tura. Perepiska Stalina s deiateliami literatury i iskusstva 1924–1952, 1953–1956*. Moscow: Chelovek, pp. 154–156. A letter written on January 27, 1937 by Stalin to Shumiatskii with detailed comments on *Velikii grazhdanin* (*A Great Citizen*, 1937) is included in: Artizov, A. & O. Naumov (eds) (2002) *Vlast' i khudozhestvennaia intelligentsia. Dokumenty TsK RKP(b)—VKP(b), VChK—OGPU—NKVD o kul'turnoi politike, 1917–1953 gg*. Moscow: Demokratiia, p. 350. Stalin liked a "good story" and Shumiatskii used this to promote his own idea that *Chapaev* epitomized a cinema that was "intelligible to the millions."
29. Troshin, A. S. (ed) *Kinovedcheskie zapiski*, no. 61, Moscow, 2002, pp. 281–346 and no. 62 (2003), pp. 115–188. Republished in: Anderson & Maksimenkov (2005), pp. 919–1053.
30. Taylor & Christie (1988), pp. 378–381, and Eisenstein, S. M. (2010) *Selected Works. Vol. III. Writings, 1934–1947*, ed R. Taylor, trans. W. Powell, 2nd edn, London: I.B. Tauris, pp. 100–105.
31. Volkova, Drobashenko, & Iurenev (1979), vol. 2, 1937–1961, p. 25.
32. See, for instance: Volkova, Drobashenko, & Iurenev (1979), pp. 41–43 et seq.
33. Volkova, Drobashenko, & Iurenev (1979), p. 76.
34. *Osvobozhdenie* (*Liberation*, 1940); *Bitva za nashu sovetskuiu Ukrainu* (*The Battle for Our Soviet Ukraine*, 1943), *Pobeda na pravoberezhnoi Ukraine i izgnanie nemetskikh zakhvatchikov za predeli ukrainskikh sovetskikh zemel'* (*Victory in the Western Ukraine and the Expulsion of the German Aggressors from the Borders of Ukrainian Soviet Lands*, 1945).
35. Anderson & Maksimenkov (2005), pp. 718–722. The ban is printed on p. 723.
36. Volkova, Drobashenko, & Iurenev (1979), vol. 2, p. 95.
37. Anderson & Maksimenkov (2005), pp. 738–740.
38. Anderson & Maksimenkov (2005), pp. 724–729.
39. Anderson & Maksimenkov (2005), pp. 747–770. The film was banned on 12 August (p. 762).
40. Elizarov, G. K. (ed) (1961) *Sovetskie khudozhestvennye fi'lmy. Annotirovannyi katalog. Tom 3*. Moscow: Iskusstvo, pp. 20–24.
41. Anderson & Maksimenkov (2005), pp. 801–811.
42. Taylor, R. (1998) *Film Propaganda. Soviet Russia and Nazi Germany*, 2nd revised edn, London: I.B. Tauris, pp. 151, 212–214.
43. Anderson & Maksimenkov (2005), p. 881.
44. Faraday (2000), p. 71.
45. See http://ru.wikipedia.org/wiki/khronologiia sovetskoi tsenzury, accessed October 3, 2011.
46. The minutes were published as: Senchakova, G. V. (ed) (1987) *Piatyi s"ezd kinematografistov SSSR. 13–15 maia 1986 goda. Stenograficheskii otchet*. Moscow:

Vsesoiuznoe biuro propagandy kinoiskusstva. See also: Burdiak, L. M. (ed) (2005) *Istoriia otechestvennogo kino.* Moscow: Progress-Traditsiia, p. 460; and Taylor, R. (1999) Now that the Party's Over: Soviet Cinema and Its Legacy, ed Beumers, B. *Russia on Reels. The Russian Idea in Post-Soviet Cinema.* London: I.B. Tauris, pp. 34–42.
47. Faraday (2000), p. 130.
48. *Zakon SSSR ot 12.06.1990 "O pechati i drugikh sredstvakh massovoi informatsii."*

7

Prohibition, Politics, and Nation-Building: A History of Film Censorship in China

Zhiwei Xiao

That the history of any national cinema is inseparable from the political history of that nation hardly needs elaboration. For those interested in Chinese cinema, it is even more crucial to view the developments of the Chinese film industry and the evolution of the film censorship apparatus against the backdrop of major political events and regime changes in the last century.[1] As a new form of mass medium, the motion pictures were introduced into China from the West at the end of the nineteenth century when the old social order was on the verge of collapse.[2] In the first half of the twentieth century, China witnessed the fall of the Qing Dynasty in 1911, the civil conflicts in the ensuing decade, social unrests, invasion and occupation by Japan, and the Civil War between the Communists and the Nationalists, which ended in the former's victory in 1949. In the second half of the twentieth century, China was involved in four international conflicts, suffered the disastrous consequences of the Great Leap Forward program, was traumatized by the Cultural Revolution, and transformed by the economic reform in the last two decades of the twentieth century. This turbulent history has left a profound imprint on the political orientation and aesthetic style of the Chinese cinema. As such, a meaningful discussion of Chinese film censorship must be situated in the context of that history.

In lieu of the close relationship between cultural production and political changes in China, the history of film censorship there can be divided into two major periods, separated by the Communist victory in 1949. Generally speaking, during the pre-Communist era, the central agenda in the official attempts to regulate cinema was to enlist film to the service of the nation

building project. By taking issue with offensive and racist screen images in foreign films and by promoting ideas and values conducive to China's modern transformation, successive censorship regimes in the first half of the twentieth century China used film censorship as a vehicle to serve their broader political objectives. In contrast, in the second half of the twentieth century, the predominant objective of the Communist effort to control the film industry was to use film as a tool to promote Marxist ideology and to ensure audience loyalty to the Party. Needless to say, within each of these two periods, there are different phases with variations of the central themes. The following discussion will be organized along a largely chronological sequence of developments.

Part I: The Pre-Communist Period

The history of China during the first half of the twentieth century is characterized by political disarray, social turmoil, and bloody conflicts on both domestic and international fronts. The fact that no regime could manage to stay in power for longer than a decade further exacerbated the political chaos and instability. Even the Nationalist government, which, in theory at least, was in power from 1928 to 1949, had limited control over the country because there were warlord regimes challenging its authority in the 1930s and then Japanese occupation of much of the country between 1937 and 1945. Given the precarious nature of the political situation, it should not be surprising that film censorship was not on the top of any regime's agenda. However, no matter how briefly in power, every regime made some attempts at regulating film production and exhibition. Collectively, their trials and errors during this period have left a rich legacy that would help shape the Communist regime's film policy in the second half of the twentieth century.

The early period, 1905–1928

Shortly after its introduction into China, movies quickly became one of the most popular forms of entertainment in many urban areas of the country, competing with traditional opera performances and storytelling for audiences and popularity. Yet, in China as elsewhere, movies were not just vehicles of entertainment, but "part of a growing battleground for control of consciousness and class loyalties."[3] The mass appeal of the movies gave rise to intense struggle for control over film exhibition and production among different social groups, political parties, and economic actors. In 1905, the Beijing Police Department issued The Eleven Rules Governing the Showing of Movies in the Evenings, which was the first official rule to govern the showing of motion pictures in China. It is worth noting that The Eleven Rules are only concerned with the safety of the movie theater's physical environment and the conduct of the audience than with the content of film itself. For instance, the document

specifically stipulates that a movie theater be equipped with ventilation system, firefighting facilities, emergency exits, and restrooms for both genders. It also requires the moviegoers to conduct themselves in civil and courteous manner and be seated separately according their gender. But it says nothing about the kinds of films that can or can't be screened.[4]

Little is known about how forcefully The Eleven Rules was enforced by the authorities, even less the impact of these rules on film exhibition in cities like Beijing. Suffice it to say here that only a few years after these rules were promulgated, the Qing government was overthrown. In the ensuing decade, China was engulfed in civil wars and became politically disintegrated. Until the late 1920s when the Nationalists nominally unified the country, China was divided into several regions, each controlled by a militarist government. Even under such circumstances, efforts to censor films continued under the auspices of the regional regimes. One common theme that emerged from these separate developments in different parts of the country is the struggle for control over film censorship between the police and the educators. Although the objectives of these two groups were not necessarily mutually exclusive, the police seemed to be more focused on preventing films from producing undesirable social consequences and inclined to take a prohibitive approach. In contrast, the educators seemed more mindful of the potential power of films to do both good and evil, and took a proactive approach to film censorship by not limiting their efforts to prohibiting "bad" films from being screened, but by promoting films of their preference as well.

Documentary evidence suggests that the police were behind many early initiatives to regulate film exhibition during the 1910s and 1920s. For instance, in 1921, the Beijing government's police department proposed a set of regulations to govern the movie theaters. The proposal placed heightened emphasis on theater management, which included registration with the police, separate seating for men and women, daily submission of the program to the police for inspection, regular reports of ticket sales, and the payment of taxes and fees. Less attention was given to the content of the film except to state that no racy, bizarre, or superstitious films were allowed.

In contrast to the predominant role the police department in Beijing played in regulating films, the Jiangsu Board of Film Censors, organized in 1923, placed film censorship squarely in the hands of the educator-elite. As the first government agency in China specifically established to censor films, the official policy of this board was to limit its intervention by focusing on the extremes: to recommend extremely good films ("good" meaning containing educational value or serving a positive function) and to ban extremely bad films ("bad" meaning injurious to social mores), leaving alone the majority that fell in between.[5]

The Film Censorship Guidelines, drafted by the Mass Education Department in 1926, progressed considerably beyond its predecessors by paying

more attention to what is on the screen rather than the physical site of film exhibition. The new rules also adopted a more flexible approach to problematic films by allowing film proprietors to delete questionable sections to avoid the entire film from being banned. Even more significantly, these new guidelines specifically stipulated that any film deemed offensive to the Chinese dignity will be prohibited. For the first time, Chinese resentment toward their racist portrayals in foreign films was articulated and codified through film censorship. Also to be noted about the 1926 document is that its criteria for approving or disapproving a film included considerations of the film's technical quality and craftsmanship. In practice, the censors would require revisions of films on account of their alleged inferior technical or artistic quality. Finally, the guidelines introduced a new orientation to the practice of film censorship in China by including an incentive component called "award for good films." What this means is that in addition to keeping undesirable films out of circulation, the censors also wanted to simultaneously promote films that conform to their taste and preference. To receive censors' endorsement and official award, a film would have to be realistic in its portrayals of social life, have a positive and uplifting moral message, encourage scientific inquiry, and bring audience some educational benefits.[6]

However, the biggest flaw in the Mass Education Department's effort at film censorship was that it did not involve the police in the undertaking. Consequently, the guidelines were never effectively implemented, even less enforced. Obviously, the exercise of censorial power is more than deciding which film to ban and which to promote at board meetings. Without the police to enforce the board decisions, the regulations were meaningless.

This lesson was taken to heart when the Education Department of the Zhejiang Provincial government organized its film censorship committee in February 1926. The Zhejiang educators invited the police to join their cause. The initial members of the Zhejiang Film Censorship Committee included 16 participants from both the Bureau of Education and the Bureau of Police. However, representatives from the education bureau outnumbered those from the police bureau by a ratio of 3:1. This organizational makeup guaranteed the educators' control of the institution.[7]

Some liberal intellectuals worried about the government's monopoly on what could and could not be seen on the screen and proposed a "public supervision" model based on the US National Board of Censorship (Review) of Motion Pictures (see Chapter 1). Their distrust of the government may have been well founded, but for the majority of people in the film industry, the more urgent and immediate problem was not the tyranny of government intervention, but rather the need for the government to play the roles of regulator, coordinator, and referee in a field characterized by lawlessness. Not surprisingly, industry leaders called for government intervention and championed film censorship.[8]

The film industry leaders' advocacy for censorship must be understood in the context of the fierce competition between the large, well-established studios and the many aspiring startups. With the rising popularity of movies in the early 1920s and the seemingly insatiable demand for films, film studios blossomed in the urban areas. Shanghai alone boasted over 140 film studios by the mid-1920s.[9] Most of these studios were in the business for quick profit and not terribly concerned about the quality of their products. In fact, the majority of these studios never finished any films. Nevertheless, they siphoned off venture capital and human talent, and brought people of questionable reputation into the industry. Audiences began complaining about the poor quality of Chinese films. Scandalous stories about movie stars' lives only fueled public disdain for the film industry. Against this backdrop, the call for government intervention by leaders of the film industry is really an attempt to establish "rules of engagement" to a field characterized by chaos and lawlessness.

Although the film censorship agencies that came into existence in the 1920s were all government bodies, on the whole, official control over the film industry during this period was minimal. There are at least three explanations for the laxity of government intervention during this phase. First, the warlord regimes during the 1920s had other priorities. Preoccupied with their political and military survival, military leaders had little time to worry about films. Second, when warlord governments did become involved in regulating movies, their control was confined to the region under their jurisdiction. Third, film as a social force had only just begun to exert influence in the 1920s; regulatory efforts were necessarily provisional and incomplete. However, this first phase of film censorship in China reveals some basic patterns that would continue into the later decades. The emphasis on the educational value of films, the educator's dominance in regulatory institutions, the carrot–stick approach, and finally, the general support for film censorship within society and especially from the film industry—these themes will continue to find their echoes in the years to come.

Centralization, 1927–1931

Due to the chaotic political situation in China during the 1910s and 1920s, neither the police nor the educators were able to develop an effective mechanism to control film exhibition in a uniform and consistent fashion. In addition, the Chinese authorities had no jurisdiction over the foreign concession areas in major metropolitan centers, where the majority of movie theaters were located. It was not until 1927 when the Nationalists came into power and gradually consolidated their control over the country that the central authorities paid increasing attention to cultural and ideological affairs and took systematic steps toward institutionalizing film censorship on a national level.

One of the earliest signs of the new regime's intent to impose ideological control came in November 1927 when the Education Department of the Shanghai Municipal Government formed a film censorship committee. At a first glance, the move seemed a simple continuation of the trend in which educators sought to assume the role of moral guardians for society. However, the social and political context was drastically different this time. First, until this point, the film censors were always associated with regional regimes and their authority was always confined to a particular locality. In contrast, the officials on the new film censorship committee in Shanghai represented a government en route to national power. Consequently, the principles under which this committee operated would have much broader ramifications for the entire country.

Secondly, given Shanghai's importance as the center of film production and exhibition in China and the most important source of income for film distributors, official intervention in this city would have more powerful effects on shaping film culture than any other places. Finally, this new film censorship agency took a strong nationalistic stance by trying to assert its authority over the foreign concessions. In their public statement, the censors made it clear that their rules and regulations would apply to Chinese districts as well as foreign concession areas, an important departure from the past.[10]

As significant as the development in Shanghai is, the new censorship rules were drafted by local bureaucrats and the enforcement of these rules were confined to one municipality. In an effort to centralize film censorship, the Ministry of the Interior of the Nationalist government published *The Thirteen Regulations on Film*. This document is worth noting for two reasons. First, it claimed the right of the central government to censor film; and secondly, it placed the responsibility to enforce the Regulations squarely in the hands of the police. Film proprietors were required to submit their films to the police bureau, not to the education departments of the local government, for approval prior to public screening.[11]

However, previewing films and deciding which ones were appropriate for public screening required an enormous amount of manpower and resources. Police departments throughout the country were understaffed and underfunded. As a result, they were reluctant to commit resources to conduct film censorship, which, in lieu of other more hideous crimes and urgent matters, was a low-priority item. In general, the police were not as much intellectually equipped to appreciate films' potential for ideological indoctrination as the educators and the Party ideologues. Usually, unless there were complaints or controversies about a certain film, the police rarely bothered to intervene.

Partly because of the Ministry's ineffective exercise of film censorship and partly because of the lobbying efforts by the ministries of Propaganda and Education, the Nanjing government ordered the Ministry of Interior to jointly draft a new set of film censorship regulations with the Ministry of Education. This subsequent new legislation, known as *The Sixteen Regulations*, was

published in April 1929, and stipulated that film censorship should be conducted jointly by officials from the departments of police, social affairs, and education at all levels of government. The earlier *Thirteen Regulations* were to be abolished. Through this turn of events, the educators were once again brought into the picture.[12]

The Sixteen Regulations signals two important departures from past practice. Firstly, the *Regulations* require the police and the educators to join forces. Up to this point, film censorship was handled either by educators who had no means to enforce their rulings, or by police officers who were not well equipped to deal with the cultural and ideological subtleties of the movies. Now, the educators were put in charge of judging film content, whereas the police were enlisted to execute the censors' decisions. Secondly, it was mandated that film censorship committees be formed at both provincial and municipal levels for the purpose of implementing *The Sixteen Regulations*. Thus, film censorship became officially instituted into the government structure at all levels; in other words, film censorship became a routine operation of the government.

Although *The Sixteen Regulations* instituted film censorship as an official component of state functions, an inherent flaw rendered the arrangement impractical. The legislation stipulated that the central government would retain ultimate authority; all local film censorship boards were responsible to the ministries of Education and Interior. While the central government was to provide guidelines and pass final judgment in the case of controversial films, the actual review of films and censorship decisions would still take place at the local level. The local censors' decisions on each film not only had to comply with *The Sixteen Regulations*, but also had to be approved by ministerial authorities, who alone could issue or withhold exhibition permits for films. However, given the state of communication and transportation at the time, it was simply unrealistic for the film censors at local level to hold up films submitted for review pending approval from the capital. Inevitably, local censors worked on the assumption that their rulings would be supported by the higher authorities in the central government. Thus, although it centralized film censorship, *The Sixteen Regulations* failed to provide for a specific mechanism via which its political objectives could be achieved. As a result, local variations continued to exist and people in the film industry complained bitterly about the arbitrary, inconsistent, and whimsical manner in which film censorship was conducted.[13]

To address the problems the central government took yet another step. In November 1930, the legislative branch of the government published China's first *Film Censorship Statute*. Unlike all previous regulations, this statute was the first piece of legislation applying to films that carried legal status.[14] Shortly afterward, the National Film Censorship Committee (NFCC) was established in 1931 under the auspices of the ministries of Interior and Education, in cooperation with the Ministry of Propaganda.[15] From this point

forward, only films carrying the NFCC seal could be screened in China. There were still to be local film censors, but their job was not to censor films, for that was to be done in Nanjing by the NFCC, but to ensure that all films shown in their jurisdictions carried a seal of approval from the NFCC. In essence, these censors were the NFCC's local representatives who helped enforce the rulings of the censors in Nanjing. These measures finally brought film censorship under the effective control of the central government, ending the situation of the previous decades in which control over films was inconsistent, sporadic, ineffective, and localized.

Film censorship and nationalism, 1931–1949

The censorship of foreign films and control over foreign film studios' activities in China during the Nanjing decade is an essential part of the history of the Nationalist Party's film censorship and accordingly should be viewed in the broader context of Chinese resistance to the cultural hegemony of Western imperialism. Although it resembled cultural warfare, Chinese censorship of foreign films had an economic dimension as well. In practical terms, it functioned to protect the native film industry from foreign competition. By subjecting imported films to restrictive regulations and curbing the expansionist maneuvers of foreign studios, the Nationalist government sought to promote the growth of the burgeoning national cinema. At the same time, by taking issue with colonial film censorship institutions in Shanghai, the Nationalist government asserted China's national sovereignty in the concession areas before their formal return to Chinese government. Although historical circumstances did not allow the Nationalist censors to achieve total victory in all the three areas, their policies and related efforts to execute them left an important legacy that would impact the film policy of the People's Republic of China (PRC) after 1949.

Foreign films, especially those produced in Hollywood, were generally popular with Chinese audiences, but they often infuriated Chinese audiences with their racist portrayals of the Chinese people. In doing so, these films greatly contributed to the colonialist imagination of China. Chinese critics were well aware that gamblers, prostitutes, and other ugly manifestations of social evils existed, but they objected to their presentation in foreign films because those films "pretend to represent the whole nation of China" when in fact they present "only the evil, and never the good side of the Chinese people."[16]

In early 1930, Harold Lloyd's film *Welcome Danger* (1929) was brought to China and sparked off a popular protest that resulted in the first official ban on a foreign film in China. From that moment on, the exhibition of films came increasingly under the control of the Nationalist State. Beginning in 1931, all films had to receive the approval from the Chinese censors before

they could be publicly screened. Although the French Concession and the International Settlement (see Chapter 10) were outside of Chinese jurisdiction, the distributors, exhibitors, and other representatives of foreign films in the concessions obeyed Nanjng's authority for two reasons. First, film exhibition had to be advertised in newspapers, and the Film Censorship regulations stipulated that films required Nanjing's approval to advertise in newspapers. Secondly, without a permit from the Chinese government censors (NFCC), it would be impossible for any film to go to other cities in China.

There were no clearly stipulated rules defining what constitutes "offensive" to Chinese sensitivities, but an examination of banned foreign films and the segments that Chinese censors penciled for deletion suggests a clear pattern of what qualified as taboo representations. These seem to include scenes that showed China as a backward country and her people as an uncivilized race, scenes in which the Chinese appeared as villains, as morally corrupt (i.e., smoking opium and gambling), or undignified (i.e., playing roles such as that of a servant), and dialogue that ridiculed the Chinese, the Chinese way of life, or referred to the Chinese in a less than respectable way.[17]

The Nationalist film censors' control over foreign films was not limited to censoring the undesirable contents of films, but also involved regulating foreign studio activities in China. From its birth, the Chinese film industry operated under the shadow of foreign film interests. Even the boom in the mid-1920s did not fundamentally alter the foreign domination of China's film market. For example, in Shanghai, which was the center of film production and exhibition in China, most first-run movie houses in the city were owned by foreigners and the majority of films shown were of foreign origin. In June 1931, only three months into its operation, the NFCC drafted the *Regulations Regarding Foreigners Shooting Films in China*, which required foreigners making films in China to obtain permission from the Chinese authorities and prohibited them from filming scenes considered derogatory of China or antagonistic to the Nationalist Party's doctrines. It further stipulated that footages shot in China would have to be approved by the Chinese censors before the film could be shipped out of China.[18] The purpose was to prevent foreigners from filming scenes that could later bring disgrace to China and Chinese people.

The genuine indignation that fueled such measures overlapped with certain practical motivations. During the 1920s and 1930s, foreign films, especially Hollywood movies, dominated China's film market. Ninety percent of the films shown were of foreign origin. In economic terms, the dominance of foreign film represented a significant drain on China's financial resources.

In 1931, lured by the potential market, Paramount Pictures planned to buy out all the Chinese film studios with a 15 million dollar offer. Allured by the tremendous "China market," Paramount intended to hire Chinese actors and directors, and make "Chinese films" (in Chinese and about Chinese lives) for distribution in China. This plan was aborted, however, because Paramount failed to garner the support and cooperation of China's business sector and

also ran into obstruction from the Chinese government.[19] In order to protect Chinese filmmakers from their foreign competitors, the government censors adopted a series of measures to safeguard the best interests of the native film industry. One may even argue that the Chinese censors willfully discriminated against foreign films.[20]

Internally, film censorship also played an important part in the Nationalist nation-building effort. First, film censorship was used as a tool to promote "standard" spoken Chinese.[21] After the NFCC was founded in 1931, it insisted that all Chinese films use easy-to-understand vernacular captions. Once Chinese studios began producing sound films, the NFCC decided that Mandarin Chinese, or *guoyu*, (the national language), should be used as the spoken language in films and prohibited the use of dialects. To further the cause of *guoyu*, the NFCC requested that film studios in China print the standard syllable chart at the beginning of each film, and that the characters in subtitles be marked with standard pronunciation.[22]

Secondly, by banning films presenting religious subjects, film censorship during the Republican period contributed to the official campaign to eradicate superstitions and promote modern sciences.[23] The category "superstitious films" (shenguai dianying) included a wide range of subject matter. It included films dealing with religious subjects such as *Ben Hur* (Fred Niblo, 1925) and *The Ten Commandments* (Cecil B. DeMille, 1923), both of which were banned in the 1930s.[24] In this particular case, the emphasis was on "shen" (gods and deities). Very few Chinese films fell into this category because Chinese films rarely dealt with religious subject matter. "Superstitious films" also included films whose plot, characters, or narrative were clearly unscientific or distorted science. For instance, *Alice in Wonderland* (Bud Pollard, 1931) and *Frankenstein* (James Whale, 1931) were banned for their "strangeness." Here, the emphasis was on "guai" (bizarre, exotic, and strange). Numerous Chinese movies made in the 1920s were subject to this criticism, cited for their portrayals of martial arts masters with magical aptitudes for throwing fire balls, flying in the sky, summoning ghosts, and so on. The Chinese term referring to this genre of films was *wuxia shenguai pian* (knight-errant, spirits, and ghost films), suggesting the close connection between the display of martial-arts skills and superstition. The popular fascination with these stories was deeply rooted in folklore and popular beliefs, topics too immense to discuss effectively here.[25] Suffice it to say, as mentioned previously, such films were myriad and extremely popular.

Thirdly, film censorship provided a crucial medium through which the Chinese public was introduced to a new set of "modern values." The Nationalist state wanted modernity in China, but rejected its inherent foreignness. This contradiction was best illustrated in the official policy toward the so-called "sexy pictures" in which modernity and foreignness were intimately linked. The presentation of women's bodies in these pictures became the focal point of discussion in the board rooms of film censors and in public forums.

Once the Nanjing government was established, the state began to take steps to curb the "liberal" trend in filmmaking. By suppressing certain types of films and promoting others, the state endorsed a new sexual morality. When banning a film or requiring the deletion of certain scenes, the Nationalist censors often used the phrase "you shang fenghua" (injurious to social mores) to justify their actions. Yet the definition of the term "injurious to social mores" remained ambiguous. Hard-core pornography may be easy to recognize, but the so-called "sexy pictures" were much more ambiguous and often eluded definition. The censors' approval of Gustav Machaty's *Extase* (*Ecstasy*, 1933), a notoriously erotic film from Czechoslovakia, and the ban on the Paramount film *Top Hat* (Mark Sandrich, 1935), a light romantic comedy starring Ginger Rogers and Fred Astaire, highlight the subjective nature of the censors' rulings on this count.

In the summer of 1937, Japan invaded China. By year's end, China's capital, Nanjing, fell and the Chinese government first retreated to Wuhan and then settled down in Chongqing, a city located deep in the southwestern part of the country. During the war, much of China's film industry fell under Japanese control and the filmmakers in "free China" produced few films. As a result, the NFCC ceased to function and was officially dissolved in 1938.

Following Japan's surrender in 1945, China was immediately engulfed in a civil war between the Nationalists and the Communists. Although a new agency called "the Bureau of Film Censorship" under the auspice of the Ministry of Interior resumed film censorship in Nationalist controlled areas, the instability of the political situation and the brevity of the Nationalist rule, which ended in 1949, meant that government control of film exhibition during this period largely followed the practice and conventions of the prewar era, with even less effectiveness and consistency. On the one hand, some politically subversive films, such as *Yi jiang chunshui xiang dong liu* (*River Flows East*, Cai Chusheng, 1947), received green light from the government censors and even official endorsement. On the other hand, as in the case of a number of controversial films, the seal of approval from the authorities did not protect these films from the harassment by popular vigilante.[26]

Part II: Film Censorship in Communist China

Film censorship during the Communist era can be divided into three distinctive periods, which correspond to the major shifts and changes in the political history of the second half of the twentieth century. The first period begins with the Communist victory in 1949 and ends with the beginning of the Cultural Revolution in 1966. The second period covers the turbulent decade of the Cultural Revolution, which did not come to an end until Mao's death in 1976. The reemergence of Deng as the paramount leader of the Communist

party in the post-Mao era and the reorientation of government policy toward economic developments ushered in what historians refer to as "the reform era," which continues to this day.

<div align="center">

1949–1966

</div>

For a brief period after the Communists came into power, the new government decided to abandon film censorship altogether because many party officials genuinely believed that the new China under their rule should be more democratic and liberal than it was under the regime they had just toppled! However, two developments quickly changed the Party's position. First, some filmmakers took advantage of the absence of censorship and produced films that seriously tested Party leaders' tolerance. The films in question did not challenge or oppose the new regime politically, but their subject matter, narrative style, and artistic quality were viewed by Party officials as trashy, trivial, tasteless, and substandard. Secondly, eight months after Mao declared the founding of the People's Republic of China (PRC), the Korean War broke out. By the end of 1950 Chinese troops were engaged in battles with the UN forces in Korea. This dramatic turn of events on the international front resulted in a drastic policy shifts within China. The Party leadership quickly abandoned its liberal pretense, tightened its control over the Chinese society, and launched an anti-Western campaign. News media, films, books, arts, and literature were all subjected to stringent censorship. The crackdown on intellectual and artistic freedom culminated in the Anti-Rightist Campaign of 1957 during which an estimated half a million people were sent to labor camp for voicing their views of the Party disapproved by the authorities.

As far as film censorship is concerned, in contrast to the way in which film was censored during the pre-Communist era whereby a specifically designated government agency was responsible for reviewing films and issuing exhibition permit, the communist government did not set up an office specifically in charge of film censorship. Instead, all matters related to film production, distribution, exhibition, and even international exchange, were placed under the supervision of the Film Bureau within the Ministry of Culture. In theory, the Bureau had the ultimate authority to issue or withhold the seal of approval for any film. In reality, the personal opinions of high-ranking officials within the party hierarchy often trumpeted the decisions made by the Bureau. As the case concerning *Wu Xun zhuan* (*The Story of Wu Xun*, Sun Yu, 1950) shows, although officials in the Film Bureau approved the film for public screening, once Mao indicated his displeasure with the film, the Bureau immediately revoked its decision and withdrew the film from commercial circulation. It was only with Mao's approval that the film was given special permission for nationwide screenings, but only as "teaching material" to educate people about Maoist view of history and class struggle.

By the mid-1950s, the Communist program purporting to nationalize Chinese economy was completed and all the privately owned and independent operated film studios were merged with state-controlled film studios, which initially numbered four—Shanghai, Beijing, August First, and Changchun. As time went on, additional film studios sprung up in other cities throughout the country—Xi'an Film Studio in Shanxi province, E'mei Film Studio in Sichuan, and Zhujiang Film Studio in Guangdong.

Without relinquishing the central government's final authority in deciding which film can and can't be produced and shown, the Communist regime delegated part of the responsibility for film censorship to the studio level. Party cells at each film studio functioned as the first line of defense. Every film script had to be approved by studio's party bosses before production could begin. When filming was finished, the edited film would be sent to the Film Bureau in Beijing for another round of official review before national distribution. Viewed from the perspective of administrative hierarchy, the Film Bureau falls under the jurisdiction of the Ministry of Culture, which parallels the Ministry of Propaganda in standing. However, due to the fact that top officials in charge of the Ministry of Propaganda usually held key positions in the Political Bureau, the highest authority within the party apparatus, the Ministry of Propaganda, possessed more power and influence than the Ministry of Culture in deciding the fate of individual films. In other words, the ultimate authority to approve or disapprove a film for public release was often in the hands of the party ideologues.

On the surface, this situation is reminiscent of the contestation for control of film censorship among the different branches of the Nationalist government during the Nanjing Decade. Upon closer scrutiny, however, the Communist government had a much more effective control over the film industry than the Nationalists for a number of reasons. First, mindful of the Nationalist failures in silencing political dissent through censorship, the Communists made deliberate efforts to learn from their predecessors' mistakes and tried to avoid the problems that plagued the film censors of the previous era. One of the strategies employed by the Communist censors was to concentrate the power of censoring films in one agency, rather than having several government branches sharing the responsibilities. Secondly, because the Communist government was a totalitarian regime with a monopoly control over all the resources in the country, including all the film studios, there was little incentive on the part of the filmmakers to push the envelope. If their counterparts in the earlier decades sometimes played the "cat and mouse" game with the Nationalist censors (NFCC), few under the Communist regime dared to take the risk. To the extent that many films produced under the auspice of the Communist government still ended up on the wrong side of the censors in the PRC, it is an indication of the constantly shifting political ideologies in China and the intense power struggle and factionalism within the party, but rarely the case of filmmakers intentionally pushing the envelope.

The Cultural Revolution (1966–1976)

To many, the Cultural Revolution represents one of the darkest periods in the political history of modern China. To this day, scholars are still debating the causes of this catastrophic event. For our purpose here, however, it is important to bear in mind that with the Maoist radicals seizing power and their ultra-leftist ideology dominating the discursive field, the tyranny of official censorship of all cultural products, including films, reached an unprecedented level. The Maoist leftists executed their political as well as ideological control over the film industry in three ways. First, they banned not only all films produced in the pre-1949 period for their alleged erroneous ideological orientations, but also the majority of the films produced during the communist rule after 1949 on account of being insufficiently revolutionary, undermining class struggle, glorifying bourgeoisie individualism, and opposing Mao's thought. Secondly, unlike the censors in the past who tended to focus on problematic films, not the filmmakers, the Cultural Revolution authorities actively pursued and persecuted makers of allegedly politically incorrect films. As a result, a large number of playwrights, directors, actors, and technicians were subjected to purge, detention, and marginalization in their profession during this decade. Thirdly, in the later phase of the Cultural Revolution, the authorities began to directly engage in producing films, initially based on the theatrical performance of the eight Beijing operas endorsed by the government and then, producing a number of feature films by 1973.[27]

In terms of the official film censorship apparatus of this period, the system is characterized by the so called "three layer" mechanism. Operationally, the formal review process of a given film begins at the provincial (in the case of Beijing and Shanghai, municipal) level, which has a committee specifically in charge of cultural affairs. Then the film along with the committee's opinions would be forwarded to the next level of review by the "cultural group," which was headed by Mao's wife, Jiang Qing, in the central government. Finally, the film would be sent to the Political Bureau, which is the highest authority within the party hierarchy, for its ultimate decision to either approve or disapprove the film's public screening.[28] The direct involvement of the party officials at the highest level in film censorship reflects the emphasis the Cultural Revolution authorities placed on the power of culture in general and films in particular.

Leaving aside the enormous human tragedies and psychological trauma, which are impossible to assess in accurate and quantifiable terms, the damage to the film industry caused by Maoist radicals is evident in the drastically reduced studio output during this period. Between 1949 and 1966, the average level of annual production of features films stayed between 50 and 60 titles. However, during the Cultural Revolution, film production first came to a complete halt between 1966 and 1973, and then, from 1973 when feature production resumed, to 1976 when the Cultural Revolution ended, no more

than three dozens of films were produced, of which only a third was actually released for public screening.[29]

In contrast to the way film censorship was exercised in the past, which was characterized by the censors carefully keeping their deliberation process secret and behind the doors, during the Cultural Revolution, the regime perfected a new method of cultural control in the form of nationwide campaign to criticize and to condemn a film. Once a film was deemed politically incorrect, the authorities would subject it to vicious attacks in the news media and engineer a deluge of negative reviews and criticisms to manufacture an extremely hostile climate of opinion against the film in question. This method of public denunciation was applied not only to domestic films, but also to foreign films. For instance, in 1972, the Italian film director, Michelangelo Antonioni, went to China on Chinese government's invitation to make a documentary film (*Chung Kuo, Cina*, 1972) about life in new China. However, when Antonioni finished his film, the Chinese officials found Antonioni's portrayal of China less than flattering and were disappointed. Subsequently, China's official news media launched an all-out attack on the film and denunciations of Antonioni appeared on the front page of every major newspaper in the country. Although the case against Antonioni was the result of internal power struggle within the party between the Maoist radicals and moderate officials responsible for inviting Antonioni and the attack on the film an attempt to discredit these officials, the way in which the film was censured represents a new development in the history of film censorship in China. Film censorship cases never made into headline news before, but now, by condemning and denouncing films not congruent with the government's point of view in a very public fashion, the regime sent warnings to all filmmakers and studio officials about the consequences of not toeing the party line.[30]

The post-Mao era (1976–present)

With Mao's death in 1976 and the reemergence in the post-Mao years of the revolutionary oligarch that was politically persecuted during the Cultural Revolution, the new regime retreated from the doctrinal extremism and ideological puritanism of the previous decade and refocused on economic developments. Although never genuinely inclined to promote democracy, the post-Mao party leadership did allow a degree of liberalization in the cultural industry unprecedented in the history of the People's Republic of China. Taking advantage of the relatively relaxed political environment, filmmakers began to explore social and historical issues from humanistic perspective, experiment with unconventional cinematic styles and genres, and try out new audiovisual techniques in their films. These momentums gave rise to what one film historian has called "new wave" filmmaking.[31] In the meanwhile, by the second half of the 1980s, as the market-oriented economic reform accelerated and

the government began to withdraw financial subsidies to film studios, the film industry moved increasingly in the direction of pursuing commercial success at the box office and away from making films for social and political causes.

China's political and economic transformation in the last three decades has also led to sea changes in film censorship. Until 1987, all films were subject to three levels of censorship. First, the studio management must provide the first checkup. If a film was cleared of this first hurdle, it would then be sent to the Film Bureau, a division in the Ministry of Culture, for another round of review. If all went well, the film would be ready for final review by officials in the Ministry of Propaganda, which held the ultimate power over all media production in the country and was responsible for cleansing the discursive field of any politically oppositional or subversive elements.[32]

By 1987, the central government decided to merge the Film Bureau, which had been a division in the Ministry of Culture up to this point, into the renamed Ministry of Radio, Film and Television. This reorganization meant that the official jurisdiction over the film industry was transferred from the Ministry of Culture to the Ministry of Radio, Film and Television (MRFT). Following the merger and in response to the changing political environment, the MRFT promulgated a series of new regulations to govern film production, distribution, and exhibition. For instance, in 1990, the MRFT jointly issued a set of rules with the Ministry of Propaganda and the Political Department of the People's Liberation Army (the unified military organization of the PRC) on the specific prohibitions for films dealing with China's recent history and involving party leaders still alive. Two years later, the MRFT drafted a guideline for film censorship. It is interesting to note that in this 1990 guideline, the MRFT claimed for itself the exclusive authority to censor films, an apparent rejection to external interference and an attempt at institutional autonomy.[33] In addition, the guideline also spells out eight prohibitions in particular, which include "violating the Constitution and the law; harming national interest, social order, national dignity and ethnic unity; deviating from major national policy; injurious to socialist ethical norms; contradicting the principle of modern sciences and promoting superstition; graphic depiction of sex, nudity, violence, and methods of committing crimes; stories or portrayals liable for causing emotional and psychological trauma to children; and finally, other inappropriate plots, images and themes to be decided by the censors."[34]

The opaque nature of the Chinese political system makes it extremely difficult for us to know how other government agencies (such as the Ministry of Propaganda) and the film industry reacted to this guideline. Suffice it to say that this document was later revised and republished in 1996 with the endorsement of the State Council, which makes it the most authoritative and most public government regulations concerning film censorship. Among other notable changes, the revised document affirmed the MRFT's ultimate authority in approving or disapproving a film's public screening and modified the wording on the specific prohibitions stipulated in the earlier guideline. Article

24 of the new regulation states that any films deemed "injurious to national unity, sovereignty, and territorial integrity; undermining national security, honor and interests; promoting separatism and causing damage to ethnic unity; leaking or revealing state secrets; racy images, superstitious messages, and violent acts; libeling and insulting; violating other prohibitions of the state" will be subjected to ban.[35]

While the changes in the legislative language offer some clues to the internal contestations among the different branches of the government for control of film censorship and the shifting political priorities of the government, it is even more important to study how censorship rules are interpreted and implemented in practice compared to how they are laid out on paper. Indeed, there is a reason why the 1996 official regulation retreated from the relatively specific language (e.g., no graphic depiction of sex and nudity) of the earlier document to the much more broad, vague, and general wording (e.g., racy image) because the ambiguous, imprecise language gives the censors more elbow room to exercise their power.

In fact, the way film censorship has been practiced in China in the last three decades is notoriously inconsistent, arbitrary, and unpredictable. Both domestic films and foreign imports have been subject to the whims of the censors and the political mood of the moment. While in some cases, the ban of certain films seems to be based on the specific stipulation of the regulations, for instance, both *Seven Years in Tibet* (Jean-Jacques Annaud, 1997) and *Kundun* (Martin Scorsese, 1997) challenge China's Tibet policy and it is no surprise that they were banned in China.[36] But in other cases, the censors' decisions seem less than logical and consistent. For instance, the censors rejected *Summer Palace* (Yiheyuan, Lou Ye, 2006) and *Lost in Beijing* (*Pingguo*, Li Yu, 2007) for their alleged graphic depiction of sex scenes, but approved *Miami Vice* (Michael Mann, 2006), which includes "steamy love scenes"[37] and *Blind Mountain* (Mang shan, Li Yang, 2007), which deals with the subject of sex slave.[38] Similarly, the censorship regulation explicitly states that "unscientific" and "superstitious" contents in films will not be tolerated. Yet, *Resident Evil: Afterlife* (Paul W. S. Anderson, 2010), a film obviously not congruent with modern sciences, nevertheless was approved for release in China.[39]

In a move to reflect both increasing professionalization and sophistication of the official control of film production and exhibition, currently, the film censorship committee, which is part of the MRFT, comprises of 24 regular members, split between five Film Bureau officials and 19 film professionals. Although minority in number, the representatives of the Film Bureau have a stronger voice in the decision-making process. Nevertheless, the inclusion of large number of film directors, cinematographers, script writers, and scholars in the committee does represent a significant departure from the conventional practice whereby party officials held a total monopoly over film censorship. To insulate the members from external influence, the identities of the censors, with the exception of the Film Bureau Officials, are kept confidential.

In some cases, the deliberation of films that deal with sensitive subject matters, such as ethnic minorities, foreign relations, historical events, or personalities, may also involve experts on those subjects who are invited on a case-by-case basis.

Given the fact that China's overall national agenda of the last three decades has been "reform," which means to change from the old ways of doing things, it is not surprising that everything in the country has been in a state of fluidity. Indeed, if there is one thing that has remained constant in the post-Mao era, that will be the change itself. Against this backdrop, it is not surprising that the film censorship apparatus and the way films are censored in China have also been changing and evolving as well and will, in all likelihood, continue to change and evolve in the years to come.

Conclusion

Film censorship in China in the past century has evolved through many phases and there are some general patterns and trends to be observed. First, the overall trajectory of this history has been the shift from sporadic, localized, and ineffective control in the first two decades of the twentieth century to more systematic, centralized, and effective official control during the 1930s under the Nationalist regime. Although the momentum of that shift was temporarily interrupted by the war with Japan between 1937 and 1945, it resumed with the Communists coming into power in 1949. In fact, one of the key characteristics of film censorship in China since the turn of the twentieth century has been the strong involvement of the state in shaping the development of film censorship institutions and the way film production and exhibition were regulated. Both the Nationalists and the Communists view film as more than just a form of entertainment and try to enlist it to the service of their nation-building project. In contrast to the American model of film censorship through Hollywood's self-regulation (see chapters 1, 2, and 14) and the British model (see Chapter 9), which treats film censorship as a legal issue,[40] in China, no film censorship cases ever went to the court. During both the Nationalist era and the Communist period, the decision made by government censors on a given individual film is final and there is no avenue for the filmmakers to appeal.

Secondly, film censorship is also conceived much more broadly in China than it is in many Western countries. While sanitizing the screen of undesirable images, the Chinese censors are also actively engaged in promoting officially endorsed cinematic narratives and imageries. In other words, the function of film censorship in China is not limited to prohibition, but also includes projecting and promoting certain cultural and political agenda. Not surprisingly, film censors in China, both before and after 1949, are often involved in the business of publically endorsing films reflective of the censors' political

position, aesthetic taste, and moral value by giving film awards, sponsoring film events, and issuing guidelines to the studios on what kinds of films they should make.

Thirdly, compared to the way film censorship regulations are written in many other countries, which tends to be extremely specific and concrete, as exemplified by the Hays Office's (see Chapter 14) stipulation on the number of seconds a kissing scene may last, the Chinese film censorship regulations are rendered in purposefully vague and ambiguous language. Both the Nationalists before 1949 and the Communists after 1949 make deliberate efforts to avoid being precise, detailed, and explicit about the exact boundary of what is and is not permissible on the screen. In doing so, the censors reserve for themselves maximum interpretative power, making it extremely difficult, if not entirely impossible, for the filmmakers to challenge censors' ruling.

Finally, film censorship in China has acquired a strong nationalistic dimension by functioning as a protection mechanism for the native film industry against Western film, especially Hollywood's economic domination, and as a line of defense against negative and derogatory cinematic representations of China in foreign films. During the Republican period, the Nationalist censors were relentless in their effort to combat the racist portrayal of China in foreign films as well as curtail foreign film interests' expansion in the country. Under communism, the imports of foreign films have been subject to even tighter control. Even during the honeymoon period of Sino-Soviet friendship of the 1950s, films from the Soviet Union and other east European countries were restricted both in quantity and in distribution scale.

As for Western films, due to the international politics of the Cold War era, they were largely absent from China between 1950 and 1980. With the economic reform picking up momentum in the post-Mao era and China's entry into the World Trade Organization, Hollywood is making a comeback. The import quota for American films was first set at 10 films per year, but then increased to 20 films per year, and now, according to a recent report, the number will be increased to 34 titles per year.[41] However, if history is any guidance, the Chinese government will continue to use film censorship to minimize the impact of American films on Chinese society in general and on the Chinese film industry in particular.

Notes

1. See Pang, L. (2011) The State against Ghosts: A Genealogy of China's Film Censorship Policy, pp. 461–476 in *Screen* 52 (4); Xiao, Z. (1994) *Film Censorship in China, 1927–1937*, PhD. Dissertation, San Diego: Department of History, University of California.
2. In the standard conventional account, film was first screened in China in late 1896. See Cheng, J. et al. (1981) *Zhongguo dianying fazhan shi* (A developmental history of Chinese cinema), Beijing: zhongguo dianying chubanshe. However, that

view is now being challenged. See Huang, D. (2007) Dianying chu dao Shanghai kao (An investigation of the initial introduction of Motion Pictures in Shanghai), *Dianying yishu* (Cinema art), 3 (May), 2007.

3. Ross, S. J. (1991) Struggle for the Screen: Workers, Radicals and the Political Uses of Silent Film, p. 337 in *American Historical Review* 96 (2).

4. *Beijing Municipal Archive* (1905), *Guanli dianying ye xi guize shi yi tiao* (Eleven rules governing movie shows in the evenings), 1509–385 (7).

5. Sheng jiaoyuhui shenyue Mingxing pian zhi pingyu (Comments on Star motion picture company's films by the censors from provincial government's education department), *Shenbao* July 5, 1923.

6. Tongsu jiaoyu yanjiu hui wei jinzhi shangyan bu liang yingju cheng bing jiaoyu bu ling (The mass education department appealed to the authorities to ban harmful films and the Ministry of Education's response), pp. 176–177 in No. 2 *Historical Archive* (ed) *Zhonghua minguo dangan ziliao huibian, di san juan* (A compilation of archival documents from the republican period, vol. 3).

7. Zhejiang jiao jing liang ting he zu dianying shencha hui (The bureaus of education and police in the Zhejiang provincial government jointly formed a film censorship committee), *Shenbao* February 8, 1926. See also the committee's rules and regulations in Shuren, Cheng (ed) (1927) *Zhonghua yingye niangjian, 1927* (The year book of Chinese film industry, 1927), Baidai gongsi: Shanghai.

8. Song, J. (1925) Dianying yu shehui lifa wenti (Film and social legislation), *Dongfang zazhi* 22 (4); for a more detailed discussion of the history of People's Institute, see Feldman, Ch. M. (1977) *The National Board of Censorship (Review) of Motion Pictures, 1909–1922*, New York: Arno Press.

9. Lee, L. (1999) *Shanghai Modern*, Cambridge: Harvard University Press, chapter 3.

10. Shi zhengfu jiang zuzhi Shanghai dianying shencha hui (Municipal government is going to set up a film censorship committee), *Shenbao* November 6, 1927.

11. Wo guo dianying jiancha xingzheng zhi yange (The evolution of film censorship in China), No. 2 *Historical Archive* 718 (67), original document is not dated.

12. Jiao nei liang bu gongbu jiancha dianyingpian guize (The ministries of education and interiors published film censorship regulations), *Shenbao* April 19, 1929, p. 11.

13. Jin, S. (1929) Dianying shencha wenti (The problem with film censorship), *Dianying yuebao* (Film monthly), 9.

14. Woodhead, H. G. W. (ed) (1969) *China Year Book, 1936*, Kraus-Thomson Organization Ltd, Reprint, p. 445. See also You, J. (2001) Jindai Zhongguo dianying wenhua chuanbo zouyi (The rise of cinema culture in modern China), pp. 94–102 in *Shenzhen daxue xuebao* (Shenzhen University Journal), 3.

15. Wu, Y. (1934) Jiao nei liang bu qian dian jian weiyuanhui zuzhi gaiyao (The organization of the former film censorship committee under the ministries of education and the interior), in Zhongguo jiaoyu dianying xiehui (ed) *Zhongguo dianying nianjian, 1934* (Chinese film year book, 1934), Nanjing.

16. K. K. K. (1925) Ping *yi kuai qian* yu *shen seng* (A review of *One Dollar* [1925] and *The monk magician* [1925]), *Yingxi chunqiu* (Cinema forum), 9.

17. Jones, D. B. (1955) *The Portrayal of China and India on the American Screen, 1896–1955: The Evolution of Chinese and Indian Themes, Locales, and Characters as Portrayed on the American Screen*, Cambridge, MA: MIT, Center for International Studies.

18. Jiao nei liang bu dianying shencha weiyuanhui (ed) (1934) *Dianying jiancha weiyuan hui gongzuo baogao* (A work report of the film censorship committee),

Nanjing, p. 21. See also China to Tighten Control on Movie Operations, p. 437 in *China Weekly Review* November 11, 1933.

19. Wan, C. (1931) Chu mu jing xin de xiaoxi (Shocking news), pp. 1–2 in *Yingxi shenghuo* (Movie life) 1 (6).

20. See the exchange between the US embassy and the Chinese foreign ministry, dated August 1930, No. 2 *Historical Archive*, 2–2341.

21. De Francis, J. (1950) *Nationalism and Language Reform in China*, Princeton: Princeton University Press, pp. 56–61.

22. Jiao nei liang bu dianying shencha weiyuanhui, pp. 15, 26, 28, 85–86.

23. Duara, P. (1991) Knowledge and Power in the Discourse of Modernity: The Campaign against Popular Religion in Early Twentieth-Century China, pp. 67–83 in *Journal of Asian Studies* 50 (1).

24. For the ban on *Ten Commandments*, see *Dianying shencha weiyuanhui gongbao* (The news bulletin of the film censorship committee), 1 (5) (1932), p. 30; for the ban on *Ben Hur*, see *China Weekly Review*, January 19, 1929, p. 347.

25. Link, P. (1981) *Mandarin Ducks and Butterflies: Popular Fiction in the Twentieth Century Chinese Cities*, Berkeley: University of California Press.

26. Xiao, Z. (2000) Social Activism during the Republican Period: Two Case Studies of Popular Protests against the Movies, pp. 55–74 in *Twentieth Century China*, 25 (2).

27. Li, S. (2006) *Zhongguo dianying shi* (History of Chinese film), Beijing: Gaodeng jiaoyu chubanshe, pp. 198–215.

28. Zhai, J. (2000) Wenge shiqi gushi dianying chu qi (The origins of feature film productions during the cultural revolution), pp. 289–302 in S. Li, K. Hu, and Y. Yang (eds) *Xin Zhongguo dianying 50 nian* (Fifty years of film in new China), Beijing: Beijing guangbo xueyuan chubanshe.

29. Zhongguo dianying ziliaoguan and Zhongguo yishu yanjiu yuan dianying yanjiu suo (eds) *Zhongguo yishu yingpian bianmu* (A catalogue of film productions in China), Beijing: Wenhua yishu chubanshe, 1981.

30. Ding, Y. (2008) *Yingxiang shidai: Zhongguo dianying jianshi* (The age of image making: a concise history of Chinese cinema), Beijing: Zhongguo guangbo dianshi chubanshe, pp. 185–187.

31. Zhang, Y. (2004) *Chinese National Cinema*, New York/London: Routledge, pp. 225–240.

32. Wenhuabu banfa dianying juben yingpian shencha shixing banfa, 1979, 12, 15 (A temporary guideline for film and film script censorship, December 15, 1979), pp. 600–601 in D. Wu (ed) *Zhongguo dianying yanjiu ziliao* (Chinese film studies: a reader in primary sources), Beijing: Wenhua yishu chubanshe.

33. There had been incidents in the past whereby a film approved by the MRFT was pulled out of circulation due to the personal views of individual high ranking government officials. See Zhonghua renmin gongheguo guangbo dianshi shi bianjibu (ed) (1997) *Dangdai Zhongguo guangbo dianying dianshi dashiji, 1984–1995* (A chronology of important events in the history of radio broad casting, film and television in contemporary China, 1984–1995), Beijing: Zhongguo guangbo dianshi chubanshe, p. 101.

34. Guangbo dianying dianshi bu dianying shiye guanliju zhengce fagui chu (eds) (1994) *Dianying fagui huibian* (A compilation of film related regulations), Beijing: Zhongguo dianying chubanshe, pp. 15–30.

35. Dianying guanli tiaoli (Regulations on film), *Renmin ribao* (People's daily), June 26, 1996 (5).

36. Ho, E. (2011) Can Hollywood Afford to Make Films China Doesn't Like, *Time*, May 25.
37. "Miami Vice" Clears Strict China Censors, *Washington Post*, August 28, 2006.
38. Sex Slavery Film Dodges Chinese Censors to Land at Cannes, May 21, 2007, http://w ww.dnaindia.com/entertainment/report_sex-slavery-film-dodges-chinese-censors-to-land-at-cannes_1098233 (accessed March 20, 2012).
39. Welkos, R. (2006) Censorship Plagues Chinese Film, *Los Angeles Times*, May 19, 2006; Coonan, C. (2010) China Censors Approve "Resident: Evil" Release, *Variety*, November 17.
40. Hunnings, N. M. (1967) *Film Censors and the Law*, London: George Allen & Unwin.
41. Boost for Hollywood Studios as China Agrees To Ease Quota on US Films, *The Guardian*, February 20, 2012, http://www.guardian.co.uk/world/2012/feb/20/china-eases-import-quota-hollywood-films (accessed March 20, 2012).

8

Film Censorship during the Golden Era of Turkish Cinema

Dilek Kaya Mutlu

This chapter focuses on Turkish film censorship during the 1960s and the early 1970s, a period not only marked by two military interventions (in 1960 and 1971), but also considered the golden era of Turkish film production. Through the release of 200–300 films a year (ranging from melodramas to comedies, action and adventure to fantastic and superhero films) and the phenomenal popularity of its film stars, Turkish cinema of the time, constituted a major pastime and a significant site of identity formation and negotiation. Thousands of film censorship reports, which constitute the primary source material in this chapter, reveal that the Turkish state, too, conceived cinema as a powerful, even rival, discursive domain where various social identities and meanings were produced and circulated.

Although, the state had no interest in supporting or directly engaging in filmmaking for state propaganda purposes, the censorship reports make clear that it ideologically invested, even at a paranoid level, in the supposed power of cinema to draw society toward national "good" or "evil." Accordingly, via commissions not officially called "censors" but "controllers," the state attempted to inscribe itself in Turkish filmmaking to ensure films conformed to its political and cultural agenda. How did the Turkish state, via film censorship, attempt to maintain its hegemony and regulate society and culture by controlling subject positions and meanings constructed by films? This chapter explores this question based on the reports of the Central Film Control Commission in Ankara,[1] which, from 1939 to 1977, was responsible primarily for examining domestic films and secondarily for reexamining foreign films rejected by two other commissions in Istanbul and Ankara, respectively.

The 1961 constitution, which replaced the first Republican constitution of 1924 and was the fundamental law until 1982, envisioned a liberal social

atmosphere and guaranteed many civil liberties, including freedom of science, art, and information (Article 21). Yet strict monitoring of films by the state reveals that in practice, such freedom was not the case. The main purpose of this chapter, however, is not simply to tell another sorry story of how an apparently democratic but actually authoritarian military state suppressed freedom of speech; it is rather to explore how such a state struggled to maintain its fragile hegemony by intervening in the processes of producing and circulating meaning in the cultural domain.[2]

Censorship Procedures and Criteria

Until 1932 there was no law regulating film censorship in the young republic of Turkey, which was officially proclaimed in 1923. However, the city governors attached to the ministry of the Interior were authorized to censor films. In 1932, film censorship was centralized and put under the supervision of two film control commissions, one in Istanbul and another in Ankara. Censorship was also extended to examine screenplays prior to shooting. Following debates concerning "obscenity" in Turkish films,[3] in 1939 the Regulation on the Control of Films and Film Screenplays was formulated based on the 1934 Police Duty and Authorization Law. According to this new regulation, which was in effect with minor revisions until 1986, foreign films were controlled either by the Istanbul Film Control Commission or by the Ankara Film Control Commission, depending on the customs office to which they were submitted. Domestic films and screenplays were controlled by another and superior commission based in Ankara, namely the Central Film Control Commission. In the case of an objection to the decision of the Istanbul or Ankara control commissions, or if no decision was reached, foreign films could be submitted for reexamination to the Central Film Control Commission, whose decision was final. However, the importer of the film could apply to the Supreme Council for a revision.[4]

The Central Film Control Commission, whose reports constitute the primary source material in this chapter, comprised five members: one from the ministry of the Interior (head), one from the police, one from the General Staff of the Army, one from the ministry of Tourism, and one from the ministry of Education. Depending on the film's subject matter, additional temporary members representing, for example, the Directorate of Religious Affairs or the ministry of Health, may have joined the commission. The occupations of the commission members imply that manifest censorship in Turkey was in the hands of the government, the police, and the military. The censorship reports, therefore, provide useful sources for examining the state's attitude toward various national and social issues in practice.

The process unfolded as follows. The censorship commissions examined a screenplay and later, if the film was allowed to be shot, the final product.

In order to gain the commissions' approval for production and exhibition (in Turkey and abroad), a film should avoid: (1) political propaganda related to a state; (2) degrading an ethnic community or race; (3) hurting the sentiments of fellow states and nations; (4) propagating religion; (5) propagating political, economic, and social ideologies that contradicted the national regime; (6) contradicting public decency, morality, and national sentiments; (7) reducing the dignity and honor of the military and propagating against the military; (8) being harmful to the order and security of the country; (9) provoking crime; and (10) including scenes that may be used to propagate against Turkey. Censorship commissions were authorized to function as custodians of social order and of the official national cultural identity. Based on these ten criteria, the commissions, via majority vote, might accept or reject a film or request some revisions, sometimes describing specifically how a scene should be shot, what the characters should or should not say, how the film should begin or end, and so on. Sometimes the commissions might accept a Turkish film but forbid its export, believing that it might discredit Turkey or give a bad impression about the quality of Turkish filmmaking.

The ten criteria of censorship were not only nationalistic but also so vague and paranoid that almost any film could be rejected if a commission desired. Remarkably, however, not rejections but conditional acceptances constituted the largest group among the censorship decisions. Accordingly, it could be argued that although film censorship was prohibitive and repressive, it was also productive in its effects, if not exactly libertarian.[5] Nijat Özön, a prominent Turkish film historian and critic of the time, once argued that censorship commissions could even be seen as "co-producers" because they frequently shaped films through specific demands and suggestions about how the objectionable content should be modified to become acceptable.[6] Consequently, the accepted form of a film might differ considerably from the version initially submitted, as in the exceptional case of the Italian-French film *I Mongoli* (*Les Mongols*, 1961), whose representation of Mongols and Mongolian Turks became a hot topic among the censors. The film began the censorship process in March 1964 as a film about the Mongol Empire under Genghis Khan's rule. After five examinations and many revisions required by the censorship commissions (i.e., omitting violent content and changing the dubbed dialogue), it passed censorship in 1967 as a Western about the—peacefully ending—struggle between anonymous Northerners and Southerners. Similarly, a socially critical film might suddenly turn into a socially conformist one with the addition of certain dialogue at the end, as was the case with the Turkish film *Hudutların Kanunu* (*The Law of the Border*, 1966), the story of a poor farmer, who survived by becoming a smuggler. The film was accepted on the condition that it ended with the smuggler telling his son, just before he dies, "You saw your father's fate. Don't be like him, return to school."[7]

Notably, film censorship involved struggles among the censors themselves. Although each member of a censorship commission represented the state, the

commission was not a coherent body. It is evident in the report on *The Law of the Border* that the film's fate during the examination was determined by the representative of the ministry of Interior, Alim Şerif Onaran. Onaran, who had a more liberal attitude toward films (as seen in reports by commissions of which he was a member), explained later that he liked the film so much that he proposed the addition to convince the others, who were determined to reject it otherwise.[8] Therefore, remembering also that decisions were made by majority vote, it would be more appropriate to conceive censorship reports as reflecting the hegemonic ideology of the state, rather than as the combined views of the commission members.

The following pages offer a thematic analysis of the censorship reports. Among the major themes that provoked censorship are: (1) violation of public morality, (2) crime, (3) misrepresentation of public authorities, (4) publicity, propaganda, or slandering of other nations, (5) incitement of socially subordinate groups, and (6) display of public religion. Apparently, most of these themes are common to other film censorship practices around the world, yet they also bear noteworthy national touches in terms of the way they were interpreted in a Turkish context. Arguably, the significance of Turkish film censorship lies not in "what," but in "why" and "how," as will be shown below through various instances of censorship.

Personal, Marital, and Family Morality

Among Turkish and foreign films, those rejected completely or partially on the grounds of contradicting public decency and morality constitute the largest group. Censorship reports discursively construct morality primarily as a matter of controlling sexuality and sexual activity and, accordingly, include numerous objections to on-screen nudity and sex. However, what make the reports more interesting in terms of their approach to morality are their highly conservative views of nudity and sex, which inevitably equate the naked body and sexuality to obscenity. Among "sexually provocative" and hence objectionable content were not only on-screen copulation (marital or non-marital) and frontal baring of male and female bodies, but any form of sexual intimacy, from lip kissing to kissing naked shoulders, as well as visuals of naked legs, bikinis, tight clothes revealing genitalia, nude models or close visuals of nude paintings, and long scenes of dancing women (especially close visuals of belly dancing). Indeed, some such frames or scenes were filmmakers' tactics to get around the commissions' strict stance on the visuals of the body—which sometimes worked and sometimes did not. Obscene and vulgar dialogue and slang and swearing were also rejected, on the grounds of maintaining a decent society.

As to marital morality, the commissions were strict in upholding the sanctity of marriage. Not only the portrayal of adultery, but even talking about it, especially on the part of the woman, was rejected. For instance, in *Ömre*

Bedel Kız (She Is Worth a Life, 1967), the commission required the omission of the words "I have even decided to cheat on my husband." In *Nankör Kadın (Ungrateful Woman,* 1963), in which a wife leaves her husband, the commission required the inclusion of dialogue implying that the couple officially got divorced.[9]

As part of protecting public morality, the commissions also objected to portrayals that allegedly threatened the sacredness of family. Different from personal and marital morality, censorship commissions interpreted family morality mainly as a matter of relationships of respect between children and parents. Any form of aggressiveness on the part of children, from talking to or about parents in anger or hatred to murdering them, was rejected. The commissions also objected to elders humiliating youth and thus required the omission of phrases such as "Yours is a piteous generation" or "Today's youth are monsters."[10]

Crime and Punishment

Filmic crime appears to be the second major theme that provoked censorship. However, what seems to have disturbed censorship commissions is not the portrayal of crime, but the absence of demonstration of legal punishment for it. This interpretation is evident in comments that demand not the omission of criminal activities but the addition of scenes showing the submission of the criminals to the police and the law or their capture by the police. The commissions also decreed that criminals should be punished only by the police and the law rather than the victims and/or their loved ones avenging the crimes. The underlying logic of the commissions' insistence on punishment by law was based on the belief that if moviegoers did not see this type of consequence, there would be a mimetic effect, threatening society's order and security. The commissions were so strict about showing judicial recourse that they did not even allow criminal characters to die before they could be legally punished.

The commissions' aversion to crime made it difficult for genre films such as the fantastic serial film *Şaşkın Hafiye Killinge Karşı (Silly Detective against Killing,* 1967), in which Killing (the Turkish version of the Italian comic strip hero, who wears a skeleton costume) performs various criminal acts such as theft and murder, passed censorship only after some criminal acts were cut, scenes of police activity were added and, in the end, Killing was captured by police. *Fantoma İstanbul'da Buluşalım (Fantoma, Let's Meet in Istanbul,* 1968), in which Fantoma and Batman meet in Istanbul, was accepted only on the condition that the criminals be ultimately captured by the police. The commissions applied the rule of the capture and legal punishment of criminals to foreign films as well. Moreover, if a film was set in Turkey, as in the case of the European coproduction *Estambul 65 (That Man in Istanbul,* 1965, a James Bond imitation), the commission inspecting the screenplay requested

the inclusion of a sequence about the Turkish police. Later, when examining the final product, the commission allowed the film's exhibition in Turkey because a scene showing a man in Turkish police uniform and some dialogue expressing that "spies were followed by the Turkish police" were added.[11] The commissions also required showing regular police activity: if a traffic accident occurred, a visual showing the police attending the scene and taking charge of the accident should be added. Similarly, if a fire occurred, the police should be shown investigating the cause. The censorship commissions naively imagined Turkish society as a place of order where the law and the police operated efficiently. They also acted as if any act forbidden in law did not exist socially by rejecting scenes of drug-taking, gambling (even children playing cards), fraud, and bribery.

Public Authorities: The Police, the Military, and Teachers

The reports include numerous interventions regarding the representation of public authorities, most predominantly the police, the military, and teachers. The commissions generally did not view policemen, military officers, and teachers, regardless of whether their roles were major or minor, as individuals or characters who might have personal desires, weaknesses, or conflicts, but as groups embodying the idea of a serious, powerful, just, and moral state. Accordingly, the censorship reports reveal close scrutiny of the bodies (both physical and institutional) and acts of these public authorities, or to put it differently, of the state's own body.

Censorship commissions were preoccupied with the conformity of haircuts and uniforms of police, soldiers, and military officers to descriptions in the official regulations. The military and police also had to be represented as serious authorities who avoided any behavior that did not conform to official moral standards. Scenes showing soldiers or officers smoking, drinking, flirting, making love, or having an illegitimate child were immediately rejected. As noted above, the commissions never allowed on-screen sex on the grounds of offending public decency and morality (Article 6); however, if a military officer was portrayed making love or even walking arm in arm with a girl while in uniform, these were rejected on the grounds of reducing the dignity and honor of the military (Article 7). The commissions also expected foreign films to portray military characters as decent and honorable because, according to their point of view, a foreign military officer did not simply represent the military of that nation but the idea of the military in general.

Police and military characters were also required to be depicted treating individuals respectfully and politely (insults not allowed) and without using brute force or corporal punishment (e.g., no whipping, torturing, or killing). More than reflecting reality, the commissions' sensitivity on this matter was a reflection of the official logic that brute force or torture must be practiced in secret and denied in public.

Besides the depiction of the police and the military as irresponsible, cowardly, passive, or weak, scenes showing them being attacked, wounded, or killed were also objectionable. Paying special attention to the (continuing) problem of military martyrs in Turkey, the commissions attempted to prevent any association of the military with death and anxiety. For instance, *Şafak Bekçileri* (*Guards of Dawn*, 1963), the story of a military aviation student, was accepted on the condition that the words "the families of martyrs" be replaced with "the families of aviators," and the main character's father's words of "We have not had a peaceful dinner for two years, since you went to military school" be replaced with the words "As your mother says, wouldn't it be better if you sent us letters often to save us from curiosity?"[12]

The censorship commissions also studied portrayals of teachers, especially regarding their behavior, decency, and morality. For instance, in *Kolejli Kızın Aşkı* (*A Schoolgirl's Love*, 1965), the commission required the omission of scenes in which a teenage girl's teacher attends her birthday party, has fun, and gets drunk. In *Kanunsuz Dağlar* (*Lawless Mountains*, 1966), the story of an idealist teacher who comes to a village to conduct social research and eventually reforms a vigilante and marries him, the commission rejected words that implied that the teacher was pregnant but unmarried. Female teachers have been inscribed within the Republican ideology as the face of modern enlightened Turkey. Accordingly, censorship commissions viewed teachers not only as role models but also as social educators. Thus, in *Lawless Mountains*, the commission also required the replacement of a sequence in which the vigilante takes revenge by killing the antagonist's wife and child with a sequence showing the vigilante giving up the idea of revenge owing to the teacher's guidance.[13]

The Other without: Foreign Nations

Among the ten censorship criteria, Article 1 (avoiding political propaganda related to a state), Article 2 (avoiding degrading an ethnic community or race), and Article 3 (avoiding hurting the sentiments of fellow states and nations) required paying attention to filmic representations of foreign states and nations. The censorship commissions interpreted these articles broadly and sometimes vaguely.

In Turkish films, the commissions objected to Turkish characters having or using foreign names, titles, and expressions. Scenes were rejected for calling a Turkish character "Mike" or a police commissioner in a comedy film "Sheriff," for singing "Happy Birthday" in English at a party scene, or for featuring Greek songs.[14] Although the commissions did not indicate any particular reason for these rejections, they might have been motivated by a narrow definition of cultural protectionism or a broad definition of foreign propaganda. The commissions also rejected any words suggesting superiority on the part of a foreign country or inferiority on the part of Turkey. For instance, in *Yanık*

Kalpler (*Lovesick Hearts*, 1968), the commission required the omission of the words "One cannot live over here [Turkey]. You won't believe me, guys, but I realized it as soon as I entered Edirne [a city on the Turkish-Greek border]. We are finished; even Greece is a hundred times ahead of us. Life is abroad, civilization is abroad."[15] The commissions were so obsessive and finicky regarding the superiority/inferiority issue that they rejected even expressions such as "British nobles" and "British nobility," a French tourist's statement of "My husband is civilized," praise for American cigarettes, and the sentence (referring to Greece) "We will never see such beautiful scenery no matter where we go in the world."[16]

On the other hand, the commissions did not allow dialogue slandering foreign nations and ethnicities either. In *Şaşkın Baba* (*Bewildered Father*, 1963), in which a Turkish girl is presented as degenerate because she frequently watches foreign films, the commission required the omission of all negative words about foreign films. Additionally, making fun of Arabs, expressions such as "enemy states," "treacherous Russians," "filthy Jew," and scenes that might defame other countries were rejected. For instance, *Beş Hergele* (*Five Rascals*, 1971), the story of five friends imprisoned in Greece for a crime they did not commit, was accepted on the condition that the prison not be presented as a Greek prison.[17]

The "correct" representation of the historical struggles between Turks and Greeks was an important concern, whether in films set during the Turkish War of Independence (1919–1923), during the Cyprus events of the 1970s, or in historical action and adventure films set in Istanbul's Byzantine period. The commissions did not allow visuals of Turks being captured, tortured, or killed by Greeks nor dialogues slandering Turks or Greeks. Yet some reports reveal that the preoccupation with Turkish-Greek conflicts was not simply a matter of neutrality or respect but of national pride mixed with fear of diplomatic conflict and ethnic unrest. For example, the commission considered *Fedailer* (*Bodyguards*, 1967), the story of a group of Turkish fighters' struggle against Greek guerrillas in Cyprus torturing the Turkish populace, unfit for exhibition because it was against national sentiments and harmful to the order and security of the country. The commission may have been anxious that the film would lead to an international dispute or create hatred against the Greek minority in Turkey. The preoccupation with ethnic unrest is evident in the report on *Allahaısmarladık İstanbul* (*Goodbye, Istanbul*, 1966), a national struggle story set in Istanbul under Greek occupation, which was accepted on the condition that the following on-screen text or voiceover be added: "This film is the story of past events. All these events belong to history. Today, Turks of Greek origin have the virtue of living as Turks."[18] The commission's demand was reminiscent of Atatürk (the founder of modern Turkey)'s famous motto, "How happy is the one who says 'I am a Turk' " and in line with the Turkish constitution, which declared (and still does) that every citizen of Turkey was a Turk.

The Other within: The Poor, the Peasant, the Worker, and the Ethnic and Religious Minority

The censorship reports are marked by an obsession with protecting Turkish society from chaos at the expense of denying the economic and social problems that existed. The commissions approached films or scenes dealing with problems of the poor and the rural or scenes of labor-management discord as revolutionary discourses that threatened social peace and order.

The commissions did not want Turkey or any part of it to be portrayed as an underdeveloped or poor place, even in documentaries.[19] If a film allegedly included such a scene, it was rejected or denied export. The commissions were also wary of the depiction of poverty in fictional films because they feared that overemphasizing the poverty of certain groups might incite communal resentment and revolt. Considering class conflict a threat to social order by definition, the commissions rejected visuals and dialogues that compared rich and poor. For instance, *Fakir Çocuklar* (*Poor Children*, 1966), was accepted on the condition that the words "Some people pay 25,000 liras for a wedding gown some are in need of 25 piaster" be omitted because they "strongly provoked classes against each other" and hence propagated political, economic, and social ideologies (i.e., socialism) that contradicted the national regime.[20]

The commissions also objected to the portrayal of poor peasants as subjects oppressed by *aghas* (all-powerful rural landowners), which was a common theme in village melodramas. Visuals of *aghas* and their relatives exploiting and torturing peasants or raping peasant women, as well as any kind of hate speech toward *aghas*, were rejected under the pretext of safeguarding social order. Often, such films were denied export so as not to portray Turkey in poor light.

Visuals or dialogues underlining workers' exploitation and oppression by wealthy bosses were also deemed a threat to social order. Especially it was social realism films that suffered from censorship for their depiction of workers as well as of peasants and the poor. The films of the Social Realism Movement (1960–1965) in Turkish cinema focused on social problems in cities and villages, including issues of class, migration, urbanization, unemployment, and workers' rights. Many of these films were either rejected outright and/or were denied export. For instance, *Bitmeyen Yol* (*Endless Road*, 1965) was considered "destructive" to the social order and thus rejected on the following grounds:

> From beginning to end, the film portrays the struggle of poorly dressed peasant emigrants coming to the city to find work. This is done sometimes in an atmosphere of tragedy and sometimes in an exploitive and manipulative manner in order to destroy our social structure. The film depicts the city's worst and most miserable places and workers in the most miserable life conditions. All employers are shown to be demonic and cruel.[21]

Revolutionary themes in foreign films were also judged threatening to social integrity and order in Turkey. For instance, the Italian-Spanish Western comedy *Il Mercenario* (*The Mercenary*, aka *A Professional Gun*, 1968) was rejected on the grounds that it depicted the Mexican Revolution, including the revolt of mine workers. Similarly, when inspecting *Remparts d'argile* (*Ramparts of Clay*, 1971), the story of a woman named Rima set in a village in southern Tunisia, the commission was uncomfortable with a salt mine workers' strike as well as with Rima's support for the strikers and her rebellious change that defied local gender expectations. The Italian satirical comedy *La Cina è vicina* (*China Is Near*, 1967), featuring two proletarian lovers, a rich bourgeois nominated for municipal office by the Socialist Party, and a 17-year-old Maoist, was rejected on the grounds that it propagated ideologies that contradicted the national regime. References to communist leaders or to Marx's views of capitalism, as in the case of Jules Dassin's *Jamais le dimanche* (*Never on Sunday*, 1960), uttering lines from Mao, and the words "I would prefer to read *Capital* instead of the Bible," as in the case of the French *Tante Zita* (*Zita*, 1968), were also rejected.[22] The commissions were so paranoid about the "propaganda of communism" in foreign films that they did not even tolerate script in Russian or Cyrillic in the opening and closing credits of Azerbaijani films.[23]

The state's anxiety about maintaining social and cultural integrity is also observed in the commissions' wariness of the filmic presence of ethnic and religious minorities in Turkey, let alone their positive or negative representation. Besides the word "minority" itself, Kurdish or Kurdish-sounding names were rejected.[24] The commissions also objected to the presence of Kurdish vigilantes under the pretext of safeguarding law and order. For example, *Dağların Taçsız Kralı Koçero* (*Koçero, the Crownless King of the Mountains*, 1964) was rejected on the grounds that the main character (whose name reveals that he is of Kurdish origin), who was "indeed a criminal and an outlaw living in the mountains," was portrayed as oppressed to arouse public sympathy. The commission also found that the word "King" in the film's title implied a "criminal guerrilla reigning and living in luxury in the mountains" and thus mitigated the power of the police. Later, the film passed censorship after its title was changed to *Dağların Kurdu* (*The Wolf of the Mountains*).[25] As for religious minorities, the commissions were especially wary of representations of Alevis, a religious tradition and cultural community in Turkey whose saints, beliefs, and practices are different from those of the Sunni orthodoxy. Besides derogatory words (e.g., *kızılbaş* [red heads]) that would be offensive to the Alevi community, the commissions rejected violent content in historical religious films that portrayed the tragedies of the Alevi community on the grounds that such visuals could lead to clashes between Sunnis and Alevis. This subject leads us to the final sections of the chapter, in which we discuss the censorship of religion.

Representation of Religion

Article 4 of the censorship criteria directly prohibited propaganda of religion in films.[26] This prohibition must be considered within the framework of the radical secularism in Turkey that was institutionalized during the early Republican era. Turkey is a predominantly Muslim but officially secular country. Turkish secularism, however, differs from Anglo-American models of secularism, in that rather than a full separation of state and religion, the state controls the public expression of religion. The Republican state rejected religion as a national marker and undertook numerous modernizing and secularizing reforms that meant distancing the country from its Ottoman-Islamic-Eastern past. However, since Islam had provided both the governing and living principles in the country for centuries and thus could not be completely eradicated from social life, the state attempted to control religious activity in the public arena rather than excluding it altogether. According to this new formulation, religion could no longer function as an organizing principle in social life but be only a private matter of belief and conscience.

The censorship reports reveal that the commissions saw themselves both as custodians of a radical secularism (pushing Islam out of the public sphere) and of a "true" Islam (a personal, enlightened, apolitical, national, and Sunni Islam). Throughout the 1960s, the commissions were strict about how religious elements were depicted in secular films of any genre set in modern times. Visuals of *namaz* (the ritual prayer), the sound of *ezan* (the call to prayer), and visuals of or references to the Qur'an were rejected on the grounds that they exploited religion and religious feelings. The commissions also required the omission of scenes showing an imam or *hoca* (the cleric or preacher of a mosque) and *imam nikâhı* (religious marriage ceremony). The filmic *hoca*, however, was tolerated as long as he served to affirm the Republican ideology and discourse, which encoded his religion as an obscurantist and reactionary force and thus an obstacle to modernization and progress.

While the censorship commissions were resistant toward references to religion in secular films, they completely disapproved of words implying rebellion against Allah or slighting his greatness and respectability. The commission's views on this issue indicated that despite its strict stance on the secularization of social life, the state did not promote atheism and irreligion but rather attempted to redefine the place of religion in modern Turkish society. Accordingly, while religion was negated as a part and principle of modern public life, it was affirmed as long as it stayed as a private belief in and respect for Allah.

A more positive attitude toward religion is observed in the commissions' control of historical religious films, which depicted the lives of Muslim saints and prophets. Despite the abundance of elements such as the ritual prayer, the

call to prayer, and the Qur'an, which were prohibited in secular films, many of the historical religious films were accepted without any reservations directly relating to religion.[27] However, more than reflecting an inconsistency, this attitude paralleled Republican secularism because it mainly confined religion to a mythical past. If a historical religious film or a part of it was rejected, it was because the film allegedly included "misinformation" or "mistakes" regarding the historical events depicted or the rules to be followed in worship. Interestingly, the majority of the films rejected in this category were those portraying figures strongly revered by Alevis. As mentioned before, the commissions were especially uncomfortable with depictions of violence in such films because of the belief that they might lead to clashes between Sunnis and Alevis in contemporary society. In order to avoid such conflict, the commissions attempted to guarantee that those films would not offend Sunni sensitivities by cleansing them of any sectarian connotations and making the religious content compatible with the norms of Sunni Islam.

The only theme that the commissions were consistently against both in secular and in historical religious films was the depiction of folk or unofficial Islam, a set of popular and mystical beliefs, rituals, and activities that were categorized by the secular state and by Islamic orthodoxy as superstitions. Depictions of folk Islamic practices such as veneration of saints and pilgrimages to and devotional activities in their shrines or graves were rejected on the grounds of exploiting religious feelings. Additionally, elements of folk religion such as rain prayer, amulets, spells, and miracles, and especially their association with religious figures such as clerics, prophets, or saints, were deemed socially harmful because they allegedly transgressed reason and blurred the distinction between religion and superstition. Besides folk Islamic practices, filmic references to religious orders and brotherhoods, known as *tarikats* and outlawed in 1925, were rejected. Arguably, the resentment toward *tarikats* and folk Islam was not simply because they represented "primitiveness"; it also stemmed from the fact that throughout Turkish history, *tarikats* had functioned as a rival source of religious legitimacy and thus were seen as subversive of the current national regime.

During the 1960s, then, censorship commissions accepted Islam as a private abstract belief in Allah and as a set of rules to be followed in worship, but they negated Islam's social function as a part and principle of modern public life. When religion was allowed to be portrayed in films, it was either as a sign of obscurantism and reactionism or as a cultural and traditional element that symbolized a mythic past (but one that should nevertheless be remembered "correctly"). However, two censorship cases in 1970 point to a significant shift in the commissions' attitude toward religion.

The internationally acclaimed director Yılmaz Güney's film *Umut* (*Hope*, 1970) tells the tragic story of Cabbar, a poor cart driver who searches for a buried treasure under the guidance of a local *hoca*. The film encodes Cabbar's decision to follow the *hoca* to improve his life instead of taking social and

political action (e.g., he rejects participating in a cart driver's strike) as false consciousness and disempowerment. It also criticizes a system that victimized and pushed the poor and naïve into the hands of *hocas* and led them to seek salvation in superstition and false hopes. The censorship commission, however, decoded the film in a different way, rejecting it on many grounds (Articles 4, 5, 8, 9, and 10). Regarding the issue of religion, the commission argued that the film promoted superstitious beliefs, and "ridiculed" religious worship and religious functionaries.[28] Arguably, the commission's stricter and inconsistent reaction to *Hope* compared to other such films was a reaction to Güney's Marxist identity and to the Marxist messages in the film and was based on the supposition that Marxists are atheists or irreligious. To put it differently, compared to the "threat" of communism, Islam was perceived as a force that should be protected and defended.

The same year *Hope* was banned, the censorship commission accepted *Birleşen Yollar* (*Uniting Roads*, 1970) despite the opposition of the police representative, who rejected it on the grounds of propagating religion.[29] Different from historical religious films, *Uniting Roads* is set in the present and tells the story of an upper-class, modern, Westernized, "degenerate" girl who is influenced by a lower-class pious university boy to adopt the Islamic way of life and to wear hijab, which she does happily. The film criticizes the Turkish modernization project as cosmetic Westernization and promotes the Islamic way of life in modern Turkey as the only means to true happiness. The commission's intolerant attitude toward *Hope* and its tolerant attitude toward *Uniting Roads* (as well as to the latter's knockoffs that followed) seemed to be related to anxiety over the rise of the radical Left that was beginning in the late 1960s and to the mobilization of Islam as a remedy for social chaos, which would gain momentum following the 1980 military coup.

Concluding Remarks

Film censorship in Turkey was not simply a case of repressing freedom of speech but rather of drawing and policing the boundaries of what could be spoken and shown on screen and how. As in other parts of the world, censorship commissions were committed to safeguarding public morality, law and order, the legitimacy of the state, and national identity and pride by objecting to any film portrayal that went against official standards. The censorship reports especially relay the Turkish nationalist discourse that constructed the Turkish nation and society as a single and homogeneous body by denying the diverse social and cultural fabric of the country. They show how the fluid concept of social order, which the state continuously considered under threat, became a pretext for the exclusion of the other from social imaginary, be it the sexual woman and man, the rebellious youth, the poor, the rural, the worker, the communist, the Kurd, the Alevi, or the pious Muslim.

Arguably, the commissions also perceived moviegoers as inferior others, in the sense that they considered them child-like subjects who were psychologically immature and whose thoughts and actions could be easily manipulated. The commissions were well aware that cinematic narratives were fictions; as proof, they accepted certain films on the condition that the fictitiousness of the narrated events be indicated via an on-screen text or voiceover. On the other hand, parallel to the state's paternalistic treatment of its subjects, the censorship commissions' beliefs that filmic crime would provoke the public toward committing crime and that showing legal punishment for crimes would prevent criminal activity; that the public would be easily convinced that the police and the military never violated human rights if they did not see it on screen; that the public would always heed on-screen teachers' conformist words; that people would believe there were no minority problems or class conflicts in Turkey if scenes portraying such problems were excised from the movie screens; and that the audience would not be able to distinguish between humor and seriousness and between political satire and propaganda, suggest credulity on the part of the censorship commissions far more than on the part of the audience.

Despite all efforts, censorship commissions' knowledge about and control over films was not all powerful. Sometimes the examination copy of a film was different from the one released. Since there was no regular examination mechanism to control films exhibited in movie theaters, filmmakers were able to alter their films once they passed censorship.[30]

Arguably, film censorship was an obstacle to the development of social and political critique in Turkish cinema. It had also been the target of harsh criticism among filmmakers and critiques. In 1963, the Turkish Worker's Party (*Türkiye İşçi Partisi*) went to Turkey's Constitutional Court, claiming that the censorship regulations contradicted the main principles of the 1961 constitution. The court, however, decided the opposite.[31] In 1977 and 1983, respectively, two new regulations came into force, but they included only minor revisions to the original law.[32] In 1986, the introduction of the Law of Cinematic, Videographic and Musical Works of Art and the Regulation on the Control of Cinematic, Videographic and Musical Works of Art, which amended the 1939 regulation, marked a major break in film censorship in Turkey. For one, the regulation of film censorship was transferred from the Ministry of the Interior to the Ministry of Culture and Tourism. Moreover, the commissions now included one representative from the Professional Union of Film Producers, Importers, and Cinema-owners and one artist from the cinema industry in addition to state representatives.[33] A gradual relaxation throughout the 1990s culminated with a new cinema law and regulation in 2005, which eliminated film censorship, replacing it with a classification system.

Notes

1. These reports are currently held in paper format by the Turkish ministry of Culture, Directorate General of Copyrights and Cinema in Ankara. They are not accessible to the general public. Researchers who want to browse this material should apply to the Directorate in writing.
2. The history of censorship in Turkey is extensive, and film censorship occupies a wide but underexplored part of it. Major sources on the topic are: Onaran, A. Ş. (1968) *Sinematoğrafik Hürriyet.* Ankara: İçişleri Bakanlığı; Tikveş, Ö. (1968) *Mukayeseli Hukukta ve Türk Hukukunda Sinema Filmlerinin Sansürü.* Istanbul: Istanbul Üniversitesi Yayınları; Özgüç, A. (1976) *Türk Sineması Sansür Dosyası.* Istanbul: Koza Yayınları; Ak, B. (1993) *Siyahperde: Türk Sinemasında Sansürün Tarihi,* compact disc, T. C. Kültür Bakanlığı and Yeşilçam Filmcilik; Makal, O. (1996) Le cinéma et la vie politique: Le jeu s'appelle "vivre avec la censure," pp. 131–145 in Basutçu, M. *Le cinéma Turc.* Paris: Centre Georges Pompidou.
3. Onaran, A. Ş. (1994) *Türk Sineması I.* Ankara: Kitle Yayınları, p. 31.
4. Filmlerin ve Film Senaryolarının Kontrolüne Dair Nizamname, pp. 12375–12377 in *Resmi Gazete* (1939) 4272; Onaran (1968); Tikveş, Ö. (1974) 22 Yıl özgürlükten sonra Türkiye'de sansürü ilk kez İngilizler 1919'da "Mürebbiye" filmine uyguladılar, pp. 3–4 in *Milliyet Sanat* 65; Özgüç (1976).
5. On the limitations of the "prohibition model" in studies of censorship, see Kuhn, A. (1988) *Cinema, Censorship and Sexuality, 1910–1925.* London: Routledge.
6. Özön, N. (1995) Denetlemenin İşbirlikçileri, pp. 295–296 in Özön, N. *Karagözden Sinemaya 2.* Ankara: Kitle Yayınları.
7. *I Mongoli,* file no. 91123/926; *Hudutların Kanunu,* file no. 91122/3449.
8. Onaran, A. Ş. (1990) *Lütfi Ö. Akad.* Istanbul: AFA, p. 123.
9. See the reports of *Ömre Bedel Kız,* file no. 91122/3823; *Nankör Kadın,* file no. 91122/2613.
10. See the reports of *Kardeş Gibiydiler* (*They Were Like Brothers,* 1963, file no. 91122/2438) and *Erkek Fatma Evleniyor* (*Tomboy Is Getting Married,* 1963, file no. 91122/2381).
11. *Şaşkın Hafiye Killinge Karşı,* file no. 91122/4008; *Fantoma İstanbul'da Buluşalım,* file no. 91122/4095; *Estambul 65,* file no. 91122/2919.
12. File no. 91122/2490.
13. *Kolejli Kızın Aşkı,* file no. 91122/3343; *Kanunsuz Dağlar,* file no: 91122/3543.
14. See the reports of *Varan Bir* (1963, file no. 91122/2494); *Temem Bilakis* (1964, file no. 91122/2948); *Sokakların Meleği Fatoş* (1971, file no. 91122/4987); and *Akdeniz Şarkısı* (1963, file no. 91122/2567).
15. File no. 91128-1/5-19.
16. See the reports of *Makber* (1963, file no. 91122/2573; *Boğaziçinde Aşk* (1966, file no. 91122/3228); *Çapraz Delikanlı* (1963, file no. 91122/2647); and *Akdeniz Şarkısı* (1963, file no. 91122/2567).
17. *Şaşkın Baba,* file no. 91122/2642; *Beş Hergele,* file no. 91122/5159.
18. *Fedailer,* file no. 91122/3727; *Allahaısmarladık Istanbul,* file no. 91122/3448.
19. See the reports of *Renk Duvarları* (1968, file no. 91128-1/5-19) and *Ana Tanrıça* (1970, file no. 91128-1-5/30).
20. File no. 91122/3691.

21. File no. 91122/3156.
22. *Il Mercenario*, file no. 91123/966; *Remparts d'argile*, file no. 91128/1-5-32; *La Cina è vicina*, file no. 91128-1/5-25; *Jamais le dimanche*, file no. 91123/903; *Tante Zita*, file no. 91111/6604.
23. See the reports of *İsmail Üvey Anne* (1963, file no. 91123/904) and *The Blade of Vengeance* (1964, file no. 91125/151-2). For further discussion of the censorship commissions' wariness of the "propaganda of Communism," see Erdoğan, N. & D. Kaya (2002) Institutional Intervention in the Distribution and Exhibition of Hollywood Films in Turkey, pp. 47–59 in *Historical Journal of Film, Radio and Television* 22 (1).
24. See the reports of *On Korkusuz Adam* (1965, file no. 91122/2977); *Seyit Han— Toprağın Gelini* (1968, file no. 91122/4167); *İmzam Kanla Yazılır* (1970, file no. 91122/4803); and *Kralların Kaderi* (1970, file no. 91122/4920).
25. File no. 91122/2929.
26. Since we discuss in detail the censorship of religion in Turkish films elsewhere, here we present only an overview of the issue. See Mutlu, D. K. & Z. Koçer (2012) A Different Story of Secularism: The Censorship of Religious Elements in Turkish Films of the 1960s and Early 1970s, pp. 71–89 in *European Journal of Cultural Studies* 15 (1).
27. The commissions asked for revisions only if the films included nudity, sex, or sexually offensive dialogues, as they did with any other non-religious film. However, the foreign film *The Ten Commandments* (1956, inspection date: 1964) was rejected on the grounds of propagating religion (file no. 91123/921).
28. File no. 91122/4905. Later, upon the application of the filmmakers to the Supreme Council, *Hope* was allowed to be screened in Turkey.
29. File no. 91122/4818.
30. Feriha Sanerk, the only female member of the censorship commissions in the 1960s, expresses this fact openly in a documentary about film censorship in Turkey. See Ak (1993). For some directors' anecdotes on this subject, see also Esen, Ş. K. (2002) *Sinemamızda Bir "Auteur" Ömer Kavur*. Istanbul: Alfa Yayınları, p. 458; Onaran (1990), p. 123.
31. Tikveş, Ö. (1966) Film Sansürü ve 1961 Anayasası, pp. 305–320 in *Istanbul Ünivesitesi Hukuk Fakültesi Mecmuası* 32; Özek, Ç. (1967) Filimcilikte Sansür ve Anayasa Mahkemesinin Konuyla İlgili Bir Kararı, pp. 954–979 in *Istanbul Ünivesitesi Hukuk Fakültesi Mecmuası* 32.
32. Çimen, M. (1977) İflasın Eşiğindeki Yeşilçam ve Sansür, pp. 33–40 in *Pınar* 71; Tatar, M. (1979) *Türkiye'de Film ve Film Senaryoları Sansürü*, unpublished master's thesis, Türkiye ve Orta Doğu Amme İdaresi Enstitüsü; Dönmez, O. (1986) Türkiye'de Film Sansürü ve Yeni Sansür Tüzüğü, pp. 24–36 in *İzmir Barosu Dergisi* 5 (1).
33. Kültür ve Turizm Bakanlığı (1989) *Sinema, Video ve Müzik Eserleri Kanunu ile Yönetmelikler*. Ankara: Kültür ve Turizm Bakanlığı and Onaran, A. Ş. (1992–1993) Yeni Film Sansür Düzeni, pp. 139–146 in *Istanbul Üniversitesi İletişim Fakültesi Dergisi* 1.

Part III

Colonialism, Legacy, and Policies

The Censor and the State in Britain

Julian Petley

In its vision statement, the British Board of Film Classification (BBFC) describes itself rather confusingly as both a "statutory designated authority" and an "independent, self-financing regulator."[1] Meanwhile the Board's *Student Guide* calls the organization an "independent, non-governmental body."[2] Matters are made even more complicated by the fact that the BBFC changed its name from the British Board of Film Censors in 1985, but still carried on censoring as well as classifying films. This chapter will attempt to clarify the status of the BBFC, and in particular, its relationship to the wider apparatus of the state.

A good deal has been written about the BBFC, but much of this concentrates on the films that the Board has cut or banned.[3] The two books[4] written by people who have actually worked for the BBFC provide rather more contextual information, but almost inevitably these insiders' views, though revealing, lack a critical perspective. This, along with a sophisticated theoretical framework, is certainly provided by Annette Kuhn,[5] but her study of film censorship in Britain covers only the years 1909–1925 and the subject of sexuality. My own book[6] attempts something similar over a slightly longer time frame (1979–2010) and on a broader front, and in this chapter I want to explore one of the themes of that book—the relationship between the BBFC and the state—in greater historical detail.

The BBFC is certainly independent of the state in the sense that it is funded by the industry that it regulates and is not part of a government department. But it is not *wholly* independent of the state, for a number of different reasons. I want to explore each of these in turn in this chapter. Firstly, I will illustrate how the founding and continued existence of the BBFC have to be understood primarily as a response to local councils' powers of film censorship.

Following this, I will explain another aspect of the Board's relationship with the state, namely the fact that it has to take account of various laws passed by parliament when classifying and censoring videos and cinema films. Here I will draw particular attention to the fact that, as a result of the Video Recordings Act 1984, video classification certificates, unlike those for films shown in cinemas, have legal force. In the following section I will show how, prior to World War II, the Board engaged in the overtly political censorship of films and enjoyed an extremely close relationship with the relevant government departments. In the postwar period, this form of censorship declined, but the BBFC still retained links, albeit not as close as before, with certain government departments, as I will go on to demonstrate. Thus the president and two vice presidents of the BBFC are designated by parliament under the Video Recordings Act 1984 as responsible for classifying (and, where necessary, censoring) all feature films distributed on video in the United Kingdom. Furthermore, when the Board's Council of Management selects a new president or vice president, the appointment has to be approved by the Secretary of State for Culture, Media and Sport[7] (who also has the power to de-designate them as the persons ultimately responsible for enforcing the Video Recordings Act). The secretary of state will also be informed, as a courtesy, when the Council selects a new director, but in this case does not possess the power of veto.[8] My point in stressing the role of politicians in these designation and appointments processes is to draw attention to the fact that the BBFC is not quite as independent of government as is sometimes supposed, and to indicate points at which the Board may on times be vulnerable to political pressures. And finally I will argue that if we are to fully understand the Board's place within the state, its activities need to be considered as part of a wider process of governmentality.

The Powers of Local Authorities

In 1909, the British Parliament passed its very first act to regulate the film industry. As Geoffrey Robertson and Andrew Nicol explain, "the 1909 Cinematograph Act gave local authorities power to impose conditions on film exhibition in order to protect the public against fire hazards, but they soon began to use them to quench the flames of celluloid passion."[9] In other words, local authorities used fire regulations, which enabled them to withhold licenses from cinemas in which there were fire risks, to refuse licenses to cinemas that showed films of which the authorities disapproved. And so, in 1912, the Cinematograph Exhibitors' Association, faced with an increasingly bewildering and damaging array of varying local censorship practices and standards, decided to form the British Board of Film Censors (BBFC), described by the *Bioscope*, November 21, 1912, as a "purely independent and impartial body, whose duty it will be to induce confidence in the minds of the licensing

authorities, and of those who have in their charge the moral welfare of the community generally."[10]

In 1924 the Board received judicial recognition when the Divisional Court upheld the validity of a condition that "no cinematograph film...which has not been passed for...exhibition by the BBFC shall be exhibited without the express consent of the council."[11] This effectively meant that as long as a local council reserved the right to overrule BBFC decisions when it disagreed with them, it was entitled to make it a condition of granting a license to a cinema that that cinema screened only films passed by the BBFC. The licensing powers of local authorities, and thus their effective ability to act as film censors, survived the passing of flammable film, although it was not until 1952 that the British Parliament actually acknowledged the BBFC, in Section 3 of the Cinematograph Act.

Local authorities' licensing provisions were re-enacted in 1982 and consolidated in the 1985 Cinemas Act. Most local authorities now adopt the "model licensing conditions" drafted by the Home Office, which include the following:

(a) No film, other than a current newsreel, shall be exhibited unless it has received a certificate of the British Board of Film Classification or is the subject of the licensing authority's permission;

(b) No young people shall be admitted to any exhibition of a film classified by the Board as unsuitable for them, unless with the local authority's permission;

(c) No film shall be exhibited if the licensing authority gives notice in writing prohibiting its exhibition on the ground that it "would offend against good taste or decency or would be likely to encourage or incite to crime or to lead to disorder or to be offensive to public feeling"[12]

And so, since, in the last analysis, the BBFC has to take into account, when classifying a film, the sensibilities of local fire brigade or watch committees, this means, as Geoffrey Robertson states, that: "the cinema, alone of art forms, is subject to moral judgement by local councils."[13]

The Laws of the Land

As noted above, in its deliberations over classifying and cutting the BBFC has also to take account of the laws of the land, and of how these are interpreted by the police, the Director of Public Prosecutions, and the courts. The Video Recordings Act is the most important of these, and is discussed below, but other laws to which the Board needs to pay close attention are the Obscene Publications Act (OPA) 1959 and 1964, the Protection of Children Act 1978, and the sections of the Criminal Justice and Immigration Act that make it illegal even to possess what the Act refers to as "extreme pornography." The

BBFC's own *Guidelines* make clear the importance of ensuring that no films or videos that it passes might infringe the laws, noting that the Board is unlikely to pass, even in the two "adults only" categories, "18" and "R18" (which latter classification entails that the material in question may be sold only in a licensed sex shop): material that may promote illegal activity, material that is obscene or otherwise illegal, material created by means of the commission of a criminal offence, and portrayals of children in a sexualized or abusive context.[14]

According to the OPA, an article will be deemed to be obscene if its effect is, "if taken as a whole, such as to tend to deprave and corrupt persons who are likely, having regard to all relevant circumstances, to read, see or hear the matter contained or embodied in it." The police and the Crown Prosecution Service (CPS) tend to confine their efforts to pursuing only material that they think juries or magistrates will be likely to find guilty under the Act. However, in order to help the BBFC in its deliberations, the CPS has actually provided it with a kind of "laundry list" that consists of the categories of material most commonly prosecuted under the OPA, and which clearly limits its freedom of maneuver in this area. These are: sexual act with an animal; realistic portrayals of rape; sadomasochistic material that goes beyond trifling and transient infliction of injury; torture with instruments; bondage (especially where gags are used with no apparent means of withdrawing consent); dismemberment or graphic mutilation; activities involving "perversion or degradation" (such as drinking urine, urination or vomiting onto the body, or excretion or use of excreta); and fisting.[15] As I have explained at some length elsewhere,[16] if the police seize material they believe to be in contravention of the OPA, the CPS has to decide whether to prosecute for a criminal offence under Section 2 or to go for a civil forfeiture under Section 3. Section 2 cases can be heard either by magistrates or by a judge and jury, but if a defendant opts for the latter, as is their right, they run the risk of a tougher sentence if found guilty. If the CPS opts for Section 3 then the material is brought before local magistrates, who can either release it or issue a summons for its forfeiture. In the latter case, any interested party can contest the summons (but very rarely does so, for fear of drawing the prurient attentions of the local press to their activities). The decisions of local magistrates cannot be enforced outside their own courts' geographical jurisdictions, and magistrates are not required to give any reasons for their decisions in Section 3 proceedings, so these add nothing to obscenity case law. Section 3 may have no criminal consequences (the proceedings are against the material and not its distributor) but it does deprive publishers of what ought to be their right to trial by jury, and of other safeguards of the criminal law. In essence, it is nothing more than a quick and convenient (for the authorities, that is) form of local censorship carried out by police who are perfectly well aware that the material in question might not be convicted by a jury, and by magistrates who may well be ill qualified to sit in judgment upon it. However, although these cases do not set precedents in any broader legal sense (as do judgments handed down in crown courts), they *do* in fact have

be made. Thus, for example, in 1936 a com-
m about the notorious Judge Jeffreys (known
unt of the 300 death sentences that he handed
nmouth's Rebellion) was told that "no reflec-
tish justice at any period could be permitted"
'Bloody Assizes' could be used."[23] The same
wn flat a script based on Walter Greenwood's
vel and stage adaptation *Love on the Dole*, with
a very sordid story, in very sordid surround-
film" and another complaining that "there is
l side of poverty."[24] And, as might be imagined
nds of the Board's senior staff), films about the
y discouraged. As Colonel Hanna put it when
oposed film on the Irish revolutionary leader
1890–1922): "it is a very controversial period,
l and unpleasant memories which both sides
alone and not raked up through the medium
e subject is treated, one side or the other will
ight result."[25] Two other scripts submitted to
pectively, *The Rising* and *Irish Story*, met with
ed, and even a specially "modified" version of
) was heavily cut by the Board. Indeed, such
ical censorship operated by the BBFC in the
, Lord Tyrrell, was able to tell the Exhibitors'
ride in observing that there is not a single film
of the burning issues of the day."[26]

C was a purely private body, financed by the
l cutting films and not by taxpayers' money.
within the definition of a state organization
ree from public scrutiny and obligations, and
ash his hands in Parliament of the responsibil-
ng any particular film, although he, along with
ociations, would have to be consulted before a
ed. But what had been created was a body that
on behalf of and in the interests of the state,
e day, but which appeared to be entirely inde-
e Secretary Herbert Morrison put it, somewhat

rious arrangement, but the British have a very
rrangements that work very well, and this works.
ne Minister who has to answer questions in the
films should or should not be censored. I think it
ne Secretary to have direct powers himself in this

wider ramifications—because they constitute one of the factors that effectively limit what the BBFC feels able to pass even at "18" and "R18."

The 1984 Video Recordings Act came about as a result of hysteria generated by moral campaigners, politicians, and the bulk of the press at the arrival of unregulated home video in a country in which cinema films had long been censored more harshly than in any other western European country, with the exception of the Republic of Ireland. Spurred into action by lurid (and frequently highly exaggerated) stories of gruesome horror films, which came to be known as "video nasties," flooding the nation's homes, stories that were fuelled by Mary Whitehouse's pro-censorship group the National Viewers and Listeners' Association and pedaled by a sensation-hungry press, Parliament passed a law that entailed that the BBFC had to classify (and, where necessary, cut or even ban outright) every feature film released on video.[17] Because these classifications—unlike the classifications for cinema films handed out by the same body—carry legal force, it became a criminal offence to distribute, rent, or sell an unclassified video, and to rent or sell a video to a person below the age stipulated in its certificate. Infringement carries a hefty fine. The Video Recordings Act was tightened up still further by being amended by the Criminal Justice and Public Order Act 1994 in the wake of the panic whipped up over the murder of James Bulger, a murder that, without a shred of proof, was blamed on the influence of horror videos, and of *Child's Play 3* (1991) in particular.[18] The amendment strengthened the penalties for breaking this particular law, and also stipulated that

> The designated authority [i.e., the BBFC] shall, in making any determination as to the suitability of a video work, have special regard (among the other relevant factors) to any harm that may be caused to potential viewers or, through their behavior, to society by the manner in which the work deals with—(a) criminal behavior; (b) illegal drugs; (c) violent behavior or incidents; (d) horrific behavior or incidents; or (e) human sexual activity.

The considerable body of child protection legislation now existing in the UK means that the BBFC has to be extremely careful that no film or video that it passes contains images of young people that might infringe the law. The Protection of Children Act 1978, as amended by the Criminal Justice and Public Order Act 1994, states that "it is an offence for a person to take, or permit to be taken, or to make any indecent photograph or pseudo-photograph of a child; or to distribute or show such indecent photographs or pseudo-photographs; or to possess such indecent photographs or pseudo-photographs, with a view to their being distributed or shown by himself or others." The 1978 legislation was further amended by the Sexual Offences Act 2003 to raise from 16 to 18 the age up to which a person is considered a child for the purposes of the Act.

The year 2009 saw the passing of the Coroners and Justice Act, Sections 62–68 of which criminalize possession of what the Act calls a "prohibited image of a child." The purpose of adding this offence was partly to close a loophole

in the already considerable battery of child protection legislation by making it possible to target nonphotographic images of children. Thus it was made a criminal offence to possess such nonphotographic images of children that are pornographic, "grossly offensive, disgusting or otherwise of an obscene character" and that focus on a child's genitals or anal region, or portray a range of sexual acts "with or in the presence of a child." This, of course, catches cartoon/graphic imagery. Prior to this, although not explicitly in the statutes, the law had been interpreted to apply to cartoon/graphic images, but only where these were realistic and indistinguishable from photographs. Now the law covers all such images of children, whether realistic or not. One of the genres of graphic imagery that it captures is *lolicon manga* or *lolicon anime*, in which childlike female characters are often depicted in an erotic manner and a style resembling *shōjo manga* (girls' comics). As already noted, the law defines a child as a person under the age of 18, but the Coroners and Justice Act adds that "where an image shows a person, the image is to be treated as an image of a child if—(a) the impression conveyed by the image is that the person shown is a child, or (b) the predominant impression conveyed is that the person shown is a child despite the fact that some of the physical characteristics shown are not those of a child." And in order to close any further loopholes, the Act states that "references to an image of a child include references to an image of an imaginary child." This measure, too, must give the Board cause for caution when considering certain kinds of Japanese animation, such as the *Urotsukidoji* series. In this context, it is significant that in 2000 the BBFC banned two extras on the DVD of Adrian Lyne's *Lolita* (1997), *The Comic Book* and *The Lake Point Cottages*, stating that

> Our main concern with these highly eroticized scenes is that they might invite feelings of arousal towards a child. We have a particular concern in the context of DVD extras where the scenes in question can be readily accessed and replayed at any speed. The obvious sexualization of a 14 year old girl with the use of such provocative detail must raise concerns about the potential misuse of this material by those predisposed to seek illegal sexual encounters.[19]

Similar concerns about nude scenes involving a 16-year-old actress led the BBFC in 2004 to ban outright a DVD of Jess Franco's dated *Frauen für Zellenblock 9* (*Women in Cell Block 9*, 1978).

Political Censorship

Let us now turn to the BBFC's relationship with government. This is certainly a great deal less intimate than it used to be, but it is also closer than is frequently supposed or suggested.

Prior to World War II, the upper echelons of the Board were staffed by people whose qualifications were essentially political as opposed to cinematic.

Thus, for former cl tary; his s Office, w Political examiner president Ireland. N had been I and wa *committe* position Pronay a of high-l highest l field of p sites for the polit and bacl

ensu in the whor stanc any, 1

That p the app this is tions ("refere matory "scenes ing up represe ities of prohib classic Nazi C

In tion, ally su result

banned before they cou pany contemplating ma as "The Hanging Judge" down in 1685 in the wa tion on the administrati and that "no phrase as year the BBFC twice tur 1933 far-from-inflamma one examiner describing ings" and "very undesira too much of the tragic an (particularly given the ba situation in Ireland were turning down the script and politician Michael C and I strongly urge that to the conflict share are b of the screen. No matter be angered and much ha the BBFC in 1938 and 19 disapproval and were nev John Ford's *The Informer was the stringency of the 1930s that in 1937 its pre Association that "we may t in London which deals wit

And yet, formally, the fees charged for classifying As such the BBFC did no run by the Home Office, v allowed the home secretary ity for cutting, banning, or the principal local authority new president could be app carried out political censor indeed of the government o pendent from both. As the H smugly, in 1942:

> I freely admit that this is a great habit of making curiou Frankly, I do not wish to be House as to whether particu would be dangerous for the F matter.[27]

Now, these historical details might be thought of as being of only academic interest were it not for two factors. Firstly, the BBFC was not entirely free from Home Office interference in recent times, before responsibility for it was passed to the Department of Culture, Media and Sport. And secondly, whilst governments are less worried today about people, and especially working class people, being "politically indoctrinated" by the modern media, and whilst the BBFC is clearly not in the least concerned about how political issues such as "relations between capital and labour" are represented on screen, both institutions are still preoccupied with the question of "media effects," which is why the classification and censorship of films and videos persists to this day.

Political Interference

In 1985, after the sudden death of BBFC president Lord Harlech, the Home Office did its best to try to impose Sir Ian Trethowan, a former BBC director general and a known supporter of Prime Minister Margaret Thatcher, as his successor. Facing stiff opposition from within the BBFC, and especially from its Secretary James Ferman, Home Office minister David Mellor implicitly threatened to establish a new agency for both film and video classification, and to exclude Ferman from participating in the appointment of presidents and vice presidents in future. However, the BBFC stood firm, and nominated Lord Harewood as Harlech's successor, whereupon Mellor and Home Secretary Leon Brittan took the quite unprecedented step of effectively interviewing him for the job, making it sound as onerous and time-consuming as possible, presumably in the hope that he would withdraw. In this they were disappointed, but they resolved that in future the Home Office would decide senior BBFC appointments.[28]

However, the next time that the Home Office was to try to exert its power over the BBFC was shortly after the election of a Labour government in 1997, in which Jack Straw was Home Secretary. Although this story revolves around a number of routine pornographic videos, it is actually extremely important to any account of the relationship between the BBFC and the state; unfortunately, it can be only briefly summarized here.[29] In 1996 Lord Harewood decided to retire, and his job was advertised. On May 23, 1997, James Ferman and the Chair of the BBFC's Council of Management, Dennis Kimbley, informed the Home Office that Lord Birkett, then a BBFC vice president, had been selected for the post from a shortlist of six applicants. According to James Robertson, Ferman was then told informally by a Home Office civil servant that "the Home Office would not accept Birkett without at least knowing the names of all the candidates and the reasons for the rejection of unsuccessful five, as well as the details of the six shortlisted candidates, their brief *curricula vitae* and a summary of the selection committee's views on each of them."[30] Straw and his minister Lord Williams of Mostyn also wanted to meet Birkett before

his appointment could be confirmed, all of which was quite unprecedented. It should also be noted that stories casting doubt on Ferman's future began to appear in the right-wing press almost as soon as Labour came to power. These carried all the hallmarks of hostile Home Office briefings, and additionally, in the case of the *Daily Mail*, which has a long history of demanding stricter censorship of cinema and television, were part of the fallout of the humiliating failure of its strident campaign to get David Cronenberg's *Crash* (1996) banned.[31] Thus in an article on August 21, 1997, headlined "Straw to Direct Film Censors Shake-up," the *Daily Mail* reported that

> Jack Straw is planning to push through a total reorganisation of the film censorship system in an effort to make it more accountable. The British Board of Film Classification has been accused of being secretive because of its refusal to explain the certificates it grants to films or identify the people who do the vetting. Concern about the running of the organisation reached its height with the decision to give the "sex and wrecks" film *Crash* an 18 certificate without cuts. To revolutionise the censorship process, the Home Secretary will use his power of veto in the appointment of the person whose job it is to run the BBFC.

But, paradoxically, it was a hangover from the previous Conservative era that really gave Straw the opportunity to flex his muscles over the BBFC. In 1996, the Home Office and the Metropolitan Police, concerned about the growth of black-market sex shops in London, suggested to the BBFC that it might be possible to relax the extremely strict guidelines covering "R18" videos, something that the BBFC had wanted to do for a long time, but had been prevented from doing by the way in which the OPA had been enforced by the police, the CPS, and the courts. It was hoped that allowing stronger material to be sold in licensed sex shops would help to drive the illegal establishments out of business. The BBFC thus relaxed its guidelines somewhat, though these still excluded a great deal of material that would be perfectly legal in almost any other EU country.

Shortly after Labour came to power the following year, Straw discovered, quite by accident, what the BBFC had done, and, being a known enemy of pornography of even the mildest kind, was absolutely furious. He ordered that the liberalization process be reversed with immediate effect and summoned Birkett to appear before him, at which point considerably more than a mild rebuke was administered. The unfortunate Birkett, appearing on the *Panorama* program "Porn Wars" on November 2, 1998, described the atmosphere at the meeting as "inquisitorial" and Straw as manifesting a "genuine sense of outrage." Indeed, when *Panorama* asked Straw to comment on the whole affair, he issued a statement that said that Lord Birkett "failed properly to exercise his responsibilities". This may sound innocuous enough but, judged by the rules that govern political discourse at these exalted levels, it is nothing less than a metaphorical smack in the face or, as the *Panorama* presenter John Ware put it, "a full frontal attack on a retired senior public servant"—which is perhaps why

the Home Office then tried to withdraw it and substitute by something more anodyne, claiming that it had been put out as the result of a "technical error"! Straw also released to the press a letter criticizing Ferman "in the strongest possible terms" for his "unacceptable, unilateral decision to liberalise the law," and this was much quoted by censoriously inclined papers, which were far more interested in criticizing the BBFC for being overliberal than criticizing the Home Office for being overbearing.

According to James Robertson, Jack Straw met Dennis Kimbley in November 1997 and made it clear that he would de-designate the BBFC's president and vice president for being responsible for enforcing the Video Recordings Act if the Home Office did not get its way over the appointment of a new president. Straw also interviewed Birkett, Andreas Whittam Smith (one of the founders of the *Independent* newspaper), and one other candidate for the job. On November 20, he informed Kimbley of his preference for Whittam Smith, and demanded changes at the BBFC. As Robertson puts it:

> The most important of these were that a senior Home Office civil servant should be present in future when the BBFC Council of Management interviewed short-listed candidates for the Presidency and Vice-Presidencies, and that the Home Secretary should be invited to comment on the shortlist to enable them to feed in their views before the Council selected a candidate.[32]

Faced with such brow-beating, Kimbley had little option but to offer the job to Whittam Smith who, however, turned out to be anything but Straw's patsy.

The Home Office also let it be known that it was reviewing James Ferman's position too. This was the cue for more yet more hostile press stories in censorious, right-wing newspapers that had regularly and loudly castigated the BBFC for being overly liberal in carrying out its duties. Particularly significant was a report in the *Telegraph*, December 9, which all too clearly, though doubtless unwittingly, highlights the peculiar relationship between the BBFC and the government of the day when it noted that: "there is an arm's length relationship between politicians and the censors, which in many ways is healthy; only in dictatorships do governments decide what people can and cannot watch. But while the politicians are happy for the BBFC to be independent of government, there is a view that under Mr. Ferman it has become a law unto itself." And that, of course, particularly in the eyes of an illiberal newspaper, would never do!

Nonetheless, this was not the end of the story. Video distributors, who had purchased the rights to certain films on the understanding that the BBFC had liberalized its "R18" guidelines, now found these videos being subject to cuts when submitted to the BBFC. They took their complaints to the Video Appeals Committee, an independent body established under the Video Recordings Act, and won. However, the Home Office refused point blank to allow the BBFC to re-liberalize its guidelines, insisting first of all that to do so would be to pass material that might contravene the OPA, and then that the material might contravene the "harm" provisions of the Video Recordings Act as well. More

appeals followed, and these too were successful. And all the while, the public fiction was maintained that the BBFC was acting entirely off its own bat in seemingly arbitrarily and inconsistently changing its "R18" guidelines back and forth, with the Home Office as absent from media accounts of this story as it was active behind the scenes.[33] In the end, matters reached a peak of absurdity when the BBFC applied for a judicial review of one of the Video Appeals Committee's judgments, a judgment with which it must have in fact agreed since it was entirely in line with the liberalized guidelines, and one can only assume that it was required to follow this course of action by an obdurate Home Office.

As it happens, the application for judicial review was dismissed, and in September 2000 the Board published a new set of "R18" guidelines, which were far more liberal than those introduced in 1997 (although still pretty restrictive by continental European standards). And although the Home Office was furious, and received a good deal of supportive coverage in the censorious press, there was actually very little it could do without flushing its own leading role in the whole affair out into the open and also making it appear as if the government wanted to intervene *directly* in the censorship of individual films—something from which, as we have seen, previous Home Secretaries have recoiled. It could, I suppose, be argued that the actions of Mellor, Brittan, and Straw actually demonstrate the resilience of the BBFC in the face of governmental pressure and interference, but they also illustrate how activist and interventionist politicians have powers at their disposal to bring the BBFC to heel, powers that are still available to the Minister for Culture, Media and Sport. The fact that these three ultimately failed to bend the BBFC to their will makes the existence of those powers nonetheless disturbing.

The BBFC, Governmentality, and Moral Regulation

Finally, let us return to the point about governmental and BBFC concern about "media effects." These are no longer conceived specifically in political terms, and fears about the effects of "propaganda" have been replaced by fears about the effects of representations of sex and violence, particularly together. In this respect it is highly significant that the two biggest controversies in which the Board has been involved in recent times have been over "video nasties" and pornography.

Up until World War II, the BBFC took exception to "themes indicative of habitual immorality," "women in alluring and provocative attitudes," "degrading exhibitions of animal passions" "passionate and unrestrained embraces," "men and women in bed together," "brutal fights carried to excess, including gouging of eyes, clawing of faces and throttling," "realistic scenes of torture," and so on.[34] And whilst it would be absurd to claim that the Board today maintains the same standards in these areas as it did in the first half of the twentieth century, it does nonetheless concern itself, to an extent that some

wider ramifications—because they constitute one of the factors that effectively limit what the BBFC feels able to pass even at "18" and "R18."

The 1984 Video Recordings Act came about as a result of hysteria generated by moral campaigners, politicians, and the bulk of the press at the arrival of unregulated home video in a country in which cinema films had long been censored more harshly than in any other western European country, with the exception of the Republic of Ireland. Spurred into action by lurid (and frequently highly exaggerated) stories of gruesome horror films, which came to be known as "video nasties," flooding the nation's homes, stories that were fuelled by Mary Whitehouse's pro-censorship group the National Viewers and Listeners' Association and pedaled by a sensation-hungry press, Parliament passed a law that entailed that the BBFC had to classify (and, where necessary, cut or even ban outright) every feature film released on video.[17] Because these classifications—unlike the classifications for cinema films handed out by the same body—carry legal force, it became a criminal offence to distribute, rent, or sell an unclassified video, and to rent or sell a video to a person below the age stipulated in its certificate. Infringement carries a hefty fine. The Video Recordings Act was tightened up still further by being amended by the Criminal Justice and Public Order Act 1994 in the wake of the panic whipped up over the murder of James Bulger, a murder that, without a shred of proof, was blamed on the influence of horror videos, and of *Child's Play 3* (1991) in particular.[18] The amendment strengthened the penalties for breaking this particular law, and also stipulated that

> The designated authority [i.e., the BBFC] shall, in making any determination as to the suitability of a video work, have special regard (among the other relevant factors) to any harm that may be caused to potential viewers or, through their behavior, to society by the manner in which the work deals with—(a) criminal behavior; (b) illegal drugs; (c) violent behavior or incidents; (d) horrific behavior or incidents; or (e) human sexual activity.

The considerable body of child protection legislation now existing in the UK means that the BBFC has to be extremely careful that no film or video that it passes contains images of young people that might infringe the law. The Protection of Children Act 1978, as amended by the Criminal Justice and Public Order Act 1994, states that "it is an offence for a person to take, or permit to be taken, or to make any indecent photograph or pseudo-photograph of a child; or to distribute or show such indecent photographs or pseudo-photographs; or to possess such indecent photographs or pseudo-photographs, with a view to their being distributed or shown by himself or others." The 1978 legislation was further amended by the Sexual Offences Act 2003 to raise from 16 to 18 the age up to which a person is considered a child for the purposes of the Act.

The year 2009 saw the passing of the Coroners and Justice Act, Sections 62–68 of which criminalize possession of what the Act calls a "prohibited image of a child." The purpose of adding this offence was partly to close a loophole

in the already considerable battery of child protection legislation by making it possible to target nonphotographic images of children. Thus it was made a criminal offence to possess such nonphotographic images of children that are pornographic, "grossly offensive, disgusting or otherwise of an obscene character" and that focus on a child's genitals or anal region, or portray a range of sexual acts "with or in the presence of a child." This, of course, catches cartoon/graphic imagery. Prior to this, although not explicitly in the statutes, the law had been interpreted to apply to cartoon/graphic images, but only where these were realistic and indistinguishable from photographs. Now the law covers all such images of children, whether realistic or not. One of the genres of graphic imagery that it captures is *lolicon manga* or *lolicon anime*, in which childlike female characters are often depicted in an erotic manner and a style resembling *shōjo manga* (girls' comics). As already noted, the law defines a child as a person under the age of 18, but the Coroners and Justice Act adds that "where an image shows a person, the image is to be treated as an image of a child if—(a) the impression conveyed by the image is that the person shown is a child, or (b) the predominant impression conveyed is that the person shown is a child despite the fact that some of the physical characteristics shown are not those of a child." And in order to close any further loopholes, the Act states that "references to an image of a child include references to an image of an imaginary child." This measure, too, must give the Board cause for caution when considering certain kinds of Japanese animation, such as the *Urotsukidoji* series. In this context, it is significant that in 2000 the BBFC banned two extras on the DVD of Adrian Lyne's *Lolita* (1997), *The Comic Book* and *The Lake Point Cottages*, stating that

> Our main concern with these highly eroticized scenes is that they might invite feelings of arousal towards a child. We have a particular concern in the context of DVD extras where the scenes in question can be readily accessed and replayed at any speed. The obvious sexualization of a 14 year old girl with the use of such provocative detail must raise concerns about the potential misuse of this material by those predisposed to seek illegal sexual encounters.[19]

Similar concerns about nude scenes involving a 16-year-old actress led the BBFC in 2004 to ban outright a DVD of Jess Franco's dated *Frauen für Zellenblock 9* (*Women in Cell Block 9*, 1978).

Political Censorship

Let us now turn to the BBFC's relationship with government. This is certainly a great deal less intimate than it used to be, but it is also closer than is frequently supposed or suggested.

Prior to World War II, the upper echelons of the Board were staffed by people whose qualifications were essentially political as opposed to cinematic.

Thus, for example, in the 1930s the BBFC president Sir Edward Shortt was a former chief secretary for Ireland, member of the cabinet, and home secretary; his successor, Lord Tyrrell, was a former Permanent Head of the Foreign Office, where previously he had founded the News Department and headed Political Intelligence. Both were also Privy Counsellors. Four out of the five examiners had military backgrounds, and the chief examiner and later vice president, Colonel J. C. Hanna, was a former deputy chief of intelligence in Ireland. Meanwhile, J. Brooke Wilkinson, the administrative head of the BBFC, had been in charge of film propaganda to neutral nations during World War I and was a member of the (secret) Criminal Investigation Department *Subcommittee on Censorship*. In other words these were men of high political position with the right contacts: the Establishment personified. As Nicholas Pronay argues, the presence of such figures in the BBFC proves "the existence of high-level contacts, of wide experience of politics and government at the highest level, and of knowledge about other operations being conducted in the field of propaganda and counter-propaganda which are the essential prerequisites for conducting political censorship."[20] Pronay concludes that what made the political censorship of films so effective at this time was that the experience and background of a figure such as Shortt

> ensured that he could be relied upon to know what was needed, who was "fully in the picture" knowing not only what was known to members of the public and whom it was "safe" to "contact" or consult. It made no difference to his "official" standing either where the money for his salary came from or what position, if any, the organisation formally possessed.[21]

That pre-WWII British cinema was subject to strict political censorship via the apparatus of the state, albeit indirectly, is thus undeniable. The fact that this is so can equally be confirmed by examining the numerous prohibitions (98 by 1930) formulated by the BBFC in this period. These included "references to controversial politics," "relations of capital and labour," "inflammatory sub-titles and Bolshevik propaganda," "incitement to class hatred," "scenes tending to disparage public characters and institutions," "scenes holding up the King's uniform to contempt or ridicule," "British possessions represented as lawless sinks of iniquity," and "wounding the just susceptibilities of friendly nations."[22] The most dramatic result of the application of these prohibitions was a ban on public screenings of most of the great Soviet silent classics, and (under the "friendly nations" provision) on any film critical of Nazi Germany.

In order to avoid costly reshoots of scenes to which the Board took exception, or even more costly outright bans of entire films, British companies usually submitted scripts to the BBFC before they were filmed. But what this could result in was a form of "invisible" censorship in which films were effectively

banned before they could even be made. Thus, for example, in 1936 a company contemplating making a film about the notorious Judge Jeffreys (known as "The Hanging Judge" on account of the 300 death sentences that he handed down in 1685 in the wake of Monmouth's Rebellion) was told that "no reflection on the administration of British justice at any period could be permitted" and that "no phrase as lurid as 'Bloody Assizes' could be used."[23] The same year the BBFC twice turned down flat a script based on Walter Greenwood's 1933 far-from-inflammatory novel and stage adaptation *Love on the Dole*, with one examiner describing it as "a very sordid story, in very sordid surroundings" and "very undesirable as a film" and another complaining that "there is too much of the tragic and sordid side of poverty."[24] And, as might be imagined (particularly given the backgrounds of the Board's senior staff), films about the situation in Ireland were strongly discouraged. As Colonel Hanna put it when turning down the script for a proposed film on the Irish revolutionary leader and politician Michael Collins (1890–1922): "it is a very controversial period, and I strongly urge that the sad and unpleasant memories which both sides to the conflict share are best left alone and not raked up through the medium of the screen. No matter how the subject is treated, one side or the other will be angered and much harm might result."[25] Two other scripts submitted to the BBFC in 1938 and 1939, respectively, *The Rising* and *Irish Story*, met with disapproval and were never filmed, and even a specially "modified" version of John Ford's *The Informer* (1935) was heavily cut by the Board. Indeed, such was the stringency of the political censorship operated by the BBFC in the 1930s that in 1937 its president, Lord Tyrrell, was able to tell the Exhibitors' Association that "we may take pride in observing that there is not a single film in London which deals with any of the burning issues of the day."[26]

And yet, formally, the BBFC was a purely private body, financed by the fees charged for classifying and cutting films and not by taxpayers' money. As such the BBFC did not fall within the definition of a state organization run by the Home Office, was free from public scrutiny and obligations, and allowed the home secretary to wash his hands in Parliament of the responsibility for cutting, banning, or passing any particular film, although he, along with the principal local authority associations, would have to be consulted before a new president could be appointed. But what had been created was a body that carried out political censorship on behalf of and in the interests of the state, indeed of the government of the day, but which appeared to be entirely independent from both. As the Home Secretary Herbert Morrison put it, somewhat smugly, in 1942:

> I freely admit that this is a curious arrangement, but the British have a very great habit of making curious arrangements that work very well, and this works. Frankly, I do not wish to be the Minister who has to answer questions in the House as to whether particular films should or should not be censored. I think it would be dangerous for the Home Secretary to have direct powers himself in this matter.[27]

Now, these historical details might be thought of as being of only academic interest were it not for two factors. Firstly, the BBFC was not entirely free from Home Office interference in recent times, before responsibility for it was passed to the Department of Culture, Media and Sport. And secondly, whilst governments are less worried today about people, and especially working class people, being "politically indoctrinated" by the modern media, and whilst the BBFC is clearly not in the least concerned about how political issues such as "relations between capital and labour" are represented on screen, both institutions are still preoccupied with the question of "media effects," which is why the classification and censorship of films and videos persists to this day.

Political Interference

In 1985, after the sudden death of BBFC president Lord Harlech, the Home Office did its best to try to impose Sir Ian Trethowan, a former BBC director general and a known supporter of Prime Minister Margaret Thatcher, as his successor. Facing stiff opposition from within the BBFC, and especially from its Secretary James Ferman, Home Office minister David Mellor implicitly threatened to establish a new agency for both film and video classification, and to exclude Ferman from participating in the appointment of presidents and vice presidents in future. However, the BBFC stood firm, and nominated Lord Harewood as Harlech's successor, whereupon Mellor and Home Secretary Leon Brittan took the quite unprecedented step of effectively interviewing him for the job, making it sound as onerous and time-consuming as possible, presumably in the hope that he would withdraw. In this they were disappointed, but they resolved that in future the Home Office would decide senior BBFC appointments.[28]

However, the next time that the Home Office was to try to exert its power over the BBFC was shortly after the election of a Labour government in 1997, in which Jack Straw was Home Secretary. Although this story revolves around a number of routine pornographic videos, it is actually extremely important to any account of the relationship between the BBFC and the state; unfortunately, it can be only briefly summarized here.[29] In 1996 Lord Harewood decided to retire, and his job was advertised. On May 23, 1997, James Ferman and the Chair of the BBFC's Council of Management, Dennis Kimbley, informed the Home Office that Lord Birkett, then a BBFC vice president, had been selected for the post from a shortlist of six applicants. According to James Robertson, Ferman was then told informally by a Home Office civil servant that "the Home Office would not accept Birkett without at least knowing the names of all the candidates and the reasons for the rejection of unsuccessful five, as well as the details of the six shortlisted candidates, their brief *curricula vitae* and a summary of the selection committee's views on each of them."[30] Straw and his minister Lord Williams of Mostyn also wanted to meet Birkett before

his appointment could be confirmed, all of which was quite unprecedented. It should also be noted that stories casting doubt on Ferman's future began to appear in the right-wing press almost as soon as Labour came to power. These carried all the hallmarks of hostile Home Office briefings, and additionally, in the case of the *Daily Mail*, which has a long history of demanding stricter censorship of cinema and television, were part of the fallout of the humiliating failure of its strident campaign to get David Cronenberg's *Crash* (1996) banned.[31] Thus in an article on August 21, 1997, headlined "Straw to Direct Film Censors Shake-up," the *Daily Mail* reported that

> Jack Straw is planning to push through a total reorganisation of the film censorship system in an effort to make it more accountable. The British Board of Film Classification has been accused of being secretive because of its refusal to explain the certificates it grants to films or identify the people who do the vetting. Concern about the running of the organisation reached its height with the decision to give the "sex and wrecks" film *Crash* an 18 certificate without cuts. To revolutionise the censorship process, the Home Secretary will use his power of veto in the appointment of the person whose job it is to run the BBFC.

But, paradoxically, it was a hangover from the previous Conservative era that really gave Straw the opportunity to flex his muscles over the BBFC. In 1996, the Home Office and the Metropolitan Police, concerned about the growth of black-market sex shops in London, suggested to the BBFC that it might be possible to relax the extremely strict guidelines covering "R18" videos, something that the BBFC had wanted to do for a long time, but had been prevented from doing by the way in which the OPA had been enforced by the police, the CPS, and the courts. It was hoped that allowing stronger material to be sold in licensed sex shops would help to drive the illegal establishments out of business. The BBFC thus relaxed its guidelines somewhat, though these still excluded a great deal of material that would be perfectly legal in almost any other EU country.

Shortly after Labour came to power the following year, Straw discovered, quite by accident, what the BBFC had done, and, being a known enemy of pornography of even the mildest kind, was absolutely furious. He ordered that the liberalization process be reversed with immediate effect and summoned Birkett to appear before him, at which point considerably more than a mild rebuke was administered. The unfortunate Birkett, appearing on the *Panorama* program "Porn Wars" on November 2, 1998, described the atmosphere at the meeting as "inquisitorial" and Straw as manifesting a "genuine sense of outrage." Indeed, when *Panorama* asked Straw to comment on the whole affair, he issued a statement that said that Lord Birkett "failed properly to exercise his responsibilities". This may sound innocuous enough but, judged by the rules that govern political discourse at these exalted levels, it is nothing less than a metaphorical smack in the face or, as the *Panorama* presenter John Ware put it, "a full frontal attack on a retired senior public servant"—which is perhaps why

the Home Office then tried to withdraw it and substitute by something more anodyne, claiming that it had been put out as the result of a "technical error"! Straw also released to the press a letter criticizing Ferman "in the strongest possible terms" for his "unacceptable, unilateral decision to liberalise the law," and this was much quoted by censoriously inclined papers, which were far more interested in criticizing the BBFC for being overliberal than criticizing the Home Office for being overbearing.

According to James Robertson, Jack Straw met Dennis Kimbley in November 1997 and made it clear that he would de-designate the BBFC's president and vice president for being responsible for enforcing the Video Recordings Act if the Home Office did not get its way over the appointment of a new president. Straw also interviewed Birkett, Andreas Whittam Smith (one of the founders of the *Independent* newspaper), and one other candidate for the job. On November 20, he informed Kimbley of his preference for Whittam Smith, and demanded changes at the BBFC. As Robertson puts it:

> The most important of these were that a senior Home Office civil servant should be present in future when the BBFC Council of Management interviewed short-listed candidates for the Presidency and Vice-Presidencies, and that the Home Secretary should be invited to comment on the shortlist to enable them to feed in their views before the Council selected a candidate.[32]

Faced with such brow-beating, Kimbley had little option but to offer the job to Whittam Smith who, however, turned out to be anything but Straw's patsy.

The Home Office also let it be known that it was reviewing James Ferman's position too. This was the cue for more yet more hostile press stories in censorious, right-wing newspapers that had regularly and loudly castigated the BBFC for being overly liberal in carrying out its duties. Particularly significant was a report in the *Telegraph*, December 9, which all too clearly, though doubtless unwittingly, highlights the peculiar relationship between the BBFC and the government of the day when it noted that: "there is an arm's length relationship between politicians and the censors, which in many ways is healthy; only in dictatorships do governments decide what people can and cannot watch. But while the politicians are happy for the BBFC to be independent of government, there is a view that under Mr. Ferman it has become a law unto itself." And that, of course, particularly in the eyes of an illiberal newspaper, would never do!

Nonetheless, this was not the end of the story. Video distributors, who had purchased the rights to certain films on the understanding that the BBFC had liberalized its "R18" guidelines, now found these videos being subject to cuts when submitted to the BBFC. They took their complaints to the Video Appeals Committee, an independent body established under the Video Recordings Act, and won. However, the Home Office refused point blank to allow the BBFC to re-liberalize its guidelines, insisting first of all that to do so would be to pass material that might contravene the OPA, and then that the material might contravene the "harm" provisions of the Video Recordings Act as well. More

appeals followed, and these too were successful. And all the while, the public fiction was maintained that the BBFC was acting entirely off its own bat in seemingly arbitrarily and inconsistently changing its "R18" guidelines back and forth, with the Home Office as absent from media accounts of this story as it was active behind the scenes.[33] In the end, matters reached a peak of absurdity when the BBFC applied for a judicial review of one of the Video Appeals Committee's judgments, a judgment with which it must have in fact agreed since it was entirely in line with the liberalized guidelines, and one can only assume that it was required to follow this course of action by an obdurate Home Office.

As it happens, the application for judicial review was dismissed, and in September 2000 the Board published a new set of "R18" guidelines, which were far more liberal than those introduced in 1997 (although still pretty restrictive by continental European standards). And although the Home Office was furious, and received a good deal of supportive coverage in the censorious press, there was actually very little it could do without flushing its own leading role in the whole affair out into the open and also making it appear as if the government wanted to intervene *directly* in the censorship of individual films—something from which, as we have seen, previous Home Secretaries have recoiled. It could, I suppose, be argued that the actions of Mellor, Brittan, and Straw actually demonstrate the resilience of the BBFC in the face of governmental pressure and interference, but they also illustrate how activist and interventionist politicians have powers at their disposal to bring the BBFC to heel, powers that are still available to the Minister for Culture, Media and Sport. The fact that these three ultimately failed to bend the BBFC to their will makes the existence of those powers nonetheless disturbing.

The BBFC, Governmentality, and Moral Regulation

Finally, let us return to the point about governmental and BBFC concern about "media effects." These are no longer conceived specifically in political terms, and fears about the effects of "propaganda" have been replaced by fears about the effects of representations of sex and violence, particularly together. In this respect it is highly significant that the two biggest controversies in which the Board has been involved in recent times have been over "video nasties" and pornography.

Up until World War II, the BBFC took exception to "themes indicative of habitual immorality," "women in alluring and provocative attitudes," "degrading exhibitions of animal passions" "passionate and unrestrained embraces," "men and women in bed together," "brutal fights carried to excess, including gouging of eyes, clawing of faces and throttling," "realistic scenes of torture," and so on.[34] And whilst it would be absurd to claim that the Board today maintains the same standards in these areas as it did in the first half of the twentieth century, it does nonetheless concern itself, to an extent that some

might find surprising, with the morality of the films that it classifies, and with the possibility that some of these might inflict moral damage on audiences. So, for example, the BBFC's *Guidelines* explain that the Board interprets the "harm" provision of the Video Recordings Act to include

> not just any harm that may result from the behaviour of potential viewers, but also any "moral harm" that may be caused by, for example, desensitising a potential viewer to the effects of violence, degrading a potential viewer's sense of empathy, encouraging a dehumanised view of others, suppressing pro-social attitudes, encouraging anti-social attitudes, reinforcing unhealthy fantasies, or eroding a sense of moral responsibility. Especially with regard to children, harm may also include retarding social and moral development, distorting a viewer's sense of right and wrong, and limiting their capacity for compassion.[35]

Recent victims of this approach have been Steven R. Monroe's remake of *I Spit on Your Grave* (2010), in which the BBFC made 17 cuts totaling 43 seconds; the original 1978 version (originally titled *Day of the Woman*, directed by Meir Zarchi), which suffered 2 minutes 54 seconds of cuts on DVD; Srđan Spasojević's *Srpski Film* (*A Serbian Film*, 2010), which suffered 49 cuts amounting to 4 minutes 11 seconds in its cinema and DVD versions; and Kōji Shiraishi's Japanese horror film *Gurotesuku* (*Grotesque*, 2009), which was banned outright. It is also worth noting that the Board takes into account, when classifying individual films, "whether the availability of the material, at the age group concerned, is clearly unacceptable to broad public opinion. It is on this ground, for example, that the BBFC intervenes in respect of bad language."[36] And in terms of films in the junior categories ("U," "PG," "12," "12A")[37] and on the borderline between categories, "such considerations as the degree of fantasy; the level of connection to the real world; and the extent to which the work presents a despairing view of the world or lacks a clear moral perspective may be important factors."[38]

Here we enter directly into the sphere of moral regulation. This is a key element of an expanded conception of government known as "governmentality," which, as Nikolas Rose, following Foucault, explains,

> refers neither to the actions of a calculating political subject, nor to the operations of bureaucratic mechanisms and personnel. It describes, rather, a certain way of striving to reach social and political ends by acting in a calculated manner upon the forces, activities and relations of individuals that constitute a population.[39]

In this view of things, ever since the eighteenth century the ways in which political rule is exercised have been transformed in that "the personal and subjective capacities of citizens have been incorporated in the scope and aspirations of public powers" with the result that "the 'soul' of the citizen has entered directly into political discourse and the practice of government." This process has gone hand in hand with the remarkable growth of a new form of expertise,

an expertise of subjectivity, deployed by an ever-increasing multitude of what Rose aptly calls "engineers of the human soul" such as psychologists, psychiatrists, social workers, therapists, counselors, and so on, so that "the human psyche has itself become a possible domain for systematic government in the pursuit of socio-political ends."[40]

This is not to suggest some kind of nightmare vision in which armies of psychological experts are deployed directly by the state with the express aim of keeping the population in a state of subjugation. As Rose puts it:

> Liberal democratic polities place limits upon direct coercive interventions into individual lives by the power of the state; government of subjectivity thus demands that authorities act upon the choices, wishes, values, and conduct of the individual in an indirect manner. Expertise provides this essential distance between the formal apparatus of law, courts, and police and the shaping of the activities of citizens. It achieves its effects not through the threat of violence and constraint, but by way of the persuasion inherent in its truths, the anxieties stimulated by its norms, and the attraction exercised by the images of life and self it offers to us.[41]

And expertise is *precisely* what the BBFC both draws on and itself offers— to both government and audiences. As its *Guidelines* state:

> In assessing legal issues, potential harm or acceptability to broad public opinion, the BBFC takes account of relevant research and expert opinion. However, such research and expert opinion is often lacking, imperfect, disputed, inconclusive or contradictory. In many cases the BBFC must therefore rely on its collective experience and expertise to make a judgement as to the suitability of a work for classification, or for a classification at a particular category.[42]

But whereas once the BBFC consulted (and indeed employed) specialists in political propaganda and countersubversion, it now turns to psychologists, psychiatrists, pediatricians, and other such "engineers of the human soul."[43] And its main function is no longer trying to ensure ideological conformity but engaging in a form of moral regulation. But in this endeavor it is, of course, hardly alone in modern Britain where, since the Thatcher era, questions of social order and control have been framed in ever more explicitly moral—and moralizing—terms. As Will Hutton put it:

> As evidence of social fragmentation mounts, there is an increasingly shrill cry to demoralize society—in which morality is regarded as the prohibition of individual actions backed by repressive legislation. Economic and social reforms, which might address the roots of these problems, are seen as a return to what has failed; instead the future is one of moral individuals, caned at school, smacked at home and wary of steep punishment in prison fixed by automatic sentencing, who keep their families together and so stand as bulwarks against social implosion . . . Nor does the talk of admonition and prohibition stop there. The climate which produces constraints and bans does not begin and end with school

expulsions and longer sentences for offenders of all ages; it extends seamlessly into the censorship of books, films and theatres.[44]

And this is as true today as it was when it was written.[45] It is thus entirely unsurprising that statutory video censorship should have been introduced in the wake of a massive moral panic about "video nasties" and that its continued existence is constantly legitimated by recourse to the idea that certain videos can engender antisocial attitudes and behavior. Similarly, the "extreme pornography" provisions of the Criminal Justice and Immigration Act were introduced in the wake of a murder committed by a man who visited websites containing sadomasochistic material, on the dubious grounds that such websites "make" people enact in real life what they see there. The BBFC cannot of course be blamed for the imposition of this or any of the other legislation mentioned in the course of this chapter. But it does have to ensure that no film that it passes is likely to infringe the laws passed by parliament, which constitutes its most direct relationship with the state, involving as it does not simply expertise in the laws themselves but also in current police, courts, and Crown Prosecution Service practice. However, it has a rather less direct but no less significant relationship with the state in that it has to take into account government thinking on relevant policy areas, and particularly those pertaining to the highly controversial area of law and order, which must inevitably make it sensitive to the ideological tenor of the times. This, to put it mildly, is not exactly liberal.

Notes

1. See http://www.bbfc.co.uk/about/vision-statement/, date accessed August 8, 2011.
2. See http://www.sbbfc.co.uk/history, date accessed August 8, 2011.
3. See, for example, Robertson, J. C. (1985) *The British Board of Film Censors: Film Censorship in Britain, 1896–1950*. Beckenham: Croom Helm; Robertson, J. C. (1989) *The Hidden Cinema: British Film Censorship in Action, 1913–1975*. London: Routledge; Mathews, T. D. (1994) *Censored: What They Didn't Allow You to See, and Why: The Story of Film Censorship in Britain*. London: Chatto & Windus; Aldgate A. and J. C. Robertson (2005) *Censorship in Theatre and Cinema*. Edinburgh: Edinburgh University Press; Lamberti, E. (ed) (2012) *Inside the BBFC: Film Censorship from the Silver Screen to the Digital Age*. London: BFI/Palgrave.
4. Trevelyan, J. (1973) *What the Censor Saw*. London: Michael Joseph; Phelps, G. (1975) *Film Censorship*. London: Victor Gollancz.
5. Kuhn, A. (1988) *Cinema, Censorship and Sexuality 1909–1925*. London: Routledge.
6. Petley, J. (2011) *Film and Video Censorship in Modern Britain*. Edinburgh: Edinburgh University Press.
7. Up until June 2001 responsibility for the BBFC lay with the Home Office.
8. I am extremely grateful to the BBFC's Senior Examiner, Craig Lapper, for clarifying the Secretary of State's exact role in the appointment of the Board's most senior staff.

9. Robertson, G. and A. Nicol (2008, fifth edition) *Media Law.* London: Penguin, pp. 820–821.
10. Quoted in Hunnings, N. M. (1967) *Film Censors and the Law.* London: Allen and Unwin, p. 54.
11. Quoted in Robertson and Nicol (2008), p. 820.
12. Quoted in Robertson and Nicol (2008), p. 824.
13. Robertson, G. (1993) *Freedom, the Individual and the Law.* London: Penguin, p. 263.
14. British Board of Film Classification (2009) *BBFC: The Guidelines.* London: British Board of Film Classification, p. 33. Also available at http://www.bbfc.co.uk/downloads#policyandresearch.
15. See http://www.cps.gov.uk/legal/l_to_o/obscene_publications/index.html, date accessed August 8, 2011.
16. Petley (2011).
17. For a detailed account of this process see Barker, M. (1984) *The Video Nasties: Freedom and Censorship in the Media.* London: Pluto.
18. This process is covered in numerous contributions to Barker, M. and J. Petley (eds) (1997), *Ill Effects: The Media/Violence Debate.* London: Routledge.
19. See http://www.bbfc.co.uk/AVV161739/, date accessed August 8, 2011.
20. Pronay, N. (1982) The political censorship of films in Britain between the wars, pp. 98–125 in Pronay N. and D. W. Spring (eds), *Propaganda, Politics and Film.* London: Macmillan, p. 114.
21. Pronay (1982), p. 115.
22. For a detailed account of these rules, see Trevelyan (1973), pp. 30–46.
23. Quoted in Pronay (1982), pp. 105, 107.
24. Quoted in Street, S. (2000) *British Cinema in Documents.* London: Routledge, pp. 26, 28.
25. Hill, J. (2000) " 'Purely Sinn Fein propaganda': the banning of *Ourselves Alone*," p. 320 in *Historical Journal of Film, Radio and Television*, 20 (3).
26. Pronay (1982), p. 122.
27. Quoted in Hunnings (1964), p. 132. It is, however, worth noting the one example of *direct* political censorship that is known about, namely the banning in 1936 of Brian Desmond Hurst's *Ourselves Alone* from being screened anywhere in Northern Ireland. (The film is set against the backdrop of the 1921 Irish War of Independence, its title is a translation of the Irish *Sinn Féin*, referring to the political party. This is actually a common mistranslation—Sinn Fein translates as "we ourselves.") This ban was undertaken by the Northern Ireland Minister of Home Affairs, Dawson Bates, under the Civil Authorities (Special Powers) Act 1922. For full details of this incident see Hill (2000).
28. This account is based on Robertson (2006), which was made possible by access to the late James Ferman's private papers, kindly granted by his wife, Monica.
29. Those interested in a full account are recommended Petley (2011), pp. 129–157.
30. Robertson, J. C. (2006) "The Home Office and the BBFC Presidency 1985–98," p. 324 in *Journal of British Cinema and Television*, 3 (2).
31. Petley (2011), pp. 115–128.
32. Robertson (2006), p. 327.
33. That is, until I revealed what was actually going on in the *Guardian*, November 5, 1999, thanks to a number of documents leaked to me from within the

BBFC. See http://www.guardian.co.uk/film/1999/nov/05/4?INTCMP=SRCH, date accessed August 8, 2011.

34. Trevelyan (1973), pp. 42–43.
35. BBFC (2009), p. 4.
36. BBFC (2009), p. 4.
37. The "U" certificate indicates a film that is suitable for all; "PG" is also a general viewing category, but the classification indicates that some scenes may be unsuitable for young children; "12" means that the film is not considered generally suitable for those under 12; "12A" is a cinema-only category, and no child under 12 may see a film with this classification unless accompanied by an adult.
38. BBFC (2009), p. 11.
39. Rose N. (1999, second edition) *Governing the Soul: The Shaping of the Private Self.* London: Free Association Books, pp. 4–5.
40. Rose (1999), pp. 1–2, 7.
41. Rose (1999), p. 10.
42. BBFC (2009), p. 4.
43. A good idea of the kinds of expertise drawn on by the BBFC can be acquired by examining the specialisms of those from whom it commissions research. Links to such research can be found at http://www.bbfc.co.uk/downloads/.
44. Hutton, W. (1997) *The State to Come.* London: Vintage, p. 8.
45. Indeed, on the very day on which I wrote these words, the British prime minister David Cameron delivered a speech in the wake of the previous week's riots. In it he stressed the need to "confront the slow-motion moral collapse that has taken place in parts of our country these past few generations. Irresponsibility. Selfishness. Behaving as if your choices have no consequences. Children without fathers. Schools without discipline. Reward without effort. Crime without punishment. Rights without responsibilities. Communities without control. Some of the worst aspects of human nature tolerated, indulged—sometimes even incentivised—by a state and its agencies that in parts have become literally demoralised." See http://www.guardian.co.uk/uk/2011/aug/15/david-cameron-riots-broken-society, date accessed August 15, 2011.

10

British Colonial Censorship Regimes: Hong Kong, Straits Settlements, and Shanghai International Settlement, 1916–1941

David Newman

...not only are we a small settlement of white men on the fringe of a huge Empire of Asiatics, but that the whole of China is in the melting pot; and that the chaotic conditions existing owing to internecine strife of Communistic propaganda make it even more necessary to be strict as regards the matter exhibited.

—Eric W. Hamilton, Hong Kong censor, 1928[1]

In the early years of the twentieth century, the power of the filmic image to entertain and to offend, to educate and to subvert, became increasingly apparent and was quickly recognized. Censorship of theatrical productions existed in many places, however, the need and impetus to censor the cinematograph evolved as authorities grappled with the power and potential of the medium. In colonial territories, censorship was an important tool of control often assigned to the police in order to maintain public order and to minimize the screening of representations perceived to be harmful to the native populations.

This chapter explores the film censorship regimes in three localities in Asia during the period of 1916–1941. Hong Kong and the Straits Settlements were British colonies, created on largely uninhabited islands in locations suitable for deep-water ports. The Shanghai International Settlement was a foreign

concession covering an area of 2259.8 hectares in a locality established as a treaty port under the Treaty of Nanking at the end of the first opium war in 1842.[2] The International Settlement was administered by the Shanghai Municipal Council (SMC), an elected body drawn from the foreigners (and later Chinese) living within the settlement. Despite being very international in composition, it originated as a British settlement, and continued to be largely controlled by British citizens.[3] Adjacent to the International Settlement was the smaller French Concession, and surrounding these the Chinese-controlled portions of Shanghai, which later became the Special Municipality of Shanghai under the Chinese Nationalists. The Straits Settlements were a collection of colonial territories and settlements around British Malaya, which were too small (aside from Singapore) to be considered colonies in their own right. In this chapter, I will focus primarily on Singapore, as this was where most of the cinemas were located, and where the Official Censor of Cinematographs for the Straits Settlements (and British Malaya) was situated. My purpose is to develop a picture of film censorship in the three locations and compare to identify the commonalities and links between them. The source materials for this chapter are largely drawn from archives in London, Washington DC, Singapore, and Hong Kong. As is frequently the case with archives, the records are fragmentary and incomplete.

In the introductory chapter, Daniel Biltereyst and Roel Vande Winkel outlined distinctions between censorship systems (overall legal framework), censorship modalities (the tools of censorship), and censorship practices (applications of the modalities). These distinctions can be applied to the censorship regimes outlined in this chapter. The legal framework for Hong Kong and the Straits Settlements were similar in that there was governing legislation enabling the establishment and operation of a censorship apparatus (the censorship modalities). Statutory regulations providing the details of the operation of the censorship apparatus supported the enforcement of the law. The case of the Shanghai International Settlement differed slightly as the Shanghai Municipal Police provided the regulations and guidelines for censorship on behalf of the Shanghai Municipal Council. In the Shanghai International Settlement, the regulations and rules were created by those who were supposed to enforce them as well, while in Hong Kong and the Straits Settlements, the governing legislation was passed by the legislature, with the responsibility of enactment and enforcement delegated to the police.

This can be contrasted with Britain and the United States, where industry-formed bodies (the British Board of Film Censors or BBFC, and in the United States, the National Board of Review and later the Production Code Administration or PCA) provided advice as to film ratings and excisions required, but did not have any legal powers to enforce or regulate. In the United States, individual state censorship bodies did have legislative power to cut or ban as they held appropriate. Both the British and US bodies impacted colonial film

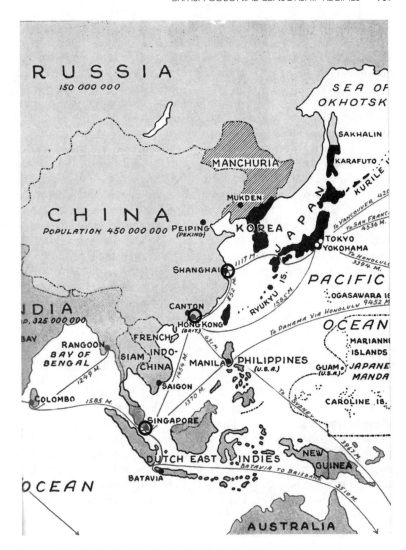

Image 10.1 Major film distribution hubs in East Asia
Source: Palmer, F. (1930) *Look to the East*. New York: Dodd, Mead and Company, frontispiece.

censorship, although in different ways. Whereas the BBFC had a more direct impact through the content and form of censorship in the different colonies and dominions, the PCA potentially had an indirect impact through the pre-production vetting of scripts in the United States (see Chapter 1), contributing to the decrease in the level of offensive scenes in films arriving in Asia during the 1930s.

The British Board of Film Censors

The origins of film censorship in the British Empire can be traced back to the Cinematograph Act of 1909, which provided local authorities in the United Kingdom with the legal basis to license cinematograph theaters. The original intent ostensibly was fire safety, although Robertson in his 1985 study on the British Board of Film Censors (BBFC) suggests that the real purpose may have been censorship (see also Chapter 9).[4] By December 1910, the prerogative of local authorities to exercise their authority in such a way as to control and regulate content was established through a legal judgment. The growth of local authority censorship of film content increasingly alarmed the film trade, who were concerned this would lead to the imposition of censorship by the central government.[5] Although local authorities were responsible for licensing the cinemas, the local police were often delegated the duty of ensuring that content met local standards. The end result of this was that after discussions with the Home Office in 1912, the film industry established a censorship board, which began operations on January 1, 1913. Before the introduction of talkies, the four examiners would sit together in a room in two teams of two each, with two films simultaneously being projected. Each team would focus on one film, and when confronted with an issue or a problem scene, would then confer with the other team of examiners as to whether there should be an excision, or in extreme cases, the film should be banned.[6] This censorship arrangement would later be replicated in the Shanghai International Settlement.

Initially, the examiners for the board had only two specific guidelines laid down for them by G. A. Redford, the first president of the BBFC: no nudity and no portrayal of the living figure of Jesus Christ. However, from early on they used much broader principles in deciding what should or should not be allowed.[7] Although the restrictions appeared to be wide ranging, very few films were totally banned.[8] As censorship developed, the BBFC continued to work without strictly following a set of written rules, as they felt they needed sufficient flexibility to judge each film in its entirety on their individual merits, with the scenes considered in their context. However, they were guided by "the broad principle that nothing will be passed which is calculated to demoralize the public, extenuate crime of view, or shock the just susceptibilities of any section of the public."[9] These guidelines were described in broad terms in a 1926 brochure published by the BBFC, portions of which are reproduced in Table 10.1. Although not portrayed as a set of strict rules, it is likely that these guidelines were well-known to censors throughout the British Empire. An example of this is a letter that the Secretary of State for the Colonies received from the Straits Settlements Government in 1930, noting that the Censor and Committee of Appeal in the Colony based their decisions on the schedule brought out in England by the BBFC in 1926.[10]

Table 10.1 Comparison of censor guidelines

British Board of Film Censors 1926 (excerpts)[a]	Straits Settlements 1925[b]	Hong Kong 1928[c]	Shanghai International Settlement 1931 (the original 1927 guidelines are in bold)[d]
Political			
Subjects that are calculated to wound the susceptibilities of foreign peoples, and especially our fellow-subjects of the British Empire	1. Binding and gagging	a) Any film showing indecency. This is extended to mean the depiction of white women in indecorous garb or positions or situations, which would tend to discredit our womenfolk with the Chinese.	**A. Films in which crime or violence and the use of firearms by evildoers form the chief attraction are prohibited. This applies particularly to long serials.** Or in which crime is displayed in an attractive or alluring light in comparison with legitimate professions or occupations
Stories and scenes that are calculated and possibly intended to forment social unrest and discontent	2. Murders of any description	b) Any film showing the white man in a degrading or villainous light	B. Films featuring prominently racial distinctions
Social			
The nude, both in actuality and shadowgraph	3. All scenes where women do not conduct themselves in a proper manner	c) Any film denoting Bolshevist or mob violence. The Chinese are easily worked up and there is quite enough mob violence going on at present.	C. Films calculated to wound the susceptibilities of any nationals, and scenes that are calculated, and possibly intended, to forment social unrest and discontent

172

Table 10.1 (Continued)

British Board of Film Censors 1926 (excerpts)[a]	Straits Settlements 1925[b]
Swearing, or language in the nature of swearing, in titles or sub-titles	4. All masked scenes
"Orgy" scenes and similar incidents oft-times incongruous and generally superfluous	5. Scenes showing Europeans in the power of natives or persecuted in some shape or form
Incidents that bring into contempt public characters acting in their capacity as such, i.e., officers and men wearing His Majesty's uniforms, Ministers of Religion, Ministers of the Crown, Ambassadors and Representatives of Foreign Nations, Administrators of the Law, Medical Men, etc.	6. Gruesome expressions
Embraces that over-step the limits of affection or even passion, and become lascivious	7. Ill-treatment and persecution of women
Impropriety of dress and deportment, including suggestive and indecorous dancing	8. All "holdups"
Offensive vulgarity and excessive drunkenness, even when treated in a comic vein	9. Immorality
Stories showing any antagonistic or strained relations between white men and the coloured population of the British Empire, especially with regard to the question of sexual intercourse, moral or immoral, between individuals of different races	10. All scenes that are likely to mean loss of prestige

Sources:
[a] TNA:PRO, HO 45/24084 ENTERTAINMENTS: British Board of Film Censors: Legal position and work of the board. British Board of Film Censors (1926) *Censorship in Great Britain*

Hong Kong 1928[c]	Shanghai International Settlement 1931 (the original 1927 guidelines are in bold)[d]
d) Pictures reflecting badly on the natives of India	**D. Films designed for untoward propaganda locally or calculated to incite to breaches of the peace in view of local conditions prevailing at the time**
e) Any film that depicts what the Chinese love to call "Imperialistic" behavior: i.e., armed conflict between the Chinese and the white man	**E. Films calculated directly to lower the moral prestige of women,** or likely to foster immorality
f) Any film that deals with racial questions, especially the intermarriage of white persons with those of other races	**F. Films calculated to bring into contempt any lawful creed or society are banned**
	G. Films featuring scenes of cruelty to men or beasts, and displaying human agony, and scenes of brutality or vulgarity, and which carry no worthy moral lesson but tend to embruten and degrade
	H. Films depicting objectionable prison scenes, and scenes displaying the Police in a false or derogatory light, also films considered likely to foster disrespect toward State Authorities, Soldiers, Magistrates, etc.
	[**Films featuring prominently the colour question**]* *This was removed and reworded in the 1931 version

[b] USNA, RG 59 Department of State Decimal Files, 1910-1929, Box 8931, 846d.4061 Motion Pictures/2. Dickins, G.F. (Sept. 5, 1925) *Local Propaganda Against American Films*, p. 6.
[c] USNA, RG 84 Hong Kong Consular Records, 840.6 Vol. 398, 1928. E.W. Hamilton to Manager, Hong Kong Amusements dated 9 Jan. 1928, enclosed in E.D.C. Wolfe, Captain Superintendent of Police to Roger Culver Tredwell, American Consul General dated 17 February, 1928.

174

Table 10.1 (Continued)

British Board of Film Censors 1926 (excerpts)[a]	Straits Settlements 1925[b]	Hong Kong 1928[c]	Shanghai International Settlement 1931 (the original 1927 guidelines are in bold)[d]
Questions of sex			
Cases in which the imminent intention to rape is so clearly shown as to be unmistakeable; also stories depicting the lives of immoral women, and scenes of street soliciting, "White Slave" traffic, and procuration	11. House-breaking or any scene that shows entry in any but the correct manner		
Crime			
Scenes demonstrating the methods of crime, which might lend themselves to imitation	12. Safe breaking		
Prolonged scenes of extreme violence and brutality	13. Any scenes liable to suggest new ideas for the purpose of crime		
Stories of which the sole or main interest is that of crime and of the criminal life, without any counterbalancing element of love or adventure	14. Strikes		
Themes calculated to give an air of romance and heroism to criminal characters, the story being told in such a way as to enlist the sympathies of the audience with the criminals, whilst the constituted Authorities and Administrators of the Law are held up to contempt as being either unjust or harsh, incompetent or ridiculous	15. Scenes likely to provoke racial feeling or religious animosity		
	16. Scenes likely to bring the laws or the administration of justice into contempt or ridicule		

[d] USNA, RG 84 Shanghai Consular Records, 840.6 Vol. 1708, 1927. Letter from E.B. Barrett, Commissioner of Police to E.S. Cunningham, Consul-General for the United States of America, dated September 18, 1927; RG 84 Shanghai Consular Records, 840.6 Vol. 2153, 1931. Letter from SMC Police Commissioner to SMC Director-General dated Feb. 13, 1931.

Colonialism and Censorship

Colonialism is a system of "domination" and unequal power relations between the colonizing state and the local inhabitants.[11] Censorship was an important tool used by colonial governments to maintain control over information, ideas, and the existing social order. Within the British Empire, the guidelines from the BBFC in the imperial center were influential in the censorship systems, modalities, and practices used elsewhere in the empire. The similarities can be seen between the guidelines used in the individual colonies or localities and the BBFC guidelines, although clearly adapted for local requirements. The emphasis and focus differed from place to place, often with fewer requirements than those of the BBFC, but with the British roots apparent. The censorship guidelines were an indicator of British hegemony, showing similar attitudes and values underlying the guidelines, although the focus and details may have differed in individual localities.

We can see evidence of this by comparing the guidelines addressing what was considered suitable relationships between Europeans and native peoples. In the BBFC guidelines, there was reference to "antagonistic or strained relations between white men and the coloured population of the British Empire." In the Straits Settlements, the definition was expanded and made more explicit, and so in addition to "[s]cenes showing Europeans in the power of natives or persecuted in some shape or form" (the opposite case of natives being persecuted wasn't addressed), reference was also made to "scenes that are likely to mean loss of prestige" and "[s]cenes likely to provoke racial feeling or religious animosity." In Hong Kong, the definitions in this area included "showing the white man in a degrading or villainous light," "'imperialistic' behavior: that is, armed conflict between the Chinese and the white man," and "racial questions, especially the intermarriage of white persons with those of other races." Although not included in the guidelines shown in Table 10.1, correspondence from the US consulate in Hong Kong in 1926 suggested that films "reflecting badly on the natives of India" were banned as a significant portion of the Hong Kong Police were of Indian ethnicity.[12] The omission of this restriction suggests that the 1928 list provided by the censor was possibly incomplete, either because it was an unwritten set of guidelines, or that individual censors had their own guidelines that they followed. Although the BBFC set out the general contours of the censorship guidelines, their application in colonial situations resulted in more focused and explicit definitions suitable for the local environment.

We can see a similar process in the guidelines relating to the portrayal of women. Female sexuality and the suggestion of white women having relationships with non-white men was a particularly sensitive subject in the colonies, although not always explicitly stated. Euphemisms were often used, such as reference to the "white slave trade" (prostitution), or the "colour issue" (primarily white women having relationships with non-white men). The question

of white men having relationships with non-white women was less of a concern, though still not something they wanted shown prominently on the screen (it was relatively common for European men in some of the colonial territories to have a local mistress, and children from that relationship).

Censorship then, was an intrinsic part of colonial governing practices, providing colonial governments a tool for the control over the dissemination of ideas and values to the colonized peoples. Although questions did arise in some colonial situations as to whether there should be a dual censorship system with different standards for Europeans and native peoples,[13] the issue wasn't apparent in the three locations outlined in this chapter.

Straits Settlements

The Straits Settlements were the earliest of the three locations to introduce formal cinematograph (film) censorship, through a 1912 amendment to the 1908 Theatres Ordinance, authorizing police to determine what scenes were suitable for public viewing, and providing them with powers to seize unauthorized films.[14] Then, in 1917 an Ordinance was introduced to further amend the 1908 Theatres Ordinance and establish the post of Official Censor of Cinematographs, along with a Cinematograph Films Appeal Committee.[15] The censorship office was set up as a branch of the Police Department for administrative purposes, and proved to be consistently profitable with a surplus contributing to government revenues.[16]

The first instance of a dedicated film censor was recorded in the *Straits Settlements Government Gazette* of October 5, 1917, in which the appointment of Mr. Neville Piggott as the Official Censor of Cinematographs was notified.[17] Prior to this, the Chief of Police used to approve films based on a written description of the film content. The tenure of Mr. Piggott was, however, extremely short; there was another notice in the *Government Gazette* of October 19 announcing the resignation of Mr. Piggott due to ill health.[18] The real reason for his very short period of service is not recorded.

Censors that followed were also temporary. The *Government Gazette* of November 2, 1917, announced that Mr. T. R. Davidson was taking up the position temporarily, followed by another announcement for Mr. J. Duncan Roberts on February 8, 1918.[19] It wasn't until the 1919 appointment of Captain Thomas Macdonald Hussey as the Official Censor of Cinematographs that there was a permanent, long-term appointee in the position.[20] An Assistant Censor was appointed the same year to assist with the workload, although this position appears to have been temporary and part-time. Captain Hussey remained the Official Censor of Cinematographs until at least 1938 (records beyond that year are not available, so it is not possible to confirm if he stayed in the position until the Japanese invasion), responsible for censoring all of the films entering the Straits Settlements, and later, the Federated

Table 10.2 Proportion of films banned in the Straits Settlements, 1927–1928 (based on footage)

	1927		First 5 months of 1928	
	% of total imported	% banned	% of total imported	% banned
American	72.0	12.0	67.5	12.0
Chinese	18.8	17.0	24.4	15.0
English feature	2.4	11.0	2.4	26.0
English topical	2.8		0.2	
German	2.9	12.0	5.0	5.0
Other origin	1.1	33.0		

Source: TNA: PRO CO 272/550/14 Straits Settlements Cinematograph Films Ordinance, Enclosure no. 725 of October 25, 1925.

Malay States. Early on he had the reputation for being very tough in his role, rejecting a higher proportion of films presented than was the case in many other countries. This resulted in questions in the British House of Commons on a number of occasions, as British films appeared more likely to be banned than those from the United States.[21] At one stage (in the first five months of 1928), 26 percent of British films were rejected outright, whereas only 12 percent of Hollywood films were banned (Table 10.2).[22] Although this was probably an aberration, there was considerable concern about what appeared to be discriminatory practices on the part of the censor against British films.

According to US consulate sources in 1925, the 16 types of scene that would be removed by the censor were similar to those removed in many other countries, and it also follows the broader contours of the BBFC guidelines (see Table 10.1).[23] These included restrictions on scenes showing a variety of criminal activities such as hold-ups, safe-breaking, and murder, as well as dignity-related scenes such those where "women do not conduct themselves in a proper manner,"[24] scenes showing Europeans under the power of natives or being persecuted in some way, or scenes likely to provoke racial or religious animosity.

In a 1930 letter to the Colonial Office, the *British International Pictures Company* claimed that 50 percent of their films were being rejected, but subsequent correspondence suggest that in some cases the films would have been allowed if the company had been willing to make a number of requested cuts to the movies.[25] The British producers and distributors did not understand in the way that the *Motion Picture Producers and Distributors of America* (MPPDA) did the specific requirements for, and sensitivities of, international markets.

Table 10.3 Analysis of films banned in the Straits Settlements, 1935–1940
(number of films)

	1935	1936	1937	1938	1939	1940
Reason						
Violence & crime						
USA	30	32	40	22	18	9
Other countries	5	3	5	10	6	2
Political, propaganda & war						
China		1	6	13	3	1
Hong Kong				9	6	1
Japan					2	
USA	1	2	1	6		2
Other countries				2	1	1
Horror & gruesome images						
USA	2	2	1		3	1
China		1	3			
Other countries		1				
Subject unsuitable for local audiences						
China	1		1			
USA			6		5	4
Total films banned by country						
(based on listings in SSGG)						
USA	36	37	52	30	29	19
Britain	5	1	2	5	6	3
India	0	1		5	3	1
Hong Kong	1		2	9	6	1
China	1	3	11	15	3	1
Other countries	2	1			3	1
Total	45	43	67	64	50	26
Annual Departmental Reports Total	49	40	68	67		

Note: The *Annual Departmental Reports of the Straits Settlements* totals do not always correspond with the numbers of films listed in the *Straits Settlements Government Gazettes*.
Source: *Straits Settlements Government Gazettes, Annual Departmental Reports of the Straits Settlements.*

By the mid-1930s, however, complaints regarding the Singapore censorship regime had reduced substantially. It isn't clear whether this was due to a shift in standards on the part of the censor or whether the changes were taking place at both the point of production and in the selection of films to be imported into Singapore and British Malaya in general.

In 1935, the Straits Settlements Government began publishing on a quarterly basis a list of films that had been banned in the colony, along with the reasons why they had been banned. A report from a US Counsel in Singapore to the State Department suggested that this was started in response to a request made by the consulate to the Straits Settlements government requesting more transparency and suggesting the approach taken by the Bombay Presidency as an example. The response back from the Colonial Secretary was positive, at least in part, as they agreed to publish lists of films that were banned, along with the reasons, although not going to the extent of publishing the details of all excisions.[26] These lists were published on a quarterly basis in the *Straits Settlements Government Gazette* from the beginning of 1935 up to the end of the third quarter of 1940. Over the nearly six years that these lists were published, it is possible to see some distinct patterns and changes in censorship. In 1935, the majority of the films banned were for reasons of violence or the portrayal of crime (and were sourced from the United States).[27] But as we move to 1940, the number of films from the United States being banned decreased, while banned films from other locations (particularly China) increased. This can be seen for the films banned in 1938: only 30 of the 64 films banned were made in the United States, and 22 of the 30 were banned due to violence. Increasingly films were banned due to reasons of politics, propaganda, or dealing with the war (see Table 10.3).

An issue that remains unanswered is how the Singapore censor handled the Chinese-language movies. There is no indication that he spoke either Cantonese or Mandarin, or that he had any staff that could translate for him. It is clear, though, that Chinese films were included among those that were banned. For example, *Midnight Vampire* (1936), *The Lady Pirate* (1937), *Wedding Tragedy* (1937), *War at Eastern Front* (1938), *A Brave Man* (1938), and *Fire over Tiongkeng* (1939) were among the Chinese and Hong Kong-sourced films banned (all titles are the English translations provided in the *Straits Settlements Government Gazette*).[28]

Hong Kong

Whereas the Straits Settlements had appointed one individual to censor all of the films coming into British Malaya (the Official Censor of Cinematograph Films for the Straits Settlements held a simultaneous appointment as Censor for the Federated Malay States, thus streamlining the censorship process), in Hong Kong the Captain Superintendent of Police (Inspector General from 1931) as Chief Censor delegated the duties to mid-level government officers. It was not unusual to find magistrates, or the Postmaster-General, or some other government official, made responsible for the viewing and censoring films in addition to their regular duties. The censors were divided into small

groups, each assigned to a small group of cinemas (or an exhibition company) and until the establishment of the Hong Kong Preview Studio in 1932, would view films in the cinemas prior to the day's screenings.[29] According to evidence provided to the Shanghai Commission on Film Censorship in 1932, at that time there were nine censors divided into teams and assigned across the colony. Each team undertook censorship for a group of theaters or for a particular exhibition company, and included women and Chinese individuals.[30]

The first explicit regulations for censorship of cinema appear to have been gazetted in November 1919 as an amendment to the 1908 Theatres Ordinance, and set out very simply that "All films and posters shall be censored by the Captain Superintendent of Police or by such person or persons as is or are deputed by him in writing with the approval of the Governor. No film or poster unless it has been duly censored under these regulations shall be exhibited."[31] Censorship in Hong Kong during the 1920s raised few concerns. A 1920 report from the US Consulate in Hong Kong describes the situation as follows: "Censorship in Hongkong is fairly liberal. There is often considerable question as to just what should be allowed before a Chinese audience with its habits, customs, and ideas differing so much from those of Europe and the United States but in general decisions lead to the side of liberality. In general films showing the work of mobs, riots, or disorder generally or suggesting the rape of women, class consciousness or lawlessness are not favoured. Nor do the Chinese favor anything suggesting nudity."[32]

In 1927, a censor in Hong Kong objected to (not clear if this means banned, though it is likely) three American films for either depicting Westerners as being inferior to Asians (the actual language was "white man as being inferior to the yellow races") or being unfair to them. The censor was of the view that nothing that would lower the prestige of Europeans in the eyes of the Chinese should be shown in Hong Kong. For one particular film, *The Vanishing Race* (1925) (likely also known as *The Vanishing American*), he considered that "it was insulting to America; a gross travesty on the treatment given by white men to Indians, objectionable because a white girl falls in love with an Indian and raises the colour question; and finally, shows individuals of the white race as villains and colored people as the injured parties."[33]

Under the circumstances, the US Consul General in Hong Kong didn't see it proper to appeal the censorship decisions. What is apparent from the documents of the period, was that during the 1920s censorship in Singapore was considered to be very stringent, in fact, among the most stringent in the world, whereas Hong Kong was perceived as having censors with a very light touch. There are very little data available for censorship in Hong Kong during this period to substantiate this. In contrast to Singapore, Hong Kong by the mid-1930s had become increasingly strict in censorship, particularly of politically sensitive subjects following the beginning of the Sino-Japanese War

in 1934. Scenes of war in China, in particular, would be banned. It should be noted that the population of Japanese in Hong Kong during this period was significant (and even more so in Shanghai).[34]

In 1931, legislation was passed introducing a Censorship Board made up of the Inspector General of Police, the Secretary for Chinese Affairs, and the Director of Education. In practice, the personnel involved in the day-to-day censorship activities didn't change as the actual censorship work continued to be delegated to lower level officials. However, the establishment of the Censorship Board provided an appeals body to consider possible disputes over decisions. A greater range of individuals also became involved in film censorship as a result of civic groups emphasizing a need to protect the morals of the community. According to a US Consulate report in July 1931, a committee of three women appointed by the Helena May Institute, a local woman's civic organization, was appointed to participate in reviewing films with the censors.[35]

Controversy over censorship decisions only became apparent in the latter part of the 1930s when two decisions banning the negative portrayal of Nazi Germany, apparently following complaints from the German Consul General to the Governor, led to protests from the Hong Kong public. Allegations were also made within the US Consular reports that the Governor was in fact a Nazi sympathizer who showed considerable favor to the Germans.[36] The first instance was the banning of a film titled *Inside Nazi Germany* (1938), part of *The March of Time* series.[37] This 16-minute (simulated) documentary film, originally released in January 1938, was purported to give audiences an understanding of life in Germany.[38] The film led to protests in a number of countries, including the United States, in some cases due to its perceived anti-Nazi bias, but in other places due to its pro-Nazi bias.[39] In Hong Kong, the censor initially passed the film for exhibition, but after representations from the German Consul General claiming that parts of the commentary were "very anti-Nazi," the censor amended the approval restricting the film to silent exhibition only. A few hours later the film was banned in its entirety, apparently due to intervention by the Governor of Hong Kong. This change was appealed, but the Board of Censors upheld the decision.[40] An official statement from the Commissioner of Police (also the Chief Censor) suggested that the decision to ban the film was not made at the request of the German Consulate, but as a result of a review by both representatives of the British residents and the German Consulate following concerns by the censor regarding the commentary.[41]

The report that follows from the American Consulate dated September 10, 1938, comments on the apparent strictness of local censors of moving picture films. This is a radical departure from earlier perceptions of Hong Kong censors doing their job with a light touch. Particular focus was placed on the absurdity of excising scenes portraying gunfire or shooting when many of the inhabitants

of Hong Kong would have been familiar with lethal violence from living under war conditions in China.[42]

Another *The March of Time* film was banned a couple of years later. A memorandum to Southard, the American Consul General, dated June 29, 1940, notes that the "Hong Kong censors are not passing Victor Jurgens' *March of Time* film on the Far East, as it is too anti-Japanese for the moment."[43] The Consulate records contain a shooting script for Hong Kong from when Jurgens visited the territory in April, 1939, along with a telegram from Louis de Rochemont asking the Consulate to advise Jurgens to stay out of Japanese-occupied territory and not to use Japanese-owned transportation. The Japanese government was also putting pressure on the Hong Kong Government not to allow the screening of films detrimental or antagonistic to Japanese interests.[44]

In 1939, another Nazi-focused film attracted the ire of the German Consul-General. *Confessions of a Nazi Spy* (1939), produced by Warner Bros., was considered the first explicitly anti-Nazi film produced by a Hollywood studio and was banned in a number of countries.[45] In Hong Kong, the German Consul-General approached the government, as also happened in other British colonies and dominions, to request that the film be banned, but after due consultation, both within the Hong Kong administration and with other governments within the British Empire, the film was released.[46]

Shanghai International Settlement

Early US Consulate records of film censorship in the International Settlement are sketchy.[47] In a report to the American Legation in Peking from the Shanghai Consulate in 1918, three permanent motion picture theaters were listed catering primarily to foreigners along with one that opened only in the summer months. These can be reasonably assumed to have been operating in the International Settlement or French Concession. Eight other cinemas are listed as catering to Chinese audiences; however, it is unclear whether any of these was located in either of the international concessions.[48] Later that year, Mr. J. B. Powell from the *Millard's Review* sent a complaint to a number of individuals in the United States complaining about certain US films that were being exhibited in China, requesting that something be done to prohibit them from being exported.[49] In the letter, Powell cites the example of two films that he felt should have been prohibited: Rae Berger's *Purity* (1916), which Powell claimed consisted mainly of views of naked women,[50] and *Unprotected* (1916), which dealt with the inhuman treatment of prisoners in prison camps in the southern states of the United States. What offended the author of the letter was the great delight with which the Germans who saw James Young's *Unprotected* would inform the local Chinese that the conditions shown were the "ordinary

American methods of treating prisoners."[51] He noted that *Purity* had been dis-allowed by authorities in the International Settlement, but was exhibited in Chinese movie theaters outside their jurisdiction. This move was probably an exception, as a 1925 report on the motion picture industry in Shanghai claims that censorship for films had not yet been introduced in China, although a 1927 report notes that the Shanghai Municipal Police had the powers through the terms of cinema licenses the right to stop the exhibition of any picture it considered undesirable.[52]

In September 1927, the SMC announced the establishment of a commit-tee for the censorship of motion picture films in the International Settlement under the auspices of the police beginning October 1, 1927.[53] The committee was made up of police officers and eventually, if not initially, was constituted as a division of the Special Branch.[54] The initial guidelines provided to police officers covered five areas (highlighted in bold in Table 10.1 earlier), with the addition of "Films featuring prominently the colour question are banned."[55] In addition, there was a right of appeal to the Board of Film Censors if a film was rejected. The impetus for this move came from the ongoing concern in the community during previous years regarding the perceived unsuitability of some of the images shown to local Chinese audiences. There was a desire to not provide a negative example to local audiences: "It was felt that viewing of par-ticular familiarity in social relations and heroism in certain forms of twentieth century banditry was teaching a lesson not desirable to have brought before them so vividly."[56] Censorship within the International Settlement was under-taken in conjunction with police from the French Concession. The approach was identical to the BBFC with two teams of examiners simultaneously exam-ining two films in the same room. As this was a joint operation between the Shanghai Municipal Police and the French Concession Police, there was an officer from each of these on each censoring team. In the event the distribu-tor was dissatisfied with the decision of the examiners, they could appeal to the International Board of Censors, a board made up of volunteers from the International Settlement and French Concession.[57]

The guidelines for the censors were amended in 1931, with the "Films fea-turing prominently the colour question" divided into two clauses and made more specific: films highlighting racial distinctions, and films that may offend on national grounds and lead to social unrest. The term "colour question" during this period was also a euphemism for mixed race relationships, which were considered highly undesirable. Whereas the BBFC code made this more explicit, it was left implicit in the Shanghai code, possibly reflecting the high degree of racial diversity in the city and interracial relationships that existed since the formation of the International Settlement.[58]

The censorship of films in the Shanghai International Settlement appears to have been comparable to, if not lighter than, that of the BBFC. Of the 650 films censored by the SMC in 1930, 602 were approved without cuts, 30 were

approved after cuts were made, 15 were withdrawn as a result of police objections, and three were referred to the full Censorship Board, who subsequently banned all of them.[59] Ninety-two percent of films were approved without cuts, and less than three percent were banned. In comparison, the BBFC in 1930 made cuts to about 8 percent of films submitted, though banned less than 1 percent.[60] Over the following years, the concerns recorded in the consular records were focused on the censorship requirements of the Chinese Nationalist Government, rather than those of the Shanghai Municipal Corporation. Although the SMC censorship continued, it was as an adjunct to the Chinese national censorship.

Conclusion

The links between the three localities were implicit; little tangible evidence is available in the archives that there were contacts between the BBFC and the local censoring authorities. We find, however, that in the Shanghai International Settlement two teams of censors would simultaneously watch films in the same room and consult with each other when they encounter questionable scenes, thus replicating the structure used by the BBFC. With similarities in censoring guidelines (though not in the details of the BBFC schedule), why then were there such differences in approach? Censorship in colonial Asia seemed to have been influenced by local conditions, as well as by the structure of the censoring institution, or the censorship system, as suggested in the introductory chapter. In the Straits Settlements, censorship was centralized (for the most part) in one individual, who dominated the position for most of the period and appeared to take a rigid approach to the removal of unsuitable scenes. There was considerable concern regarding maintaining the prestige and dignity of the European, particularly European women and authority figures, across the various censorship guidelines, with a fear of a crude "hypodermic needle" theory of strong media effects showing up, assuming the susceptibility of native audiences to all that was portrayed on screen and possible inclination to imitate the onscreen portrayals. This was in line with what was evident in many other colonies where onscreen suggestions of challenging the authority or position of the colonial power (or European people in general) were not countenanced. Although this concern also existed in Hong Kong, the decentralized nature of the censorate, along with the relationships that likely developed between exhibitors and censors over time, resulted in a less rigid environment. The restrictions still existed, though not always included in the written guidelines. An example of this was the restrictions on the negative portrayal of East Indians since a significant portion of the Hong Kong Police force originally came from India.

 The Shanghai International Settlement, for the brief period that it was fully responsible for censorship in the treaty port, appears to have been the most

liberal of the three. Shanghai had the reputation for being a very cosmopolitan city with a considerable range of vices freely available (particularly within the French Concession). Within that context, the police appeared to be a lot more liberal in what they considered acceptable representations on screen. But even within this environment, they had to take into account the large number of Chinese viewing the films, as well as the offence taken toward disparaging portrayals of Chinese, and make appropriate excisions accordingly.

Whereas at the beginning of the period moral concerns had a greater prominence, by the mid-1930s, political concerns were more important. This is in part due to the deteriorating political situation in China and the relationship with Japan, but might also be due to a greater awareness on the part of producers, distributors, and importers of the moral concerns in the local market.

Over time, the censorship practices evolved in all the three locations in response to changing social and political attitudes and circumstances, as well as changes that came about in the films themselves. Although the influence of the BBFC can be seen in each of the localities, local requirements and attitudes shaped the individual guidelines.

Notes

1. United States National Archives, College Park (hereafter USNA), RG 84 Hong Kong Consular Records (hereafter Hong Kong), 840.6 Vol. 398, 1928. E. W. Hamilton to Manager, Hong Kong Amusements dated January 9, 1928, enclosed in E. D. C. Wolfe, Captain Superintendent of Police to Roger Culver Tredwell, US Consul General dated February 17, 1928. Eric W. Hamilton was a senior Hong Kong government official who also fulfilled the role of film censor during the period covered by this chapter.

2. Bergère, M. (2009) *Shanghai: China's Gateway to Modernity*. Trans. Janet Lloyd. Stanford: Stanford University Press, pp. 17–18; Dong, S. (2000) *Shanghai: The Rise and Fall of a Decadent City*. New York: HarperCollins. The French Concession was about half the size of the International Concession, and immediately adjacent. Although both continued to be Chinese sovereign territory, foreign residents enjoyed extraterritorial privileges, which meant that in the Shanghai International Settlement (and other Treaty Ports), many foreigners were not subject to Chinese laws, but would be tried only by their own consuls or in their respective nations' courts.

3. Although the French initially joined the International Settlement in 1854, they split off in 1862 and continued to administer the French Concession themselves separate from the Shanghai Municipal Council. See Bergère (2009), pp. 45–46. The Greater Shanghai Municipality (or Special Municipality of Shanghai) was created in 1927 with the inauguration of the Nationalist government to bring all of the Chinese parts of Shanghai under one administration. Three years later, the Shanghai International Settlement's taxpayers voted to allow five Chinese members to be seated on the Shanghai Municipal Council, resulting in the British losing their majority on

the council. Dong (2000), pp. 209–210. This was the largest of the foreign concessions on land leased from China. The others included Tientsin, Hankow, Shameen Island, and Kiukiang. Weihaiwei and Hong Kong, although (at least partially) on land leased from the Chinese, were both British sovereign territory. No attempt is being made here to chronicle the development of film censorship in Shanghai outside of the International Settlement, as it is a complex subject, requiring a full chapter in its own right.

4. Robertson, J. C. (1985) *The British Board of Film Censors.* London: Croom Helm, p. 3.

5. Robertson (1985), p. 4.

6. Cinema Commission of Inquiry (1917) *The Cinema: Its Present Position and Future Possibilities, Being the Report of and Chief Evidence Taken by the Cinema Commission of Inquiry Instituted by the National Council of Public Morals.* London: Williams and Norgate, pp. 244–245.

7. Cinema Commission of Inquiry (1917), p. 104. Pages 254–255 list a code of 43 rules of situations that were disallowed by the examiners.

8. Early records for the BBFC are fragmentary, but there are indications from evidence presented by the BBFC Secretary, Brooke Wilkinson, to the Cinema Commission of Inquiry (1917), that for the years 1913–1916, less than 0.4 percent of films were rejected outright, although approximately 10 percent in 1916 required some excisions (p. 214). Annual Reports of the BBFC from the 1920s suggest that the very low level of outright rejections continued, although the proportion of films requiring cuts increased. 1921, 433 of 1,960 films required cuts; 1923, 237 of 1,923 films; 1925, 361 of 1,885 films; 1928, 345 of 1,947 films. See Annual Reports of the British Board of Film Censors, 1921, 1923, 1925 and 1928.

9. The National Archives, Public Records Office of the United Kingdom (hereafter TNA: PRO), CO 323/1045/1 Film Censorship—Colonies. Letter dated October 4, 1929 from Secretary for Native Affairs, Gold Coast to the Under-Secretary of State, Colonial Office, p. 3.

10. TNA: PRO, CO 323/1118/9 Film Censorship. Letter from "Officer Administering the Government" to Right Honourable Lord Passfield Corner, Colonial Office dated December 5, 1930, p. 2.

11. Osterhammel, J. (2005) *Colonialism: A Theoretical Overview* (2nd ed., trans. S. L. Frisch). Princeton, NJ: Marcus Wiener Publishers, p. 4; Shohat, E. & Stam, R. (1994) *Unthinking Eurocentrism.* New York: Routledge, pp. 15–18; Cooper, F. (2005) *Colonialism in Question: Theory, Knowledge, History.* Berkeley, Los Angeles & London: University of California Press, pp. 26–28.

12. United States National Archives, College Park, Maryland (hereafter USNA), RG 84 Hong Kong, Vol. 374, 840.6. Letter from Treadwell, US Consul General, Hong Kong to E. S. Cunningham, American Consul General, Shanghai, dated April 24, 1926.

13. This was discussed in particular with regard to some of the African colonies. See: UK Colonial Office, *Report of the Colonial Films Committee,* 1930, Cmd. 3620.

14. Wan, A. W. M., Chang, P. K. and Aziz, J. (2009) Film Censorship in Malaysia: sanctions of religious, cultural and moral values, pp. 42–49 in *Jurnal Komunikasi, Malaysian Journal of Communication,* 25.

15. *Straits Settlements Government Gazette* (*SSGG*) September 28, 1917, No. 1237, pp. 1624–1625. Straits Settlements Government. Ordinance No. 22 of 1917, *Theatres (Amendment) Ordinance.* In addition to establishing the post of Official

Censor, the Ordinance established a Committee of Appeal with seven members, four appointed by the Governor and three elected by the Justices of the Peace. Three were to be considered a quorum for the purpose of hearing an appeal. The Inspector-General of Police was appointed as Chair of the Appeals Committee.

16. *Straits Settlements Blue Books.* These provide annual details of personnel employed, their salaries, and other office expenditure.

17. *SSGG* October 5, 1917, No. 1288, p. 1661.

18. *SSGG* October 19, 1917, No. 1386, p. 1740.

19. *SSGG* November 2, 1917, No. 1431, p. 1804. Davidson appears in the Singapore Jury List of December 7, 1917 with his occupation listed as engineer for the Singapore Oil Mills. Roberts appointment appears in *SSGG* February 8, 1918, No. 167, p. 193.

20. *SSGG* February 22, 1924, No. 326, p. 271. There appears to have been an oversight in announcing Hussey's appointment. The official notification does not appear in the *SSGG* until February 1924 after notification of his leave of absence on full salary for eight months is announced. The date of appointment given in the *SSGG* is February 3, 1920, while the *Straits Settlements Blue Book* lists it as December 24, 1919. A possible explanation for this is that he was appointed in London (there is no record of Hussey on the local jury lists before this), with the December date representing when he left London. The February date would be when he began duty in Singapore.

21. United Kingdom, *House of Commons Debates*, June 17, 1927, Vol. 207, cc1364-6W; United Kingdom, *House of Commons Debates*, November 4, 1930, Vol. 244, cc685-6W.

22. TNA: PRO CO 272/550/14 Straits Settlements Cinematograph Films Ordinance, Enclosure no. 725 of October 25, 1925.

23. USNA, RG 59 Department of State Decimal Files, 1910–1929, 846d.4061/2. Dickins, G. F. (September 5, 1925) *Local Propaganda against American Films*, p. 6.

24. Ibid.

25. TNA: PRO CO 323/1073/5 Film Censorship—Colonies.

26. USNA, RG 84 Singapore, Box 275, 840.6. Keblinger, W. (September 18, 1935) *Film Censorship*, pp. 2–3.

27. Films banned for reasons of violence or crime included: *Midnight Alibi* (1934), *Treason* (1933), *Menace* (1934), *Times Square Lady* (1935), and *I Am a Thief* (1934). See USNA, RG 59 Department of State Decimal Files, 1930–1939, Box 6250, 846d.4061/17, Keblinger, W. (September 18, 1935) *Film Censorship*, encl.

28. USNA, RG 59 Department of State Decimal Files, 1930–1939, Box 6250, 846d.4061/18, Davis, M. (October 17, 1936) *Censorship of Motion Picture Films*, Encl. 1; USNA, RG 59 Department of State Decimal Files, 1930–1939, Box 6250, 846d.4061/20, Davis, M. (April 17, 1937) *Censorship of Motion Picture Films*, Encl. 1; USNA, RG 59 Department of State Decimal Files, 1930–1939, Box 6250, 846d.4061/22. Davis, M. (October 16, 1937) *Censorship of Motion Picture Films*, Encl.; USNA, RG 59 Department of State Decimal Files, 1930–1939, Box 6250, 846d.4061/24. McEnelly, T. (April 21, 1938) *Censorship of Motion Picture Films*, Encl.; USNA, RG 59 Department of State Decimal Files, 1930–1939, Box. 6250, 846d.4061/26. Patton, K. S. (October 25, 1938) *Censorship of Motion Picture Films*, Encl.; USNA, RG 59 Department of State Decimal Files, 1930–1939, Box 6250,

846d.4061/31. Patton, K. S. (October 21, 1939) *Censorship of Motion Picture Films in the Straits Settlements,* Encl.

29. The government rented a small editing studio for film censorship purposes in the Gloucester Building from July 1, 1932 (*Hong Kong Administrative Reports* [1932] Appendix K: Report of the Inspector General of Police for the Year 1932, p. K3). In the case of one of the senior censors, this timeframe clashed with his duties as a magistrate and court hours, and so apparently the government allowed a local film distributor to install a 35-mm projector in his home to enable him to view and censor films at his convenience. See Archives New Zealand, IA 83 3 British and British Colonial Films, 1919–1930. *Star* (February 1, 1930) Talkies in the Orient (newspaper clipping in the file. The story was originally written by the Shanghai correspondent of the *New York Herald-Tribune*). Although the veracity of this report hasn't been confirmed from other sources, this was very likely referring to Eric Hamilton, who spent part of his career as a Police Magistrate.

30. Shanghai Municipal Council (SMC), *The Municipal Gazette* (October 14, 1932) Report of the Commission Appointed by the Shanghai Municipal Council to Examine the Question of Film Censorship in the International Settlement, p. 461.

31. *Hong Kong Government Gazette (HKGG)* (November 7, 1919) No. 518, Regulations under Section 6 of the Places of Public Entertainment Regulation Ordinance, 1919, p. 465.

32. USNA, RG 84 Hong Kong, Vol. 284, 840.6, 1920. Cudleson, G. E. (January 19, 1920) *Moving Pictures in Hongkong,* p. 10.

33. USNA, RG 84 Shanghai, 840.6, Vol. 1708, 1927. Letter from Treadwell, US Consul General, Hong Kong to E. S. Cunningham, American Consul General, Shanghai, dated December 3, 1927, p. 2. The film was likely also known as *The Vanishing American,* directed by George Seitz and distributed by the Famous-Lasky Corp.

34. USNA, RG 84 Hong Kong, 840.6, Vol. 457, 1932. Edgar, D. D. (1932) *Motion Pictures,* p. 2. Census statistics don't break out Japanese specifically, and although there were some much higher estimates available, the author estimates the number of Japanese resident in Hong Kong to probably have been between 1500 and 3000. Bergère (2009), p. 208, suggests that there were 30,000 Japanese living in Shanghai in 1932.

35. USNA, RG 59 Department of State Decimal Files, 1930–1939, Box 6526, 846g.4061 Motion Pictures/2. Jenkins, D. (July 24, 1931) *Censorship of Talking Picture Films in Hong Kong,* p. 2. The Helena May Institute was a woman's civic organization that operated a residence for young single women as well as sponsoring lectures, concerts, and exhibitions of an educational nature. In all likelihood, one woman was attached to each of the censorship teams in the colony.

36. *Hong Kong Daily Press* (June 15, 1938), quoted in USNA, RG 59 Department of State Decimal Files, 1930–1939, Box 6256 846g.4061 Motion Pictures/13, Southard, A. (June 15, 1938) *"March of Time" Film Banned by Governor of Hong Kong—Nazi Influence with Hong Kong Government?,* p. 3.

37. TNA: PRO FO 371/21701 Political, "Exhibition of film 'Inside Nazi Germany' at Hong Kong," pp. 58–60; USNA, RG 59 Department of State Decimal Files, 1930–1939, Box 6256, 846g.4061 Motion Pictures/13–16.

38. Although the original footage was shot in Germany, most of the film was reshot in the United States before release. See Fielding, R. (1978). *The March of Time, 1935–1951.* New York: Oxford University Press, pp. 186–201.

39. Chicago Bans Film Exposing Situation under Hitler's Rule (January 19, 1938). *The Washington Post*, p. X26; Bell, Nelson (January 20, 1938) *"The March of Time"* Fades Out of Amusement Scene, Bowing to Country's International Relationships! *The Washington Post*, p. X6.
40. The matter was raised in the British House of Commons where Mrs. Adamson (MP) asked the Secretary of State for the Colonies, Mr. MacDonald, regarding this. No further information is provided in the British Foreign Office records remaining in the UK Public Records Office beyond a clipping from *Hansard* (CO 371/21701). The film itself had been permitted in England, but a cinema chain in the United States refused to screen it due to its perceived pro-Nazi bias. More details are provided in US Consulate records from Hong Kong, in which 20 pages of reports and comments are devoted to the incident (Box 6256, 846g.4061 Motion Pictures/13–16, Hong Kong, RG 59 Department of State Decimal Files, 1930–1939, USNA). The film itself has been preserved by the US Library of Congress as "culturally significant." The issue in Hong Kong appears to have been the tone of the voiceover, stridently didactic. The report dated June 16 from Addison Southard, the American Consul General, suggested that both the Governor, Sir G. A. S. Northcote, and his aide-de-camp, Captain S. H. Batty-Smith, had a sympathetic attitude toward Germany, but the discontent regarding this wasn't openly spoken about in Hong Kong due to the level of autocratic powers that the Governor possessed. Southard cited a number of examples in which the Governor or his aide-de-camp appeared to give greater deference to the German Consul than those from other countries.
41. USNA, RG 59, Southard, A (June 18, 1938) *"March of Time" Film Banned by Government of Hong Kong.* There are newspaper clippings from the *Hong Kong Press* dated June 17, 1938, regarding the official statement in a report dated June 18, from Southard to the US Secretary of State. One of the clippings appears to be an editorial questioning why the censor took the action he did and banned it when citizens in Britain were free to view the film.
42. USNA, RG 59 Department of State Decimal Files, 1930–1939, Box 6256, 846g.4061 Motion Pictures/16, 1938. Southard, A. (September 10, 1938) *Criticism of Too Strict Film Censorship in Hong Kong.*
43. USNA, RG 59 Department of State Decimal Files, 1940–1944, 846g.4061, Memorandum for Mr. Southard, dated June 29, 1940.
44. Kar, L. and Bren, F. (2004) *Hong Kong Cinema: A Cross-Cultural View.* Lanham, MD: Scarecrow Press, p. 133. They note that actual scenes of fighting against the Japanese were banned by the Hong Kong government as a result of Japanese pressure.
45. Ross, S. J. (2004) Confessions of a Nazi Spy: Warner Bros., Anti-Fascism and the Politicization of Hollywood, p. 57 in Kaplan, M. and Blakley, J. (eds) *Warners' War: Politics, Pop Culture & Propaganda in Wartime Hollywood.* Los Angeles: The Norman Lear Center, USC Annenberg. Downloaded from http://www.learcenter.org/pdf/WWRoss.pdf
46. USNA, RG 84 Hong Kong, Box 66, 840.6, contains a letter from Warner Bros. dated July 24, 1939, informing the consulate of the delays with the film. An accompanying file memorandum dated August 10, 1939, by A. E. S. (Southard) notes that the film had been released for exhibition and no intervention was necessary from the American Consulate. There is also a handwritten note on TNA: PRO, FO 371/21701

Political—USA, Showing of film "*Confessions of a Nazi Spy*," p. 235, noting that the Hong Kong government had been enquiring about the film.

47. Unlike the sections on the Straits Settlements and Hong Kong, the only archival source on the Shanghai International Settlement available to consult were the US Consular records. As a result, the information is less reliable and rather sketchy.

48. USNA, RG 84 Shanghai, 840.6, Vol. 1184, 1918. Perkins, M. F. (June 7, 1918) *Motion Pictures for Commercial and Propaganda Purposes*, p. 2. In most of the US Consular records, no differentiation is made between the different municipalities or administrations within Shanghai.

49. USNA, RG 84 Shanghai Consular Records, 840.6, Vol. 1184. Letter from J. B. Powell to Nelson T. Johnson, American Consul-in-Charge dated August 29, 1918. The masthead of *Millard's Review* describes itself as "a weekly journal devoted to the economic, political and social development of the Republic of China," and was headquartered in Shanghai. The letter was sent to the Censorship Boards in San Francisco and Washington, DC, the US Secretary of State (Hon R. Lansing), and George Creel at the Bureau of Public Information.

50. Powell likely overstated the occurrence of nudity in *Purity* (Rae Berger, 1916), where a central character worked as a nude model in films. It is not clear that there are multiple naked women in the film.

51. USNA, RG 84 Shanghai, 840.6, Vol. 1184,1918. Letter from J. B. Powell to Chairman of San Francisco Censorship Board, dated August 28, 1918.

52. USNA, RG 84 Shanghai, 840.6, Vol. 1557, 1925. Jacobs, J. E. (October 15, 1925) *Shanghai as the Center of the Chinese Motion Picture Industry*, p. 14; USNA, RG 84 Shanghai Consular Records, 840.6 Vol. 1708, 1927. Cunningham, E. S. (September 26, 1927) *Censorship in Shanghai of Motion Picture Films*, p. 2.

53. USNA, RG 84 Shanghai, Vol. 1708, Cunningham (1927), p. 1.

54. Wakeman, F. Jr. (1995) *Policing Shanghai, 1927–1937*. Berkeley, Los Angeles, and London: University of California Press, p. 337.

55. USNA, RG 84 Shanghai, 840.6 Vol. 1708, 1927. Letter from E. B. Barrett, Commissioner of Police to E. S. Cunningham, Consul-General for the United States of America, dated September 18, 1927.

56. USNA, RG 84 Shanghai, Vol. 1708, Cunningham (1927), p. 1.

57. *SMC, The Municipal Gazette* (October 14, 1932) Report of the Commission Appointed by the Shanghai Municipal Council to Examine the Question of Film Censorship in the International Settlement, p. 458.

58. Because of the paucity of eligible European women in the settlement, the maintenance of Chinese concubines and children borne of those relationships, were common practice. See Dong (2000), p. 28.

59. USNA, RG 84 Shanghai, 840.6, Vol. 2153, 1931. Letter from SMC Police Commissioner to SMC Director-General, dated February 13, 1931.

60. British Board of Film Censors (1930) *Annual Report*, p. 6.

"We do not certify backwards": Film Censorship in Postcolonial India

Nandana Bose

This chapter will provide a succinct introduction to the Indian state's film censorship laws, policies, and practices, and then move on to a chronological overview of evolutions in film censorship in post-colonial India by focusing on two crucial historical periods of the 1970s and 1990s that were marked by a series of censorship controversies and protracted legal wrangles.[1] Although mainly restricted to manifest censorship of popular Hindi cinema produced by the Bombay film industry, I shall also make occasional references to regional cinemas and new wave, art, and documentary films.

The necessity for some form of manifest, state-sponsored precensorship stems from a deep-rooted belief by the elite that a powerful medium such as cinema should be controlled for the consumption of the "public," an euphemism for excitable, irrational "masses" who must be protected from being "exposed to psychologically damaging matter."[2] One of the reasons for justifying the state control of cinema is that "while the media ... is free, regarding films it is considered necessary in the general interest to examine the product before it goes out to the public because it is an audio-visual medium whose impact is far stronger than that of the printed word."[3] These dubious assumptions about the nature of audiences, audience reception, and the necessity for film censorship are validated by the following Supreme Court verdict:

Film censorship becomes necessary because a movie motivates thought and action and assures a high degree of attention and retention It can, therefore be said that the movie has unique capacity to disturb and arouse feelings. It has

as much potential for evil as it has for good. It has an equal potential to instil or cultivate violent or good behaviour. With these qualities and since it caters for mass audience who are generally not selective about what they watch, the movie cannot be equated with other modes of communication. It cannot be allowed to function in a free market place as does the newspapers or magazines. Censorship by prior restraint is, therefore, not only desirable but also necessary.[4]

The Supreme Court verdict is based on the oft-cited and problematic assumption that moving images have a direct, causal, and quantifiable impact on "passive" audiences. It adopts the "hypodermic needle model approach," the pitfalls of which are well documented in media studies.[5]

Colonial Legacy

Censorship laws in independent India are the legacy of British colonialism, which sought to frustrate the articulation of nationalist sentiments, to thwart suggestions of self-governance and Indian independence through the mass medium of cinema, and to protect the reputation of the colonial woman from the prying eyes of natives. This is borne out by what Someswar Bhowmik points out:

> the film censorship machinery in pre-independence India took care of three basic concerns of the colonial government: a) to deny the Indian audience access to communist or socialist ideals ("propaganda" in their language) reflected in the Soviet cinema; b) to ensure that the spirit of freedom and independence did not reach the audience of a colonised country easily and regularly through western, mainly American films, and c) to prevent the crystallization of nationalist paradigm in the Indian cinema.[6]

Colonial censorship can be traced back to the promulgation of the Cinematograph Act of 1918, which enabled provincial governments to establish authorities to examine and certify films but did not provide any guidelines based on which films could be certified. As Tejaswini Ganti notes, provincial boards in Bombay, Calcutta, Madras, and Rangoon had been set up by 1920 and a certificate issued by any of these boards was valid throughout British India, but could be revoked in any province by the provincial government. The first film censored in colonial India was *Bhakta Vidur* (1921) since the authorities discerned tacit nationalist intentions embodied by a character that was based on Mahatma Gandhi, leader of the freedom struggle and father of the nation.[7] The 1918 Cinematograph Act was not amended until India won its independence in 1947.

Two years later, the Cinematograph (Second Amendment) Act of 1949 established the Board of Film Censors (later renamed Central Board of Film Certification [CBFC] in 1983) while retaining regional subcommittees to

review non-Hindi-language films. It also created two categories of censor-ship certificates: "A" for films restricted to adults (18 and older) and "U" for unrestricted exhibition. January 1951 onward the autonomy of the various regional censor boards originally established under the 1918 Cinematograph Act was abolished, and by 1952 "the foundations of a post-colonial infras-tructure for film censorship had been laid."[8] The Cinematograph Act of 1952 invalidated all existing regional boards and granted the central government the authority to form a Board of Film Censors (BFC) consisting of a chairperson and nine members. The 1952 Act was amended in 1981 and 1984 and two new certification categories were added in 1983: "UA" for "unrestricted pub-lic exhibition—but with a word of caution that Parental (sic) discretion [was] required for children below 12 years," and "S" for public exhibition restricted to any special class of persons,[9] such as doctors. Over the years, efforts have been made to add more classifications but they have not been supported by the various governments and Parliament. In 2002, the late Vijay Anand, then CBFC chairperson and eminent filmmaker, had to quit his position as he fell foul of the Ministry of Information & Broadcasting (I&B) when he proposed to introduce the classification of "X" and designate special theater halls that could screen pornographic films.

In the late 1960s, the government set up a 15-member Enquiry Committee on Film Censorship (1968) headed by Justice G. D. Khosla, a former Chief Jus-tice of the Punjab High Court. The Khosla Committee report, as it came to be known, was an aberration in the history of Indian film censorship because of its progressive outlook on the role of censorship in modern India, and its thor-ough scrutiny of the then prevalent CBFC's *modus operandi*, which were found to be inconsistent, arbitrary, and inefficient.[10] Its recommendations included the introduction of a three-tier classification system, replacing the earlier two-tier one of "U" or "A," by also granting "G" for films fit for universal exhibition but requiring children to be accompanied by adults; and the setting up of an independent censorship body that would be free from state interference. Unfortunately, it is due to the following sentence, which grabbed the attention of the film industry, government officials, media, and ordinary citizens, that the report has been best remembered, causing a great deal of controversy on its publication:

> If, in telling the story it is logical, relevant or necessary to depict a passionate kiss or a nude human figure, there should be no question of excluding the shot, provided the theme is handled with delicacy and feeling, aiming at aesthetic expression and avoiding all suggestions of prurience or lasciviousness.[11]

The "liberal" underpinnings of this report were considered ahead of its time and "construed as an advocacy for unhindered libertarianism" incompatible with Indian social and cultural norms and ethos.[12] While the report pro-voked strong reactions and heated debates at the time,[13] it was ignored by

the state. Nevertheless, this report continues to be referenced in contemporary debates and discussions on censorship by liberal filmmakers, scholars and artistes, especially whenever there are perceived threats to the right to freedom of expression such as during the Emergency in the mid-1970s, a period of crisis for Indian democracy when basic human rights was severely compromised.

Post-colonial Legal Provisions for Censorship of Hindi Cinema

The Indian state censors through several legal provisions that sanction direct intervention and regulation of cinema. These codes are, first, the aforementioned Cinematograph Act of 1952, which was enacted after the 1918 Cinematograph Act, promulgated during British colonial rule, was repealed; second, the 1994 revision of the 1952 BFC guidelines;[14] and third, the Indecent Representation of Women (Prohibition) Act of 1986, "the single most important landmark in the history of censorship in modern India"[15] since the female body and Indian womanhood have often been conflated with the nation, national honor (*izzat*), and dignity, and has been a site of intense ideological and political contestation.[16] These legal provisions emanate from Article 19, Clause 1(a) of the Constitution, which guarantees to every citizen of India the right to freedom of speech and expression. However, Clause 2 of Article 19 modifies this freedom by "reasonable restriction" and reads as follows: "[The] law imposes reasonable restrictions on the exercise of the right conferred . . . in the interest of the sovereignty and integrity of India, the security of the state, friendly relations with foreign states, public order, decency or morality or in relation to contempt of court, defamation or incitement to an offence."[17] This is the constitutional provision adopted by the Cinematograph Act of 1952, as amended in 1981 and 1984, and is supplemented by the Cinematograph (Certification) Rules, 1983, and the Guidelines to the Board of Film Censors (BFC). Through this Act, the state exercises its stranglehold on filmmaking by making it obligatory for every producer to obtain the censor certificate of clearance before the release of the film for public exhibition, and display the same onscreen before every public screening of the film. In addition to these cinematograph laws, issues relating to "obscenity," "vulgarity," and "indecency" in written or visual materials are decided in accordance with Sections 292, 293, and 294 of the Indian Penal Code of 1860, framed during the colonial rule, and based on an English case *Regina vs. Hicklin,* decided in 1868.[18]

As instituted by the Cinematograph Act of 1952, the CBFC continues to be a state-run body controlled by the Ministry of Information & Broadcasting, and its chairperson and non-official members are appointed by the central government. It has been (and continues to be) subject to political interference

and manipulation by those in power, and often confronts a lack of freedom to pass free and fair judgment, in contrast to the freedom an independent, industry-led censorship body would enjoy. On the occasions when it does make impartial decisions, the Ministry of Information & Broadcasting can ask the Board to justify its action if there is a public protest. The CBFC's headquarters are located in Mumbai, and it has nine regional offices all over India. The Regional Offices are assisted in film examination by Advisory Panels, the members of which are nominated by the Central Government drawn from different walks of life and professions for a period of two years. The CBFC is divided into a two-tier jury system for film certification: the Examining Committee and the Revising Committee. Also, there is the Film Certification Appellate Tribunal (FACT) for hearing appeals against the CBFC's decision.[19] It is headed by a chairperson, usually an influential lawyer, and comprises of three persons appointed by the central government, and was instituted as part of a judgment in the famous *K. A. Abbas vs. The Union of India* (1971) case involving the documentary *Char Shaher Ek Kahani* (*A Tale of Four Cities,* 1968), "a landmark in the history of film censorship in India."[20] The film was initially denied a "U" certification, due to brothel scenes amongst other reasons; the government finally relented after a protracted legal battle that concluded in the Supreme Court. Abbas had also amended his petition so as to challenge precensorship and term the Cinematograph Act 1952 "vague." His interventions have had far-reaching consequences in determining subsequent censorship cases.[21]

The history of censorship of cinema in India has been one driven predominantly by practices of excision and not certification, despite what the name of the Board may suggest, which has been at best a cosmetic change from the "Board of Film Censors" to the "Board of Film Certification" in 1983. A perusal of the CBFC's annual reports and deletion lists reveals a preoccupation with the length of footage excised and the percentage of shot sequences reduced or substituted instead of following any aesthetic principles of viewing films in their entirety. An example from the excision list of *Zakhm* (*Wound,* 1998; Table 11.1) illustrates my point.[22]

Implementation of the aforementioned classifications remains problematic due to weak laws, ineffectual, inconsistent, and often corrupt law enforcement agencies in the various states and union territories, and an inefficient and bureaucratic judiciary. It is common knowledge that exhibitors and producers have devised strategies to exploit loopholes in the censorship process. Exhibitors have been known to insert the excised portions of films that have already been censored, and interpolate pornographic scenes from foreign films at the time of exhibition; and producers often shoot extra footage of provocative scenes in case the Board demands a percentile reduction. These industrial responses circumventing the legal procedure raise serious questions about the purpose, efficacy, and relevance of censorship practices and policies of the CBFC.

Table 11.1 CBFC's suggested modifications for *Zakhm* (*Wound*, 1998)

Sr. No.	Reel No.	Description
1	VII	1] The junior policeman should also be depicted as a Hindu to balance the portrayal of the Police Department. (The Junior police man is addressed as Pawar establishing him as a Hindu character)
2	VI	THE FOLLOWING CUTS ARE DIRECTED BASED ON THE RECOMMENDATION OF THE HOME MINISTRY, GOVT. OF INDIA. 1] Deleted the scene depicting a member of the police force as being an inactive witness to an assault on a member of a particular community. (*Replaced with approved visuals & dialogues: 120 ft. 14 frsm,* author's emphasis)
3	VII	2] Deleted the scene where a member of the police force is shown offering to settle scores personally on behalf of a particular community.
4	XIV	3] Deleted in the scene where a Hindu mob is shown rushing into the hospital to stop the body of the hero's mother, a Muslim, being taken out for burial, the visuals where members of the mob have been shown wearing saffron head bands. (*Replaced with approved visuals: 63 ft. 06 frms.,* author's emphasis)

1970s State Censorship during Emergency (1975–1977)

From June 1975 to March 1977 India was in a state of "emergency" declared by Prime Minister Indira Gandhi's Congress government, under Article 352 of the Constitution of India, on the ground that the security of India was threatened by internal, divisive forces. What ensued was a veritable dictatorship that invested extraordinary powers in the executive, suspended constitutional freedoms, gagged the Press, and violated basic human rights by the arbitrary implementation of the Maintenance of Internal Security Act (MISA) and the Defense of India Rules. This dark chapter in the history of Indian democracy witnessed unprecedented levels of state regulation, intervention, and censorship of Indian culture and cinema. The then I&B Minister Vidya Charan Shukla unleashed a series of blatantly repressive measures that were collectively responsible for the fear psychosis that gripped the Indian film industry. His reign of terror ranged from threatening film stars with MISA if they did not actively participate in party propaganda; banning the famous singer-actor Kishore Kumar's songs on All India Radio (AIR) after he failed to appear at a

Youth Congress in Delhi;[23] and suddenly ordering the government TV channel, Doordarshan, to telecast the popular Hindi film *Bobby* (1973) so as to coincide with an opposition party protest rally in 1977 as a bizarre strategy to keep audiences at home and glued to their television sets in a desperate attempt to keep people from attending that rally.[24] The Indian films that were banned included Gulzar's *Aandhi* (*The Storm*, 1975) "because people in power close to Mrs. Gandhi, if not herself, thought 'Aandhi' was simply (Mrs.) Gandhi with the G cut off,"[25] and *Andolan* (1975) due to fears that its depiction of the 1942 Quit India movement "might excite a similar revolution during the Emergency".[26] Other repressive measures included banning the exhibition of classic foreign films such as *The Godfather* (1972), *The Exorcist* (1973), *The Day of the Jackal* (1973), and *The French Connection* (1971) due to newly revised stringent policies on sex and violence;[27] and allegedly destroying Amrit Nahata's political satire, *Kissa Kursi Ka* (*The Tale of the Throne*, 1975), for which Mr. Shukla, along with Mrs. Gandhi's son Sanjay Gandhi, were later formally charged with criminal conspiracy by the Central Bureau of Investigation (CBI) in July 1977.[28]

Rumors and stories abound about Shukla's notorious *modus operandi* and his harassment of film personalities as chronicled in film magazines *Screen* and *Filmfare*, and leading newspapers such as *Times of India*.[29] In a book excerpt titled *Shukla in Filmland: Bluff, Bluster and MISA*, Kamla and D. R. Mankekar reveal "Shukla's style was to bluff, bluster and terrorise to get what he wanted . . . In the film industry as elsewhere Shukla had his henchmen who functioned as intermediaries between Shukla and the industry to strike various deals."[30]

Shukla's close friendship with the legendary producer and then president of the All India Film Producers Council, G. P. Sippy, was well known and explained the enigma behind the release of a violent blockbuster like Sippy's *Sholay* (*Flames*, 1975) by the censors despite a ban on sex and violence at the time.[31] In another sordid incident reflecting the arrogance and highhandedness of Shukla, B. K. Karanjia (also known as BKK in the media), the then chairman of the Film Finance Corporation (FFC), was forced to resign as chairman of the managing committee of the Bombay International Film Festival barely 11 days prior to the festival so that Sippy could take his place. Such examples of nepotism became commonplace during the Emergency, and in due course even Sippy would be embarrassed by his association with Shukla.[32]

Some of Shukla's other diktats included initiating the free broadcast of films on television, on the pretext that it would serve to publicize and raise the standard of Hindi cinema, by browbeating and bullying producers and "in doing so he not only inflicted severe financial losses on the producers concerned, he also did considerable damage to the cause of TV," according to B. K. Karanjia, now editor of *Filmfare*;[33] advocating stricter censorship of lurid journalism by film magazines that he "criticised . . . for their lack of interest in the technological advance of the film industry . . . [instead] carrying semi-pornography

for making money";[34] and inveighing against "the display of cinema hoard-
ings with obscene and objectionable scenes of films when they had been cut
from the films themselves by the censors."[35] Besides cultural stultification, the
business of filmmaking suffered gravely under the reign of the Shukla mafia.
One of the reasons for the stagnancy in film exports in 1976–1977 was due to
the "quixotic censorship policy, which contributed to the delay in the export
of pictures" that placed Indian films in a disadvantageous position.[36] In 1976,
after the enforcement of strict censorship of violence, and the ban on drinking
scenes, enormous extra expenditure was suspected to have been incurred by
producers since numerous complete and in-production films were required to
be reshot to conform to new censorship norms introduced under Shukla.[37]

Popular Hindi cinema was not the only type of filmmaking in 1970s India
that attracted the wrath of the censors in the years leading up to the Emer-
gency. New wave, regional "art" films, and documentaries were also caught
in the web of censorship, such as the Kannada film *Samskara* (*Funeral Rites,*
1970), which won the 1971 National Film Award after being initially banned;
the Tamil film *Tughlak* (1971) directed by Cho Ramaswamy; M. S. Sathyu's Par-
tition film *Garm Hawa* (*Scorching Winds,* 1975); and *Prisoners of Conscience*
(1978) by India's most famous documentary filmmaker Anand Patwardhan.
Even plays written by the eminent Marathi playwright Vijay Tendulkar such as
Shakaram Binder (1972) and *Ghashiram Kotwal* (1972), a political satire, did
not escape punitive measures of being temporarily banned.

On March 13, 1977, in a historic show of support and solidarity for the
opposition Janata Party (People's Party) in the elections, a massive rally was
organized by the film industry in Bombay, which was attended by film person-
alities such as Dev Anand, Pran, and Shatrughan Sinha. Several stars had been
summoned to campaign for Congress party candidates and threatened with
dire consequences if they didn't.[38] Shukla's electoral defeat in March 1977 was a
"welcome relief" for the film industry, which celebrated it "with a score of vic-
tory parties"[39] as he had come to be regarded as "the symbol of censorship and
its misuse during the Emergency ... [and] the architect of the government's
one-sided barrage of pro-Indira propaganda ... which later boomeranged on
the Prime Minister and the Congress."[40] According to Vijay Anand, "The Min-
ister, or for that matter the government had used censorship as a weapon
to threaten film makers ... and so also the authorities controlling raw stocks,
imports and exports. These controls came in handy for Mr. Shukla to bully the
industry."[41]

The 1990s "Censor Wave" and beyond

The historical conjuncture of economic liberalization, unstable political gov-
ernance, globalization (sparking fears of Americanization and "cultural inva-
sion" by the West), the entry of foreign and private satellite communications,

and the rise of Hindu nationalism (known as *Hindutva*) in the early 1990s led to the intensification of regulatory concerns about Indian culture and cinema.[42] The growing popularity of the Hindu nationalist Bharatiya Janata Party (Indian People's Party, BJP) was responsible for the gradual "saffronization"[43] of India. Hindu Right's "sexualization of the visual field"[44] relating to sculpture, television broadcasting, cinema, and even paintings is crucial for an informed understanding of the 1990s censor wave provoked by "transgressive" sexual images in popular Hindi cinema. The prolonged legal battle over the allegedly "obscene" song lyrics *Choli ke Peechey kya Hai* (*What's Beneath the Blouse*) in *Khalnayak* (*The Villain*, 1993), starring the then reigning queen of the Bollywood industry, Madhuri Dixit does, "exemplify the kind of rhetoric used by the BJP and its affiliates to instigate and mobilize public outrage and moral panic regarding sexually explicit and/or violent films."[45] One such film was Shekhar Kapur's *Bandit Queen* (1994), a film based on the real-life-story of the notorious female bandit Phoolan Devi, with graphic portrayal of rape and sexual humiliation. It became the center of a big controversy and intense debate from the moment it was released in September 1994. Devi herself filed a petition in the Delhi High Court demanding the film be banned as it allegedly violated her right to privacy. Describing *Bandit Queen* as a film about "rape, sex and vendetta," the Censor Board recommended ten major cuts and some general ones.[46]

Deepa Mehta's provocative and religiously irreverent lesbianism-centric film *Fire* (1996) caused a furor among conservatives who inveighed against the depiction of "abnormal sexuality" although it had surprisingly been passed by the CBFC with just one cut.[47] After mob violence by fringe elements, it was recalled from theaters for another review, only to be passed by the board again. Ashish Rajadhyaksha argues that "the real right at stake . . . was not so much Deepa Mehta's right to express her ideas on film . . . but, rather, the Indian *people's* right to receive (or not receive) this expression once it had been sanctioned by the Indian state as fit for its public,"[48] thus reorienting the dynamics of censorship from a spectatorial perspective rather than from the conventional authorial position. Other censorship controversies involved the much excised Mira Nair's *Kamasutra: A Tale of Love* (1996), a smoking Shabana Azmi as the eponymous *Godmother* (1999), and Kumar Shahani's *Char Adhyay* (*Four Chapters*, 1997), set in the terrorist phase of the Indian freedom movement, which made the mistake of showing bare breasts. Although more liberal decisions have been taken under the aegis of the former CBFC chairperson Sharmila Tagore (2004–2011), there was some brouhaha about a kiss between two leading stars, Aishwarya Rai and Hrithik Roshan, in the immensely popular action flick, *Dhoom 2: Back in Action* in 2006. It should be noted that the conspicuous and intriguing absence of the screen kiss in Hindi cinema is a manifestation of self-regulation by the Bombay film industry up until the late 1980s. It has been theorized by Madhava Prasad in Marxist terms as symbolic of the "prohibition of the private," which produces and maintains the

illusion of precapitalist, feudal community bonds and disavows the threatening existence of the couple, considered symptomatic of the intrusion of capitalist modernity and individualism.[49] In 2009, bare-backed images of the actress Kareena Kapoor on *Kurbaan* (*Sacrifice*, 2009) posters outraged activists belonging to the extreme Hindu right-wing, anti-Muslim party *Shiv Sena* (Army of Shiv),[50] who sent her a sari to cover up. Words like "Bombay" being used instead of "Mumbai" in Karan Johar's *Wake Up, Sid!* (2009) provoked the displeasure of Hindu nationalists in Mumbai, forcing Johar to tender an apology to the right-wing leader Raj Thackeray and insert a textual disclaimer.

Visual representations of sex and (female) sexuality were not the only provocations that instigated moral panics, outrage, and often violent reactions. Issues of possible religious "hurt," possible incitement to communal violence, and preemptive measures taken to avoid potential law and order problems marked the release of *Bombay* (1995) and *Zakhm,* and the production of *Water* (2005), the last one becoming a victim of "mob censorship" staged by angry Hindu nationalists who torched the sets of a film condemned even before its first shot had been filmed. Focusing on the various stages of censorship of the contentious film *Bombay,* Lalitha Gopalan reveals the extent to which the influential Shiv Sena leader Bal Thackeray (uncle of the above-mentioned Raj Thackeray), acting as "the ex-officio Board of Censors," was involved in censoring the film at the post-production stage.[51] Lalitha Gopalan's case study confirms the nature of power play to be diffused, competing and hierarchical with various lobbies with vested interests and parochial agendas, putting pressure on a film. The subsequent box-office success of *Bombay* due to publicity generated by "the volatile combination of state censorship, the interference of ex-officio forces, such as Bal Thackeray, and the Muslim leaders' outcry"[52] condemning the film also exemplifies the productive nature of censorship.

The Indian public sphere in the 1990s was a minefield that the Bombay film industry had to negotiate cautiously as censorship became a public performative act initiated by extralegal, extraconstitutional interventions by interest groups, powerful entities such as "[Bal] Thackeray [who] was speaking as though he *were* the Indian state,"[53] and non-state agents and institutions. For a growing number of Indians, Bal Thackeray did represent an authentic site of power who could intervene and even mediate as he did in the *Ek Chotisi Love Story* (2002) imbroglio starring Manisha Koirala who had sought his intervention to prevent the film's release. According to Koirala, the director Sashilal K. Nair had inserted objectionable scenes, using her body double, without her consent. Feeling exploited, she had taken the director to court but since she wanted immediate justice she preferred Thackeray's speedy intervention.

More recently, films have been unofficially boycotted for extraneous reasons that have little to do with the form or content of the film per se. The boycott of the superstar Aamir Khan's film *Fanaa* (*Destroyed in Love,* 2006) by exhibitors and distributors due to Khan's vocal support of groups agitating against the Narmada dam construction in the BJP-administered western state of Gujarat is

one such example. Earlier *Parzania* (2005), a film on communal riots and vio-
lence in Godhra, Gujarat, had not been released by exhibitors due to the fear of
violent protest by nationalist fringe groups. The superstar Shah Rukh Khan's
comment that Pakistani cricketers should be allowed to play in the domestic
cricket league in India drew the ire of the right-wing, which stalled the release
of *My Name Is Khan* (2010) for a few months. All three controversies demon-
strate how the film industry and the fate of their films were becoming casualties
of local nationalist politics and regional chauvinism.

There have been more controversies that prominently featured in print and
broadcast media in 2011: first, Balaji Telefilms, the producer of the "scary date
flick" *Ragini MMS* (2011) was asked to remove three sexually explicit, "vul-
gar" scenes despite being given a "A" certification; and second, the insertion of
producer Anurag Kashyap's abrupt, awkward-sounding verbal disclaimer that
drug use and alcohol consumption is injurious to health before the beginning
of *Shaitan* (2011), revealing the presence of the CBFC's interventionist dic-
tates. The third high-profile controversy involving the alleged foul language
and fecal humor in *Delhi Belly* (2011) is an instance of the CBFC's sudden lib-
eralism and the deliberate relaxation of self-censorship by the Bombay film
industry's young blood. *Bhaag D. K. Bose aandhi ayi* ("Run, D. K. Bose, a
Storm Is Coming") is an infamous line from a hit song featured in the run-
away box office success *Delhi Belly,* coproduced by Aamir Khan's company, and
starring his nephew Imran Khan. Certified as an adult film with the tagline
"S#!t Happens," this irreverent black comedy targeting the increasingly afflu-
ent and sizeable youth population, was surprisingly passed without any cuts
by the CBFC, and has since landed the Board in trouble with concerned par-
ents because "D. K. Bose" if read backward or played in loop amounts to an
expletive in Hindi. Justifying its decision to keep the supposed obscenity intact,
Pankaja Thakur, the sole and senior committee member who passed the film,
is quoted to have said that "we [the CBFC] do not certify backwards."[54]

From top-down state regulation and control in the 1970s to various censo-
rious "publics," and the emergence of numerous competing sites of censorial
power in the 1990s, there were (and continue to be) increasing instances of
censorship after the CBFC has cleared films for public exhibition instead of the
prerelease censorship that had been the norm till then. Tejaswini Ganti refers
to this trend as "supercensorship," which refers to "efforts by organized non-
government groups to prevent films that the Censor Board has approved from
being shown in theatres."[55] Whilst the crude censorship tactics of the Emer-
gency remain a blot on the history of Indian democratic freedom that should
act as a reminder of the political follies of censorship, two decades later the
propensity for supercensorship expressed itself through pressure tactics rang-
ing from law suits, out-of-court financial settlements, effigy-burning, police
interventions to vandalizing of cinema halls and death threats. It is the free-
dom to censor rather than the pursuance of the right to freedom of expression
that seems to have become the democratic aspiration (indeed, mantra) of
twenty-first century India.

Acknowledgment

I wish to acknowledge the support of the Office of Research and Sponsored Programs at the University of North Carolina Wilmington (UNCW) for my archival research in India over the summer of 2011 through the Charles L. Cahill Award.

Notes

1. For key literature on the history of film censorship in India, see Vasudev, A. (1976) *Liberty and License in the Indian Cinema.* New Delhi: Vikas; Mehta, M. (2006) What Is Behind Film Censorship? The Khalnayak Debates, pp. 170–187 in Bose, B. (ed) *Gender & Censorship.* New Delhi: Women Unlimited; Mehta M. (2001) *Selections: Cutting, Classifying and Certifying in Bombay Cinema,* unpublished thesis. Minnesota: The University of Minnesota. For censorship of cinema in the British colonial period, see Arora, P. (1995) "Imperilling the Prestige of the White Woman": Colonial Anxiety and Film Censorship in British India, pp. 36–50 in *Visual Anthropology Review,* 105/11 (2); Chowdhry, P. (2000) *Colonial India and the Making of Empire Cinema: Image, Ideology, and Identity.* Manchester: Manchester University Press; Jaikumar, P. (2006) *Cinema at the End of Empire.* Durham: Duke University Press; and Prasad, M. (2004) The Natives Are Looking: Cinema and Censorship in Colonial India, pp. 161–172 in Moran, L. J., Sandon, E., Loizidou, E., and Christie, I. (eds) *Law's Moving Image.* London, Sydney, Portland, Oregon: Cavendish Publishing; and for an explanation of self-censorship of the kiss in postcolonial India, see Prasad, M. (1998) The Prohibition of the Private, pp. 88–113 in Prasad, M. (ed) *Ideology of the Hindi Film: A Historical Construction.* New Delhi: Oxford University Press.
2. CBFC (1998) *Annual Report of 1998.* Ministry of Information and Broadcasting, Government of India, p.1
3. Ibid.
4. Ibid.
5. The media-effects model (aka "hypodermic needle theory"), which proposed that mass media had a direct, immediate, and powerful effect on its audiences, has been disproved by new assessments based on election studies by Lazarsfeld, Berelson, and Gaudet (1944/1968) and is considered an obsolete approach in mass communications theory. It has been replaced by a variety of other, more instrumental models, like the two step of flow theory and diffusion of innovations theory. For more, see Lazarsfeld, P. F., Berelson, B., and Gaudet, H. (1968) *The People's Choice: How the Voter Makes Up His Mind in a Presidential Campaign.* New York: Columbia University Press; and Katz, E. and Lazarsfeld, P. (1955), *Personal Influence.* New York: The Free Press.
6. Bhowmik, S. (2009) *Cinema and Censorship: The Politics of Control in India.* New Delhi: Orient Blackswan, p. 66.
7. Ganti, T. (2009) The Limits of Decency and the Decency of Limits: Censorship and the Bombay Film Industry, p. 91 in Kaur R. and Mazzarella, W. (eds) *Censorship in South Asia: Cultural Regulation from Sedition to Seduction.* Bloomington and Indianapolis: Indiana University Press.

8. Bhowmik, S. (2009) *Cinema and Censorship,* p. 67.
9. "About CBFC." Official CBFC website. See http://cbfcindia.gov.in/.
10. The Khosla Committee was surprised to discover that CBFC members, most of whom were not cine-literate, did not watch and appraise films themselves, a duty that was delegated to the advisory panels attached to regional offices.
11. Bhowmik, S. (2009) *Cinema and Censorship,* p. 183.
12. Ibid., p. 185.
13. The Khosla committee recommendations elicited a large number of letters to the editor and reactions from leading industry personalities, many of whom misread the report as one advocating for more kissing and nudity.
14. The Information and Broadcasting (I&B) Ministry recommended revising the CBFC guidelines in order to curb "obscenity and vulgarity." According to "New Instructions For Film Censorship," published in *Film Information* (December 17, 1994), the consequent "revisions" added to the already existing list of "objectionable visuals" under categories titled *Violence and Vulgarity* were as follows:

 1. Selectively exposing women's anatomy (e.g., breasts, cleavage, thighs, navel) in song and dance numbers, through suggestive and flimsy dresses, movements, zooming particularly in close-shots [sic].
 2. Double meaning dialogues referring to women's anatomy (e.g., breastsor apples or some other fruits).
 3. Stimulation [sic] of sexual movements (e.g., swinging of car, cot).
 4. Man and woman in close proximity to each other or one over the other and in close proximity and making below-the-waist jerks suggesting copulation.
 5. Pelvic jerks, breast swinging, hip jerks, man and woman mounting on each other, rolling together, rubbing women's body from breasts to thighs, hitting/rubbing man with breasts, sitting on each others thighs and waist with entwined legs, lifting and peeping inside a woman's skirt [sic] squeezing woman's navel and waist.
 6. Vulgar kissing on breasts, navel, buttocks upper part of thighs.
 7. Coins, etc. being put inside blouse and other types of eve-teasing as there is invasion of privacy of women's body.
 8. Disrobing women

15. Bose, B. (ed) (2006) Introduction, in *Gender & Censorship.* New Delhi: Women Unlimited. For details of the Act, see pp. 101–106.
16. For a discussion on the censorship of the female form and its conflation with the national imaginary, communal and national honor, see Chatterji, P. (1993) *The Nation and Its Fragments.* Princeton University Press; Ghosh, S. (1999) The Troubled Existence of Sex and Sexuality: Feminists Engage with Censorship, in pp. 233–260 in Brosius C. and Butcher M. (eds) *Image Journeys: Audio-Visual Media and Cultural Change in India.* New Delhi, London: Sage Publications; Kapur, R. (1996) Who Draws the Line? Contemporary Issues of Speech and Censorship in India, pp. 20–27 in *Economic and Political Weekly,* 31 (16–17); Kapur, R. (1997) The Profanity of Prudery: The Moral Face of Obscenity Law in India, pp. 293–302 in *Women: A Cultural Review,* 8 (3); Mehta, M. (2006) What Is Behind Film Censorship? The Khalnayak Debates, pp. 170–187 in Bose, B. (ed) *Gender &*

Censorship. New Delhi: Women Unlimited; John, M. E. and Nair, J. (eds) (1998) *A Question of Silence? The Sexual Economies of Modern India.* New Delhi: Kali for Women.

17. CBFC, p. 1.
18. For more on the trajectory of debates on gender and censorship by Indian feminists over the last 25 years, see Bose (2006).
19. For more details, see the FACT website http://mib.nic.in/fcat/default.htm (accessed on January 5, 2012).
20. For an in-depth analysis of this landmark case on freedom of expression in Indian cinema, see Rajadhyaksha, A. (2009) *Indian Cinema in the Time of Celluloid: From Bollywood to the Emergency.* Bloomington/Indianapolis: Indiana University Press, p.178.
21. Ibid., pp. 177–178.
22. See http://cbfcindia.gov.in/html/uniquepage.aspx?lang=HINDI&va=zakham& Type=search.On the CBFC website [http://cbfcindia.gov.in/], detailed excisions for certain films recommended by the Board can be viewed by entering the name of a film in the search field and selecting the language from the drop-down box.
23. See Mankekar K. and Kamla D. R. (July 22–August 4, 1977) Shukla in Filmland: Bluff, Bluster and MISA, p. 17 in *Filmfare.*
24. Old "Bobby" print telecast to foil Janata rally (October 27, 1977), p. 13 in *Times of India.*
25. Freeze Shots (April 15–28, 1977), p. 17 in *Filmfare;* see also "Aandhi" ban goes (February 6, 1976), p. 1 in *Screen.*
26. Scared of a Revolution (May 13–26, 1977), pp. 26–27 in *Filmfare.*
27. Mohamed, K. (June 9, 1975) The "Exorcist" awaiting only formal ban, p. 5 in *Times of India;* Saari, A. (June 11, 1976) National Cultural Policy in Action: The Why for New Censor Line, p. 1 in *Screen.*
28. Sanjay, Shukla charged: "Kissa Kursi Ka" case (July 27, 1977), p. 2 in *Screen.* This high-profile case of the "missing" film came to exemplify the repression of the Indira Gandhi government. The film was interpreted by the Congress government and CBFC as an unflattering critique of the Gandhi family since the lead protagonist bore striking resemblance to Sanjay Gandhi. Numerous reports of its remake and subsequent censorship, even under the new Janata government, which had assumed power by defeating the Congress Party in the general elections in March 1977, can be found in newspapers and film magazines. For more, see "Kissa Kursi Ka" to Be Remade (July 29, 1977), p. 1 in *Screen;* Shamim, M. (November 19, 1977) Censor Board recommends 15 cuts in "Kissa Kursi Ka," p. 5 in *Times of India.*
29. For more, see Shukla Wants Cinema Solely under Centre (September 24, 1976), p. 1 in *Screen;* Film Censorship to be strict: Shukla (September 29, 1976), p. 14 in *Times of India;* End interference, says filmmakers (March 14, 1977), p. 3 in *Times of India;* Harassed during emergency, says filmmaker (April 15, 1977), p. 5 in *Times of India.*
30. Mankekar (1977), p. 17.
31. Ibid. In an interview with Dev Anand, who refused to toe the ruling Congress Party's line on several occasions including not signing Shukla's notorious television contract, he says, "I like 'Sholay,' it's a beautifully shot film, but if 'Sholay' can be passed, almost any film should be passed." See Subramaniam K. N. (May 27–June 9, 1977) Dev Anand: "Don't Let the Government Interfere," pp. 15–17 in *Filmfare.*

32. FFC's Untold Story (May 13–26, 1977), p. 45 in *Filmfare.*
33. Karanjia, B. K. (April 15–28, 1977) For the Film Industry a New Dawn of Freedom, p. 10 in *Filmfare.*
34. Saxena B. B. (April 27, 1976) No Take Over of Industry, Says Shukla: Censorship to Be More Rigorous, p. 1 in *Screen.*
35. Steps against obscene posters: I. B. Ministry urges States to curb menace (August 6, 1976), p. 1 in *Screen.*
36. Another reason for low export earnings was ascribed to the near-takeover of the film export trade, at Shukla's behest, by a sick corporation that bought films that came for registration at the same prices as offered by overseas buyers. The export trade was in a state of panic and for about six months, there was a virtual stoppage of exports. See Desai, M. S. M. (August 26, 1977) Stagnancy in Exports in 1976–1977: Shukla's policies cause long trade suspension, p. 1 in *Screen.* Another repressive trade policy that had been mooted by Shukla was to change the basis for the imposition of excise duty on films from footage to a 10 percent *ad valorem* system, which sent shock waves through the industry. See Desai, M. S. M. (July 15, 1977) Ad Valorem A Shukla Invention? Industry being made a scapegoat, p.1 in *Screen;* Untold story of excise levy (July 29, 1977), p. 19 in *Screen.*
37. Fresh talks with Shukla on Censorship: Trade may need Rs. 10 crores to recoup (May 28, 1976) p. 1 in *Screen.*
38. Khatib, A. A. (April 15–28, 1977) This must not happen again!: Interview with Vijay Anand, p. 18 in *Filmfare;* also see As Shukla goes to the polls—Filmland Kicks Back (April 1–14, 1977), p. 34 in *Filmfare.*
39. Mankekar (1977), p.19.
40. V. C. Shukla—biggest poll casualty in M.P., (March 22, 1977), p. 9 in *Times of India.*
41. Khatib (1977), p. 19.
42. Hindu nationalist discourses played a catalytic role in the raging censorship debates, in many instances causing or exacerbating the 1990s censor wave. For more on the influence of the Hindu Right on 1990s Hindi cinema, see Bose, N. (2009) The Hindu Right and the Politics of Censorship: Three Case Studies of Policing Hindi Cinema (1992–2002), pp. 22–33 in *The Velvet Light Trap: A Critical Journal of Film and Television,* 63 (Spring).
43. The official color of the BJP is saffron, hence the term "saffronization."
44. John, M. E. (1998) Globalisation, Sexuality and the Visual Field, p. 368 in John, M. E. and J. Nair (eds) *A Question of Silence? The Sexual Economies of Modern India.* New Delhi: Kali for Women.
45. Bose, N. (2010) The CBFC Correspondence Files (1992–2002): A Discursive Rhetoric of Moral Panic, Public Protest and Political Pressure, p. 69 in *Cinema Journal,* 43 (3).
46. See the CBFC website for a detailed description of the recommended excisions for *Bandit Queen:*http://cbfcindia.gov.in/html/uniquepage.aspx?lang= HINDI& va=bandit queen&Type=search. For a detailed account of controversies over cultural and sexual regulation that triggered moral panics in early to mid-1990s, see Ghosh, S. (1999) The Troubled Existence of Sex and Sexuality: Feminists Engage with Censorship, pp. 233–260 in Brosius, C. and M. Butcher (eds) *Image Journeys: Audio-Visual Media and Cultural Change in India.* New Delhi/London: Sage.
47. For a legal-feminist perspective on *Fire,* see Kapur R. (April 20–27, 2000) Too Hot to Handle, pp. 53–64 in *Feminist Review* 64 (Spring) and Kapur R. (1996) Who Draws

the Line? Contemporary Issues of Speech and Censorship in India, pp. WS15–WS30 in *Economic and Political Weekly*.

48. Rajadhakshya (2009), p. 173.
49. For more on the theorization of the absence of the kiss in popular Hindi cinema, see Prasad, M. (1998) *Ideology of the Hindi Film*.
50. The party is based in Mumbai in the state of Maharashtra, where the Bombay film industry is also located. Its leader is the powerful and charismatic Bal Thackeray and its activists are known to be violent, destructive, and lawless.
51. For a detailed account of the protracted censorship of *Bombay* by various extra-constitutional forces, particularly the insidious role played by Thackeray, see Gopalan, L. (2005) *Bombay*. London: British Film Institute.
52. Gopalan (2005), p. 33.
53. Rajadhakshya (2009), p. 172.
54. For more on this controversy, see Lalwani, V. (June 17, 2011) DK Bose lands Censor Board in trouble, in *Mumbai Mirror, Times of India*. See http://m.timesofindia.com/PDATOI/articleshow/8885495.cms
55. Ganti, T. (2009) The Limits of Decency and the Decency of Limits: Censorship and the Bombay Film Industry, p. 115 in Kaur R. and W. Mazzarella (eds) *Censorship in South Asia: Cultural Regulation from Sedition to Seduction*. Bloomington/Indianapolis: Indiana University Press.

Irish Film Censorship: Refusing the Fractured Family of Foreign Films

Kevin Rockett

Despite the great social and cultural changes that have occurred in Ireland since its independence in 1922 and the fact that the explosion in new technologies has both challenged film's dominance and led to film no longer exclusively being presented in cinemas, the legislation governing the public exhibition of film in Ireland remains largely unchanged since 1923 when the Censorship of Films Act was introduced. According to the Act, anything "indecent, obscene or blasphemous" or "contrary to public morality" should be cut or banned altogether.[1] As we approach the 90th anniversary of Irish film censorship, this chapter sets out to provide a historical and cultural overview of the Act. The chapter notes how conservative Catholic and secular liberal censors alike have sought to retain the Act's anachronistic, and at times anomalous, key terms, and suggests that the Act has become increasing irrelevant, most especially so in the context of new distribution technologies and the consequent shift in viewing practices from within public spaces to private ones.

Cultural Protectionism and the New Irish State

Prior to the introduction of filmed entertainment in Ireland, there was in the country an already well-honed Catholic–nationalist movement opposed to all forms of imported popular culture on the grounds that much of it served as a vector for material anathema to the principles of Catholics (as in English newspaper reporting of divorce cases) and nationalists (as in English music hall acts, which were often of a jingoistic nature, particularly during the Boer

War). By the time of the opening of Ireland's full-time cinemas (1909–1914), by which point films had shifted away from actuality in favor of more challenging drama productions, often featuring fractured families, independent women, and an urban modernist sensibility, not only had both the Catholic church and cultural nationalists[2] grew in power within the broader society, but also their respective attitudes to cinema and more generally to expressions of urban or alien (secular) modernity, were becoming even more closely aligned and entrenched. It was in this context that in 1916[3] Dublin Corporation, the country's most important municipality, followed the evolving British example and interpreted the existing 1909 legislation (Cinematograph Act, see also Chapter 9) regarding cinema as conferring the right to regulate and censor the content of films. Despite strong protests from film exhibitors, the reinterpretation of the Act through which annual cinema licenses were issued on compliance with certain public health and safety conditions, led to as it transpired 100 films being banned in Dublin over the following six-year period. While this figure might appear high within a European or contemporary context, it was extremely low in terms of what would follow and reflects less on the quality of the films or the morality on the censors, but on the shambolic administration of the Act's censorship provision. Dublin Corporation, adopting the approach within theater censorship, assessed films only after their screening, thus allowing many films to complete their short run before an edict could be issued, or to escape scrutiny altogether.

Unsurprisingly then, when a separate Irish state began to seem a reality in 1921, a broad inter-denominational alliance, which favored more rigorous film censorship, began to demand that the new sovereign entity give urgent consideration to replacing the censorship powers invested in the 1909 Cinematograph Act with a national film censorship regime administered by the new government. To that end, and even though the civil war was continuing, an inter-denominational delegation met with Kevin O'Higgins, the minister for Home Affairs (now Justice), in February 1923 and within four months the Censorship of Films Act 1923 was passed into law, thus ending the power of Irish local authorities to censor films. It proved to be the opening salvo in a predominantly Catholic-led protectionist campaign aimed at restricting all alien influences in culture, including literature, dance, and music. The Censorship of Publications Act was passed in 1929; the Dance Halls Act, which sought to contain the body's sexual desire by allowing further clerical surveillance of public dancing, in 1935, while "jungle music" [jazz] was prohibited from the national radio station. As might be expected, Lenten pastoral pronouncements, often of a hysterical nature, issued by Catholic bishops scapegoated these cultural pursuits for the country's ills, with cinema, for example, being blamed for anything from emigration, as it lured young girls to the big city, to the corrupting of the family through exposure to consumerism.[4]

The 1923 Act, which continues unchanged in its essentials to the present, requires that a film must be passed by the Official Film Censor, a state official,

before it can be screened publicly anywhere in the jurisdiction. While the Censor's decision can be appealed by the film's distributor with final adjudication passing to a nine-person appeals board, which historically has always included senior Catholic and Protestant clerics, appointees of the archbishops of Dublin, in practice, and with the exception of a brief period in the 1960s, there have been few significant policy differences between the two branches of censorship. In contrast to the detailed censorship criteria of the British Board of Film Censorship (BBFC) (from 1913, see Chapter 9) and the later American film industry's self-regulation of the "Don'ts" and "Be Carefuls" (1927), reformulated in the Production Code (1930–1934) (see chapters 1, 2, and 14), the 1923 Act states that a film may not be certified for public exhibition if it is deemed to be "indecent, obscene or blasphemous" or is "contrary to public morality." Such subjective terms have allowed Irish censorship policies to be endlessly malleable as is clear from the fact that on average during the first 20 years of film censorship, about 100 films per year were banned, principally by the first censor, James Montgomery[5] (1923–1940), while, over the last 20 years, less than one per year was banned.

Underpinning all national film censorship in Ireland from its beginning to the mid-1960s was the acceptance of the exclusive position of the traditional nuclear family as the basic unit of the state. Therefore, any cinematic representation that deviated from the moral values associated with, or which in any way challenged, the family (for instance references to or representations of abortion, birth control, homosexuality, extramarital affairs, and divorce), was banned or cut. Furthermore, these early censors took the view that anything that was illegal in the new Irish Free State (e.g., divorce), or was, from a conservative perspective, socially transgressive (e.g., women smoking or drinking alcohol), should be removed with the films cut or banned accordingly. Indeed, for James Montgomery, who admitted to knowing nothing about cinema, representations that infringed the Ten Commandments, which he took as his censoring guide, were to be denied to Irish audiences. Given the Fifth Commandment's prohibition on murder, it is surprising that any Western or gangster films were ever screened in Ireland. However, sex and domestic violence, with their more pervasive sensuality, their potential to arouse both empathy and voyeurism, and their closer relation to the everyday experience, have tended to preoccupy Irish censors more than the kind of violence within classical Western and gangster films. Such was the extent of the censors' activities that even dignified representations of religious events were not immune from censorship. Following the dictate of the Catholic archbishop of Dublin, who opposed any films being shown in public that represented the sacraments, not only was Erich von Stroheim's *The Wedding March* (1928) banned, but also cut was a factual film featuring Pope Pius XI at Lourdes saying mass, from which the elevation of the Host was cut.

The second defining feature of censorship in this period was that almost all films were certified for general audiences only, with less than ten films,

including Alfred Hitchcock's *Psycho* (1960) and Michael Powell's *Peeping Tom* (1960), given over 18 certificates, though both examples cited were initially banned and only passed after extensive cuts. This practice of refusing to distinguish between children and adults, in line with the state's "infantalizing" of its citizen evident in its protectionistic social, economic, and cultural policies, no doubt contributed to the extreme level of censorship, whereby from 1923 to 1965, roughly 2500 films were banned—five times the banning by the BBFC from its beginnings in 1913 to the early 1970s[6]—and another 10,000–12,000 were cut. Yet, despite the activities of the Irish censors, who, it should be remembered, were censoring films that had already passed through filtering processes, including from 1934, the strict regime of the Production Code Administration and the Irish-American-influenced Legion of Decency, and the BBFC, Catholic lay and clerical agitators in Ireland continued to press for stricter censorship. Indeed, by way of response, the (Catholic) National Film Institute of Ireland began to issue their own ratings of films released in Ireland in 1954 (a practice that only ended in 1972).[7] Arguably, for some, including perhaps the first film censor, only (socially unacceptable) suppression of cinema itself would have been satisfactory.

Exposing the Contradictions and Liberalization

Though the liberalization of film censorship in Ireland only began in the late 1960s, nevertheless, 20 years prior to this, creaks in the system were becoming apparent following the production both in Europe and in America in the postwar period of films for adult audiences. By the 1950s, it was European rather than American cinema that was posing the greatest challenges for conservative censors in all countries. While Great Britain, for example, responded in 1951 by introducing the "X" certificate, which limited screenings to over 16s, a policy similarly adopted in other countries, the more interventionist censors in Ireland refused to issue adult-only or age-limitation certificates on the grounds that these "would arouse [in both the excluded and included constituencies] unhealthy curiosity" in such films, and as a result Irish cinema-goers experienced a version of cinema perhaps unique in the world whereby many of these adult-oriented films, even if in heavily cut versions, were released in Ireland for a general audience. Though a number of these "transgressive" films, such as Roberto Rossellini's short *Il Miracolo* (*The Miracle,* 1948), which helped to break down censorship restrictions in the United States, were not submitted to the Irish censor as distributors knew how they would be dealt with, when other such films were submitted they were routinely cut to ensure that a Catholic or innocent sensibility would not be challenged. For instance, Vittorio De Sica's *Umberto D* (1952) and Giuseppi De Santis's *Riso Amaro* (*Bitter Rice,* 1950)—two films aesthetically and formally related to Rossellini's short as they were neorealist—were released with

six cuts (including references to the "house of assignation" and to pregnancy),[8] and ten cuts ("Silvana's' erotic dance and her 'showing too much leg' while sitting on a bed"),[9] respectively, with the latter's title also changed to *The Harvesters*.

Nevertheless, despite the severity of film censorship, which, at times, even extended to removing a film's central element such as in *Anatomy of a Murder* (Otto Preminger, 1959), which was cut at 57 places to eliminate references to the central trope of rape, prior to the 1960s, Irish audiences were largely unaware of the levels of state intervention. Furthermore, many, particularly in urban areas, continued to regard cinema as *the* experience of the week, in part a reflection of the paucity of entertainment or cultural alternatives. Indeed, while cinema-going elsewhere, such as in Britain, saw a dramatic decline, in Ireland audience numbers actually grew in the postwar period up to 1954 and only thereafter began to decline gradually until 1960 when the decline became more pronounced.[10]

By the early 1960s, however, even the Irish censors were beginning to recognize that the absence of age differentiation was leading to serious anomalies, something that a new generation of secular liberal film critics began to mercilessly expose, not least in the context of the fact that few British new-wave films were being passed for public exhibition in Ireland and those that were, were so mutilated that they were almost unrecognizable. When, for the first time, film exhibitors and distributors joined the chorus of criticism of film censorship policy, the state was obliged to act. Belatedly, in 1965, the minister for justice, Brian Lenihan, gave his approval for limited certificates to be issued. (Two years later, the minister also liberalized book censorship through the expedient of the "12-year rule" whereby banned books become automatically unbanned after 12 years.)

Nevertheless, liberalization proved a torturous process and despite films being categorized as over 16s or over 18s, and even, in rare instances, over 21s, in a great many cases such films continued to be heavily cut. Though *The Graduate* (Mike Nichols, 1967), for example, was eventually passed with an over-18 certificate by the appeal board, having been banned by the film censor, it was passed only after cuts, 11 in total, which transformed the nature of Ben's (Dustin Hoffman) relationship with Mrs. Robinson (Anne Bancroft) into a furtive, seedy affair and dramatically reconfigured the sexual chemistry between them. Such "moral" editing recalls earlier censorship practices whereby according to James Montgomery he routinely "improved" films, such as, in films featuring divorce and remarriage, by eliminating all references to the first marriage, thus making the second marriage in effect the first and only relationship, thereby ensuring that Irish audiences would not be contaminated by the concept of divorce. Under this new liberal regime, Irish audiences finally were allowed to view adult material, or at least see unmarried people engaging in sexual relationships, but the scenes were limited or edited to the point where often the important context was lost.

By the early 1970s, the strains between the then very conservative film cen-sor, Christopher Macken, a psychiatrist, appointed in 1964, and the more lib-eral appeal board were leading, for the first time in the history of national cen-sorship, to public controversy concerning the increasing divergence between the two branches of censorship. However, following the retirement of Macken in 1972 and the appointment of Dermot Breen, though no liberal, a more streamlined censorship regime was reestablished. Breen, the director of the Cork Film Festival, set a precedent for all future censors, in that not only had he a background in films—his three successors, Frank Hall (1978–1986), Sheamus Smith (1986–2003), and John Kelleher (2003–2009), were all involved in tele-vision or film production—but also he was, generally speaking, more practical rather than idealist in his decisions. Breen began to adapt censorship practice to the changing social and cultural environment, one in which the power of the Catholic church and the moral values associated with it were on the decline, while the ideas and aspirations of the generation that had experienced 1960s' youth culture and its subsequent iterations came to the fore. More than them it was an environment in which critiques of censorship became part of ongoing public discourse within an increasingly questioning media.

One significant form by which censorship was relaxed was the "seven year rule." Introduced in 1970, it allowed the judgment on a film—whether it was banned, cut, or given limited certification—to be reviewed after seven years. It was through this legislative amendment that *Monty Python's Life of Brian* (Terry Jones, 1979), banned by Frank Hall in 1980 under the blasphemy pro-vision in the 1923 Act, was passed uncut in 1987 by Sheamus Smith albeit with an over-18s certificate. Smith, as a former television producer and film stu-dios' executive, not only took the position that films should not be cut, but also, repositioning himself more as a classifier than as a censor, only rarely banned films. During his almost 17 years in office he only banned 10 films and cut 16. However, many of the small number of films he did not pass includ-ing Abel Ferrara's *Bad Lieutenant* (1992), Oliver Stone's *Natural Born Killers* (1994), and Robert Rodriguez' *From Dusk till Dawn* (1996), were subsequently certified, usually for video release (as their theatrical life had passed), either through the appeal board or under the seven-year rule.

Thus, by the 1990s Irish film censorship was more or less aligned with its British counterpart, even if Ireland tends to be less concerned than its neigh-bors about "language," and more concerned about sex. Unsurprisingly, in this context the one major difference between Ireland and other jurisdictions has been with regard to pornography. While most other Western countries have found various mechanisms to allow for the public consumption of "soft" and "hard" core pornography, often through specialized "adult-only" theaters, no such avenues have opened up in Ireland with regard to the legal exhibition of pornography in public theaters. Nevertheless, the availability of new con-sumer electronics products, namely the domestic videocassette recorder (and its digital successors) and personal computers linked to the internet, but also

the television, has brought about a paradigmatic shift in accessibility whereby previously forbidden representations can be readily accessed and Irish censorship restrictions are not only legally or otherwise bypassed, but also diluted as censors try to keep apace of the reality. Consequently, by the early 2000s, films that could be characterized as "soft" pornography, and for private viewing rather than theatrical presentation, became widely available in DVD outlets, with many such retailers featuring an "adult" DVD section of the *Playboy* magazine type. While the availability of this material poses particular challenges for the state and censorship, not to mention film exhibitors, perhaps the biggest difficulty is ensuring how these images can be confined to the "correct" or the appropriate-age target audience, given that these images are being viewed in the home.

The Family as the Unit of the State

As has been noted above, the yardstick used by Montgomery and other early film censors was the family as the basic or foundational unit of the state. Therefore, films that directly or indirectly challenged the notion of the ideal family, or included representations unsuitable for a child, were cut or banned accordingly. While such a view of the family and that of the nurturing (stay-at-home) mother and supportive (working) father was enshrined in the 1937 Irish Constitution and "protected" by the state ban on married women working within the civil service (removed only in 1973, four years prior to discrimination in employment generally on the grounds of sex being made illegal), it is one that bears little relation to reality. Today, not only are one-third of Irish children born "out of wedlock," but also the home has been exposed as the primary place of abuse for many children such that an amendment to the Irish constitution was passed in November 2012 to ensure the formal protection of children.

While the new wave of more liberal censors, more attuned than their predecessors to the messy realities of society and not so often bound by ideological straitjackets, have responded to "problematic" representations of nontraditional families and traditional families in negative light, and other non-child friendly images, by issuing age-limitation certificates, the proliferation of new distribution formats located within the domestic environment presents a serious challenge to the effectiveness of the censor. Though the issue of enforcement has occasionally surfaced with regard to the (sometimes relaxed) regulation of age classification by cinema managers, when it comes to the issue of enforcing age-limitation certificates within the private space of the family home, the state, it would seem, is powerless. This is of particular interest given the increased number of technological devices in homes, or used outside it, on the move, as it were, through which films and/or games can be accessed, and the changing nature of the Irish family, whereby increasingly

techno-savvy children are often allowed to wander freely and unsupervised in cyber and other screen-based spaces.

It is a historical coincidence that the first record of a film being available on video in Ireland is September 1979, the same month as Pope John Paul II visited the country. This visit—his first abroad—has come to be seen as the last high watermark of Catholicism in Ireland. Afterwards the church's authority has been diminishing such that in July 2011 Irish prime minister Enda Kenny was able to make an unprecedented and direct attack on the Vatican because of its refusal to cooperate in the investigation of child sexual abuse cases involving Irish clergy. The new "democratic" distribution of screen-based representations through the VCR and the circulation of material that had been banned or that would never have been submitted to Irish censors presented new challenges. In the wake of moral panics generated by an hysterical media over films such as Meir Zarchi's *I Spit on Your Grave* (1978) and Abel Ferrara's *The Driller Killer* (1979), and following Britain's introduction of the 1984 Video Recordings Act (designed in response to its own, often reactionary, "video nasties" campaign—see Chapter 9), Ireland passed into law the Video Recordings Act 1989.

In contrast to the vagueness of the 1923 Act, the 1989 Act, which, importantly, makes no provision for cutting of films and extends the remit of the 1923 Act in that films passed for theatrical or public exhibition are automatically entitled to a video certificate, includes detailed and specific prohibitions, with many of these copied from or based on prohibitions listed in the 1984 British Act. According to the 1989 Act, a censor has the power, among others, to reject films for video (or similar formats such as laser disk or DVD) if a film or images therein would induce people to commit crimes; or, would be likely to stir up hatred against people on the basis of religion, nationality, and, significantly in the Irish context, sexual orientation—an amendment to the bill accepted reluctantly by the government at a time when the more assertive gay rights agitation was taking hold and that eventually led to the decriminalization of gay relationships in Ireland in 1993. Other clauses state that films were to be banned if they *might* "deprave or corrupt" people "who *might* view them"; while the "depiction of acts of gross violence or cruelty (including mutilation and torture) toward humans or animals" was to be prohibited.

While it could be argued that all such "offensive" representations were already covered within the subjective and more malleable criteria of the 1923 Act, as this writer highlighted in a report to the minister for justice in 1987, the references to violence and cruelty "greatly extends censorship as it has applied to films. The mere depiction or representation [no matter how brief or justifiable within the context of the film] of any acts of gross violence or cruelty will lead to automatic banning of a video film."[11] Given that a single frame is enough to deny a film a video/DVD certificate and that films must be passed or banned in their entirety, it is perhaps to be expected that the Official Film Censor, who also oversees the administration of video censorship, carried out

by a panel of censors, views a theatrical film with an eye to what will happen to the film when released on video/DVD. It was perhaps for this reason that in 1997 Sheamus Smith ordered a single cut of about 35 seconds from David Cronenberg's *Crash* (1996) of a homosexual encounter in the hope that it would stop the film's release on video due to the costs involved in preparing a cut copy for Irish distribution. However, the distributors accepted the expenses and the film was released on video. Nevertheless, by the 2000s, such interventions in theatrical films had largely disappeared.

From the beginning of video censorship in Ireland, video censors have not so much been interested in films made for a mainstream audience (though at times such films, including Tod Browning's 1932 film *Freaks*, have failed to get passed),[12] or even, since the early 2000s, "soft" pornography and erotica, as they have been committed to containing transgressive or explicitly challenging, often pornographic, or disturbing gross-out films, a number of which might be characterized as "video nasties." Indeed, from 1991 and the banning of Ken Russell's *Whore* (1991)—the first video to be banned in Ireland, quickly followed by the notorious "video nasty" *Slaughter/Snuff* (1971; 1976) and the more mainstream horror *The Texas Chainsaw Massacre* (1974)—to 2003, of the considerable 3200 videos banned, almost all could be classified as pornography, extreme horror, or 1970s sexploitation films with a sample range of titles including *Deep Throat II* (1974), *Russ Meyer's Up!* (1976), *Zombi 2* (*Zombie Flesh Eaters,* 1979), *The Erotic Adventures of Bonnie & Clyde* (1988), *Nightmare on Porn Street* (1988), and *Booberella* (1992). (Some of these, including Russ Meyer's films, have since been certified.)

Furthermore, it seems that a significant proportion of these were not, in the first instance, submitted to the video censors, but seized by customs officers at seaports and airports (much of it thought to be gay pornography). Nevertheless, ownership of such material for personal use is legal. In fact the dramatic drop in video/DVD titles banned in the 2000s owed in part to a legal mechanism whereby prosecutions were made under the 1989 Act following confirmation from the censor that the seized films were without Irish certificates. While only five DVDs were banned in 2007 (including the video game *Manhunt 2;* and a number of adult/pornography titles), there were no prohibitions either in 2008 or in 2009, with 6690 titles being certified in 2009, a drop from 2006 when there were 9926 certifications, many from film studios' back catalogues, but almost 22 times the number certified for theatrical release. Despite the considerable difference between the number of titles submitted for video and theatrical films, the movies of these two kinds released in 2009 for over-18s were both 6.2 percent. Although reflecting both the vast amount of children's material made for the straight-to-video market and the level of classic reissues, the G or PG category within video was 44.3 percent compared to 23.5 percent for theatrical films.[13] Nevertheless, the range and ratios of certification classes, in both theatrical and video censorship, places Ireland within mainstream Western classification.

In line with the evolution of censorship in Ireland, the title of Official Film Censor was changed to Director of Film Classification in 2008. Indeed, the then censor, John Kelleher, a former national television and independent film producer, made explicit the new role by emphasizing that it was providing consumer information and commentary rather than being engaged in censorship per se. With this change of policy, prohibition and cutting went out of practice. Thus, the office's website states that it provides "the public and parents in particular with a modern and dependable system of classification that protects children and young persons; has regard for freedom of expression; and has respect for the values of Irish society." Its approach to classifying cinema films and video/DVDs is guided by three main principles: "We believe that adults (i.e., persons over 18) should be free, within the law, to choose what they wish to view. We have a duty to protect children and young persons from harm. We strongly encourage and promote the exercise of parental responsibility."[14]

A further responsibility of the film classification office is video games. However, these are not classified under the Video Recordings Act 1989, but under the voluntary code of the Pan European Games Information (PEGI) system of which Ireland is a founder member. Nevertheless, the Irish classifiers are proposing, as part of a review of the 1989 Act, that the PEGI classifications be incorporated into the Act and given the same status as existing video classifications. While only a few controversies have surrounded PEGI classifications, even if many object to the violent and often sexist nature of some games, the same issue surrounds video/computer games as DVDs and films available for download, that is, how is it possible to enforce adherence to (national) age-limitation certification given that these are consumed within the private sphere, notwithstanding their leakage into the broader (semi-) public sphere through shared youth culture. Indeed, classifiers have been to the fore in expressing concern regarding the challenges posed by the home entertainment market. For example, the Irish classification office, in response to "video-on-demand" via the internet, has initiated meetings with the relevant parties in an attempt to clarify potential regulatory and/or advisory avenues. Ultimately, however, it is a societal and cultural issue rather than a technical or legal one not just because of the nature of the internet, but because the point of consumption is in a protected private space and intrusion into that space is forbidden under the Irish constitution.

The Internet and Screen Surveillance in the Home

Though it was recognized at an early stage in the development of the internet that it was beyond the power of state regulators to impose local controls, in Ireland, as happened elsewhere, an Internet Advisory Board was established in February 2000. With former deputy film censor Audrey Conlon appointed chairwoman, its approach has been to offer guidance on best practice with

regard to the use of the Net with advice ranging from having computers in family rooms only where an adult can observe what is being viewed, to the education of young people in their use of social network sites (SNS), such as being made aware of the potential risks in revealing personal information online, to "grooming" by pedophiles and other predators. Indeed, the earliest moral panics in relation to the Net were largely focused on networks of pedophiles exposed as grooming children and/or exchanging illegally produced (sexual) images of children being abused or raped. These globally circulating images and documents of abuse also found their market in Ireland, mostly, as was the case elsewhere, among middle-class, and often married, males.

While the resulting court cases, which continue to grow in number and extremity, with some leading in Ireland to custodial sentences prosecuted under the Child Trafficking and Pornography Act 1998 (also targeted at sex tourism), can be seen as just a minor, though vile, aspect of the internet, it is the case that more mundane and consensual adult material is increasingly available on the Net. Without much effort, and not requiring the payment of any fees, an unsupervised child can, quite easily, view sexually explicit material of a kind that, prior to the internet, was unavailable in Ireland, and in other places only circulated through state-regulated sex cinemas or sex shops. The reality of children accessing inappropriate material and otherwise behaving without due care to their personal safety online is of particular concern not least given that within many modern families, even when there are high levels of protection in place vis-à-vis the public street, and apart from a dilution in optimal levels of care that an increasing number of children face in Ireland as a result of practical and cultural factors,[15] children are often permitted to go online via such devices as the family computer, their own smart phones, and even their DSi consoles, with little or no supervision from parents or other guardians, or, are allowed, through neglect or otherwise, to access age-inappropriate DVDs and games, often of a violent or misogynistic nature.

Indeed, the combination of mobile phone ownership by children and their use of social network sites reveals that regulators and many parents are losing the "battle" not only to contain what teenagers might watch or with whom they might engage, but also of pre-teens or tweenagers, too, who are one of the main demographics being targeted by advertisers. Despite the fact that the policy of social network sites (SNS) such as Facebook is not to permit under 13s to have an account, the reality, as a 2011 European Union survey of SNS usage revealed, is that an average of 38 percent of 9–12-year-olds use SNS, with Ireland just below the average at 35 percent, though, as in Britain, considerably less, only 14 percent of 9–12-year-olds, have their profiles set "public," perhaps a result of the success of various internet campaigns highlighting the dangers.[16] However, a 2011 survey conducted by the Irish Society for the Prevention of Cruelty to Children (ISPCC) found that over one-third, or 36 percent, of primary school children (mostly aged 11) did not know how to keep their social network accounts private.[17] In any case, such are the concerns that in September 2011

the Irish Data Commissioner announced an investigation into all aspects of Facebook's information retention and distribution policies.[18] Incidentally, the same month saw drinks firm Diageo, formerly Guinness, reveal a promotional deal whereby its advertisements would be carried on Facebook, raising, once again, concerns about the spread of the teenage drinks' epidemic to preteens.

While 86 percent of households reported in a comprehensive 2009 Irish survey that they had computers, only 8 percent of 9-year-olds had a computer in their bedroom. However, one-third of all children who had a computer at home recorded that they were allowed to use the internet without adult supervision. In their use of the Net, the nine-year olds reported that it was used most frequently for playing games (cited by 86 percent), followed by surfing for school projects and fun (50 percent) and for watching movies (29 percent).[19] More disturbingly, in October 2011 the ISPCC revealed that of the 15,196 secondary-school-aged young people (54 percent aged 14–16; 33 percent aged 11–13) surveyed, 44 percent of them used the internet in their bedroom.[20] However, even if the home computer is closely monitored, the increasing availability of smart phones among children makes effective supervision extremely difficult. Mobile phone ownership, or, more pertinently, smart phone usage with its built-in Internet software, by the same 9–16 year olds, is becoming more widespread with, in Ireland, almost all 13 year olds and almost half of 10 year olds having mobile phones, while 45 percent of the latter group have televisions in their bedrooms.[21] Thus, the main impediment to full access by tweenagers and teenagers alike to all aspects of the internet, including the proliferation of cinema films, old and new, mainstream and pornographic, is the cost of topping-up the mobile/smart phone or paying the monthly bill, rather than parents denying or restricting their children's access to such media.

In the context of these new technological devices and the profound sociocultural changes in Ireland, particularly acute since the mid-1990s to mid-2000s consumer boom, Ireland's censorship history can now be regarded as quaint and paternalistic, and thus may be sneered at by modern secular liberals. However, it would seem that there is insufficient reflection within public discourse of what it has given way to, and the fact that one extreme has been replaced by another, such that now many young people are at risk of being psychologically scarred not by restrictions, but by post-1960s' liberalism and a heightened notion of individualism.

Notes

1. For a more detailed account of the issues discussed, see Rockett, K. (2004) *Irish Film Censorship: A Cultural Journey from Silent Cinema to Internet Pornography.* Dublin: Four Courts Press.
2. Cultural nationalism promoted Irish-Ireland sports, the restoration of the Irish language and activities such as Irish dancing, music, and drama.

3. This was only a few months after the Easter Rising, which heralded in eight years of intermittent war against the British occupation of Ireland and led to a civil war between nationalists and republicans over the partition of the country following the 1921 Anglo-Irish treaty.
4. For an account of Catholic film policies in this period, see Chapter 7 in Rockett (2004), *Irish Film Censorship.*
5. James Montgomery was a retired employee of the Dublin Gas Company, and, in common with all film censors and members of the appeals board until the 1970s, he had no background in film. He had the advantage over other candidates for the post of Official Film Censor in being a friend of the minister for Home Affairs.
6. Robertson, J. C. (1989) *The Hidden Cinema: British Film Censorship in Action, 1913–1972.* London/New York: Routledge, p. 2.
7. For the history of the National Film Institute of Ireland, see Rockett, K. with E. Rockett (2011) *Film Exhibition and Distribution in Ireland, 1909–2010.* Dublin: Four Courts Press, Chapter 8.
8. Official Film Censor's reserve no. 9524, August 23, 1957, National Archives of Ireland. However, no certificate for the film seems to have been issued as the distributor perhaps withdrew the film rather than agree to the cuts.
9. Official Film Censor's reserve no. 7822-23, no. 25389, certificate issued on October 3, 1950.
10. Though the Irish have been regarded as among the greatest cinema-goers in the world (at present they are just above the European average)—a status also suggested by a dominant memory among many Irish people, especially prevalent in memoirs and in oral history projects for the interwar period—the reality of this does not stand up to scrutiny and in part was a consequence of long queues outside cinemas. However, these were largely for cheap seats with the (empty) dearer seats above the incomes of the majority of patrons. In the mid-1930s, for example, when Britons went to the cinema 22 times per annum, Irish people only went 6 times, and though Dubliners, who accounted for 60 percent of Ireland's total box office receipts, had an average of 23 annual visits, this was less than that of many major British cities.
11. Kevin Rockett to Minister for Justice, December 7, 1987, in Rockett (2004), *Irish Film Censorship,* p. 284.
12. *Freaks* had its video ban renewed in 1999 because it was deemed "grossly offensive" to disabled people. Also *I Spit on Your Grave* had its ban reconfirmed in 2010.
13. Of the 307 feature films certified for theatrical distribution in 2009, no film was banned; 103 (33.5 percent) had 15A certificates; 72 (23.5 percent) were G (General) or PG (Parental Guidance); 57 (18.6 percent) were limited to over 16s; 56 (18.2 percent) had 12A certificates; while only 19 films (6.2 percent) had over 18s certificates. Videos for the same year were certified as 1839 (27.4 percent) for 15 year olds; 1468 (21.9 percent) for 12 year olds; 2964 (44.3 percent) G or PG; and 419 (6.2 percent) for over 18s.
14. See the Irish Film Classification Office's website, www.ifco.ie
15. These might include parents working outside the home, or, at another level, embracing the relatively recent ideas of the entitlement to quality "me" time, and that children are best served by having independence foisted on them instead of guiding them to that point in a supervised and directed environment.
16. See www.eukidsonline.net

17. See *National Children's Consultation and the Internet,* Irish Society for the Prevention of Cruelty to Children, 2011, accessed at http: www.ispcc.ie/Media/ Publications October 2011.
18. Facebook is the most popular SNS in Ireland with 34 percent of 9–16 year olds using it compared to the next highest, Bebo, which has 22 percent of this age cohort, while 41 percent do not use SNS. See *EU Kids Online,* www.eukidsonline.net
19. *Growing Up in Ireland, National Longitudinal Study of Children: The Lives of 9-Year Olds* (2009), Dublin, Stationery Office, pp. 122–123.
20. See note 17.
21. *Growing Up in Ireland, National Longitudinal Study of Children: The Lives of 9-Year Olds* (2009), Dublin, Stationery Office, pp. 118–123. It should be noted that televisions and VCR/DVDs in bedrooms, and the amount of time spent playing video games, was greatest among lower income groups and in one-parent families.

Part IV

Censorship Multiplicity, Moral Regulation, and Experiences

13

Nollywood, Kannywood, and a Decade of Hausa Film Censorship in Nigeria

Carmen McCain

One of the most striking stories in recent global film history is the dramatic rise of the Nigerian "video film" industry, dubbed Nollywood, a prolific low-budget film industry based in Africa's most populous country. Turning out over a thousand feature films a year, the Nigerian film industry relies mostly on digital video technology and "straight to video" releases, which are sold on DVD and video CD in the informal economy of the west African market.[1] A former British colony, Nigeria, was cobbled together from around 400 different ethnicities and language groups, the largest of which are Hausa, Igbo, and Yoruba. After gaining independence in 1960, Nigeria suffered a civil war, from 1967 until 1970, and a series of military coups. Now a federation of 36 states, the country is in its third period of civilian rule, which began in 1999 with the handover of the military to a democratically elected government.

While the international media regard the Nigerian popular video industry as a novelty, state-sponsored cinema began in Nigeria in the colonial era and continued into the age of television. The most commercially successful feature films were those that developed out of the popular Yoruba travelling theater in the 1970s. Unlike the more internationally celebrated Francophone African cinema, often funded and promoted by France, commercial Yoruba cinema was largely self-supporting.[2] When structural adjustment programs imposed by the International Monetary Fund (IMF) in the mid-1980s caused the Nigerian economy to shrivel, popular theater filmmakers and business entrepreneurs began to turn from unaffordable celluloid production to the

more economical option of shooting on VHS video. By the late 1990s, most had adopted digital technology.[3]

Because video cameras and computer editing programs were low-cost and user-friendly, the industry was self-sustaining and largely self-taught. Video films were shot, edited, and reproduced in Nigeria by Nigerians, for the most part to be seen on TVs and VCRs in homes and in small video viewing centers rather than in cinemas.[4] As Brian Larkin has pointed out, piracy networks that developed around the distribution of Hollywood and Bollywood films facilitated the legal distribution of local videos. Former pirates became legitimate distributors called "marketers," who had access to a gigantic Nigerian market—a population of over 167 million by 2011.[5] Piracy networks also made the videos available to audiences beyond the reach of local marketers. The popularity of the films and their stars grew beyond Nigerian borders into the rest of Africa and beyond. By 2002, this thriving video film industry had become known as Nollywood, seen increasingly as a counterpart to the popular American and Indian cinemas.[6]

The cultural and religious diversity of Nigeria—the south identifying largely with Christianity and the north with Islam, though each region has large minority populations of the other faiths—fostered distinct regional video industries. Jonathan Haynes notes that just as the name "Bollywood" conceals the diversity of the multiple language industries within India, so also does the name "Nollywood" obscure the diversity of what is being made in the country.[7] Within Nigeria, there are separate but thriving film industries in Hausa, Yoruba, and the official national language of English, as well as upcoming industries in smaller languages such as Bini, Efik, and Ibibio.[8]

This chapter will address official censorship in Nigeria and will focus on censorship of the Hausa film industry, popularly called Kannywood, from 2001 until 2011, exploring political discourse in which Muslim identity is employed to both suppress and defend the creative arts. The information presented here is based on field research carried out in northern Nigeria from June to August 2006, and June 2008 to January 2012, using qualitative ethnographic research methods of interviewing members of the Hausa film industry and its critics as well as participant observation in editing studios and on film sets.

Censorship in Nigeria and the Birth of the National Film and Video Censors Board

For almost as long as there has been film in Nigeria, there has also been censorship. In 1912, nine years after the first newsreels were shown in Nigeria, the British colonial government put forth the "The Theatre and Public Performance Regulation Ordinance," which regulated exhibition space of performances and films. In 1933, a formal censorship board was founded by statutory appointment to censor both propaganda films and commercial films imported

by the Colonial Film Unit and business people, as well as local church productions. As Paul Ugor points out, colonial censorship policies were mainly concerned with security and protecting their interests.[9] Following independence, the colonial laws were revised to become the "Cinematographic Act" of 1963/4 forming the Federal Board of Film Censors (FBFC).[10] The new law, which applied to local and imported films, included prohibitions against "expos[ing] people of African descent to ridicule and contempt" or "encourage[ing] racial religious or ethnic discrimination" and layered onto colonial concerns that films not "undermine national security," "encourage illegal or criminal acts," or "reinforce corruption of private and public morality." The FBFC incorporated new members in 1971 and was reconstituted in 1977. The 16 members of the board represented various government bodies, as well as Christian and Muslim interest groups, and were split into four regional censors committees. In 1987, a supplemental "Communication Policy" was written, "which touched on areas relating to the educational and entertainment value of films, its capacity for promoting national unity, and its potential for enhancing national culture."[11]

Ademola James observes that by the late 1980s, it had become obvious that the 1963 law, which covered only cinema, was no longer relevant in the current "video invasion." Not only were dozens of local films now being made on video, but also thousands of video clubs were renting out pirated videos of uncensored foreign films, which gave rise to fears about cultural imperialism. In 1993 the FBFC was dismantled and replaced by the National Film and Video Censors Board (NFVCB), which began to function as an agency on June 15, 1994, with Ademola James as its pioneering executive director. The 1993 law expanded the definition of "film" beyond celluloid to cover video and established a classification system for viewers.[12] Building on the nationalist principles of its predecessors, the national censorship act is a broad-ranging law that licenses and regulates exhibition space and distributors, and requires every film, foreign or local, to be submitted for review before release. Censorship guidelines include concerns about national unity and regulate violence, obscenity, and negative cultural stereotypes, as well as the technical quality of the films.[13] By 2001, the NFVCB had established a zonal office in the northern city of Kano, one of the most prolific film production centers in the country, to complement film registration services offered in zonal offices in southwestern Lagos, southeastern Onitsha, and the centrally located capital of Abuja.[14]

While federal censorship seemed largely based on developmental and nationalist concerns, the board under Rosaline Odeh, executive director of the NFVCB from 2001 to 2005, became more active in censoring content ostensibly to protect Nigeria's cultural and religious sensibilities. She put a rating of "18" on "films containing violence, ritual, sex crime etc." and in an attempt to remove "violence, rituals, voodooism and the like from our airwaves" banned any such film from television broadcast.[15] Ugor notes that critics accused Odeh of "subjecting film censorship to what they considered to be narrow Catholic

Image 13.1 The NFVCB seals a video shop in Kaduna, Nigeria, for purported violation of regulations

Christian dogmas,"[16] yet Odeh's strict Christian views on censorship were paralleled by Islamic censorship developed by the northern state of Kano shortly before she took office.[17]

Islam in Hausaland and the Controversy Surrounding the Hausa Film Industry

The ancient walled city of Kano, now the capital of Kano state, was one of the seven major Hausa city states in what is now northwestern Nigeria. As an important trade center in West Africa, Kano had been exposed to Islam since at least the fourteenth century. Following the early nineteenth century Islamic revolution led by ethnic Fulani scholar Usman dan Fodiyo against what he saw as the corruption and oppressiveness of the ruling Hausa elite, mixed urban dwellers began to identify themselves as "Hausa-Fulanis."[18] When colonialism was introduced after the British conquest of Kano in 1903, Islamic scholars

began to express anxieties about foreign ideas and activities they saw as corrupting Hausa-Fulani Muslim culture. The cinema was symptomatic of these fears. First built in the 1930s by Lebanese businessmen and situated in new colonial areas where settlers from all over Nigeria lived, the cinemas, which from the 1960s screened mostly Indian films, were seen as un-Islamic spaces, havens for thugs and prostitutes.[19] When in the 1990s, the young Hausa video film industry, centered in Kano, began to rapidly grow alongside the southern Nigerian industry, it was branded with many of the same unsavory associations. The first Hausa video films in the late 1980s and early 1990s grew out of drama groups that had produced content for television before turning to making independent productions, and many early films were based on the controversial *soyayya* (love) novels, a thriving market of Hausa language literature that deals with romance and family politics. The novels drew accusations of being overly influenced by Indian films and were often condemned in sermons from the mosque. Indeed, according to Abdalla Uba Adamu, "the Kano State Government set up a Books and Films Production Control Agency in 1996. The Agency was established principally to monitor the publishing of books and home videos and censor their contents, grade them appropriately for public consumption." But while an edict to back the activities of the agency was drafted, it was never released by the government, and the control agency fell by the wayside.[20]

As video films became more popular, they drew into the profession young people who had first come to love the medium through watching Indian films in cinemas and on television and videos at home. Many of the same contradictions surrounding cinema culture also applied to the Hausa video film industry. As Larkin notes,

> For most Hausa, cinema is not serious, detracting youths from proper *tarbiyya* (religious training), yet many attend precisely because they feel they receive moral instruction, and there is no question that this instruction (and not just escapism) is one of the pleasures of cinema.[21]

However, the forms of instruction the youth found valuable were sometimes the very aspects that put them into conflict with the larger society. Adamu recounts the furor that occurred over several early Hausa films. Upon the release of *Saliha?* (1999), a film about a girl, Saliha, who constantly wore the head and neck covering, the hijab, as a sign of her virtue only to be revealed as having had sex before marriage, "a fatwa (Muslim clerical ruling) of death sentence was issued on the director and the producer of the film by a religious group in Kaduna." The group insisted the film be taken off "the market and the film's makers apologize to the Muslim community for what was seen as disrespect for Islam." After the first screening of another film, *Malam Karkata* (*Twisted Teacher,* 1999) "dealing with a rogue marabou who insisted on sexual gratification for dispensing spiritual consultation to emotionally distressed

women," marketers "vowed not to stock, sell or distribute the film." Adamu points out the conflict between filmmakers who seek to reform society through exposing hypocrisy and a public that considers respect for privacy as essential to Islamic identity.[22] Another source of conflict was the Bollywood-style song-and-dance sequences between young men and women often wearing Western clothing included in most of the films. Although filmmakers often argued that the films would not sell without singing and dancing, the films drew the ire of religious leaders and the elite. They were seen as introducing "alien values" and spoiling the upbringing of Muslim children. Zulkifl Dakata, for example, states that while Hausa language films replaced the Indian film in the market, "instead of using our culture to promote and sustain our indigenous development," they "unfortunately went on to continue serving us with the same elements that have always threatened to degrade" it.[23]

The stakeholders in the Kano film industry, which by 1999 was known as Kannywood, took measures to address concerns about morality. Sabo Nayaya describes how distributors "established their own censoring committee" and refused to sell any videos not previewed by the committee. "[T]he objective was to do away with obscenities and other unwanted portions" they believed would "bring chaos or cause disaffection between the people."[24] Alhaji Musa of Malam K'ato video shop recounts how video sellers heard negative feedback about the films from their customers. When he visited the NFVCB office in Abuja before a zonal office was established in Kano, he realized that only one of the film reviewers understood Hausa. Though a main objective of the NFVCB was to make sure the films did not disrespect other ethnicities or religions, Alhaji Musa was concerned that they didn't understand Hausa culture or religion. Coming back to Kano, he called a meeting of the marketers' association and other film stakeholders after which they opened an office that would review films before they were released on the market.[25]

The marketers' review board was formed during a time of widespread campaigning for the reimplementation of Shari'a law, the Islamic judicial system in effect from the revolution of reformer Usman Dan Fodiyo until the British conquest. When civilian government was reinstituted in Nigeria in 1999 after years of military rule, the newly elected governor of northwestern Zamfara state interpreted the 1999 constitution as allowing northern states to implement Shari'a law. The masses began to demand that this law be instituted all over the north. Although there was some amount of opposition from northern Muslims and widespread protests by Christian minorities that led to a series of violent conflicts, political rhetoric presented Shari'a as a way to bring justice to the poor and right the damage done against the Islamic state by colonialism, which had, as Mamman Lawan Yusufari argued, "bequeathed a 'one-legged' Sharia" by limiting Islamic law "only to personal and business matters."[26] Kano Governor Rabiu Musa Kwankwaso bowed to political pressure, and on June 21, 2000, Shari'a law was publically declared in Kano. Among the evils "sanitized" were prostitution, alcohol consumption, and filmmaking.[27]

Abdulkarim Mohammad, the first president of the Motion Picture Practitioners Association of Nigeria (MOPPAN), an association founded in 2000 to advocate for northern filmmakers with the federal government, recalled the sudden pronouncement on December 13, 2000 "from the Kano state government prohibiting the sales, the production, and the exhibition of films in Kano state because of the introduction of Shari'a." MOPPAN helped associations, including the Kano State Filmmakers Association, Kano State artist's guilds, cinema owners, and cassette sellers associations, present their cause to the government, listing the number of filmmakers involved in each association and the "average capital" brought by each person into the industry. As Mohammad puts it, although they "embraced" the government's "pronouncement wholeheartedly because it is through Shari'a," they appealed to the government to provide them "an alternative means of livelihood" or allow them to continue making films. In reply the government asked the filmmakers to come up with a solution.[28]

Birth of the Kano State Censorship Board

The solution the filmmakers came up with was state censorship. In 1999 the second NFVCB-sponsored National Film and Video Forum had recommended that the NFVCB "be the only film and video regulatory body in the country" so that the existence of multiple boards would not stifle "the fledgling industry."[29] However, when Mohammad and other filmmakers perused the law, they realized that "if any state government feels that there are some provisions of the NFVCB that are not taking adequate care of the locale of the state, they are at liberty to create their own state censorship boards." MOPPAN worked with the state government to create the Kano State Censorship Board (KSCB), which would enable filmmakers to return to work, while also providing a political concession to the religious leaders who had urged a ban on the industry. Henceforth filmmakers wanting to access Kano markets would be required to pass their films through both the NFVCB and the KSCB before release.[30]

Much of the "State Censorship Film Board Law 2001" and regulations enacted on February 1, 2001, reproduce almost word for word, criteria from the 1993 NVCB law stipulating that films should have educational value and should not encourage violence, criminality, obscenity, blasphemy, and religious or ethnic conflict. New regulations specific to Kano prohibit men and women from entering the same auditorium unless the cinema provides a "hijab" separating men from women, which in effect meant that women were no longer admitted into cinemas. The law also gives the board power to "register the State film Industry operators and other related persons" and to regulate film producers, publishers, and distributors.[31]

According to Mohammad, the film industry was given four out of 16 seats on the censorship board, which also included representatives of various

government agencies and at least two "Islamic scholars of high repute."[32] For the most part, the bureaucratic oversight of the law proved to be the political compromise that enabled filmmakers to continue working, although they began to self-consciously present themselves as "Shari'a compliant." Actors were often listed as *masu fadakarwa* (sermonizers) in the closing credits of films, and Matthias Krings writes about a proliferation of "Islamic conversion films" shortly after the introduction of Shari'a, dramatizing the superiority of Muslims among the pagan people, though romantic singing and dancing films were still the most commercially successful.[33] According to Nayaya "singing and dancing between male and female" was prohibited;[34] however, this prohibition was rarely enforced, not even in 2003 when a new governor, Ibrahim Shekarau, was voted in after campaigning on promises that he would better implement Shari'a law. As a part of his program, he instituted the Hisbah Board (Shari'a police) and a Societal Reorientation Directorate "aimed at combating indiscipline and "restoring our cherished values": "uprightness, good manners, patriotism, and respect for law and order" through social initiatives.[35]

At the KSCB in 2006, six out of the ten prohibitions listed in a flyer distributed to filmmakers titled "*Ka'idojin Duba Fina-Finai*/Criteria for Reviewing Films" specify concerns about un-Islamic behavior, such as close dancing between men and women, or women wearing form-fitting clothing or leaving their hair uncovered.[36] Despite these rules, the board usually tolerated the frequently donned Western dress and controversial storylines that often included violence or sexual innuendo, but they did occasionally ban films. One of these was the *cinema vérité* film *Bakar Ashana* (*Black Matches*, 2004), produced by Aminu Bala, which explores the ambiguous world of prostitution. Because Bala censored the film with NFVCB but bypassed the KSCB, the board ordered him arrested and fined, as well as the ban and seizure of the film from Kano shops.[37]

While MOPPAN tended to be concerned with encouraging positive portrayals of Hausa society, some younger filmmakers pushed boundaries with edgy content, claiming that they were attempting to correct society by mirroring it. Aminu Bala passionately defended *Bakar Ashana* as a film that educates girls about the dangers of prostitution.[38] Filmmaker Abbas Sadiq had internalized unwritten censorship rules. While directing me in a special appearance in one of his films, *Martaba*, in July 2006, he stopped me from shaking a man's hand, saying that the censorship board didn't allow men and women to touch. All the same, he resented the board and the public opinion in Kano it stood for, insisting that where he had grown up in the north-central city of Jos, young people wore Western clothes and mingled freely. "They should know that Nigeria is not a uni-cultural state. Nigeria is a multi-cultural state," he said mentioning that he had received emails from people all over the country and even abroad appreciating his films. "Culture is not static," he argued. "It always changes."[39]

Sex Scandal in a Shari'a State and the Tenure of Abubakar Rabo Abdulkarim

In August 2007, a scandal shattered any remaining cordiality between the censorship board and the film industry. A leaked mobile phone video of a Hausa actress, Maryam Hiyana, having sex with a lover, Usman Bobo, spread quickly around Kano through illicit Bluetooth transfers. Although the video had been made privately and had no relation to the industry, it was called the first Hausa "blue film." The scandal confirmed public fears about filmmaking. Vice President of MOPPAN at the time, Ahmad Sarari, claimed that clerics "used the opportunity to call for our heads" and that actors and actresses were being harassed in public.[40] MOPPAN called for the suspension of film production for three months and quickly expelled Hiyana and 17 other members suspected of "unethical conducts" that might bring "the film profession to disrepute."[41] The KSCB further imposed a five-year ban on films in which Hiyana appeared.[42]

In September 2007, the governor appointed Abubakar Rabo Abdulkarim, formerly deputy commandant of the *hisbah*, as executive secretary of the KSCB. His title was soon inflated to "director general." Rabo, as he was called by the film industry, interpreted the censorship law rigidly. In a press release, he laid down stringent new guidelines: production companies were required to employ people with diplomas and certificates in the field and have a "minimum of N 2.5 million [naira, around $16,000 (USD)] as working capital." Scripts had to be submitted to the board for approval, and singing and dancing were banned. He also pushed MOPPAN's original suspension of film activities to six months, until February 2008, required that literary works be submitted for censorship, and that authors, publishers, and booksellers must individually register with the KSCB.[43]

The new regulations regarding production company finances or educational requirements for practitioners indicate concerns similar to those of the NFVCB about the "professionalization" of the industry, although with only one active film school in the country at the time, such stipulations were almost impossible to meet. They also indicate a desire to more strictly control the artists themselves, especially women in the industry. Although the law had made provision for the registration of artists, this had never been enforced, as it was considered to be the responsibility of the filmmakers' associations. Additionally, although MOPPAN had an unwritten practice of disallowing women to act after they were married, this is the first time that specific characteristics were required of film stakeholders by state law. On the individual registration forms, single women involved in the industry were required to "state reasons/circumstances." All women involved in the industry were required to be under the care of a male guardian who had to sign a document agreeing that he would be "liable" if his ward broke the rules. Married women were officially banned from acting. Standards on dressing in films were also tightened with stipulations that "Female actresses are henceforth banned from appearing in

any film wearing trousers, skirts and mini/night gowns that are erotic/sexually harassing" and also are "banned from having combed out hair"; "Male artistes must not play any role in a film wearing tight cloth, very short attires or passionate [sic] barbing, which does not suit our customs and cultures."[44]

From 2007 to 2011, over a thousand people employed by the film and entertainment industry were arrested and fined or served prison sentences, including singers, editors, marketers, video viewing center owners, and video gaming center employees. Rabo seemed to judge success by the number of arrests. In an undated progress report published on the KSCB website, item 21 referred to the "menace of the TV game," which had been banned. "[M]ore than 1000 culprits were arrested and prosecuted by mobile court after disregards to calls and warning while about 1,500 TV sets and other equipments were confiscated by the court."[45] Most of those arrested were taken to a "mobile" court attached to the censorship board and were sentenced within a few hours, often without having a lawyer present.

Among the most famous arrests were those of Adam A. Zango, Rabilu Musa, and Hamisu Lamido Iyan-Tama. Director, actor, and singer Adam Zango was arrested shortly after Rabo assumed power. He was accused of obscenity and releasing his uncensored music video album *Bahaushiya* (*Hausa Girl,* 2007) during the ban. The album included a track condemning hypocrites who sexually abuse young girls, a track where Zango danced on a rubbish heap calling on youth to improve Nigeria, and several tracks in which dancing girls exposed their midriffs. Zango was punished with a large fine and a three-month prison sentence.[46] Rabilu Musa (Ibro), the most famous comedian in northern Nigeria, was arrested with fellow comedian Lawal K'aura. They were accused of having a production company they did not register with the board and for releasing an uncensored film *Ibro A Loko* (*Ibro in the Ally,* 2007). Rabo later claimed that the charges did not refer to the film *Ibro A Loko,* which had been censored before his tenure, but to an uncensored compilation of singing and dancing sequences excerpted from various films that had the same title.[47] Although the comedians denied both charges, Rabilu Musa and Lawal K'aura did not have a lawyer to plead for them, and K'aura claimed that they followed the advice of "court workers" to plead guilty so that the judge would "have mercy" on them.[48] They were sentenced to two months in prison. The popular press speculated that Ibro was arrested because one of the songs from *Ibro A Loko* had been used by fans to mock the governor.[49] Hamisu Lamido Iyan-Tama, one of the oldest and most respected directors in the industry as well as a former gubernatorial candidate who had run against Shekarau, had won awards from previous administrations of the KSCB for his family-friendly films. He was arrested on his return from the Zuma Film Festival in Abuja, where his film *Tsintsiya* (*Broom,* 2008), featuring an interethnic interreligious romance that promoted national unity, had won "best social issue film." Although he had made radio announcements that his film was not for sale in Kano, he was arrested because a few copies had been found in the office of a

video shop raided by the censorship board. Despite having a receipt for registration, he was also accused of not registering his company with the board. He spent three months in prison. Later all charges were dropped and his record cleared.[50]

The harsh penalties filmmakers and marketers suffered for ostensible censorship violations, as well as requirements like having to pass a script through the censorship board before shooting or individually registering with the board, led many of them to flee the state, moving their film productions a few hours' drive south to the more liberal cities of Kaduna, Jos, and Abuja, which were not subject to the censorship laws in Kano state. The new center of Hausa film production shifted to Kaduna. Although many filmmakers continued to take their works to the KSCB so as to access the powerful Kano market, others identified themselves as "Nigerian filmmakers," using their certificate from the NFVCB to bypass the KSCB. After the arrests began, such films were generally labeled "not for sale in Kano" and if found in Kano were known as "cocaine."[51]

Ironically the actions of the KSCB, taken to protect what Rabo called the "clean and respected clan" of the Hausa-Fulani ended up opening the Hausa film industry to the wider nation.[52] Indeed, Kannywood star Ali Nuhu believed:

> the ban may have been a blessing in disguise. Most of my colleagues had never thought of leaving their comfort zone up until now. And after this, they've come to realise that moving opens your eyes to a whole new world of ideas. Unlike the previous setting that was largely local, which restricts the kinds of activities you can engage in as an artist, there is a lot more improvement now.[53]

Filmmakers and musicians claimed they did not have to be defined by Kano, that they were Nigerians and could sell their art in the 35 other states of the nation. Using this reasoning, MOPPAN and various filmmaking associations engaged in a series of lawsuits against the censorship board. MOPPAN was placed in the ironic position of challenging the state assembly for passing a law MOPPAN had helped create, claiming that there were aspects of the law being implemented that contradicted the NFVCB. Representatives of MOPPAN argued that once the national board approved their film, they should be able to show it anywhere in the country.[54] This was backed up in writing from the NFVCB. The "Frequently Asked Questions" page of their website, confirms, "The Censors Board has a national coverage. Once a film or video work has been passed by any of its zonal committees, it can be exhibited in any part of the Federation."[55]

The Contradictory Impulses of Censorship

In an interview with me, Rabo expressed his fears of "adulteration" of Hausa-Fulani culture by outside influences. If their culture "is being poisoned, or [...] misrepresented in [...] creative arts, obviously there will come a time

where Hausa-Fulani will have no place to be traced."[56] This nativist desire to protect culture from alien influences is parallel to what Achille Mbembe calls an "Afro-radical" ideal. Both nativism and Afro-radicalism, Mbembe argues, operate from the same episteme of "autochthony, each spatio-racial formation" having "its own culture, its own historicity, its own way of being," believing that the wound of the colonial encounter, "cannot heal until the ex-colonized rediscover their own being and their own past."[57] While a rebellion against what Tejumola Olaniyan has called the "the seeming inevitability of" foreign "dominance in the lives of the natives" is understandable,[58] nativist thought at its extreme adapts the simplified and controlling vision of the world presented by colonialism, essentializing as the only "genuine culture" that which is most useful to those in power. Although the KSCB law included many passages from the NFVCB regulating disrespectful representations of the religions and ethnicities of the nation, in practice, the KSCB under Rabo attempted to "liberate" Kano from the nation with a narrow definition of culture that does in fact discriminate against and repress diversity of culture or opinion.

Yet, as Mbembe points out, Africans have long dealt with multiplicities of cultures and assimilation of new thought. The history of Islam in Africa is one in which "the state is only one example of the possible forms of social organization legitimized by the Prophet. In other traditions, it is the political authority itself that is shrouded in suspicion. Does it not risk corrupting the religious?"[59]

The conflict between the KSCB and the filmmakers articulates what Olaniyan has called the difference between a "sacred" essentialist and a negotiable "secular" process-oriented propositions of identity.[60] Both censors and filmmakers frequently express devotion to promoting Islam and "passing a message" through film. Both sides also often express support for the ideals of Shari'a law. However, the censorship board focuses more on protecting, guarding, and controlling the masses and their culture, while filmmakers and their allies seek to expose hypocrisy and demonstrate the consequences of excess.

Rabo's public use of religious rhetoric made it difficult for the "secular" NFVCB to intervene without appearing to meddle in religious freedoms. In a savvy move in June 2009, then director general of the NFVCB, Emeka Mba, appointed Ahmad Sarari, then vice president of MOPPAN and brother of Iyan-Tama, as the NFVCB zonal coordinator of the northwestern region of Nigeria, giving a Muslim member of the Kano film community authority from the national body. Filmmakers claimed both national and Muslim identities. After Rabo made accusations about the supposed illicit sexual behavior of the filmmakers, the Kano State Filmmakers Association took him to a Shari'a court for slander, demonstrating that ideally Islamic law cuts both ways.[61] Although court cases were bogged down by bureaucracy, the artists' most powerful weapon against the government was their creative work. Musicians working with the film industry responded to censorship with fiery songs. Their invectives were subsequently banned by KSCB but passed, as the homemade Hiyana sex video had, through Bluetooth on mobile phones.[62] One musician,

imitating the comedic voice of Ibro, composed a satirical song *"Sankarau ya kama ni"* (Meningitis seized me, 2009) playing on the rhyming words of *sankarau* (meningitis) and Shekarau (the governor) to metaphorically retell the story of Rabilu Musa's arrest and imprisonment. Adam Zango responded to his prison time with a song *"Oyoyo"* (Welcome, 2008) calling on God to deal with those who had imprisoned him. Musicians like Nazir Ahmad Hausawa with *"Girgiza Kai"* (Shake Your Head, 2008) and Aminuddeen Ladan Abubakar with *"Hasbunallahu"* (Allah Is Sufficient, 2009) followed this pattern, singing prayers to God to punish those who kept them from their livelihoods.

If Rabo accused filmmakers of sexual misbehavior, the filmmakers fired back with films that exposed the sexual sins of an outwardly pious elite. In Aminu Bala's film *Jagora* (*Guidance*, 2009), when a businessman is killed by his servant, an imam claims the man was pious, but a lawyer reveals that he kept a mistress and was trying to rape the servant when she stabbed him. Saeed Selbar's *Kyalli* (*Glitter*, 2010) reveals a politician, who campaigns on promises to send filmmakers back to "pushing wheelbarrows in the streets," to be having an affair with an actress as well as having had an extramarital affair in which he fathered two influential members of the entertainment industry. He is eventually captured on camera murdering a rival. In even more direct jab, the film *Jidda* (2010) and the forthcoming sequel *Dr. Rabo,* written and produced by Nasir Gwangwazo, presents a lecherous doctor named Rabo who extorts sex from a woman, Jidda, in return for treating her dying husband.

In telling these stories, filmmakers capture the rhetoric of the youth, who often complain about the hypocrisy of leaders who use Shari'a to punish the poor while they themselves commit worse sins. Although the Hiyana scandal became representative of all that the critics feared about the industry, there was a strong backlash among youth against the demonization of Hiyana and the film industry. The actress became an unlikely folk hero. Stickers of her likeness were plastered on buses, taxis, and motorbikes all over the north. Adamu points to blogs that sprang up online defending Hiyana as a victim and pointing back at a hypocritical society and "errant ... Islamic scholastic establishment."[63] One pseudonymous female wrote "The uproar and self-righteous indignation expressed over the issue is almost laughable ... because we are a nation that selects known adulterers as leaders."[64]

In an ironic twist of fate, in August 2010 during the holy fasting period of Ramadan, newspapers and radio reported that Rabo was caught by the police parked with a young girl in suspicious circumstances. Rumor had it that the police, after a Hollywood-style car chase, found the girl's underwear in the car.[65] Although Rabo continued to carry out the occasional raid on musicians and filmmakers, he had lost the respect of much of society. In the gubernatorial elections a few months later, the All Nigeria Peoples Party (ANPP) of the Shekarau government, who had given license to Rabo and the most extreme critics of the film industry, was voted out and Kwankwaso, the Peoples Democratic Party (PDP) governor under whom the KSCB was first founded, was

Image 13.2 Filmmakers on a film set in August 2010 gather around to read the news of Rabo's sex scandal

voted back in, resuming office in June 2011. MOPPAN and a league of popular actors had campaigned for Kwankwaso, believing that he would bring back the original interpretation of the KSCB as a protective agency run by and for artists. They were not disappointed. On November 25, 2011, Kwankwaso appointed Ahmed Dahiru Beli, the original head of the KSCB, as the executive director once again. Members of the film industry, including Rabilu Musa, who had been imprisoned by the previous board, were given seats on the board.[66] The board had come full circle in the ten years between 2001 and 2011. The events had a mixed-up poetic justice that seemed to come straight out of a Hausa film: the governor who first banned film in Kano came back promising the salvation of the film industry; the censor appointed after a sex scandal to "sanitize" a film industry was disgraced by his own sex scandal; an actor imprisoned by the censors board was appointed to the board in the next political tenure. A public discourse that idealized politicians' promises to use Islamic law to protect culture moved toward indignation over how those same politicians abused Shari'a to hide their own corruption.

 The first ten years of state censorship in Kano illustrate both the political contradictions of censorship and the increasing difficulty of formal state censorship in a digital world. Rabo's attempts at suppressing the industry had coincided with the rise of social media, Bluetooth technology, and satellite television stations dedicated to showing Nigerian films. Driving the filmmakers out of Kano, had, in fact, made them less dependent on the ancient Kano market. As a result of attempts to "sanitize" and control the industry, many

filmmakers had become more outward-looking and media-savvy. Once Rabo was out of office, filmmakers splintered into associations that no longer looked to MOPPAN for guidance and many film stakeholders who had supported Kwankwaso during the elections turned against his party during a January 2012 national economic crisis when the ruling PDP government removed fuel subsidies and the cost of living doubled. They remarked that they were accountable not to the politicians but to the masses who watched their films. It seems that the local censorship crisis had made filmmakers both more independent and politically confident, which in future might prove to be a training ground for a larger national struggle.

Acknowledgments

This research was made possible with the support of the Fulbright Hays grant, the Ebrahim Hussein Fellowship for Research in African Literature, the Harvey Fellowship, the West Africa Research Association Pre-Doctoral fellowship, and the Department of Mass Communications at Bayero University, Kano.

Notes

1. According to a 2010 report by the Verification Unit of the National Film and Video Censors Board, 1612 Nigerian films were submitted to the board in 2010. 1114 were approved for release. See NFVCB (2010) *Annual Report for 2010 from Film Verification Unit,* December 31.
2. Ukadike, N. F. (1994) *Black African Cinema.* Berkeley: University of California Press.
3. Haynes, J. (ed) (2000) *Nigerian Video Films,* Revised and Expanded Edition. Athens, OH: Ohio University Centre for International Studies.
4. Some Hausa and Yoruba films continued to screen on a circuit of individual film shows in cinemas to recoup costs before being released on video. See Haynes (2000) for a historical description of Yoruba film shows, and my interviews with Hausa filmmakers Saeed Selbar (2008) in Jos and Abbas Sadiq (2006) in Kano. Recently there has been an upsurge of larger budget "new Nollywood" films that run for several weeks to months in multiplex cinemas in Nigeria's largest cities.
5. Larkin, B. (2008) *Signal and Noise: Media, Infrastructure, and Urban Culture in Nigeria.* Durham/London: Duke University Press; National Population Commission (2011) Nigeria's over 167 Million Population: Implications and Challenges, NPC, http://www.population.gov.ng, date accessed December 15, 2011.
6. Adamu mentions that the term "Nollywood" was first used on September 16, 2002 in *The New York Times,* whereas the Hausa film industry has been called "Kanywood" since August1999 when Kano-based *Tauraruwa/Star* magazine started the usage. See Adamu, A. U. (2010) North of Nollywood, South of the Sahara: Cultural Dynamics in the Marketing of Hausa Video Films, p. 2 in *Nollywood a National Cinema: An International Workshop,* July 7–9, 2010, Kwara Hotel, Ilorin, Nigeria.

7. Haynes, J. (2007) "Nollywood": What's in a Name?, p. 106 in *Film International*, 5 (4).
8. English language films, which according to 2010 statistics make up around 12 percent of the films produced in Nigeria, are widely exported across Africa and into the African Diaspora and are best known by the Western media. Nigerian language film industries, the largest of which are Yoruba (at around 55 percent) and Hausa (at around 30 percent), cater mostly to their own language communities in Nigeria and surrounding countries. In 2005, the South African satellite company M-Net began to beam English language Nigerian films across Africa with their station "Africa Magic" and in 2010 opened "Africa Magic Hausa" and "Africa Magic Yoruba," which broadcast across West Africa. Because Nigerian language films aired by M-Net are subtitled in English, they reach potentially wider audiences than they had before satellite broadcast was started. See NFVCB (2010), and the Africa Magic website at http://beta.mnetafrica.com/AfricaMagic/.
9. Ugor, P. (2007) Censorship and the Content of Nigerian Home Video Films, pp. 1–22 in *Postcolonial Text*, 3 (1).
10. James, A. (2007) *The Making of Nigeria's Film and Video Revolution*. Lagos: Publicomm Associates, p. 1.
11. Ugor (2007), p. 5.
12. James (2007), pp. 1–6.
13. NFVCB (1993) NFVCB Act. Chapter N 40.
14. NFVCB (2002) *Film and Video Directory in Nigeria*. Abuja: NFVCB, pp. 57–59.
15. Ibid., p. 59.
16. Ugor (2007), p. 12.
17. Odeh's successor, Emeka Mba, who took over as director general of the NFVCB in 2005, was less concerned with content. He insisted several times, during a round table on July 22, 2011, at the *Nollywood in Africa, Africa in Nollywood* conference held at Pan-African University, Lagos, that the government could not control subject matter. Instead, he devoted his tenure to attempts at formalizing the distribution system to fight piracy.
18. Abdul, M. O. A. (1973) *The Historical Origin of Islam (with Some Reference to West Africa)*. Lagos: Islamic Publications Bureau.
19. Adamu writes that Lebanese distributors initially showed mostly American and British films in their cinemas, but that in November 1960 following Nigerian independence, Indian films were introduced and proved to the most popular films in northern Nigeria. Larkin reports that by the 1990s Indian films were shown five nights a week, while Hong Kong and American films were shown the other two nights. See Adamu, A. U. (2008) The Influence of Hindi Film Music on Hausa Videofilm Soundtrack Music, pp. 156–157 in M. Slobin (ed) *Global Soundtracks: Worlds of Film Music*. Middletown, CT: Wesleyan UP; and Larkin (2008), p. 157.
20. Adamu, A. U. (2004) Loud Bubbles from a Silent Brook: Trends and Tendencies in Contemporary Hausa Prose Fiction, in 8th Janheinz Jahn Symposium on *African Language Literatures: Production, Mediation and Reception*, November 17–20, 2004, Universität Mainz, Mainz, Germany, p. 24.
21. Larkin (2008), p. 149.
22. Adamu, A. U. (2007) *Transglobal Media Flows and African Popular Culture*. Kano: Visually Ethnographic Productions, p. 81.

23. Dakata, Z. (2004) Alienation of Culture: A Menace Posed by the Hausa Home Video, p. 251 in A. U. Adamu, Y. Adamu and Jibril, U. F. (eds) *Hausa Home Videos: Technology, Economy and Society*. Kano: Center for Hausa Cultural Studies.

24. Nayaya, S. (2004) Kano State Censorship Board: Functions and Structure, pp. 233–234 in Adamu, Adamu and Jibril (2004).

25. Malumfashi, B. Y. (2011) Ni ne musabbabin k'irk'iro Hukumar Tace Fina-finai ta Jihar Kano—Alhaji Musa na Malam K'ato (1), p. 21 in *Aminiya*, June 24.

26. Yusufari, M. L. (2004) Sharia Implementation in Kano State, International Conference *The Implementation of Sharia in a Democracy: The Nigerian Experience*, Abuja. July 7, 2004, http://www.gamji.com/article3000/NEWS3706.htm, date accessed June 1, 2011.

27. Ostien, P. (ed) (2007) *Sharia Implementation in Northern Nigeria 1999–2006: A Sourcebook. Volume III: Sanitizing Society*. Ibadan: Spectrum Books.

28. Mohammad, A. (2011) Interview with author, May 2.

29. James (2007), p. 69.

30. Mohammad (2011).

31. Kano State Censors Board (2001) State Censorship Board Law 2001, Cinematography (Licensing) (Censorship) Regulations 2001, KSCB, http://kanocensorsboard.com/Index.htm, date accessed June 23, 2011; NFVCB (1993).

32. Mohammad (2011).

33. Krings, M. (2008) Conversion on Screen: A Glimpse at Popular Islamic Imaginations in Northern Nigeria, pp. 45–68 in *Africa Today*, 54 (4).

34. Nayaya (2004), p. 235.

35. Shekarau, I. (2004) *Social Re-Orientation Inaugural Address and Action Plan*. Kano: Kano State Government (cited in Ostien (2007), p. 7).

36. KSCB (2006) *Ka'idojin Duba Fina-Finai*, [flyer], July 2006.

37. Adamu (2008), p. 166.

38. Bala, A. (2009) Interview with author, March 7.

39. Sadiq, A. (2006) Interview with author, June 30.

40. Sarari, A. (2009) Interview with author, January 27.

41. Sarari, A. (2008) Brief Report on the State of Film Industry in Kano State, Nigeria, in *AfrikNews*, February 18, www.afrik-news.com/article12615.html, date accessed June 1, 2011.

42. Karofi, H. (2007) Kano Government Condemns Actress, p. 6 in *Daily Trust*, August 24.

43. Abdulkarim, A. R. (2007) Press Briefing on Additional Guidelines for Registration of Production Companies, Publications and Stakeholders, KSCB, September 21, date accessed June 23, 2011. In case of writer registration, the national Association of Nigerian Authors executive intervened in August 2008, and Rabo settled for writers being registered with writers' associations, which would forward the list of writers to the KSCB. See Sheme, I. (2008) Kano Censorship—ANA National wades, in *Bahaushe Mai Ban Haushi!* August 25, http://ibrahim-sheme.blogspot.com, date accessed June 23, 2011.

44. KSCB (n.d.) Artiste Registration Form; Script writer and Others Registration Form; Undertaking; Film Censorship Guidelines, KSCB, 2011. http://kanocensorsboard.com/DownloadForms.htm, date accessed June 23, 2011.

45. KSCB (n.d.) Kano State Censorship Board Progress Report for the May 2007 to Date, KSCB, . http://kanocensorsboard.com/AboutUs.htm, date accessed June 23, 2011 Though undated, the report mentions events up to December 2008.
46. Ibrahim, Y. A. and Malumfashi, B. Y. (2007) How Adam A. Zango Ended up in Prison, pp. 14–15 in *Weekly Trust*, September 29.
47. Abdulkarim, A. R. (2009) Interview with author, January 27.
48. Kaura, L. (2008) Interview with author, November 16.
49. Maikatanga, S. and Giginyu, I. M. (2008) Rabo ya binne Ibro a gidan yari, pp. 10–14 in *Fim*, November, 107.
50. Iyan-Tama, H. L. (2011) Interview with author, August 13.
51. McCain, C. (2011) The "second coming" of Kannywood, A *Tunanina*, June 26, http://carmenmccain.wordpress.com, date accessed December 1, 2011.
52. Abdulkarim (2009).
53. Aminu, A. B., Alao, O. and Tijjani, A. T. (2008) Why I'm Leaving Kano—Ali Nuhu, pp. 18–19 in *Weekly Trust*, March 27.
54. Mu'azu, S. (2009) Interview with author, January 22.
55. NFVCB (n.d.) Frequently Asked Questions, NFVCB, http://www.nfvcb.gov.ng, date accessed December 22, 2011.
56. Abdulkarim, (2009).
57. Mbembe, A. (2002) On the Power of the False, Translated from French by J. Inggs, p. 637 in *Public Culture*, 14 (3).
58. Olaniyan, T. (2009) *Arrest the Music! Fela & His Rebel Art and Politics*. Ibadan: Bookcraft, p. 242.
59. Mbembe (2002), p. 637.
60. Olaniyan, T. (1996) "Uplift the Race!": "Coming to America," "Do the Right Thing," and the Poetics and Politics of "Othering," pp. 103–104 in *Cultural Critique*, 34.
61. Gwangwazo, N. (2009) Police Arrest DG Kano Censors Board, *Bahaushe Mai Ban Haushi!* August 4, date accessed June 1, 2011. http://ibrahim-sheme.blogspot.com/2009/08/police-arrest-kano-censors-board-dg.html, date accessed June 1, 2011.
62. McCain, C. (2009) Mobile Court Bans Listening to 11 Hausa Songs, A *Tunanina*, June 8, http://carmenmccain.wordpress.com/2009/06/08/mobile-court-bans-listening-to-11-hausa-songs/, date accessed June 23, 2011
63. Adamu, A. U. (2010) Private Passion, Public Furor: Youth Entertainment, Sexuality and the Islamicate Public Space in Northern Nigeria, p. 298 in H. Walkili, H. Mohammed, et al. (eds) *The Nigerian Youth: Political Participation and National Development*. Kano: Mambayya House.
64. Yarshila (2007) Hausa Porn Video: The Naked Truth, p. 14 in *Daily Trust*, September 6.
65. MOPPAN (2010) Press Release: Calling on Gov. Shekarau to Investigate Allegations of Sex Scandal against Abubakar Rabo, A *Tunanina*, August 31, http://carmenmccain.wordpress.com/2010/08/31/press-release-from-the-motion-pictures-practitioner-association-of-nigeria-moppan-calling-for-investigations-into-the-sex-scandal-against-abubakar-raboo-the-on-the/, date accessed June 1, 2011
66. Afakallah, I. (2012) Personal communication with author, January 5.

14

The Legion of Decency and the Movies

Gregory D. Black

In Giuseppe Tornatore's *Cinema Paradiso* (1988), a nostalgic look at grow-
ing up in a small Sicilian village, the local movie theater dominates the
social life of the town. Everyone went to the movies for entertainment, infor-
mation, excitement, and romance. But at least one person feared the power
and influence this modern entertainment had on the villagers: the local priest.
The priest insisted on previewing and censoring the films before they contam-
inated his flock with the infectious immorality of the outside world. The priest
insisted that every screen kiss be removed. As one frustrated villager com-
plained: "I haven't seen a kiss in 20 years!" The experience of watching *Cinema
Paradiso*, while humorous, was shared by movie fans worldwide. Convinced
that films were capable of seductively changing the moral and ethical values
of audiences, censors and moral guardians from Sicily to Hollywood fought to
control the content of movies.

Nowhere was this truer than in America. Almost from their inception the
movies were subjected to some form of censorship or regulation. By 1915 a host
of state and local censorship boards were in place to impose local community
standards on the movies. The industry challenged the legality of this "prior
censorship" but the Supreme Court ruled in 1915 in *Mutual Film v. Ohio* that
movies were not protected free speech.[1]

It was to prevent a proliferation of these organs of censorship, and to clean
up the image of the industry caused by a series of sex scandals in the early
1920s, that the industry created a trade association in 1922, the Motion Pic-
ture Producers and Distributors of America (MPPDA), and hired Will Hays,
the architect of Warren Harding's 1920 presidential victory, as its spokesman.
Despite the efforts to control film content, Hays was constantly dogged by
protests from religious and civic leaders who claimed that films were still

immoral, and by the increasing strictness of state and municipal censors. The advent of sound films in the late 1920s simply complicated the situation. Now, instead of exaggerated pantomime, film stars used dialogue. Men and women openly discussed their love affairs on the screen, criminals bragged about their crimes, and politicians spoke cynically about the important issues facing the government. This new openness delighted movie fans but infuriated the moral guardians.

What Hays sought to develop was some mechanism that would allow the movies to continue to attract huge numbers of paying customers, children and adults, while at the same time would mute the protests of a very vocal, but influential, minority. Ironically, it was a religious institution, the Catholic Church, which offered Hays a solution in 1930. Father Daniel Lord, a professor of dramatics at St. Louis University and Martin Quigley, a staunch lay Catholic and owner and publisher of the industry trade journal, *The Motion Picture Herald*, presented Hays with a set of guidelines they believed, if followed by the studios, would clean up the movies.[2]

The basic premise of the Production Code was that "no picture should lower the moral standards of those who see it." Recognizing that both evil and sin were a legitimate part of drama, the code stressed that no film should create a feeling of "sympathy" for the criminal, the adulterer, the immoral, or the corrupter. Films must uphold, not question or challenge, the basic values of society. What Lord wanted films to do was to illustrate clearly to audiences that "evil is wrong" and that "good is right."[3] The Code was adopted with little fanfare by the industry in 1930 and served as the foundation for industry regulation until the adoption of the ratings system in 1968. But in the next few years the industry only made half-hearted efforts to enforce Lord's code. In the early 1930s a series of flashy gangsters—Edward G. Robinson in *Little Caesar* (1930), James Cagney in *The Public Enemy* (1931), and Paul Muni in *Scarface* (1932)—murdered their way to the top of the gang world and to the top of the box-office charts. Father Lord felt betrayed by the rash of gangster films that flooded the screen in this short three-year period. He told Hays that it didn't matter if criminals were killed or arrested in the last reel. In his opinion, gangsters had to be banned from the screen.[4]

Lord was even more shocked by the increased sexuality that sound brought to the screen. No actress represented this new type of entertainment more than Mae West. In 1932, Paramount Studios brought West to Hollywood. Audiences loved West's humor in *She Done Him Wrong* (1932) and *I'm No Angel* (1933). West used a heavy dose of sexual innuendo, satire, and comedy to both shock and amuse audiences. *The Motion Picture Herald* declared West one of the box-office champions of 1933. Nor was Mae West the only actress who used her sexuality to entertain. Jean Harlow cavorted with a married man (Clark Gable) in *Red Dust* (1932). Marlene Dietrich seduced an aging professor in *The Blue Angel* (*Der Blaue Engel*, 1930). In *Possessed* (1931), Joan Crawford starred as the mistress of a married politician. Cecil B. DeMille combined sex and violence in

Sign of the Cross (1932), which one Catholic publication condemned as "downright filth." Moral guardians were aghast when RKO (Radio-Keith-Orpheum) announced plans to film the Sinclair Lewis novel, *Ann Vickers,* whose heroine has an abortion, multiple lovers, an illegitimate child, and lives happily ever after.[5] The demands for increased movie censorship received a tremendous boost when in the spring of 1933 a sensational book published by Henry James Forman, *Our Movie Made Children,* openly accused movies of corrupting youth. Forman boldly charged that 72 percent of all movies were unfit for children and were "helping to shape a race of criminals." *Our Movie Made Children* became a national best seller.[6]

The pressure on the movie industry increased tremendously when the newly appointed Papal Apostolic Delegate to the United States, Monsignor Amleto Giovanni Cicognani, declared "a massacre of innocence of youth" was taking place in the theaters. "Catholics are," said Cicognani, "called by God, the Pope, the Bishops, and the priests to a united and vigorous campaign for the purification of the cinema, which has become a deadly menace to morals."[7] The speech kicked off the Catholic campaign to create a Legion of Decency. In a matter of months more than seven million people, mostly Catholics, had promised to boycott immoral movies. This boycott, during the deepest throes of the depression, shook the industry to its core.

When the Catholic Church offered to soften its boycott if the industry would appoint a Catholic censor and give him the authority to enforce the 1930 code written by Lord, Hays readily accepted. The Production Code Administration (PCA) was created in July, 1934, and Joseph Breen, an active lay Catholic, was appointed Director. The industry bosses knew they had to cooperate with Breen. From New York, Harry Warner of Warner Bros. cabled studio executives: "If Joe Breen tells you to change a picture, you do what he tells you."[8] The Catholic Church was in an unusually powerful position in 1934 to dictate terms to Hays. While only representing 20 percent of the total population, in large urban areas—Chicago, New York, Boston, Philadelphia, Cleveland, and Detroit—Catholics represented close to one-half the population. These cities were vital to the economic health of the industry because the studios owned and operated elaborate first-run theaters that exhibited their films. The Church also controlled national and local media. Most of the 103 American dioceses published a newspaper. Clerical publications such as *The Catholic World, America,* and *Catholic Digest* were widely read. Catholic opinion was also broadcast over the airwaves. *The Catholic Hour* and radio priest Father Charles Coughlin held millions spellbound and stood ready to condemn the movies.

Called to action by the Bishops, Legionaries began attacking Hollywood in 1933/34 on all fronts. Priests began publishing lists of forbidden films and leading local boycotts of theaters that dared exhibit them. But few could agree on what was moral or immoral. RKO's *Of Human Bondage* (1934), for example, was labeled indecent in Detroit, Pittsburg, and Chicago but Catholics in other

areas were free to see the film. The industry howled foul and the national press relished publicizing the inconsistencies of blue-nose priests.[9]

The Bishops quickly realized that if the Church were to retain its influence over Hollywood, they would have to create a single voice for the movies. However much they respected Breen, they also realized he might tame Hollywood or he might succumb to the glamour and glitter of the studios. To protect their position and to keep pressure on the PCA and Breen, the Church created the National Legion of Decency in 1935 and placed it administratively in the Catholic Charities Office in the New York archdiocese—far from the reaches of the Hollywood studios. Father John Daly, from St Gregory's Church in New York and a professor of psychology at the College of St. Vincent, was appointed Executive Secretary.[10] The task of determining the moral values of the movies was given to the Catholic women's organization, the International Federation of Catholic Alumnae (IFCA). In 1922 under the direction of Rita C. McColdrick, the IFCA had created a Motion Picture Bureau, headed by Mrs. Mary Looram. For 12 years Looram and her staff of volunteers published reviews of good films, which they urged Catholics to support. Films they considered vulgar, tasteless, or immoral were simply ignored. Under the Legion the women were directed to name and condemn immoral films.

The Legion and the IFCA quickly constructed a four-tier system to classify movies:

A1 Unobjectionable for general patronage
A2 Unobjectionable for adults
 B Objectionable in parts
 C Condemned

The first two classifications told Catholics there was no objectionable material in the film but parents were warned to be careful of taking young children to an A2 classification. The B ratings was more confusing because while lay Catholics considered a B film approved, some Bishops and priests believed all B films unfit for Catholic audiences.

In February 1936, the National Legion of Decency issued its first classification of films. Charlie Chaplin's *Modern Times* (1936) was placed in the A grouping despite "a few vulgarities." Marlene Dietrich's *Desire* (1936) was approved for adults in spite of "a few long, drawn out kisses and suggestive remarks." No films were condemned but several were placed in the B classification including Boris Karloff's *The Walking Dead* (1936) because this Frankenstein spin-off implied that the mad doctor created life in his laboratory. Within the year, controversy erupted within the newly created Legion. An early test case was Mae West's *Klondike Annie* (1936).[11] The PCA's Breen at first rejected the film but when Paramount complied with all of his demands, the PCA issued a seal of approval. Legion reviewers considered the revised version harmless and awarded a B. Martin Quigley, however, branded the

film an "invasion of public and private morality" and demanded that Father
Daly be removed. Bishops in Omaha, Detroit, and Washington, DC demanded
Catholics boycott the film.[12] Fans flocked to theaters in record numbers to
see what all the fuss was about. In Kansas City, the Newman Theater grossed
6000 dollars over the weekly average and theaters in New York City, Buffalo,
Denver, Louisville, Los Angeles, and San Francisco reported similar increases.
Quigley was mortified when he read in his *Motion Picture Herald* that the
film was averaging a weekly increase of $2500–$8500 per theater in national
release.[13] Quigley lost the battle over *Klondike Annie* but he won the war when
the Bishops placated him by replacing Daly as Executive Director. Father John
McClafferty was appointed and served until 1947.

While the Legion of Decency is often thought of as a huge bureaucratic arm
of the Catholic Church, in fact it was minuscule. McClafferty's support staff
consisted of a secretary, Mrs. Mary Looram (IFCA), and a handful of volun-
teers. After the PCA gave its final approval for a film, a print was shipped to
New York for Legion inspection. The Hollywood studios agreed that Legion
approval was necessary before they duplicated any film for distribution and
exhibition. After the reviewers saw a film they submitted written evaluations
and recommendations for classification to Looram. She and McClafferty tab-
ulated them and made a final decision on a classification for each film they
reviewed.

By mid-1937 there were only occasional differences of opinion between
Breen's PCA and the Legion. In 1938, for example, only a small fraction—
32 out of 535 PCA-approved films—were given a B classification and no film
from a major studio was condemned. In fact, no PCA-approved film was con-
demned by the Legion for the remaining years of the decade. But a decade later
the industry was in a state of collapse and the Legion was condemning record
numbers of foreign and domestic films.[14]

The collapse of Hollywood in the decade following World War II has been
thoroughly documented and chronicled in scores of books. But the basic
facts are so startling that they merit a brief summary. By the end of the war,
Hollywood was truly the entertainment capital of the world. In 1946 some
90 million fans jammed the nation's theaters every week and the industry
churned out 378 feature films to satisfy the seemingly insatiable demand of
movie fans. Box-office revenues soared to a record 1.6 billion dollars.[15] On the
world stage Hollywood stood alone. The war had all but destroyed the vibrant
prewar film industries in France, Italy, and Germany. In the immediate postwar
period Hollywood flooded European screens with films produced during the
war. To the casual observer everything pointed to Hollywood's continued
worldwide domination of the movie industry. Five years later the industry
was drowning in a sea of red ink. Movie attendance declined by 40 percent
and profits collapsed by some 90 million dollars as Americans chose televi-
sion over movies. As if the loss in attendance was not enough, Hollywood
suffered another and perhaps an even more damaging economic blow in

May, 1948, when the Supreme Court declared the movie industry an illegal monopoly. Popularly known as *The Paramount Decision [334 US 131]*, this case struck down vertical integration—production, distribution, and exhibition—that had been the economic foundation on which the glitter and glamour of Hollywood was built. Censorship was a major element of this monopoly. The majors agreed they would not produce, nor would they play, a film in any theater under their control (the five major studios controlled 2800 first-run theaters) that did not carry the industry PCA seal or a Legion rating of A or B.

By the mid-1960s the once powerful and glamorous studios were in disarray. Their fleets of huge, ornate picture palaces had been sold off by court order, their stable of stars was gone, the original industry moguls were retired, and the huge sound stages were reduced to producing TV sitcoms. MGM, Paramount, Twentieth Century Fox, Warner Bros.—names that evoked fascination, power, money, and glamour—were now mere cogs in international media conglomerates. In was in this post–World War II era, especially from the late 1940s to the early 1960s, that the Legion of Decency reemerged as a major film censor. Howard Hughes, the billionaire playboy who functioned as an independent film producer (*Hell's Angels* [1930] and *Scarface* [1932]) despised Will Hays and the MPPDA. He refused to play by the rules of the Hays Office and released uncut versions of *Scarface* in states and cities without censorship boards. While Hughes had many critics, he was praised by the *New York Herald Tribune* as the only "producer who has the courage to come out and fight this censorship menace in the open. We wish him a smashing success."[16]

In 1941 Hughes completed *The Outlaw* (1943), yet another Hollywood version of the exploits of William Bonney, aka Billy the Kid. The film was as controversial as *Scarface* and generated more publicity for an unknown actress, Jane Russell, than any other film in history. When the PCA reviewed the completed film, they were shocked but not surprised. There was, the PCA noted, a strong suggestion of an illicit relationship between the three main characters: Doc (Walter Houston), Rio (by Russell), and Billy (Jack Buetel). But it was the exposure of Jane Russell's breasts that caused the most concern. She was photographed in a low-cut peasant blouse that the PCA believed exposed too much flesh. The PCA denied Hughes a seal and Hughes in turn simply shelved the film. In 1945, with *The Outlaw* gathering dust at RKO studios, the industry quietly announced the retirement of Will Hays. Eric Johnston, another solid Republican, who had been most recently president of the US Chamber of Commerce, was appointed his successor. Shortly after Johnston took over the Motion Picture Producers and Distributors Association (MPPDA), which he changed into the Motion Picture Association of America (MPAA), Hughes decided to release *The Outlaw* to the general public. It was condemned by the Catholic Legion of Decency, denounced in pulpits from coast to coast, banned by state and municipal censorship boards, savaged by the critics, and broke box-office records wherever it was allowed to play. *Variety* reported that a three-week run in Chicago generated almost 300,000 dollars in box-office

revenue despite, or perhaps because of, Catholic protests and pickets.[17] The *Los Angeles Daily News* reported major "traffic jams" at all locations when the film opened.[18] When in May *The Outlaw* moved to Father Daniel Lord's diocese, St. Louis. Picket lines greeted movie fans outside Loew's State in downtown St. Louis as children marched with banners urging "HELP US OUTLAW THE OUTLAW." *Variety* reported that the "controversial flicker is the best coin getter" in the city. The film broke all local box-office records generating more than 60,000 dollars in a three-week run.[19]

Hughes and *The Outlaw* illustrated how ineffective Catholic boycotts had become. The more clergy denounced films like *The Outlaw* the more people flocked to the theaters. The film grossed more than 5 million dollars. In 1947 Father Patrick Masterson succeeded Father McClafferty as executive director of the Legion. Masterson watched in horror as *The Outlaw* did a bonanza at the box-office in Catholic areas throughout the country. Masterson was determined to stop Hollywood from making similar films and reassert Legion control. However, it was very clear by 1947 even to Legion officials that the lack of a Production Code seal or condemnation by the Legion of Decency was no longer a portent of financial disaster.

David O. Selznick was the first to feel the Legion's wrath following *The Outlaw*. In 1939 his lavish production of Margaret Mitchell's *Gone with the Wind* solidified Selznick's reputation as one of the greatest filmmakers in Hollywood history. In 1947 he submitted a script for a lavish six million dollar lusty horse opera, *Duel in the Sun*. The PCA demanded major rewrites of the script to eliminate what Breen viewed as a highly charged sexual relationship between Pearl (Jennifer Jones) and Lewt (Gregory Peck). Selznick, unlike Hughes, and his writers reworked the script to establish the moral base the PCA demanded. Lewt was clearly depicted as evil—he destroyed Pearl, murdered, and was a fugitive from justice when he was killed. Pearl had been drawn unwillingly into his web and she suffered humiliation and death for her weakness. Selznick told his assistants to stress the point that "Lewt and Pearl are going to pay the wages of sin" in all conferences with PCA representatives. He believed that Breen and the PCA would be more receptive "toward the script . . . if they know that God punishes these two sinners." Lewt becomes a common outlaw and he and Pearl die for their sinful relationship.[20] With those changes, the PCA issued a seal of approval.

Selznick, at this point, made a fatal error. He had a PCA seal and was anxious to book the film before submitting to the Legion. The press première at the Hollywood *Egyptian Theater* on December 30, 1946, went off without a hitch. The local Los Angeles papers, including the *Los Angeles Times*, were less than effusive but not hostile. *Variety* warned exhibitors that "rarely has a film made such frank use of lust" and still carry the PCA seal; however, the trade paper reminded theater owners that the "sex angle alone makes for boff b. o."[21] Within days of the opening, however, Archbishop John Cantwell of Los Angeles blasted the film. He warned all Catholics "they may not, with a free conscience," see the film until the Legion issues a classification. He warned Catholics that

Duel in the Sun "appears to be morally offensive and spiritually depressing."[22] Selznick vowed to fight. He commissioned the Gallup Poll to determine what the impact of a condemned rating by the Catholic Legion would have on the general public. He was delighted to learn that Gallup figures showed only 5 percent stated they would not go to a C rated film. This loss would be more than offset, Gallup reported, by those who would be attracted to the film by the criticism and publicity generated.[23] But Selznick received no support from the mainstream Hollywood community. When he learned that many of the theater chains had a clause written into booking contracts that released them from their obligation to play a film if it carried a C (condemned) rating, he decided to reedit his film. Unlike Hughes, Selznick could not afford to lose access to the nation's first-run theaters. In the end, he made all the cuts demanded by the Legion, with Martin Quigley's help, in order to have the condemned rating changed.

The battle over *The Duel in the Sun* illustrated the Legion's real power that came from its ability to limit distribution of films. Exhibitors were reluctant to book a film condemned by the Legion because they feared local boycotts that would last far beyond the run of any particular film. Despite the Gallup Poll, theater chains in an era of declining attendance simply did not want to challenge the Legion. It was a foreign film from Italy, Roberto Rossellini's *The Miracle* (*Il miracolo*, 1948) that brought Legion activities to the attention of a national audience. In December, 1950 Rossellini's *The Miracle*, starring Anna Magnani as a demented peasant woman who believes she has been impregnated by St. Joseph, opened in New York City. The film was destined to fade quickly from the public view until it was condemned by the Legion as a "sacrilegious and blasphemous mockery of Christian and religious truth." The controversy heated up when New York's Francis Cardinal Spellman said the film was a "despicable affront" to Christianity inspired by communist propaganda. The New York state censorship board responded by banning the film as sacrilegious.[24] Catholics threw up pickets across the country to protest the movie. But in the end, it was the Supreme Court, not the Catholic Church, that had the final say. In 1952 the Court ruled in *Burstyn v. Wilson* (343 US 495) that films were "included within the free speech and free press guarantee of the First and Fourteenth Amendments." Nor could a state ban a film for religious reasons under the separation of church and state provisions of the Constitution. This action reversed a 1915 decision (*Mutual Film v. Ohio*) that had placed movies outside First Amendment protection.[25] As film historian Tino Balio noted, the immediate impact of divorcement was that: "Without first-run theaters, the Big Five lost its power to enforce the strictures of the Production Code Administration."[26] Theater chains and owners were now free to choose whether or not to play films without a code. It was their choice to accept or reject a film condemned by PCA or the Legion of Decency.

While the Legion lost the war over *The Miracle*, it continued to condemn films it considered to be immoral. *The Moon Is Blue*, Otto Preminger's 1953 sex

comedy, provides an excellent illustration of the continuing battles for control of the American screen. In 1951 Preminger negotiated an independent producers/directors contract with Twentieth Century Fox that gave him final cut authority over all his films. The first project Preminger chose was a Broadway play, F. Hugh Herbert's sex farce, *The Moon Is Blue*.

The independent film of the same title, released in 1953, successfully challenged the authority of the PCA to control the content and exhibition of films in the United States. The film also played a major role in undercutting the power of the Catholic Legion of Decency to function as the unofficial moral watchdog of the American cinema. The plot of the play was simple. A handsome New York architect meets a cute struggling actress on the observation platform of the Empire State Building. They are attracted to one another. Don invites her to dinner, Patty accepts. This young woman is neither shy nor demure—but rather startlingly direct. When they arrive at Don's apartment, Patty tells her date she's glad he doesn't mind. "Mind what?" he asks. "Oh, men are usually so bored with virgins. I'm glad you're not." More sexual banter unfolds. Cynthia, Don's ex, lures him out of the apartment and sneeringly refers to Patty as a "professional virgin." Don is furious and storms back to the apartment where he discovers Patty's father, a tough old Irish cop who promptly busts him in the jaw and drags his errant daughter home. The next day the two meet again on the observation platform at the Empire State Building. Don proposes marriage and Patty accepts.

Preminger signed William Holden to play Don. David Niven, who specialized in playing suave, debonair playboys, was perfect for David. For the ingénue, Patty, Preminger gambled on a Hollywood unknown, Maggie McNamara. When the film script was submitted to the PCA, Breen rejected it because of the light attitude toward seduction, illicit sex, chastity, and virginity. The Legion of Decency followed suit and announced on June 9, 1953, that *The Moon Is Blue* was condemned because "the subject matter . . . in its substance and manner of presentation seriously offends and tends to deny or ignore Christian and traditional standards of morality and decency and dwells hardly without variation upon suggestiveness in situations and dialogue."[27] Cardinal Spellman denounced the film as "an occasion of sin."

Prior to the *Paramount* and *Miracle* decisions, Preminger would have been forced to censor his film in order to get access to industry theaters. But by 1953 he could ignore both the PCA and the Legion. And he did. In Omaha, Archbishop Gerald T. Bergan followed Spellman in attacking the film but long mobs flocked to the theater. *The Moon Is Blue* did record business in Chicago, Buffalo, Boston, St. Louis, and other major urban areas with large Catholic populations. It generated 3.5 million dollars at the box-office and ranked 15th for 1953. The film clearly proved that there was an adult audience for films and that audiences, both Catholic and non-Catholic, would attend good films regardless of PCA or Legion opinion.

A disappointed Martin Quigley told Cardinal Spellman that *The Moon Is Blue* was "attracting from large to very large audiences" in New England, New York, Texas, Chicago, and Denver. It was all very "disheartening" to Quigley who had been instrumental in creating the Legion in 1934. Legion director, Father Thomas Little (who had recently replaced Father Masterson), confirmed the bad news to Spellman.[28] Even more disheartening to Quigley, Spellman, and the Legion was the action taken by the courts. Maryland's censor, Sydney R. Traub, had banned *The Moon Is Blue* because it was immoral and did not carry a PCA seal, but that decision was overturned by Judge Herman M. Moser who held in December, 1953, that the film was "neither obscene, indecent, immoral, nor tending to corrupt morals." The judge also found the Production Code clause that stated seduction could never be subject for comedy "absurd if literally enforced and ... fatally vague as a legal standard."[29]

It was increasingly clear that the Legion's ability to rule Hollywood was coming to an end. Within the church the Legion had always been controversial—some Bishops demanded obedience and others ignored the Legion. As early as 1946, Catholic University's Francis J. Connell, Dean of the School of Sacred Theology, stated in an article in *American Ecclesiastical Review* that there was "no strict obligation in obedience to follow the Legion's decisions."[30] Father John C. Ford, S. J., a professor of moral theology at Weston College, argued that: "There is no universal obligation binding Catholics in the United States under pain of sin to stay away from pictures classified as condemned by the Legion of Decency."[31] By the late 1950s the Legion came under attack by prominent Catholic theologians such as Father John Courtney Murray who questioned whether or not the church had the authority under Canon Law to forbid individual Catholics from attending condemned films. Murray argued it did not and that a Catholic did not sin by attending a condemned film. Murray delivered a mortal blow to Catholic censorship of movies.[32]

Audiences agreed and continued to ignore the Legion. Another comedy, released six years after *The Moon Is Blue,* illustrated just how far attitudes toward popular entertainment had changed. *Some Like It Hot* (1959), directed by Billy Wilder, is considered a classic by contemporary scholars, critics, and fans. Yet in 1959 the film was seen by many as a prime example of bad taste, if not indecency. The basic plot was very simple. Two out-of-work Chicago musicians (Tony Curtis as Joe/Josephine and Jack Lemmon as Jerry/Daphne) accidentally witness the St. Valentine's Day Massacre. Fleeing from the mob, they escape by dressing as women and join an all-girl band heading to Florida. The band's leading singer, Sugar, played by Marilyn Monroe, wears as little as possible and both Joe and Jerry go nuts trying to maintain their female disguise. Sugar's ambition is to marry a millionaire and when they reach Florida the band is greeted by a group of playboys—including Osgood E. Fielding III (Joe E. Brown) who immediately falls in love with Daphne (Lemmon). Naturally, the film is full of double-entendres, sexual comedy, and cross-dressing.

In the end Osgood finally discovers that Daphne is really Jerry but he says as the two ride out to his yacht: "Well, nobody's perfect."

Without question the PCA and Legion of Decency would have condemned any film that featured the kind of bawdy humor of *Some Like It Hot*. But by 1959 even the censors were conflicted by the film—some were outraged, others thought the film appropriate adult entertainment.[33] The PCA issued a seal of approval but Father Little labeled the film "outright smut" and decried its theme of "transvestism with its clear implication of homosexuality and lesbianism." To Little, the film was the "most flagrant violation of the spirit and the letter of the Production Code" in recent memory.[34] The Legion threatened to condemn the film and warned all Catholics that *Some Like It Hot* was "seriously offensive to Christian and traditional standards of morality and decency."[35] But MPAA president Eric Johnston refused to cave in to Legion pressure to censor the film. He told Bishop James McNulty that "not a single (secular) reviewer has been in the slightest way critical of this film" and that the critics had "nothing but praise for it as a hilariously funny movie."[36] Johnston added the "we can only trust that the general public" will agree that the film is not immoral. In the end, the Legion issued a B classification (Morally objectionable in Part) for the film that allowed Catholics to attend. Johnston was right. *Some Like It Hot* was a 1959 box-office hit generating eight million dollars in its initial run and several million more in second and third releases. The film was nominated for six Academy Awards winning one for Best Costume. This award certainly made Legion officials shutter because they had objected strenuously to the costumes of Marilyn Monroe.

The decade of the 1960s saw even greater changes in mainstream movies and the popular acceptance of nudity, sex, and violence. The box-office champion of 1960 was the Walt Disney production *Swiss Family Robinson*, a film that fit more comfortably into the culture of the 1950s. More representative of the decade were films like *Psycho* (1960), *Spartacus* (1960), *Tom Jones* (1963), *The Pawnbroker* (1965), *Who's Afraid of Virginia Woolf?* (1966), *The Graduate* (1967), *Guess Who's Coming to Dinner* (1967), *Bonnie and Clyde* (1967), *Easy Rider* (1969), and *The Wild Bunch* (1969). These films not only featured screen-splattering violence and casual nudity but also attacked, as other cultural icons had, the traditional assumptions about love, sex, marriage, politics, and religion held so dearly by, as the new generation loved to say, the establishment.

The Bishops were not foolish old men. They clearly recognized by mid-decade that the Legion had a negative image among Catholics and the movie-going public. In an attempt to soften the concept of the organization as censors, they had created new categories of classification that allowed Catholics to see films that portrayed adultery in a nonjudgmental manner, and discussed, however obliquely, homosexuality, drug addiction, impotence, divorce, and a multitude of other human activities that would have appalled Father Lord. In addition, the Bishops approved a change of name. The Legion

officially became The National Catholic Office for Motion Pictures (NCOMP) in November, 1965. But the function of NCOMP was still the same as the Legion's—to screen and attempt to alter content of films it did not approve of. And most people, even some Catholic publications, still called it the Legion. In 1965, for example, the Legion reviewed 269 films and forced producers to make changes in 32 in order to get a favorable rating. That same year the Legion condemned 15 films; 12 were foreign and even the Legion had to admit that "most condemned films were of little importance."[37]

In 1966, Jack Valenti replaced Eric Johnston as head of the MPAA. In a short two years the movie industry eliminated the PCA and moved to a ratings system (G, all ages admitted; PG, all ages admitted, parental guidance suggested; R, 16 or with parents; and X, only persons 18 and older to be admitted) that would give movie-goers information on the content of all films (see also Chapter 2). When some Catholics protested, for example, that teenagers were going to see *Who's Afraid of Virginia Woolf?*, NCOMP's Father Patrick Sullivan argued: "If any teenager sees this film and is 'corrupted' by it, it will be because his own parent has knowingly taken him into the theater." On the other hand, if adults wanted to see it "we cannot intrude upon what is alone their right and obligation, namely, the exercise of individual responsibility in conscience." Adult Catholics, Sullivan argued, were perfectly capable of deciding on whether or not they wanted to see this film. It was a matter of individual choice and conscience.[38]

One by one the old forces of censorship departed. Joseph Breen, who retired as PCA director in 1954, died in 1964. His mentor, Martin Quigley, died the same year. Msgr. Little, long since wearied of his movie mission, retired with the quip that he wanted "to die in the Stations of the Cross, not looking at Gina Lollobrigida."[39] Several years later, however, he admitted that when he was younger moral issues seemed "stark blacks and whites" but in the post–Vatican II revolution within the church those same "issues seemed less simple and more complex, and assumed various shades of gray." And so it seemed to the Catholic Church and most Americans.[40]

For more than three decades the Hollywood film industry allowed its PCA and religious clerics to determine what was acceptable popular entertainment. The Legion of Decency always claimed that it did not censor movies and only classified them for Catholics. However, Legion archives, open to scholars, paint an entirely different picture. The Legion demanded themes offensive to them be removed before they be exhibited. The industry cooperated with this system because it was good for business. Any film approved by the PCA and blessed by the Catholic Church, for example, was universally seen as clean entertainment. Hollywood films were truly family entertainment.

In the 1930s and 1940s there were occasional protests for more freedom of the screen from professional critics and some directors but movie fans said little. They voted with their feet and flocked to see their favorite stars until the postwar era radically changed the movie industry. During the golden era of the

studios, Hollywood gave up its freedom to explore important social, political, and economic issues for the safety of harmless entertainment. In the postwar era of television, government rulings on monopoly and free speech radically altered the movie industry. By the 1960s Americans were no longer willing to boycott films judged to be immoral by industry censors or clerics posing as moral guardians.

Notes

1. Jowett, G. (1989) "A Capacity for Evil": The 1915 Supreme Court Mutual Decision, pp. 59–78 in *Historical Journal of Film Radio and Television,* 9 (1). See also Chapter 2.
2. Black, G. (1994) *Hollywood Censored: Morality Codes, Catholics and the Movies.* New York: Cambridge University Press, pp. 37–40.
3. Black (1994), pp. 51–60.
4. Black (1994), p. 162.
5. Walsh, F. (1996) *The Catholic Church and the Motion Picture Industry.* New Haven: Yale University Press, pp. 82–83.
6. Black, G. (1989) Hollywood Censored: The Production Code Administration and the Hollywood Film Industry, 1930–1940, pp. 167–189 in *Film History,* 3 (3).
7. Leff, L. & J. Simmons (1990) *The Dame in the Kimono: Hollywood, Censorship, and the Production Code.* New York: Grove Weidenfeld, pp. 42–43.
8. Doherty, T. (2007) *Hollywood's Censor: Joseph I. Breen & the Production Code Administration.* New York: Columbia University Press, p. 70.
9. Black (1994), p. 183.
10. Walsh (1996), pp. 100–105. See also Facey, P. W. (1974) *The Legion of Decency: A Sociological Analysis of the Emergence and Development of a Social Pressure Group.* New York: Arno Press; Skinner, J. (1993) *The Cross and the Cinema: The Legion of Decency and the National Catholic Office for Motion Pictures, 1933–1970.* Westport, Conn.: Praeger.
11. Black, G. (1998) *The Catholic Crusade against the Movies.* New York: Cambridge University Press, p. 26.
12. Black (1998), p. 28.
13. Black (1994), pp. 223–230.
14. Black (1998), p. 37.
15. Jowett, G. (1976) *Film: The Democratic Art.* Boston: Little, Brown, pp. 344–350.
16. Black (1998), p. 131. For earlier criticism of Hughes, see Quigley, M. (May 28, 1932) Hughes and Censorship, p. 17 in *Motion Picture Herald.*
17. *Variety,* March 20, 1946, p. 20.
18. *Los Angeles Daily News,* April 4, 1946 in *The Outlaw,* PCA Files, Margaret Herrick Library, Academy of Motion Picture Arts & Sciences (AMPAS), Beverly Hills, Calif.
19. *Variety,* May 15, 1946, p. 12 and May 22, 1946, p. 22.
20. Lee, S. C. (1985) *Pending Catholicization: The Legion of Decency, Duel in the Sun and the Threat of Censorship,* M.A. Thesis, University of Texas-Austin, p. 16.
21. "boff b.o." means "outstanding box office" in *Variety* lingo. *Variety,* January 1, 1947, p. 14.

22. Father John Devlin to Rev. Patrick J. Masterson, October 4, 1947, box 57, Archdiocese Archives of Los Angeles, Mission Hills, CA.
23. Selznick to Scanlon and O'Shea, February 8, 1947, box 596, David O. Selznick Papers, University of Texas.
24. Crowther, B. (1951) The Strange Case of "The Miracle," pp. 35–39 in *The Atlantic Monograph*, 187.
25. *Burstyn v. Wilson*, 343 US 495 (1952), pp. 17–18. For a larger discussion of this case, see Westin, A. (1961) *The Miracle Case: The Supreme Court and the Movies*. Tuscaloosa, Alabama: University of Alabama Press; Wittern-Keller, L. & R. J. Haberski (2008) *The Miracle Case: Film Censorship and the Supreme Court*. Lawrence: University Press of Kansas; Johnson, W. B. (2008) *Miracles & Sacrilege: Roberto Rossellini, the Church and Film Censorship in Hollywood*. Toronto: University of Toronto Press. See also Chapter 2.
26. Balio, T. (1976) *The American Film Industry*. Madison: University of Wisconsin Press, p. 405.
27. Black (1998), pp. 206–207.
28. Quigley to Spellman, July 27, 1953, *The Moon Is Blue*, National Legion of Decency Archives [hereafter as LOD Archives], Archdiocese of New York, New York, New York.
29. See *The Moon Is Blue*, PCA. United Artists and Holmby Productions v. Sydney R. Traub, et al., Baltimore Docket 295, Folio 16, December 7, 1953.
30. Connell, F. (1946) How Should Priests Direct People Regarding Movies?, p. 245 in *American Ecclesiastical Review*, 114. See also Connell to Little, April 19, 1954, box 1, Martin Quigley Papers, Georgetown University, Washington, DC.
31. Kelly, G. & J. Ford (1957) The Legion of Decency, pp. 387–433 in *Theological Studies*, 18.
32. Black (1998), pp. 145–146.
33. See also Biltereyst, D. (2011) Censorship, Negotiation and Transgressive Cinema: *Double Indemnity, Some Like It Hot* and Other Controversial Movies in the United States and Europe, pp. 145–159 in McNally, K. (ed), *Billy Wilder, Movie-Maker*. Jefferson: McFarland & Comp.
34. Little to McNulty, March 4, 1959 and McNulty to Eric Johnston, March 4, 1959, *Some Like It Hot*, LOD Archives.
35. Ibid.
36. Eric Johnston to Bishop McNulty, March 18, 1959, *Some Like It Hot*, Ibid.
37. 47th Annual Meeting of the Bishops, pp. 60–65, NCCB.
38. Sullivan to Hyle, June 16, 1966, *Virginia Woolf*, LOD Archives.
39. Leff & Simons (1990), p. 274.
40. Walsh (1996), p. 323.

15

Blessed Cinema: State and Catholic Censorship in Postwar Italy

Daniela Treveri Gennari

Film censorship in Italy was as rigorous throughout the 1950s as it had been under Mussolini's regime. The postwar period represented, however, a decisive moment: Italy experienced one of the highest box-office intakes in Europe and a new film law, introduced by Giulio Andreotti in 1949, transformed censorship practice into a preventative form of control under the ideological and legislative pressure of the Catholic establishment. This crucial turning point would set a standard practice—slightly modified in 1962 and again in 2007, but substantially the same—in which state censorship would be echoed by that of Catholic Church, whose main aim was to "promote a moralizing cinema."

This chapter intends to explore the relationships between the powers of the Italian state and the Roman Catholic Church in order to understand the shifts in the legal and ethical underpinnings of film censorship. I will look at state legislation, the involvement of the Catholic Censorship Commission, and the attempts made by Italian producers to comply with stringent institutional and religious prohibition practices. I intend to assess the impact state and Catholic preventative censorship had on production, distribution, and exhibition. This will allow me to unveil the complex mechanism that was in place when the state operated in a dual role of film financier and censor, and the Catholic Church intervened on commercial productions and influenced artistic autonomy thanks to a widespread network of parish cinemas. Moreover, partnerships and disagreements between institutional and religious censorship bodies will be taken into account as negotiation between the Vatican, the state, and the film industry was often a key aspect of film regulation.

This chapter will further suggest that while, on the one hand, the state and Catholic censorial practices profoundly affected the modes of consumption of film, on the other, several were the loopholes found by the industry, enough to circumvent film control in the country, produce controversial films, and distribute them in the parish cinema networks.

Film Censorship before 1945

The first legal intervention in public censorship can be traced back to 1889, when in the law approved for public security prefects were given the power to forbid shows (theater shows in particular) when they endangered morality and public order.[1] In 1907, cinema specifically drew the interest of Prime Minister Giovanni Giolitti, who then expressed his intention of controlling national film production "in the name of public morality."[2] Two years later the Catholic Church expressed concern, when a decree signed by Cardinal Pietro Gasparri forbade clergy to attend cinemas.[3] In 1913 the *Revisione Cinematografica* (Cinema Censorship, CC), the legal body authorizing films to be publicly screened, was created,[4] and in the same year censorship legislation was first developed with an official circular (February 20, 1913) showcasing Giolitti attacking films that "show blood, adultery, robbery and other crimes" as well as films "which offer a negative portrayal of the police and a positive one of the criminals"; as well as the "ignoble stimulations to sex [. . .], as well as films which encourage social class hostility and offense to the national dignity."[5] A decree[6] introduced the following year aimed to forbid shows (in public and private) that can be morally offensive. This was very much in line with what the Catholic Church felt at the time when the new medium of cinema was emerging: in the same year (1914), Mario Barbera's article in the prestigious Jesuit journal *La Civiltà Cattolica* attacked the "moral disorder" of films and their portrayal of promiscuity, discouraging families from taking their children to public screenings.[7] During the war years (1915–1918) censorship, it seems, got harsher, with several topics being recommended to be forbidden in cinema: ridiculing Austrian soldiers, portraying criminal life (mafia and camorra for instance), and even blood transfusions.[8] The real turning point, however, came about in 1919, when a new decree introduced a preventative control on scripts, which dictated that they to be presented before the beginning of shooting in front of a first-degree commission, which from the following year included two police officers, a magistrate, a mother, a representative of an educational or humanitarian organization aimed at protecting the morality of people, as well as an expert each in art, literature, and marketing.[9]

However, as Guido Bonsaver and Robert Gordon argue, under Mussolini's regime (1922–1945) a "complete, capillary control of culture by the state" took place and fascist censorship became "a well-oiled and sophisticated mechanism."[10] The new 1923 law, whose guidelines came into effect after the Second

World War, introduced a specific revision procedure for films that were to be exported. Export of films could be prevented in case there were scenes that compromised economic and political interests as well as the "dignity of the nation," and good international relations. This law, while making the commission more bureaucratic, still maintained the presence of the mother on the commission. According to Perry Willson, the mother embodied the role of the "domestic creature" and the "angel," whose primary role was to breed and educate "new Italians for the Fascist state."[11] The female contributors to the nation in Fascist Italy hinged on their roles as mothers who were at the same time educators and "guarantor of private and public morality, of spiritual integrity and of faith."[12] Ernesto Laura's belief[13] that the presence of the mother on the commission was urged by the Catholic environment is therefore no surprise. In 1933, for instance, the need to control what Catholics could watch in parish cinemas had led to the creation of a *Commissione di Revisione* (Catholic Censorship Committee, CdR) whose members were not dissimilar from the governmental one and included—together with a Catholic journalist, a theologian, and a religious representative—a Catholic mother.[14]

However, the Catholic establishment had expressed interest in regulating cinema and cinema policy well before the creation of the CdR, and before the official intervention of Pius XI's *Vigilanti Cura*'s encyclical in 1936, where a need for censorship was openly expressed, praising the American Legion of Decency's activity in their attempt to "patronize no cinema entertainment which offended Christian morals and the right precepts of life" (see also Chapter 14).[15] A wide-ranging analysis of "the theoretical and practical interventions" on the role of cinema is available in several Catholic journals and newspapers, where "curiosity and anxiety" and "interest and control" are the feelings expressed toward the new medium in official and unofficial documents.[16] In the years 1914–1917 *La Civiltà Cattolica* had already discussed the dangers of cinema to the physical and mental health of its audiences and the desire to produce educating films had already been accompanied by the need to control national cinema production. Leo XIII's blessing of the camera in 1898 during the shooting of the film *Pope Leo XIII* (1898) by William Kennedy and Laurie Dickson—often described as the first encounter between cinema and the Catholic Church[17]—certainly marks the beginning of the use of cinema to spread faith, and is representative of the desire of the Catholic establishment to legitimize the social and religious role of film. However, this desire became a necessity in a later period—which Elena Mosconi defines as the organizational phase (1909–1921)[18]—in which the fear of the secularization of Italian society encouraged a stronger educative role of the medium. It is not surprising, therefore, that in these years the control over the film industry was tightened at a dual level, both from the government and from the Vatican.

The pages of *La Rivista del Cinematografo* (the Catholic film journal started in 1928) show a deep involvement of the Catholic establishment in the discussion around censorship and cinema. In February 1929, an article written

by Gaetano Festi reminds the reader that in most cases censorship was still a compromise between art and industry, trying to please both but ultimately not able to satisfy either, invoking Fascism to renew its approach to censorship, morality, and cinema.[19]

In 1933 discussions on the topic assumed an international slant when the news of an American Code for moralization of cinema (see chapters 1, 2, and 14) is praised in the *Rivista del Cinematografo*[20] as an example of censorship based on Christian principles and self-imposed guidelines by film professionals to encourage production of films with high levels of morality and quality. The issue of quality was not neglected by the Italian government, which, however, dealt with it in a very different way. When in 1934, the *Direzione generale della cinematografia* (General Directorate of Cinematography, DGC) was created, the real censoring power lay in the hands of senior civil servants, all obviously fascist representatives. However, according to Ernesto Rossi,[21] Mussolini was not guilty of overcontrolling national film production. He didn't need to overcontrol, as he had already found it to be under the tight control of the "liberal governments" that had "wired it like a sausage" under the control of the police. Amongst the responsibilities of the DGC was examining and assessing the scripts of all Italian films in production with the official intention of identifying products of high artistic quality and thereby improving the standard of the national production. This is, however, a clear example of preventative censorship, which has often been criticized by artists and filmmakers and which shaped the development of the national film industry. What in the US case was managed by a self-imposed guidelines by the film professionals was still managed by the government in the Italian case, with the support of the Catholic Church.[22]

In April 1935 the *Centro Cattolico Cinematografico* (Catholic Cinema Centre, CCC) was created to—amongst other responsibilities—classify films and to distribute those classifications to all the Catholic institutions throughout the country.[23] The urge to balance morality and cinema was expressed again in the following years. Bishop Luigi Civardi's book *Il cinema di fronte alla morale* [Cinema in front of morality] (1940) was defined at the time as a moral code for the cinema and can certainly help to assess the application of Catholic morality in the film industry of the time. Civardi's text—addressed to exhibitors, censors, as well as film critics—explains how the CCC was the office in charge of controlling all films produced, classifying them according to Catholic morality, and informing the Catholic community of the classification.[24] In his attempt to define morality, art, and their relationship, Civardi defined as immoral anything that would threaten religious and civic authority, and which would encourage rebellion and anarchy, or which would discredit religion and the country.[25] Through its weekly publication of the *Segnalazioni cinematografiche*, the CCC pronounced moral judgments on films being released and advised on those that were suitable to be screened or that could be screened if the appropriate cuts were made.[26] In 1943, in *La Rivista del*

Cinematografo[27] the CCC addressed cinema spectators directly, giving precise indications of how to behave in relation to films. In order to comply with the directives of the Vatican, the spectators were supposed take the guidance of the *Disco Rosso,* the publication in which each film coming out would be classified by the CCC's Censorship Committee.

A case reported in *La Rivista del Cinematografo*[28] is a perfect example of the pressure exerted by the Catholic Church over film industrial organizations: in 1942, Duilio Coletti's film *Il mercante di schiave* (*Merchant of Slaves,* 1942) was condemned by the CCC as unsuitable for screening in parish cinemas. This verdict was highly significant in terms of the figures of the Catholic exhibition in comparison to public movie theaters.[29] Being excluded from the Catholic cinema circuit represented a substantial loss of profit, when considering that the number of parish cinemas increased from over 400 in 1934 to over 4000 at the end of the 1960s (one-third of all cinemas nationwide). The film's production company Colosseum-film decided to make the appropriate changes to be approved and the consequent agreement with the CCC to revise the moral classification of the film was no surprise. In this way, once a film was allowed to be screened in parish cinemas, pressure was applied to ensure distribution companies could accelerate the delivery of the "correct" copies of the film. This form of censorship created an interesting process within the film industry: more and more producers started to approach the CCC in order to gain an ecclesiastic assent for their films, hoping not only to be approved for parish cinemas, but also to pass state censorship automatically, with its close links to the Vatican.[30] This procedure played a significant role all throughout the postwar period, when cinema, the state, and the Catholic Church operated symbiotically on the censorship front.

Censorship in the Postwar Period

The continuation of censorship legislation from the Fascist period to postwar Italy has been acknowledged by scholars. David Forgacs is clear in asserting it in terms of "a certain model of party-state interpenetration: the interdependency of party and state under Fascism," which is renewed after 1953 in the Christian Democrat "occupation of the state."[31] Philip Cooke agrees on the continuation of censorship between 1923 and postwar legislation, specifically referring to the new *Ufficio centrale per la cinematografia* (Cinema Central Office, UCPC), which—according to a new decree passed in 1945—"had the power to forbid the screening of films and could ask for cuts to be made."[32] The new law approved on May 16, 1947, was for all the other provisions exactly the same as the 1923 legislation and it also made films eligible for a financial grant if their scripts had been pre-approved by the UCPC, reinforcing the government's existing powers of censorship in the process of assessing new Italian films and guiding the domestic production in accordance with precise

ideological objectives.[33] This precautionary form of censorship is certainly more powerful than the more general Article 21 of the Italian Constitution (introduced in 1948). This article was only able to set standards of acceptable moral behaviors by prohibiting shows that went against *buon costume* (common decency). The 1947 law—which shaped the national film production throughout the 1950s and had only minor modifications in the new legislation approved in 1962—is defined by Vittorio Caldiron as "an impenetrable blockage, a crushing bottleneck [...] for our cinema."[34] The *Commissione per la Revisione Cinematografica* (Commission for Cinematographic Revision, CRC), in fact, had the power to prevent screening of films as well as withdraw the award of the 8 percent artistic quality bonus.[35] If a screenplay was not approved, the finished film was not given permission to be screened: a means by which the government sought to determine the character of film directors' artistic output.[36] This aspect of the law was strongly criticized both by Italian exhibitors and by the opposition MPs[37] and was seen by Mino Argentieri as an attempt to force film production into a total dependence on the government, in which the financial support for a national production must be secured by adherence to precise governmental instructions.[38]

Giulio Andreotti's attempt (in his role of Undersecretary to the Presidency of the Council of Ministers from May 31, 1947 to January 12, 1954) to isolate "problematic films" (as Argentieri put it) as well as to crystallize the boundaries of Italian neo-realism, shows the continuity with the Fascist regime's previous attempt at controlling national film production.[39] This level of continuity in cultural policy "meant that a whole system of networking between a dominant party and state agencies was carried over from Fascism to the Republic, despite the change in political colours and the nature of the political project."[40]

The tight control over the film industry was not seen favorably by its representatives and practitioners. However, according to Alfredo Baldi, between 1947 and 1949 few films were modified or cut.[41] In order to dispel the myth of excessive state control over cinema, Giuseppe Ermini, Undersecretary to the Presidency of the Council of Ministers in 1954, declared that from 1949 till 1951 only five films (one Italian, two French, one American, and one Austrian) were rejected by the CRC; only one each in 1952 and 1954, and three in 1953.[42] Investigating the censorship system of the time, Mino Argentieri and Ivano Cipriani read these figures in a different way. They argue that it is self-censorship, in which the limited number of cuts or rejections ordered during those years should not be interpreted as a lack of intervention.[43] In fact, in order to avoid official censorship, film producers would attempt to comply with most of the recommendations of the censorship board when presenting the script. This is what Rossi defines as the most serious form of censorship, where the producers negotiate with the civil servants in order to obtain governmental approval.[44] However, the real problem lay in the procedure of funding, 18 percent of which was supposed to be granted to films of a higher quality. However, as these contributions are linked to the box-office receipts, art films

such as Vittorio De Sica's *Ladri di biciclette* (*Bicycle Thieves*, 1948) or Luchino Visconti's *La terra trema* (*The Earth Trembles*, 1948) would get one-tenth or one-twentieth of popular films such as Mario Mattoli's *I pompieri di Viggiù* (*The Firemen of Viggiù*, 1949) and Giacomo Gentilomo's *La cieca di Sorrento* (*The Blind Woman of Sorrento*, 1954).[45] Self-censorship was unfortunately not a new device: in 1945 the *Associazione Nazionale Industrie Cinematografiche e Affini* (National Association of Cinematographic and Related Industries, ANICA) had become aware of the importance of producing morally acceptable films and published their own *Codice per la cinematografia* (Cinema Code), which provided clear guidelines on what was within acceptable limits in films and covered areas such as obscenity, sexual relationship, vulgarity, religion, and national feelings. This is precisely the point Bonsaver and Gordon argue when they find it necessary to open up the "definitions of the term censorship in a number of different ways."[46] They accept the unlegislated censorship, that is the self-censorship, as one of the definitions, which is precisely what has been common practice in postwar Italy, when "cultural artifacts are produced already with a view to what will prove most likely acceptable to the censors" or precensorship, when "personal negotiations" take place between artists and censors in a discrete way.[47] Self-censorship had already been encouraged in a short article in *La Rivista del Cinematografo* in 1929. When forced to confront the issue of sound in cinema, the priest Carlo Canziani had urged film producers to develop a broader sense of "seriousness and morality" and had also urged government to become stricter. Canziani had also stated that "if producers are certain that their films—if unsuitable—will be blocked, they would insert in their films those aspects which will surely allow them to be approved."[48]

However, self- and precensorship were not the only praxis that shaped the panorama of the postwar national film industry. Bureaucratic obstructionism (work-to-rule) was another method: slowing down granting of the seal for exhibition of a film nationally and internationally was another way to throw a spanner in the works of filmmakers. For instance films such as Giuseppe De Santis's *Caccia tragica* (*The Tragic Hunt*, 1947) and Vittorio De Sica's *Sciuscià* (*Shoeshine*, 1946) had to wait for several months for the approval to be screened in South America.[49] Baldi identifies several other ways of hindering the film production: denying the approval for coproduction (necessary in the Italian film industry, which is fragmented in small and medium film production companies); denying the credit of the *Banca Nazionale del Lavoro* (Italian National Bank, BNL) necessary for financially fragile companies; and more repressive devices after the censorship seal is given, such as confiscation of films by magistrates after the intervention by citizen groups or ordering cuts under pressure from police stations.[50] These practices have been confirmed in an article by Tommaso Chiaretti, which states that up until 1961, no film had been really condemned for obscenity. This is because filmmakers had already acquiesced to the censor's demands before production of their films began.[51] It is only in 1962 that a change in the censorship legislation took place with the approval of

the Law 161. However, despite introducing new procedures and reorganizing the first- and second-degree commissions,[52] this law still maintained a form of preventative censorship, which hanged as the Sword of Damocles over national cultural policies threatening the seizure of films after their opening in cinemas.[53] Therefore, what Kendall Phillips defines as one of the aspects of the history of film censorship—a dramatic "legal battle"—does not really exist in Italian cinema, where the production of controversial films is interrupted at a much earlier stage.[54] It is significant at this point to investigate not only the reasons for those negotiations but also the parties involved, as in the specific case of Italy, the state operated closely within the purview of the Catholic Church.

State, Church, and Censorship in the Postwar Period

If "censorship lies *within* the frame of the social contract, within the scope of the 'legitimate violence' exercised by the state over its subject,"[55] in the Italian case, the influence of the Vatican and the Catholic establishment over film production and censorship represents a crucial aspect of the "social contract" to which Alberto Abruzzese refers. In order to understand the specific framework within which the Italian state operates, it is important to remember how Forgacs differentiates Italy from the wider Western European pattern of governance: "The entwinements of Catholic norms and prescriptions with secular ones—to do largely with the civic power of the Church and the Catholic movement and the central position of the DC [*Democrazia Cristiana*, or Christian Democrats] as keystone of post-war coalitions, notably in the center-right period, which included the whole of the 1950s, after the exclusion of the left from government (1947) and before the start of power sharing with socialists (1963)."[56]

This is why the role of the Catholic Church and its links to the government is central to the postwar period, delimited by Forgacs to the years 1947–1963. To put it more directly, as Enzo Sallustri does, "in Italy democracy was either Christian or non-existent."[57] Crucial to this period and the reconstruction of the film industry in the post-Fascist era is Giulio Andreotti, whose leading role as Undersecretary to the Presidency of the Council of Ministers (May 1947–January 1954) allows him to supervise cinema legislation and oversee policy areas such as censorship of national and international films, as well as funding of national film productions. In this capacity Andreotti can also represent the interests of the Vatican, with which he has forged strong links.[58] Vitaliano Brancati's suggestion of a possible coalescence of interests between the government and the Catholic establishment is made possible thanks to Andreotti's strong centralization of power (through the cinema law of December 1949), which is in line with the wishes of the Vatican. While Andreotti is able to build a working relationship with all the constituent parts of the industry—producers, distributors, and exhibitors—at the same time he develops a cultural strategy

that in many ways reflects the one promoted by the Vatican. This approach has been described by Forgacs as "At all levels, then, the way the state interacted with 'culture' in the case of this particular medium [film] was on the one hand to meet demands being expressed by the industry that produces and distributes films—demands for protectionism, subsidy of domestic product, facilitation of export—and on the other hand to contain or repress through censorship the freedom of expression of the industry."[59]

It is precisely for this reason that analyzing the Catholic intervention into the film industry in the postwar period is so crucial to understanding censorship in Italy. Investigations of how the Vatican intervened into film censorship and freedom of expression of the film industry must be taken into account when studying this aspect of the history of Italian cinema. The entanglements between the Vatican and the Christian Democrats (represented by Andreotti) in terms of cultural policies have significantly affected production and distribution of national and international films in the post-1945 era.

While Pius XI's contribution to the discussion of cinema in his 1936 *Vigilanti Cura* had already set the ground for the need for moral control over the new medium, it is with Pius XII's two speeches on the "Ideal Film" (June 21 and October 28, 1955) that the Vatican's new approach to cinema was established. These speeches also demonstrate the Catholic Church's attempt to reconcile with technology and modernity.[60] However, in the first of his two speeches, Pius XII also—as Mariagrazia Fanchi observes—confirms the need identified by his predecessor for a system of surveillance, which would guarantee the moral and artistic quality of film production.[61]

The watchfulness and response of public authorities, fully justified by law to defend the common civil and moral heritage, was made manifest in various ways: through the civil and ecclesiastical censure of pictures, and if necessary, through banning them; through the listing of films by appropriate examining boards, which qualify them according to merit for the information of the public, and as a norm to be followed. It is indeed true that the spirit of that time, unreasonably intolerant of the intervention of public authority, would prefer censorship coming directly from the people (June 21, 1955).

This self-regulating activity "coming directly from the people," however, did not seem to be a possibility at that time. If one only looks at the top ten films in terms of box-office intake in the year before Pius XII's speech, all of them had received a negative valuation from the CdR of the CCC.[62] The spectators Pius XII refers to in his speeches seem to have chosen a type of cinema that is not in line with the Vatican's preferences. The decision to create an extensive network of parish cinemas (from around 450 at the end of the war to over 5000 in 1953, out of a total of 14,880 cinemas)[63] came as an attempt not only to exert a positive influence over film producers by creating a market for their products' distribution, but also a way to exercise a level of control over Catholic audiences, by advising them on the most suitable films. The slogan "a cinema for each bell tower"[64] is indicative of a rigorously

structured organization, which has been regulated since 1949 by the creation of the *Associazione Cattolica Esercenti Cinema* (Association of Catholic Exhibitors, ACEC). This wide network of parish cinemas was facilitated by Andreotti's Law of the same year, which allowed parish cinemas to flourish.[65] Amongst the guidelines given in the ministerial circular n. 9419/A.G. 37 (May 3, 1950), there was the clear imposition that parish cinemas could only show films approved by the Vatican. However, things on the ground were quite different. In his book on the relationship between the government and the cinema, Rossi states that parish cinemas were not only commercial businesses like every other cinema and often run by nonreligious managers, but also showed films of any kind— often those that had not been endorsed by the CCC.[66] This difficult situation led to the creation of small commissions and subcommissions, which could better control local parish cinema-related activities and protect unquestionable ecclesiastic desires.[67]

Despite such a rigid framework set up by the CCC, the archive of the *Azione Cattolica* (Catholic Action) has several documents that describe the discomfort expressed by individual parishes toward films improperly screened and the difficulty of the ecclesiastic establishment mediating between audiences' desires and parishes' concerns. In the autumn of 1942, a series of letters, written by a priest to the bishop of Recanati-Loreto (central Italy) Aluigi Cossio, forced the bishop to involve the Deputy Director of the Catholic Action in Rome in intervening in the matter and taking action. The dispute was about a local cinema, *Cinema Vittoria,* which still worked under the control of the ecclesiastic authority. The case is exemplary not only because it shows how several of the films condemned by the CCC were shown in this cinema (as for instance Dominique Bernard-Deschamps's *Tempête* [Thunder over Paris, 1938], heavily condemned by the CCC for its immorality and brutality, but still shown in Cinema Vittoria), but also because it seems that the bishop had adopted a soft approach, which he himself defined as the "lesser evil principle." In one of his letters (October 21, 1942), meant to calm the priest's rage, the bishop explained how until the CCC will not provide them with their own production, some less appropriate films are better than variety shows, which are "nests of prostitution" and bad examples for the younger generations. What is interesting about this correspondence is the double standard practiced by the bishop in terms of censorship. On the one hand, the bishop suggests the Catholic Action gets one of its members involved in state censorship committees in order to ensure a stricter control over the films circulated, doing exactly what Argentieri calls servility of state censorship to the Catholic Church.[68] But on the other hand he responds to the priest explaining that the "moral climate can vary from city to city and what is a source of sin in one place can be different in another."[69] One can only assume that this system of strict control over film production and morality in films at the time did not function well, so cinema managers used several ploys to avoid Catholic and state censorship. Moreover, as is often indicated in the primary sources of the time, many were the

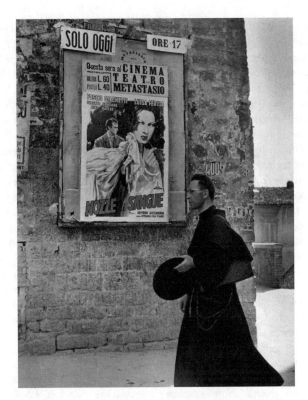

Image 15.1 A priest outside the *Cinema Metastasio*, where Goffredo Alessandrini's controversial film *Nozze di sangue* (*Blood Wedding*, 1941) was shown
Source and permission: Corbis

complaints about the scarce distribution of the CCC's film recommendations. A circular issued by the Headquarters of the Catholic Action (April 25, 1941) invites the Catholic press to more widely distribute the CCC film evaluations following Pius XI's recommendation in his *Vigilanti Cura* to spread the CCC moral judgment to all priests and the faithful. On the contrary, the fear of attracting spectators to unacceptable films forced the Catholic establishment to impose a restriction on all parishes to avoid showing the plots of these films on the churches' walls, which could distract those who came to attend mass (see Image 15.1).

Conclusion

The two-fold approach of the Vatican toward the film industry, which Dario Viganò describes as being divided between anxiety and hope, characterizes the

development of Italian cinema in the postwar period.[70] However, the relationship between film and censorship began to change when the compact nature of the DC starts to dissipate and their iron-like strong relationship to the Vatican begins to weaken.[71] From the 1960s, censorship started losing its grip[72] and from the end of the 1970s not only were reedited versions of films linked to commercial breaks imposed by private broadcasters[73] but also the "Catholic veil thrown over sex" was "lifted in part by the rise of private broadcasters like Berlusconi."[74] In 1984—with the Craxi–Casaroli agreement—Catholicism ceased to be the state religion, and in 2000 the scorn of religion (introduced by the Fascist regime in 1930 after the Lateran Pacts) was declared illegitimate by the Constitutional Court. It seems that this was the point in time when "crushing bottleneck" for Italian cinema, which Caldiron had referred to in 1961, ceased.[75] In 1962 a new law, which was a slightly revised version of the previous legislation but without any change in the fundamental procedure of films, was enacted after a censorship committee's decision. The only other minor change was introduced in 2007, when producers were given the opportunity to self-certify their films (at the risk of being heavily fined if their self-certification did not correspond to the official one). However, the *Commissione Nazionale per la Valutazione dei Film* (National Committee for the Evaluation of Films, CNVF), which was created under the control of the *Conferenza Episcopale Italiana* (Italian Bishops' Conference, CEI) on July 15, 1968, is still active today with its regulations and new moral and pastoral criteria of films—binding together a much reduced parish cinema network.[76] Its influence, nevertheless, should not be underestimated. For example, Antonello Grimaldi's film *Caos Calmo* (*Quiet Chaos*, 2008), whose sex scene CEI's youth section don Nicolò Anselmi labeled as "vulgar and destructive," was one of the most viewed YouTube videos of the year.[77]

Notes

1. Law June 30, 1889, n. 6144; Baldi, A. (1994) *Lo sguardo punito. Film censurati 1947–1962*. Rome: Bulzoni Editore, p. 12.
2. Welle, J. P. (2004) Early Cinema, *Dante's Inferno* of 1911, and the Origins of Italian Film Culture, p. 30 in Iannucci, A. (2004) *Dante, Cinema and Television*. Toronto: University of Toronto Press.
3. Valli, B. (1999) *Il film ideale: i cattolici, il cinema e le comunicazioni sociali*. Milan: Franco Angeli.
4. The level of the government's control over cinema gains the support of a movement around the conservative newspaper *Il Giornale d'Italia*. In its pages, the Attorney General of the Court of Appeal of Rome, G. B. Avellone, defined cinema as "the seediest part of a vulgar and appealing industry," inviting local authorities to intervene by confiscating films to avoid their screenings and Italian women not to watch immoral shows; see Sallustro, E. (ed) (2007) *Storia del cinema italiano. Censure. Film mai nati, proibiti, perduti, ritrovati*. Cinisello Balsamo: Silvana Editoriale, p. 26. This form of abstinence was referred to again by Andreotti when praising this form of protest against immorality used by the American Catholics. See Andreotti,

G. (1952) Censura e censure. Lettera dell'On. Andreotti al Consulente Ecclesiastico del C.C.C, p. 7 in *La Rivista del Cinematografo,* 12.

5. Graziosi, M. & P. L. Raffaelli (eds)(1999) *Si disapprova. Mostra con materiali inediti dagli archivi della censura cinematografica e opere di arte visiva.* Rome: Anica Edizioni, p. 33. However, in the same year, the law June 25, 1913, n. 785 authorizes the government to control national film production and the import of foreign films, with a tax of 10 cents per each meter of film, disguising censorship under a tax measure. Baldi (1994), p. 13.

6. Regio decreto May 31, 1914, n. 532.

7. Douin, J. L. (2010) *Dizionario della censura nel cinema. Tutti i film tagliati dalle forbici del censore nella storia mondiale del grande schermo.* Milan/Udine: Mimesis Edizioni, pp. 321–322.

8. Baldi (1994), pp. 13–14. See Catholic press on taboo topics: De Mori, G. (1938) Il cinema e i criteri di censura, pp. 105–107 in *La Rivista del Cinematografo,* XI (5), May 1938.

9. "In reality, however, the script is still presented to the first Committee together with the finished film: preventative control is applied rigorously from the beginning of 1935. [My translation]" Baldi (1993), p. 15.

10. Bonsaver, G. & R. Gondon (eds) (2005) *Culture, Censorship and the State in Twentieth-Century Italy.* Oxford: Legenda/MHRA, p. 2. Vittoria, A. (2005) Fascist Censorship and Non-Fascist Literary Circles, pp. 54–63 in Bonsaver, G. & R. Gordon (2005), p. 56.

11. Willson, P. (1996) Women in Fascist Italy, p. 80 in Bessel, R. (ed) *Fascist Italy and Nazi Germany: Comparisons and Contrasts.* Cambridge: Cambridge University Press.

12. Baldi (1993), p. 19.

13. Laura, E. G. (ed) (1961) *La censura cinematografica: idee, esperienze, documenti.* Rome: Edizioni di Bianco e Nero, p. 12.

14. In an article in *La Rivista del Cinematografo* (1950: 5), Albino Galletto, President of the Catholic Censorship Committee (CdR), justified the Committee's moral sensibility by stating that its members are all fathers and mothers. See: Galletto, A. (1950) I giudizi morali sui film, p. 5. in *La Rivista del Cinematografo,* 2.

15. See http://www.saint-mike.org/library/papal_library/piusxi/encyclicals/vigilanti_cura.html, point 11. Retrieved October 16, 2011.

16. Casetti, F. & S. Alovisio (2006) Il contributo della Chiesa alla moralizzazione degli spazi pubblici, p. 100, in Eugeni, R. & D. Viganò (eds) (2006) *Attraverso lo schermo. Cinema e cultura cattolica in Italia.* Rome: Ente dello Spettacolo.

17. Casetti & Alovisio (2006), pp. 102–103. Mosconi, E. (2006) Un potente maestro per le folle. Chiesa e mondo cattolico di fronte al cinema, p. 155 in Eugeni & Viganò (2006).

18. Mosconi (2006), p. 155.

19. Festi, G. (1929) Armi per la nostra Battaglia (con parole altrui), pp. 45–46 in *La Rivista del Cinematografo,* II, n. February 2, 1929, p. 45.

20. May 1931 Year IV, n. 5, p. 139; August 1931 Year IV, n. 8, p. 219.

21. Rossi, E. (1960) *Lo Stato cinematografaro.* Florence: Parenti editore, p. 111.

22. See Fredda, L. (1949) Il cinema in *L'Arnia,* Rome 1949, Section III, p. 148, and Baldi (1993), p. 20. The close relationship between the Government and the Vatican is often referred to in secondary literature. Douin (2010: 322), even reminds us that not only in 1932 the official Vatican newspaper, *L'osservatore romano,* had praised

Italian film censorship as the best in the world, but also that in 1935—before start-ing working on a new film censorship legislation—Luigi Freddi (head of the DGC) felt the need to consult with the Jesuit priest Tacchi Venturi.

23. *Cine Annuario* 1948, p. 45; *Guida Cinematografica* 1963, XXX. However, in 1933 the need to control what Catholics could watch in the parish cinemas had already led to the creation of a *Commissione di Revisione* (Censorship Committee).

24. Civardi, L. (1940) *Il cinema di fronte alla morale.* Rome: Centro Cattolico Cinematografico. Civardi (1940), p. 17. See Covi, A. S. J. (1950) Come giudicare un film? pp. 6–9 in *La Rivista del Cinematografo,* XXIII (1), January 1950. See Avetta, I. (1950) Films buoni... per caso. Chi ha pensato ai quattromila parroci preoccupati per un pubblico che, mal contato, sarà di un milione di persone?, p. 14 in *La Rivista del Cinematografo,* XXIII (1), January 1950. Avetta's article raises the need of films that are deliberately and from the start based on sound prin-ciples. See also Andreotti's explanation of Christian morality and of a Christian cinematographic conscience in Andreotti, G. (1952) Censura e Censure, p. 4 in *La Rivista del Cinematografo,* 12.

25. This concept of immorality is present in another seminal volume: Canals, S. (1961) *La Chiesa e il cinema.* Rome: Ente dello Spettacolo. Canals, pp. 95, 121–141, which links immorality closely to the dangerous power cinema could exercise over people, while also looking at concepts such as family, state, and religion, and at how films should deal with them in order to influence people in a positive manner.

26. The need to amend immoral films has been justified in an article in *La Rivista del Cinematografo,* in which this additional editing process is operated by the Catholic priests only to remove those immoral scenes as dangerous as "drugs added to food" (dcc. (1936) La deprecata "correzione" dei film, p. 28 in *La Rivista del Cinematografo,* IX (2), February 1936).

27. Official journal of the CCC (1943), p. 66.

28. Un esempio (1943), p. 29 in *La Rivista del Cinematografo,* XVI (3).

29. Treveri Gennari, D. (2008) *Postwar Italian Cinema. American Intervention, Vatican Interests.* New York: Routledge, pp. 70–71.

30. Argentieri, M. (1974) *La censura nel cinema italiano.* Rome: Editori Riuniti, p. 89; Argentieri, M. & I. Cipriani (1961) Quindici anni di "vigilanza" (1945–1960), pp. 1536–1560 in *Il Ponte—Rivista mensile di politica e letteratura.* XVII (11), November 1961; see also the interview to Giulio Andreotti, p. 103 in Viganò, D. (ed) (2005) *Pio XII e il cinema.* Rome: Ente dello Spettacolo. This close relationship between film producers and the CCC is reported in the article: a.g. (1951) Perchè arrivare alle forbici, p. 2 in *La Rivista del Cinematografo,* XXIV (4), where a.g. (pos-sibly Albino Galletto, President of the Catholic Censorship Committee) is surprised by the number of production companies requesting a "moralising process" of their films directly to the CCC.

31. Forgacs, D. (2005) How Exceptional Were Culture–State Relations in Twentieth-Century Italy?, pp. 17–18 in Bonsaver & Gordon (2005).

32. Decree (October 5, 1945 n.678). Cooke, P. (2005) The Italian State and the Resistance Legacy in the 1950s and 1960s, p. 120 in Bonsaver & Gordon (2005).

33. Law (n. 379). Vitti, A. (1996) *Giuseppe De Santis and Postwar Italian Cin-ema.* Toronto: University of Torornto Press, p. 98; Farassino, A. (ed) (1989) *Neorealismo—Cinema italiano 1945–1949.* Turin: E.D.T.; Baldi (1994), p. 23, however, states that preventative script approval was seen more favorably by the revision commissions.

34. Caldiron, V. (1961) La censura in Italia dagli inizi del secolo al dopoguerra, p. 1517 in *Il Ponte—Rivista mensile di politica e letteratura*, XVII (11), November 1961.
35. Brunetta, G. P. (1982) *Storia del cinema italiano dal neorealismo al miracolo economico 1945–1959*. Rome: Editori Riuniti, p. 55.
36. Brunetta, G. P. (1991) *Cent'anni di cinema italiano. Vol. 2 Dal 1945 ai giorni nostri*. Rome-Bari: Laterza, pp. 14–15.
37. The former do not approve of a system in which State funding is partly determined by a bureaucratic committee and not by the audience. The latter, on the other hand, are of the view that too much power is being placed in the hands of "public officials," a development that might jeopardize the freedom of the film industry. See Dl sulle disposizioni sulla cinematografia (CdD, seduta del 14/12/1949), p. 9; regarding the opposition of the exhibitors, see Villa, M. (1950) Il Presidente della Repubblica ci dà ragione, p. 1 in *A.G.I.S.—Bollettino di informazioni*, VI (95), March 1–15, 1950.
38. Argentieri (1974), pp. 73–74.
39. Argentieri (1974), pp. 73–74.
40. Forgacs (2005), pp. 17–18.
41. Baldi (1994), p. 23. See also Sallustro (2007), p. 60. On December 10, 1947 the left wing newspaper *Unità* publishes a letter signed by—amongst others—the filmmakers Mario Camerini, Alessandro Blasetti, Mario Soldati, Vittorio De Sica, Alberto Lattuada, Pietro Germi, Luchino Visconti, Michelangelo Antonioni, and Federico Fellini. The letter criticizes a certain fascist approach to national film production. In 1954 a group of film professionals, journalists, and theorists (Roberto Rossellini, as well as Gina Lollobrigida, the film critic Gian Luigi Rondi, and the Belgian Jesuit Felix Morlion) created an organizing committee to investigate—amongst the problems of Italian cinema—the issue of censorship, criticizing an obsolete legislation. See: Si è costituito in Roma un comitato promotore per lo studio dei problemi della cinematografia italiana (1954) p. 6 in *La Rivista del Cinematografo*, XXVII (5), May 15, 1954. See also Baldi (1994), p. 23.
42. Argentieri (1974), pp. 111–112.
43. Argentieri, M. & I. Cipriani (1957) Censura e autocensura, p. 1355 in *Il Ponte—Rivista mensile di politica e letteratura*, XIII (8–9).
44. Rossi (1960), p. 115.
45. Moscon, G. (1957) Una legge da rispettare, p. 1329 in *Il Ponte—Rivista mensile di politica e letteratura*, XIII (8–9), August–September 1957.
46. For more information on the *Codice pr la cinematografia*, see Treveri Gennari, D. (2008) *Post-War Italian Cinema*, pp. 104–105; Bonsaver and Gordon (2005), p. 6.
47. Bonsaver and Gordon (2005), p. 6.
48. Canziani, C. (1929) Film sonoro, p. 101, in *La Rivista del Cinematografo*, II (4), April 1929.
49. Argentieri & Cipriani (1957), p. 1342.
50. Baldi (1994), p. 24.
51. Chiaretti, T. (1961) Il cinema e' innocente, p. 10 in *Vie Nuove*, XVI (4), January 28, 1961.
52. Replacing the civil servants with educators nominated by the Ministry.
53. Caretti, P. (1994) *Diritto pubblico dell'informazione*. Bologna: Il Mulino, p. 151; Sallustro, E. (ed) (2007) *Storia del cinema italiano. Censure. Film mai nati, proibiti, perduti, ritrovati*. Cinisello Balsamo: Silvana Editoriale, pp. 85–92.

54. Phillips, K. R. (2008) *Controversial Cinema. The Films That Outraged America.* London/Westport: Praeger, p. 3.

55. Abruzzese, A. (2005) Censorship in the Time of Berlusconi, p. 183 in Bonsaver & Gordon (2005).

56. Forgacs (2005), p. 19.

57. Sallustri (2007), p. 63.

58. In his *Ritorno alla censura* (195, Bari: Laterza), Vitaliano Brancati reminds us that when Andreotti took control of the Cinema Office in Via Veneto, the employees immediately understood his desire to follow the "order of the Jesuits, the Catholic Action and the fascists, toward which the Catholic Action never stopped winking". See Rossi (1960), p. 115.

59. Forgacs (2005), p. 10.

60. De Marco, V. (2005) Il contesto sociopolitico dei due discorsi, p. 20 in Viganò (2005).

61. Fanchi, M. (2005) Il film ideale in relazione al soggetto, ovvero agli spettatori a cui il film è destinato, pp. 65–78 in Viganò (2005), p. 71.

62. Fanchi (2005), p. 73.

63. Rivelazione dei teatri e dei cinematografi esistenti in Italia al 30 gennaio 1953, Roma, S.I.A.E.

64. See Viganò, D. (2004) Prefazione, p. 14 in Lonero, E. & A. Anziano (eds), *La storia della Orbis-Universalia. Cattolici e neorealismo.* Turin: Effatà Editrice; also see Brunetta, G. P. (1978) Mondo cattolico e organizzazione del consenso: la politica cinematografica, pp. 425–432 in Isnenghi, M. & S. Lanaro (eds) *La Democrazia cristiana dal fascismo al 18 aprile: movimento cattolico e Democrazia cristiana nel Veneto, 1945–1948.* Venice: Marsilio Editori.

65. In the article published in 1956 and titled "L'esercizio cattolico" (*La Rivista del Cinematografo*, 6, pp. 26–27) Mons. Francesco Dalla Zuanna, president of *Catholic Exhibitors' Association* (ACEC), admitted that the substantial increase of parish cinemas was only possible thanks to the intervention of the prime minister. By defining the distinction between commercial and parish cinemas, he allowed the parish cinemas to have their own clearly defined characteristics and therefore build on their own strength.

66. Rossi (1960), p. 124.

67. Argentieri (1974), p. 47.

68. Letter to Mons Giuseppe Borghino, Vice Direttore Generale ACI, December 9, 1942; see also Argentieri (1974), p. 92.

69. Letter to Padre Giuseppe Gentilucci, October 21, 1942.

70. Viganò (2005), p. 9.

71. Sallustri (2007), pp. 78–80.

72. The Law n. 161 approved in 1962 runs the censorship until the replacement of the Ministero del Turismo e dello Spettacolo with the Dipartimento Spettacolo (directly linked to the Presidency of the Council of Ministries) in 1995, when a new commission was set up but the main principles of the 1962 law remained.

73. Sallustro (2007), p. 100.

74. Abbruzzese (2005), p. 182.

75. Sallustro (2007), p. 77. In July 2007 a new bill—while requesting the abolition of preventative film censorship—introduced a new age limit (10 years old) to control violence in films and videogames. Sallustri (2007), p. 109.

76. See http://www.cnvf.it/. Retrieved November 23, 2011.

77. *Caos Calmo,* affondo della Cei. «La scena di erotismo è troppo volgare» (2008), in *Il Corriere della Sera* (February 12, 2008) http://cinema-tv.corriere.it/cinema/08_febbraio_12/caos_calmo_affondo_cei_346613d6-d96e-11dc-8c3c-0003ba99c667.shtml. Retreived August 13, 2011.

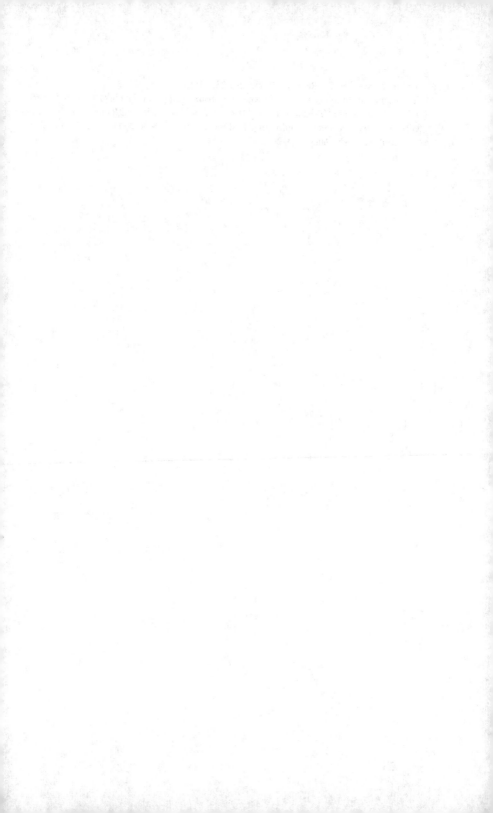

Film Censorship in a Liberal Free Market Democracy: Strategies of Film Control and Audiences' Experiences of Censorship in Belgium

Daniel Biltereyst

In Belgium this has been the position from the very beginning: no censorship of films for adults has ever existed in any form. [...] There is here a well-tested prototype for a completely liberal approach to the screen.
—Neville March Hunnings in *Film Censors and the Law (1967)*[1]

For what March Hunnings and other authors writing about film censorship systems around the world inform us,[2] the film policy of the small kingdom of Belgium was quite distinctive. Not only that there was no regulation in terms of import quotas, contingent laws, or other measures to protect local film production, but the country was also quite unique because it did not have a compulsory film censorship system. Film producers, distributors, or exhibitors were not obliged to show their movies to a censorship board but could distribute and screen them freely. In theory, this liberal film policy served as a gateway for Belgian audiences to consume unreservedly such controversial films that were considered to be politically dangerous or morally risqué.

Although there was no censorship system, in practice the Belgian film market had many constraints. First, as in many other Western liberal democracies,

these constraints included a whole battery of legal instruments in relation to the protection of public order and security, public morality, or the protection of children and minors. These forms of prior control, conditions, limitations, or restrictions prescribed by law could be (and effectively were) regularly applied to a popular public entertainment like cinema.[3] Secondly, March Hunnings's praise for the Belgian "completely liberal approach to the screen" omits the fact that there was a compulsory film control system for movies for children under 16 years, and that this system had some unexpected implications for distributors and exhibitors who worked in a business that was, until the 1970s, to a very large extent oriented to family entertainment. This came on top of commercial restrictions for distributors, who had to take into account the limited size and the multilingual character of the local film market—conditions that often kept them from releasing controversial movies or urged them to cut "objectionable" scenes from those pictures.[4] And finally, as we will try to delineate in this chapter, other social forces and institutions like the Church, and various political and ideological organizations, were heavily involved in the field of cinema, which they saw as an important ideological weapon and as a site of struggle, and in which they tried to influence the patterns of film distribution, exhibition, and consumption.

In this chapter we will argue that even in a liberal democracy like Belgium, where censorship is said to be minimal or even forbidden by constitution, various forms of surveillance and control mechanisms coexist(ed), and that many of these initiatives, as Jim McGuigan argued, "routinely occur[s] behind the backs of the public."[5] In line with more recent thinking about censorship as a complex and ambiguous concept (see Introduction), we will approach censorship as consisting of various forms of constraints and restrictions to the free distribution, exhibition, and consumption, and we will consider, as Sue Curry Jansen contended, the official, overt, and "regulative" forms of censorship as well as the more diffuse or "constituent censorship."[6]

This issue of a multiplicity of censorship, including secretive acts of censorship, which even in a liberal democracy often remain invisible to the public, the press, and society at large, is intriguing, not only because it raises fundamental questions about the legality of these acts and about societal power struggles around cinema but also because of the veil of undue secrecy in a democratic environment. This view of cinema as a site of struggle and censorship in an attempt to influence what audiences will finally see also throws up the largely unexplored question of censorship's efficiency and its impact on the (often uninformed) audience and society. This chapter, which starts by dealing with Belgium's liberal film control policy and the different constraints to it, will therefore report on an oral history project investigating how regular film viewers experienced these attempts at censoring and influencing their cinema-going practices.[7]

Modalities, Practices, and Discourses of Censorship

Ever since the start of the film industry, Belgium was widely considered by major film producers to be a small but interesting market. One of the most industrialized and prosperous countries in Europe before the First World War, the small kingdom had a lively film exhibition scene with a high attendance rate and a wide range of cinemas. The country had no significant film production of its own, importing movies from all major film production centers with a predominance of French and American titles. This image of an open film market tallied well with the broader liberal policies in matters of politics, economy, religion, freedom of speech, and the media developed by the country's successive governments since Belgium's independence in 1830. In continental Europe, the 1831 Belgian Constitution was long considered to be a seminal piece of liberalism and popular democracy, with references to freedom of the press and an article explicitly guaranteeing that censorship could never be established.[8] These principles were also applied to other media, and when the movies became a widely popular form of entertainment and gave rise to public debates over its control, attempts to censor the medium were systematically countered on the basis of these constitutional arguments.

Free-market liberalism and media freedom, however, did not prevent laws being imposed on cinema. The first legal regulations were enacted in 1908, in the form of a Royal Decree on public safety in film venues, soon followed by a range of other regulations at a city and municipality level.[9] As happened in the United States (see chapters 1 and 14) and in other Western countries (chapters 5, 9, and 12), censor boards, or other local forms of content regulation were already installed before the First World War, as a result of an ever-growing public resentment against the dangers of cinema.[10] Since 1907, the Belgian (anti-) cinema debate was fuelled on a more national level by discourses and actions of various conservative and Catholic pressure groups. In the period preceding the German invasion of Belgium in August 1914, organizations such as the *Ligue contre l'Immoralité* (League against Immorality) and the *Ligue du Cinéma Moral* (League for Moral Cinema) succeeded in heralding the issue of cinema as a "school of vice" (*"l'école du vice"*), "crime," or "immorality" front page news in the press and thereby making it prominent on the agendas of local administrations and Parliament, where the Senate debated the question in May 1914.[11] Before the war, however, no central censorship measures were taken in Belgium, although local public prosecutors and other judicial forces received orders from government to pay attention to what the influential Catholic minister of justice, Henry Carton de Wiart, had called in 1913 "the great number of violations in these obscure theaters, most notably scenes of rape, crime and violence, as well as offences against public morality."[12] This legislation on public order and morality became an important tool for local burgomasters and city majors in responding to complaints about cinemas and

particular movies, a pattern of governmental behavior that continued well into the 1970s. Although no systematic research has been done so far on these forms of local censorship, case studies on the problems encountered by Soviet films such as Sergej Eisenstein's *Bronenosets Potyomkin* (*Battleship Potemkin*, 1925)[13] or by French vaudeville movies during the interwar period[14] indicate that this level of local censorship on the basis of public order and morality was an efficient means for people to boycott controversial movies. This censorship strategy, which was also conducted after the Second World War, mainly consisted of pressure groups trying to upset public order with the aim of forcing local municipal or city powers to act against such cinema theaters that exhibited controversial movies.[15]

During the Great War, the German occupiers applied strict censorship laws. After the war, the Belgian anti-cinema movement continued to lobby for the *"assainissement"* (literally, "cleaning up") of cinemas. The economic and social disaster the war wrought helped the movement to spread its ideas about moral decay and the criminogenic effects of cinema, especially on children. These ideas were to a large extent also shared by progressive, liberal, and leftist organizations, including the socialist party, which saw state initiatives on the protection of (often parentless after the First World War) children as a weapon against social and economic decay. This bizarre alliance ensured that the issue of film censorship remained on the political agenda, and led to the September 1920 law on film control.[16] From an international perspective, the Belgian law was unique. Confronted by arguments that a film censorship law conflicted with the constitutional principle of press freedom, the socialist minister of justice, Emile Vandervelde, proposed a compromise solution. The 1920 law did not require film distributors or exhibitors to show their movies to a film control board unless they wanted to screen the films for audiences that included children or young adolescents under 16. Many distributors submitted films to the board for commercial reasons, while others chose to screen their movies for adults only without the censors' approval. Vandervelde explicitly argued that the Belgian regulation was *not* a censorship law, that the board could not reject movies for religious, ideological, or political reasons, and that it was concerned only with protecting children.[17]

The Belgian Board of Film Control (BeBFC, in Dutch: *Filmkeuringscommissie*, in French: *Commission du Contrôle des Films Cinématographiques*),[18] which started its operations in 1921 and thus became the central organization for regular film control, only had a restricted set of censorship modalities: next to giving the "children allowed" seal, it could also mark movies as "children not allowed" or with a "16 years" restriction. In some cases the five-member commission, which was appointed by the minister of justice, could decide to cut movies in order to give the "children allowed seal." A longitudinal analysis of the board's decisions indicates that the BeBFC was quite severe in its everyday workings (Graph 16.1).[19] The BeBFC's censorship practices indicate that during the interwar period only one-third (37.1 percent) of the movies

Graph 16.1 Proportions of BeBFC's decisions: children approved (CA), children approved with cuts (CA-C), and children not approved (CNA)

examined received the "children allowed" seal without cuts, while another quarter (23.6 percent) had to have material eliminated before receiving the seal. The remaining films (39.2 percent) were rejected, receiving the "children not allowed" seal. The proportion of cut films during the postwar years was still fairly high, especially during the 1950s and 1960s when it reached a height of 41 percent (in 1961). After 1970, the percentage of cuts dropped considerably to completely disappear from the early 1990s onward. Overall, for the period between 1922 and the 1980s, approximately one-third of the movies was labeled "children not allowed," a similar proportion received the unproblematic "children allowed" seal, and the other third had to cut in order to receive this seal.

This analysis, which is based on the systematic examination of the BeBFC's daily minutes, does not cover the outcomes of all the negotiations between the board and the distributors. When looking more closely at the concrete procedure of censorship, for instance by examining the BeBFC's correspondence, one can only conclude that the cuttings registered in the minutes were only the tip of the iceberg. In reality, so it appears, distributors frequently applied "*coupures préalables*" (prior cuttings) in order to get the permission to show their products to children and families. As one of the many examples of this kind of preemptive cutting or self-censorship, we can refer to the case of Michael Curtiz' *Casablanca* (1942), which was first submitted to the BeBFC in November 1945, receiving a "children not allowed" seal on the basis of a vaguely formulated criticism against the movie's "troublesome atmosphere which does not fit for children."[20] Only in May 1946, after a long process of negotiation and lists of preventive cuttings suggested by Warner Bros., did the movie receive a "children allowed" permission, leading to the cynical observation by the BeBFC's examining commission that "the

MINISTÈRE DE LA JUSTICE

Commission du Contrôle des Films Cinématographiques

PROCÈS-VERBAL

de la Séance du _7 Mai 1946_

S'ction _2 d'appel_ _____ sous la présidence de M_ _le Substitut_

Présents MM. _Busschan_

C. en Busschaer √

M. Doby Herlin √

Mr l'Avocat Chôteau √

Mr R.Pella √

NUMÉRO	TITRES DES FILMS EXAMINÉS	DÉCISION	NOMBRE DE VOIX	OBSERVATIONS COUPURES DEMANDÉES ET MOTIFS DES REJETS
√	" Casablanca " H.f.	admis	5/5	Observation: le film a subi plusieurs coupures, et est devenu assez décousu.
√	Chanson nègre 2f.	admis	5/5	

LE PRÉSIDENT,

de Buss

Image 16.1 BeBFC's minutes for _Casablanca_ (May 7, 1946)
Source: BeBFC.

movie had received several cuts, and it has become quite scrappy" (in French: "_décousu_") (Image 16.1).[21]

The board, which most of the time remained "_la grande muette_" (literally "the big silent") and did not communicate about its reasons for cutting movies to the wider audience, was very precise and coercive in indicating what and where distributors had to cut their movies. An analysis of these "suggested" incisions indicates that the BeBFC was most sensitive about images of violence

(39.2 percent of all cuts), crime scenes (18.2 percent), and depictions of sex and eroticism (22 percent). For more than 50 years, the Belgian film control system, which is still in operation today, remained restrictive,[22] and its common practice of cutting films was only abandoned as late as 1992.[23] In recent years, however, the BeBFC, which is only authorized to control theatrical movies (not for DVD's or games), has become extremely tolerant, mostly awarding "children allowed" seals, even up to the point of becoming (or being seen as) irrelevant. In a few cases this tolerance attracted criticism, like in the case of Steven Spielberg's *Saving Private Ryan* (1998), for which the board's "children allowed" seal was condemned by indignant parents' organizations.[24] Debates on the board's patronizing attitude, however, are even more exceptional. One of the rare examples is Tim Burton's *Batman* (1989), which received a 16 years rating for reasons of violence, a decision that was strongly criticized by Warner Bros., other distributors, and the national film press.[25]

Looking back at the BeBFC's history, however, the paradox was that while it was in principle nonobligatory and never applied to adults, it was, at least until the 1970s, severe for most commercial movies seeking to reach the widest audience. On the other hand, it remained liberal in the sense that many controversial movies, including erotic and politically dangerous pictures like Soviet films, could be shown freely in film venues without the board's control. Since the end of the 1950s, when the sociodemographic composition of the film audience changed and more controversial (auteur) films came into the market, a growing number of distributors preferred no longer to submit these pictures to the film censor (e.g., movies by Luis Buñuel or Federico Fellini were rarely presented to the BeBFC). In practice, however again, in some extreme cases, other mechanisms were applied in order to hinder the free distribution and exhibition of unsubmitted films. Next to boycotts and censorship on a local level, cases are known where government and diplomatic pressures were used in order to prevent particular movies from being screened in the kingdom. This was, for instance, the case with the banning of *Battleship Potemkin,* the international diplomatic storm around Herbert Wilcox's Edith Cavell movie *Dawn* (1928),[26] or with the troubles around the American exploitation film *Nudist Land* (1938) in 1939, where various Catholic pressure groups forced the government to alarm the US Secretary of Commerce to stop the export of this kind of exploitation movies.[27]

The key players in many of these controversies were conservative pressure groups. By far the most powerful lobby seeking to discipline the free circulation of movies consisted of a variety of Catholic organizations. As soon as cinema became a successful form of entertainment, Catholic laymen, priests, and organizations became aware of its potential influence. Confronted by the emergence and success of commercial film theaters, particularly in rural areas where the Church still enjoyed a wide moral and social hegemony, local Catholic groups started to lobby for a "clean" cinema and even entered into the territory of the film industry. In Belgium, as in some other western European countries

with a Catholic majority, after the Great War, initiatives for clean a cinema were taken in fields as diverse as film production, distribution, exhibition, classification, and criticism (see chapters 3, 12, 13, and 14). Belgian Catholics were quite early joining forces and, well before Pope Pius XI's 1936 *Vigilanti Cura* Encyclical Letter, they created a series of organizations that tackled the film problem in an integrated manner. Between the mid-1920s and 1933, they established a strong network of film organizations including Catholic distributors, a chain of cinemas, and a film control board. In February 1928, for instance, they set up a network of cinemas under the umbrella of the Catholic Film Central (CFC, in Dutch: *Katholieke Filmcentrale*, French: *Central Catholique du Film*), which aimed to operate as both an exhibition cooperative and a lobby group. In the next few years, the CFC started to classify and censor all movies on the Belgian film market for its wide range of parochial and other Catholic cinemas, and in 1931 the Catholic Film Control Board (or the CFCB, in Dutch: *Katholieke Filmkeurraad*, in French: *Comité Catholique de Sélection*) was established. This CFCB systematically rated movies by using specific codes (from 1, or movies for all, to 6 referring to morally very dangerous movies). These codes and "black lists" of "objectionable" and "condemned" movies were published in Catholic newspapers and they were also widely distributed and shown in parish halls and other Catholic public spaces. Although this film control board did not have any legal status underpinning its activities, it clearly functioned both as an additional censorship agency and as an influence on the workings of the official BeBFC, which was persistently criticized by Catholics for being too liberal in its enforcement of cinematic morality. In 1931, the network launched Filmavox, which operated as an independent commercial distributor, working for Catholic cinemas and the CFC's members. Finally, inspired by the American Legion of Decency's successful campaigns (see Chapter 14), which was triumphantly followed by the Belgian Catholics, the CFC created a wider mass movement. The Catholic Film League (CFL, in Dutch: *Katholieke Filmliga*; in French: *Ligue Catholique du Film*) operated through local units, which played a central role in organizing Catholic-inspired screenings, controlling the morality of regular film venues, and organizing concrete actions and boycotts against "unhealthy" pictures and cinemas. Finally, in 1933, all those organizations were officially brought together under one umbrella movement, the Catholic Film Action (CFA, in Dutch: *Katholieke Filmactie*; French: *Centre Catholique d'Action Cinematographique*).

From the end of the 1920s until the 1960s, these Catholic film organizations were considered to be among the most powerful players in nearly every segment of the film industry. The key to this power was the network of Catholic cinemas, an assortment of film venues that included many small parish halls in rural areas with only a few weekly screenings as well as large independent regular cinemas loosely associated with the CFC. The Catholic presence in the field of film exhibition certainly disturbed commercial film enterprises,

but it also inspired other ideological groups to compete in the field of film exhibition. In ways quite comparable to what happened in the Netherlands and some other countries, Belgian society was "vertically" divided in several segments, or "pillars," based on religion or ideology. This process of "pillarization" involved the existence of a wide range of social institutions differentiated along these ideological lines, including political parties, schools, trade unions, and hospitals.

This phenomenon of a segregated, pillarized society, which only began to lose power and influence in the 1970s, also affected the field of leisure and the media, and cinema and film exhibition in particular. Along with the liberal policy toward cinema at large, competition among the dominant pillars provides a key explanation as to why the statistics for the Belgian film exhibition market were usually high.[28] The main protagonists in this pillarized society were of a Catholic, socialist, liberal, and Flemish-nationalist signature, and all of them were active for some time in film exhibition as part of the propaganda and other activities by which they sought to extend their social and political influence. It is difficult to measure the power of those different blocks in the area of cinema, but a systematic in-depth investigation into the ideological signature of film venues in a significant selection of towns and cities with regular screening in Flanders[29] reveals that in most of the places some form of pillarized film exhibition took place from the early 1910s onward. From the end of the 1950s onward, when the overall cinema attendance figures gradually crumbled, the number of pillarized film venues decreased dramatically. Among the ideologically inspired cinemas, Catholics clearly took the lead, followed by cinemas within the socialist and Liberal pillar. If we consider this selection of cities and municipalities to be fairly representative of the Flemish (and by extension the Belgian) film scene, we get an idea of the substantial role played for several decades by ideological film exhibition. Between the 1930s and the 1960s, between a quarter to a third of the film venues were known to belong to one or another ideological or religious organization. In 1957, when the expansion of cinema venues reached its peak, a quarter of the 1585 cinemas in Belgium would have belonged to one of the pillars.[30]

Summarizing this first part, it is clear that, although the BeBFC officially had a monopoly on film control, whereby it had a clearly defined set of "regulative" censorship modalities and practices, other disciplinary forces entered the field of cinema with more diffuse forms of "constituent" censorship.[31] A key question about this multiplicity of censorship institutions and their modalities, practices, and discourses is to what were extent these efforts to influence film content, film programming, and eventually regular filmgoers' behavior, were really effective. Was the Catholic Film Action effective in guiding audiences? Similar questions can be raised about the effectiveness of other forms of censorship, including local interventions, government actions, and, of course, the regular control of most film titles by the BeBFC. How

did people experience this kind of disciplinary forces in the realm of everyday life? To what extent did people know about and experience cuts or age restrictions?

The Experience of Censorship

These questions all relate to audiences' everyday experiences of how the state censors, ideological pillar organizations, and other institutions sought to influence film culture and cinema-going habits. In an attempt to grab those questions, we will rely on an oral history project that aimed to engage with the lived experiences of ordinary moviegoers within their social, historical, and cultural contexts. By means of individual in-depth interviews and inspired by cultural studies in general, and Annette Kuhn's "ethnohistory" approach in particular, we wanted to investigate the role of cinema within audiences' everyday life and leisure culture.[32]

The oral history project, on which the following analysis is based, concentrated on former filmgoers in the Flemish city of Ghent. For the period under consideration, the city counted 170,358 inhabitants in 1930, 148,860 in 1970, and due to a restructuring of the borders of the suburbs in 1977, 239,959 in 1980. In the heydays of cinema, in the 1950s, Ghent counted 25 and 30 cinemas, including some belonging to the pillarized circuit. The respondents were mainly selected and found in homes for elderly people or through responses to calls in local newspapers. Although we were not looking for statistical representativeness, we strove for sufficient variation in terms of age, class, sex, and ideological background. A total of 62 inhabitants of Ghent were interviewed concerning their movie-going habits from the 1930s to the late 1970s. The sample comprised of a slightly greater number of women (56.5 percent) than men, all born between 1912 and 1959. The length of the interviews varied according to the storytelling capacities of our respondents, with an average of around one hour per interview. The interviews dealt with particular themes, including questions in relation to the interviewees' memories of censorship and the role of the church and other pillars.

The oral history project produced a set of extremely rich and diversified information about the importance of movies, the social experience of cinema-going, and the role of this activity in everyday life.[33] Taking into account that the peak movie-going period of people's lives was before the age of 25, the largest part of our respondents' stories focused on the period between the 1930s and mid-1970s. Although this is a broad time span, many respondents talked about it as if it were one homogeneous period. As other oral history studies have underlined, this is partly due to the fact that memories are highly selective and subjective, distorted by time and clouded by nostalgia—all of which occlusions posed problems for interpretation. The selective workings of personal and collective memories include strategies of

repetition, fragmentation, narration, the use of anecdotes, and the tactics of forgetting and of adapting past experiences to contemporary views of specific social issues.

These considerations have wide-ranging implications for historical research, especially for the issues at stake in this chapter where people might want to either minimize or exaggerate the past impact of state control or of the Church and other societal institutions that have lost their power today. This might particularly be the case for the Catholic Church, but also by extension for the other traditional pillars. Analyzing the interview transcripts in this light, we came to the conclusion that most respondents confirmed the moral and societal power of the Roman Catholic Church for the period they were discussing. They also knew about the Catholic film initiatives because, as one respondent argued, "in nearly every village there was a priest who had a projector . . . and a film venue" (JV, male, born in 1930).[34] According to another male respondent discussing the postwar period, the Church had effective power in the field of cinema because "priests talked about film when they were on their pulpit" and "yes, the church could make or break a movie" (GVV, male, 1936).

While these observations seem to confirm the Church's power, respondents often minimized its influence when discussing their own movie-going habits, insisting with some conviction that they chose their theaters and movies freely. Ideology, it seemed, did not matter because "people didn't worry about it":

> Even in the socialist cinema people didn't talk about politics. In fact, in none of the film venues. They did in the cafés near the cinemas, but never in there.
>
> (AVM, male, 1919)

People chose a cinema on the basis of the quality and attractiveness of the program, of the atmosphere, and much less on the basis of any ideological consideration:

> That was a socialist cinema, yes. But they showed all kinds of movies. American, German, you name it. The audience didn't care. The only thing that mattered was the film.
>
> (VVS, male, 1928)

While cinemas in a socialist network were perceived as somewhat more adapted to the regular cinema experience, at least at the level of the variety of movies, Catholic movie venues were often seen as family cinemas, or as the ideal places to go and see movies with children and other relatives. The movies screened in these venues were chosen by the CFC or by local priests so that, as one interviewee put it, people "knew that one shouldn't expect too many dangerous things" (GM, male, 1921). Deciding whether to visit a commercial or a Catholic theater depended on social habits as well as on its location in the neighborhood and the ticket price. If the purpose was to have a day out with

the family and see a movie, a Catholic movie theater became a potential choice. But when going out with their partner or with friends, Catholic theaters were a less attractive option because of their strict rules of conduct, and our Catholic respondents opted to go to a commercial theater instead.

When Catholic respondents were asked to describe the Catholic movie theaters in the city, it immediately became clear that this type of theater never came close to fulfilling its purpose as an alternative for the commercial circuit. Catholic cinemas and the other venues in the pillarized system were usually cheaper, but respondents often described them as "not real cinemas," especially when compared to city center palaces. Many of the characteristics with which they associated Catholic movie theaters stood in direct opposition to their expectations of a "real" cinema: Catholic venues were described as small, dark, uncomfortable, and technically less suitable for movie screenings.

Programming was another point of concern. Most Catholic cinemas had only a limited number of screenings per week and often opened only at weekends. Commercial cinemas in urban areas played on a daily basis with continuous programming, so that people could walk in at any time they wanted. The Catholic venues lacked the perceived image of accessibility, which enabled cinema to become the dominant form of leisure activity. In addition, the films screened in Catholic theaters were frequently considered to be second-rate, old, and inferior to the ones played at commercial theaters.

> What did they show? Those were films that were really old and totally worn-out, the leftovers really. The ones they could get at a cheap price, because they couldn't afford expensive movies. They played one or two box office hits from a few years before, but all the rest [...] well, that was just what they could get.
>
> (JA, male, 1941)

In comparison to the big cities, the tension between ideological and commercial theaters in smaller villages was much higher. In Flanders it was not uncommon for small villages to have two or three movie houses, usually including a Catholic venue and sometimes a socialist one. Many respondents indicated that in these small-scale communities with a high level of social control, local priests often preached against commercial theaters and "bad movies." The priests' moral power also worked at a face-to-face and interpersonal level, through school masters, parents, or pressure exerted on cinema owners or other people working in the local film business:

> Our local priest was absolutely against our cinema. He regularly visited my aunt (who owned the local movie theatre) to drink coffee. But whenever he was on the pulpit during mass, he was always preaching against the cinema.
>
> (MVD, male, 1934)

The Catholic film organization also made sure that its film classification codes were nailed to the church door, in schools, and other public spaces within the

Catholic network. The codes were also published in a variety of magazines, leaflets, and newspapers with a Catholic orientation. When the codes used by the CFC were mentioned to our respondents, they immediately produced a smile of recognition with almost every one of our respondents. Many of the Catholic respondents testified that they used the classification system exactly as intended by the Catholic leaders and that parents also used the codes to decide which movies were suitable for their children. The system, however, also had a countereffect in that forbidden movies had a strong appeal to audiences. Stories of children sneaking into adult screenings and of Catholic adults tempted to see a forbidden movie featured prominently in our interviews:

> Sometimes I realized during a movie that my parents wouldn't have let me go and see that movie. Because of our Catholic background. And then you walked out of that movie feeling guilty. I entered the theatre out of curiosity, but I walked out knowing that I shouldn't have done that. My parents wouldn't have liked it. They wouldn't approve.
>
> (MH, male, 1941)

One of the social institutions that was mentioned many times by the respondents when talking about who tried to influence their choice of films, cinema, and their cinema-going behavior in general, is the education system. While many respondents spoke about films being shown at school and they even referred to some film education, they also repeatedly argued that this was the place where "bad" movies and cinemas were heavily condemned. This was closely linked to the Catholic hegemony in the educational system:

> We often received warning, but of course we went to a Catholic school. Some teachers really exaggerated in their condemnation of particular films and cinemas.
>
> (JD, male, 1938)

> My brother and I went to the Saint Barbara College in Ghent, a very severe Catholic school. I remember that some of the fathers and teachers were sent around in order to control who went to cinemas.
>
> (PB, male, 1947)

When asked about the workings of the state control board, most people knew about the BeBFC's existence and they tried to underline the board's effectiveness by offering dramatic examples of how movies had been cut, or by referring to the effective police control in cinemas:

> You had to be careful, because, if a cinema was caught three times on letting in children for forbidden movies, they could be closed. It was a strict control.
>
> (MT, female, 1935)

One of the respondents, who had worked at the Ghent police vice squad, energetically talked about different cases of prints taken into possession and other forms of legal action against cinema owners. These actions attracted a lot of attention precisely because "what is forbidden is alluring to people" (JD, male, 1935). The BeBFC's most visible strategy of disciplining or regulating cinemagoing was imposing age restrictions, a practice that was visible in the program, on posters and movie stills. Putting stickers on the pictures, for instance "to hide a naked breast" (GV, female, 1937), was a common practice, but again it often had an effect opposite of what was intended, and for some *risqué* cinemas amounted to a marketing strategy. Many respondents joyfully recalled adventurous attempts to get into cinemas where movies with age restrictions were scheduled. The interviews revealed an array of ingenious tactics, from using make up and dressing like an adult ("we dressed like our mothers, a long skirt and blouse, a *décolleté*, and so we could enter" [AF, female, 1942]) to manipulating identity cards:

> My friends could get in but they were all one year older than me and I had an identity card and that was written with a pen. I have one indicating 1941. I turned it into a zero and then I could get in.
>
> (HGT, male, 1941)

These bold stories about evading controls at the cinema's entrance are, however, put into a less audacious perspective if we take into account the numerous stories about the weak enforcement of age restrictions, and the many descriptions of how easy it was to get in. As a former policeman said,

> There were many cinemas in the city. We went to the cinema about once a week. And then we were looking for minors and that's about it. Often we went to a cinema, just for ourselves, to watch a movie or something.
>
> (JDM, male, 1944)

Another BeBFC strategy, which was not publicly announced, was cutting movies. The interviews, however, showed that people knew about this and complained about it, although not strongly enough to be of any consequence. One exhibitor suggested that

> Sometimes there was a little controversy around it. But I do not remember that people, so to say, were traumatized by it [laughs].
>
> (JD, male, 1942)

People were most often annoyed about cuts because these limited the pleasure of watching a movie:

> Yeah, those pieces cut out of the movie were really annoying, and you could see it technically: they were badly put together. They were technically bad. Usually it

was a nude scene . . . Even censorship of language, like swearing for instance. And then there was a "beep". It was terrible. Ah, we often talked about it.

(AL, female, 1942)

Technical problems of clumsy editing and sound were only one issue. People were most aware of censorship through its effect on the film's narration, with scenes of violence and eroticism often deleted. These cuts were usually experienced as annoying cosmetic exclusions, but in some cases deletions caused real problems for the audience to follow the story. Too many cuts could provoke an audience response, as in the case of the juvenile delinquency movie *Rock around the Clock* (Fred F. Sears, 1956), in which a large number of cuts drove the young viewers to "yell and jump on their seats" (MT, female, 1935). Another extreme form of rebelling against the BeBFC's strategy was to watch the movie elsewhere:

If we wanted to see that movie, we went to France . . . to Lille . . . half an hour by car . . . In France they showed more. Yes, we often drove to Lille because my husband said, they give the original version there, no cuts.

(AL, female, 1942)

These were extreme reactions, and people more frequently argued that cuts were, so to speak, part of the game. To some extent, people seemed to accept those practices and downplay their effect on the movie viewing experience, although they now often denounce them nostalgically as obsolete and paternalist:

You could see it, because then there was a problem with the story. You knew that there was a jump in it. But the pieces that were cut out . . . these were usually no atrocities, but at that time a bare knee was already too much.

(CW, male, 1938)

Again, the productivity of the censorship system often lay in the attractiveness of getting around the system, or in being attracted to the forbidden fruit:[35]

Sure, as a Catholic you had to be good. But these quotations in the newspapers were excellent to show you where kids weren't allowed, so you'd know that those were the ones you definitely had to see!

(AV, male, 1933)

Conclusion

One of the "Good Lies" of the Enlightenment project, Curry Jansen argued, was that "it abolished censorship" and that it has "silenced criticism of constitutive censorships."[36] In liberal democracies like the Belgian one, however,

where (film) censorship is constitutionally condemned and freedom of speech and media are actively promoted, some of these founding principles seem to be contradicted when disturbing images or worldviews are suppressed. The Belgian case is interesting because the kingdom is often referred to as an extreme example where, at least for adults, there never was a compulsory film censorship. In practice, however, as we tried to argue, various kinds of constraints to a free film distribution, exhibition, and consumption were in action. These included formal and official kinds of censorship such as the one exercised by the BeBFC, along with more unofficial and diffuse ones as those developed by Catholic film organizations, schools, or film distributors themselves. This situation resulted at the end in two separate systems of censorship and classification codes, which in some cases were joined by other disciplining institutions that came into action (e.g., government, diplomacy, law courts, local administrations, religious organizations, schools, family).

This situation in which multiple institutions used different kinds of practices (e.g., cuts, legal and moral condemnations) and discourses (e.g., on the protection of children, of public order and morality) in their attempt to control cinema, draws a picture of a Deleuzian "control society" in which the BeBFC was in the frontline of a systematic film control, which was occasionally supplemented by a network of other sites and institutions within which movies and cinema-goers were located. Although this system of a robust, multiple, and mutually reinforcing censorship strongly influenced what kind of films were distributed, screened, and consumed in cinemas, one should not overlook the many possibilities left for alternatives and eventually resistance. It was not a close system, and we should not overlook the fact that there was a competition between institutions, where, for instance, the BeBFC was often severely attacked by the local film industry. Within the Belgian system, also, many unsubmitted films were effectively screened for adults only, as well as there was a fairly well-developed range of "ciné-clubs," where controversial pictures were shown in private screenings.

In an attempt to assess the effectiveness of strategies of control on audiences and their cinema-going habits, we used observations obtained from oral history research. We do not want to provide definitive answers on issues such as the impact of censorship or the possible forms of resistance, but we do come to the conclusion that people were very much aware of these forces and that the respondents admitted the power of the BeBFC, the CFC, and the educational system, the last one being closely related to a hegemonic Catholic worldview. Of course, respondents as cinema-goers of yore frequently tried to evade or escape this kind of constraints, up to the point where systems of control could have an inverse effect by promoting censored movies. Following Michel de Certeau's terminology, we could interpret this kind of evasive cinema-going practices as tactics,[37] or attempts to circumvent authorities' top-down control.

However, it is good not to overestimate these audience tactics, while equally remaining critical of oral history and historical audience studies as a method

for investigating questions of power, control, and censorship. Next to criticism in relation to the selective workings of personal and collective memories, and to the tactics of forgetting and of adapting past experiences to contemporary thinking about particular social issues, we should not forget that most of the actual forms of censorship had a secretive character, thus remaining unknown and unnoticed to audiences. Tactics of evasion or audience's bottom-up resistance are also of a quite different nature than top-down, institutional forms of power. In the respondents' memories, tactics of resistance also frequently remained innocent and playful, at least in the context of cinema, rather than constituting a conscious act of resistance. The BeBFC's censorship or the Catholics' attempt to create a pillarized viewing pattern was explicitly denounced by some, and it was often seen as annoying, but most people also seemed to look back on it as part of the game of viewing, and even as acceptable as long as they believed they had a choice.

Notes

1. March Hunnings, N. (1967) *Film Censors and the Law.* Liverpool: Allen & Unwin, pp. 394–395.
2. For instance, Phelps, G. (1975) *Film Censorship.* London: Letchwork, p. 242.
3. For a wider context, see Stevens, L. (2002) *Strafrecht en seksualiteit.* Antwerp: Intersentia.
4. The Kingdom of Belgium covers an area of 30,528 square km, and it consists of three parts: a French-speaking southern region (Wallonia), a densely populated, Dutch-speaking region in the northern part (Flanders), and the bilingual capital of Brussels. The Belgian population grew from 6.7 million at the beginning of the twentieth century to 10 million at the end of the century. Belgium now has a population of 11 million people.
5. McGuigan, J. (1996) *Culture and the Public Sphere.* London/New York: Routledge, p. 156.
6. Curry Jansen, S. (1988) *Censorship: The Knot That Binds Power and Knowledge.* New York/Oxford: Oxford University Press.
7. This chapter will rely upon three research projects. The part on film control in Belgium is based on the results from the research project: *Forbidden Images: A longitudinal research project on the history of the Belgian Board of Film Classification (1920–2003)* (project funded by the FWO/SRC-Flanders, 2003–2006). The oral history part is based on two projects: (1) *"The Enlightened City": Screen culture between ideology, economics and experience. A study of the social role of film exhibition and film consumption in Flanders (1895–2004) in interaction with modernity and urbanization* (project funded by the FWO/SRC-Flanders, copromoters: Philippe Meers and Marnix Beyen, University of Antwerp, 2005–2008); (2) *Gent Kinemastad. A multimethodological research project on the history of film exhibition, programming and cinema-going in Ghent and its suburbs (1896–2010) as a case within a comparative New Cinema History perspective* (project funded by the Ghent U Research Council BOF, 2009–2012).

8. See "Belgium," pp. 45–46 in Green, J. and Karolides, N. J. (2005) *Encyclopedia of Censorship*. New York: Facts on File. Hagwood, J. A. (1960) "Liberalism and constitutional developments," pp. 190–192 in J. Bury (ed) *The Cambridge Modern History: The Zenith of European Power 1830–70*. London: CUP.

9. Royal Decree, July 13, 1908. See Convents, G. (2007) Ontstaan en vroege ontwikkeling van het Vlaamse bioscoopwezen (1905/1908–1914), p. 31 in D. Biltereyst and Ph. Meers (eds) *De Verlichte Stad*. Leuven: LannooCampus.

10. Depauw, L. and Biltereyst, D. (2005) De kruistocht tegen de slechte cinema. Over de aanloop en de start van de Belgische filmkeuring (1911–1929), *Tijdschrift voor Mediageschiedenis* 8(1): 3–26. On the USA, see Grieveson, L. (2004) *Policing Cinema: Movies and Censorship in Early-Twentieth-Century America*. Berkeley: University of California Press, p. 23.

11. Wets, P. (1919) *La Guerre et l'Enfant*. Mol: Ecole de Bienfaisance de l'Etat. Collette, A. (1993) *Moralité et immoralité au cinéma*. Liège: Université de Liège (MA thesis).

12. Plas, V. (1914) *L'enfant et le Cinéma*. Anderlecht: Cops, pp. 48–49.

13. Biltereyst, D. (2008) *Will We Ever See Potemkin?* The historical reception and censorship of S. M. Eisenstein's *Battleship Potemkin* (1925) in Belgium, 1926–1932, *Studies in Russian and Soviet Cinema*, 2(1): 5–19.

14. Biltereyst, D. (2006) "Down with French *vaudevilles!*" The Catholic film movement's resistance and boycott of French cinema in the 1930s, *Studies in French Cinema*, 6(1): 29–42.

15. A key target were film theaters specialized in (semi-) erotic or pornographic movies.

16. The film control law was voted in Parliament on September 1, 1920 and published in the *Moniteur Belge/Belgisch Staatsblad* on 18th of February as the *Loi du 1er septembre 1920 interdisant l'entrée des salles de spectacle cinématographique aux mineurs âgés de moins de 16 ans* (in French), or *Wet waarbij aan minderjarigen beneden 16 jaar toegang tot de bioscoopzalen wordt ontzegd* (in Dutch).

17. See Vandervelde's internal circular "*Voorschriften aan de Afgevaardigden*," Brussels May 24, 1921. Rijksarchief Beveren (RAB), EA DEAD 2001, document 1172.

18. The official French-language name of the Belgian board for film control was *Commission du Contrôle des Films Cinématographiques*. The September 1920 law translated this into Dutch as *Commissie van Toezicht op de Bioscoopfilms*, later changed into *Toezichtscommissie der Kinemavertooningen*. The most common Dutch-language name, however, was *Filmkeuringscommissie*. In this article we prefer to use an English translation (Belgian Board of Film Control, or BeBFC).

19. These data are based on a systematic coding of a major sample of the movies submitted to BeBFC. This longitudinal research was based on the analysis of the original minutes, located in the BeBFC's archive. The *Forbidden Images* inventory database included data from more than 10,000 film titles. The analysis does not cover the period from April 1941 to September 1944, when the German occupiers stopped the BeBFC's workings.

20. BeBFC Archive, *Casablanca* file, Procès-verbal November 27, 1945.

21. BeBFC, *Casablanca* file, Procès-verbal March 7, 1946.

22. See Biltereyst, D., Depauw, L. and Desmet, L. (2008) *Forbidden Images A Longitudinal Research Project on the History of the Belgian Board of Film Classification (1920–2003)*. Gent: Academia Press. For an analysis of crime and violence, see

Depauw, L. (2009) *Paniek in Context. Een interdisciplinair, multimethodisch onder-zoek naar het publieke debat over geweld in film tijdens het Interbellum in België.* Gent: Department of Communication Sciences (PhD thesis).

23. The last film being cut was Charles Gassot's *Méchant Garçon* (1992, *Bad Ronald*). BeBFC Archive, *Méchant Garçon* file, Procès-verbal August 6, 1992.
24. BeBFC Archive, *Saving Private Ryan* file, Procès-verbal September 1, 1998.
25. Jottard, F. and Leclercq, Ch. (1990) *Attention, les enfants regardent.* Brussels: ReForm.
26. Biltereyst, D. and Depauw, L. (2006) Internationale diplomatie, film en de zaak *Dawn.* Over de historische receptie van en de diplomatieke problemen rond de film *Dawn* (1928) in België, *Belgisch Tijdschrift voor Nieuwste Geschiedenis/Revue Belge d'Histoire Contemporaine,* 36(1–2): 127–155.
27. Trumpbour, J. (2002) *Selling Hollywood to the World.* Cambridge: Cambridge University Press, pp. 223–225.
28. For an international comparison, see Dibbets, K. (2006) Het taboe van de Nederlandse filmcultuur: Neutraal in een verzuild land, *Tijdschrift voor Mediageschiedenis,* 9(2): 46.
29. Flanders is the Dutch-speaking region in the northern part of Belgium. Finlander has a surface area of 13,522 square km, a population of 5.9 million and a population density of 434 inhabitants per square km.
30. See Biltereyst, D. (2007) The Roman Catholic Church and film exhibition in Belgium, 1926–1940, *Historical Journal of Film, Radio and Television,* 27(2): 193–214.
31. Other forces, which are largely under-researched, include the juridical and educational system.
32. Kuhn, A. (2002) *An Everyday Magic. Cinema and Cultural Memory.* London: I.B.Tauris, p. 6.
33. More information on the oral history part: Meers, Ph., Biltereyst, D. and Van de Vijver, L. (2010) Metropolitan vs rural cinemagoing in Flanders, 1925–1975, *Screen,* 5(3): 272–280.
34. In this and the following quote we don't use the respondent's full name, but use abbreviations. We also refer to the interviewee's age and his/her gender (male, female).
35. See on this concept in relation to film censorship, Kuhn, A. (1988) *Cinema, Censorship, and Sexuality, 1909–1925.* London: Routledge. Müller, B. (ed)(2004) *Censorship & Cultural Regulation in the Modern Age.* Amsterdam: Rodopi.
36. Curry Jansen (1988) *Censorship,* p. 10.
37. De Certeau, M. (1984) *The Practice of Everyday Life.* Berkeley: University of California Press.

Notes on Contributors

Daniel Biltereyst is a professor in Film and Cultural Media Studies at the Department of Communication Studies, Ghent University, Belgium, where he leads the Centre for Cinema and Media Studies (www.cims.ugent.be). He is the author of over 150 articles and essays, mainly on screen culture, audiences, public controversy, and censorship. His work has appeared in many journals (including *Cultural Studies*; *European Journal of Cultural Studies*; *Historical Journal of Film, Radio and Television*; *Media, Culture & Society*; *Screen*; *Studies in French Cinema*) and in edited volumes such as *Je t'aime ... moi non plus: Franco-British Cinematic Relations* (Berghan, 2010), *The Handbook of Political Economy of Communications* (Wiley-Blackwell, 2011), and *Billy Wilder, Moviemaker* (McFarland, 2011). He is the editor, along with Richard Maltby and Philippe Meers, of *Explorations in New Cinema History: Approaches and Case Studies* (Wiley-Blackwell, 2011) and *Cinema, Audiences and Modernity: New Perspectives on European Cinema History* (Routledge, 2012).

Gregory D. Black is Professor Emeritus at the University of Missouri-Kansas City, USA. He published two reference works on the American Catholics and Hollywood: *The Catholic Crusade against Hollywood, 1940–1975* (Cambridge University Press, 1998) and *Hollywood Censored: Morality Codes, Catholics and the Movies* (Cambridge University Press, 1994). He also co-authored *Hollywood Goes to War: How Politics, Profits and Propaganda Shaped World War II Movies* (with Clayton R. Koppes, The Free Press, 1987).

Nandana Bose is an assistant professor at the Department of Film Studies in the University of North Carolina Wilmington, USA. She has published on Indian cinema, gender, and censorship in such journals as *Cinema Journal*, *Velvet Light Trap*, *Studies in South Asian Film and Media*, and *Feminist Media Studies*, and has co-edited a special issue for *Scope: An Online Journal of Film Studies* entitled *Using Moving Image Archives*.

Jon Lewis is a professor of English at Oregon State University, USA, and the author of the landmark book *Hollywood v. Hard-Core: How the Struggle over Censorship Created the Modern Film Industry* (New York University Press, 2000). Recently he also published *American Film: A History* (W.W. Norton,

2008) and *The Godfather* (BFI Film Classics, 2010). He is the editor of *Looking Past the Screen* (Duke University Press, 2007, with Eric Smoodin), *The End of Cinema as We Know It . . . American Film in the Nineties* (New York University Press, 2001) and *The New American Cinema* (Duke University Press, 1998). His work has appeared in edited volumes and journals such as *Afterimage, Cineaste, Cinema Journal, Film International, Film Quarterly, Journal of American History*, and *JumpCut*. He was the editor of *Cinema Journal* from 2002–2007.

Martin Loiperdinger is a professor of Media Studies at the University of Trier. From 1993 to 1997 he was Deputy Director of the German Film Institute—DIF. He received his PhD from Goethe University Frankfurt for his *Rituale der Mobilmachung* (Leske + Budrich, 1987) on Leni Riefenstahl's *Triumph of the Will*. His contributions to film and cinema studies include articles, books, exhibitions, DVDs, and also television features (on the history of color film, the Lumière brothers, advertising film, and the avant-garde). From 1992 to 2006, he co-edited *KINtop*, the German yearbook of early cinema, with Frank Kessler and Sabine Lenk, and since 2011 he is the co-editor of *KINtop—Studies in Early Cinema*. With Uli Jung, he co-edited *Geschichte des dokumentarischen Films in Deutschland*, vol. 1 (Philipp Reclam, 2005). He co-curated the DVDs *Crazy Cinématographe 1896–1916*, and *Screening the Poor 1888–1914*. He edited *Celluloid Goes Digital* (WVT, 2003), *Travelling Cinema in Europe* (Stroemfeld/Roter Stern, 2008), and *Early Cinema Today. The Art of Programming and Live Performance* (J. Libbey, 2011). Since 2005, he is conducting the research project *Screen1900*, at the Media Studies Department at the University of Trier.

Carmen McCain is a PhD candidate in the Department of African Languages and Literature at the University of Wisconsin, Madison, USA, currently writing her dissertation on the Hausa film industry in Nigeria. She is a columnist with Nigeria's *Weekly Trust* and coordinates the blog for the Hausa Home Video Resource Centre at Bayero University, Kano. Her work has appeared in the *Journal of African Cinemas* and *Journal of African Media Studies*, and in edited volumes such as the *Wiley-Blackwell Companion to African Religions* (2012) and *Facts, Fiction, and African Creative Imaginations* (Routledge, 2010).

Dilek Kaya Mutlu is an assistant professor at the Department of Graphic Design, Bilkent University, Ankara, Turkey, where she teaches popular culture and media reception. Mutlu has published essays in national and international journals (including *Middle Eastern Studies, European Journal of Cultural Studies*, and the *Historical Journal of Film Radio and Television*) on a variety of topics, including the history of Turkish cinema, Turkish Yeşilçam stars and their audiences, the exhibition and censorship of American films in Turkey, the censorship of religion in Turkish films, and Islamic consumption patterns. She is

the author of *The* Midnight Express *Phenomenon: The International Reception of the Film* Midnight Express (The Isis Press, 2005; Georgias Press, 2010).

David Newman is an instructor in the Faculty of Communication, Art and Technology, Simon Fraser University, Vancouver, Canada, where he has completed his PhD studies with a doctoral thesis on early government film policy in the British imperial Pacific. His work has been published in various readers including *The Contemporary Hollywood Film Industry* (Blackwell, 2008) and *Cross-Border Cultural Production* (Cambria Press, 2008).

Francisco Peredo-Castro is a professor in History and Communication Processes at the Center for Communication Studies in the Faculty of Political and Social Science, UNAM—Mexico City, Mexico, where he leads the project 'Sociocultural History of Mexican Cinema'. His work is on the history of Mexican and Ibero-Latin American diplomatic relations with cinema. He is the author of *Alejandro Galindo. Un alma rebelde en el cine Mexicano* (IMCINE, 2000) and *Cine y propaganda para Latinoamérica. México y Estados Unidos en la encrucijada de los años cuarenta* (UNAM, 2004/2013). He is member of the Mexican National System of Researchers (SNI—CONACYT). He has led the Center for Communication Studies (CECC—FCPyS—UNAM), and the Master Program for High School Education on Social Science (MADEMS—CS).

Julian Petley is a professor of Screen Media in the School of Arts, Brunel University, UK. He is also chair of the Campaign for Press and Broadcasting Freedom, a member of the advisory board of *Index on Censorship*, and the co-principal editor of the *Journal of British Cinema and Television*. He has published numerous books on media censorship, including *Freedom of the Word* (Index on Censorship/Seagull Books 2007), *Freedom of the Moving Image* (Index on Censorship/Seagull Books 2008), *Censorship: A Beginner's Guide* (Oneworld 2009), and *Film and Video Censorship in Modern Britain* (Edinburgh University Press 2011). His work on film censorship has also appeared in journals such as the *Journal of Popular British Cinema*, *Screen*, and *Sight & Sound*.

Kevin Rockett is a professor of Film Studies in the School of Drama, Film & Music, Trinity College Dublin, Ireland. His books include *Irish Film Censorship: A Cultural Journey from Silent Cinema to Internet Pornography* (Four Courts Press, 2004); *Cinema and Ireland* (Taylor & Francis, 1987, with Luke Gibbons and John Hill); *Neil Jordan: Exploring Boundaries* (Liffey, 2003, with Emer Rockett); and most recently, *Magic Lantern, Panorama and Moving Picture Shows in Ireland, 1786–1909*, and *Film Exhibition and Distribution in Ireland, 1909–2010* (both with Emer Rockett, Four Courts Press, 2011).

Richard Taylor is Emeritus Professor of Politics & Russian Studies at Swansea University, Wales. He is the author of numerous articles and books on Soviet

cinema, including *The Politics of the Soviet Cinema, 1917–1929* (Cambridge UP, 1979/2008); *Film Propaganda: Soviet Russia & Nazi Germany* (2nd edn, Croom Helm, 1998); and studies of Eisenstein's films, *The Battleship Potemkin* (I.B. Tauris, 2000) and *October* (BFI, 2002). He has also co-edited *The Film Factory: Russian & Soviet Cinema in Documents, 1896–1939* (Routledge and Kegan Paul, 1988/1994); *Inside the Film Factory: New Approaches to Russian & Soviet Cinema* (Routledge, 1991/1994); *Eisenstein Rediscovered* (Seagull Books, 1993, with Ian Christie); and *Stalinism and Soviet Cinema* (Routledge, 1993, with Derek Spring). He has edited and part-translated the British Film Institute edition of Eisenstein's writings in English, republished by I.B. Tauris in 2010, and is the General Editor of the *KINO* series of studies of Russian and Soviet cinema for I.B. Tauris. He has recently been working on the Stalinist musical.

Daniela Treveri Gennari is a program lead and principal lecturer in the Film Studies at Oxford Brookes University, UK. Her monograph *Post-War Italian Cinema: American Intervention, Vatican Interests* was published by Routledge in 2008. Her work on Italian cinema, censorship, and Catholicism also appeared in readers such as *Italy on Screen* (Peter Lang 2010) and journals such as *October* and *New Review of Film and Television Studies*. Her British Academy Mid-Career Fellowship funded study *Memories of Cinema-Going in Post-War Rome* is the pilot project for a three-year research on *Lost Audiences in Italy*, funded by the AHRC, which will start in 2013.

Roel Vande Winkel is an associate professor at the University of Antwerp (Research Group Visual Culture) and at the University College LUCA School of Arts. He is an affiliated researcher at the KU Leuven and an associate editor of the *Historical Journal of Film, Radio and Television*. His work was published in international academic journals such as *Javnost, Communications: The European Journal of Communication Research, Critical Studies in Media Communication, Historical Journal of Film, Radio and Television, Filmblatt, Historical Reflections, Journal of Film Preservation, Film International*, and *Journal of Scandinavian Cinema*. He edited the volumes *Cinema and the Swastika* (with David Welch) and *Perspectives on European Film and History* (with Leen Engelen). He is currently finalizing his monograph *Nazi Newsreel Propaganda in the Second World War* (forthcoming from Academia Press, 2013).

Pierre Véronneau was head of collections at the Cinémathèque Québécoise and is one of the leading Canadian film historians. He is associated with the Université de Montréal and the Université du Québec, and is a part-time teacher at the Concordia University, Canada. He received his PhD in History from the Université du Québec à Montréal in 1986, writing on the National Film Board of Canada. He has published many essays in edited volumes and numerous articles in international academic journals such as *Film History, Cinémas, 1895, Revue d'histoire de l'Amérique française, Québec Studies*, and various monographs on cinema in Québec and Canada, including work on

David Cronenberg (*La beauté du chaos*, Éditions du Cerf-Corlet, 2003). He has curated exhibitions, such as *L'Aventure cinéma (v.o. québécoise)* (2006) and *De Nanouk à l'Oumigmag : le cinéma documentaire au Canada* (2001).

Laura Wittern-Keller is a lecturer in US History at the University at Albany, State University of New York, USA. Besides essays in edited volumes, Wittern-Keller published two critically acclaimed books on the legal challenges to American film censorship: *Freedom of the Screen: Legal Challenges to State Film Censorship* (University Press of Kentucky, 2008) and *The Miracle Case: Film Censorship and the Supreme Court* (University Press of Kansas, 2008, co-authored with Raymond J. Haberski, Jr.).

Zhiwei Xiao is an associate professor of History at California State University, USA. He is the author of the *Encyclopedia of Chinese Film* (Routledge, 1998, co-authored with Yingjin Zhang). His work on Chinese cinema also appeared in journals and anthologies such as *Modern China, Chinese Historical Review, Twentieth Century China*, and *Cinema and Urban Culture in Shanghai, 1922–1943* (Stanford University Press, 1999).

Index

Harewood, Lord (G. H. H. Lascelles), 157
Harlan, J., 36–7
Harlech, 5th Baron (W. D. Ormsby-Gore), 157
Harlow, J., 242
Harnack, F., 89
Harvesters, the, *see* Riso Amaro
Hausawa, N. A., 235
Haynes, J., 224
Hays, W., 1–2, 9, 53, 127, 241–3, 246
Heads or Tails, *see* Pile ou face
Hearst newsreels, 66
Heaven Split, *see* Cielo dividido
Helena May Institute, 181, 188
Hell, *see* Infierno
Hell's Angels (1930), 246
Hennig, R., 82
Henreid, P., 94
Henry and June (1990), 47
Hernández, J., 72
Herod's Law, *see* Ley de Herodes
Hessen (State), 84–5
Heydrich, R., 91
Hicklin standard, 33, 45, 194
Higher Principle, *see* Vyšší princip
Hilito de sangre, un (A Trickle of Blood, 1995), 72
Hiroshima mon amour (1959), 56
Hisbah Board, 230
History of an Unemployed Man, *see* Meet John Doe
Hitchcock, A., 42, 210
Hitler, A., 86–8, 93, 95, 100, 189
Hiyana, M., 231, 234–5
Hoffmann, D., 211
Holden, W., 249
Hollywood, 1–2, 6–11, 15–16, 20–3, 28, 30–3, 37, 42–7, 54, 63, 65–9, 71, 75–8, 93, 102, 116–17, 126–7, 130, 177, 182, 224, 235, 241–54
Holmby Productions v. Vaughn, 32
Holy Synod, 97
Home Office (Great Britain), 151, 156–60, 163, 170
Home Secretary (Great Britain), 155–9
Honduras, 69

Hong Kong (special administrative region), 5, 7, 167–8, 171, 173–175, 178–82, 184–90, 238
Hope, *see* Umut
House of Commons (Canada), 59
House of Commons (Great Britain), 177, 187
House I Live In, *see* Dom v kotorom ia zhivu
House of Women, *see* Casa de mujeres
Houston, W., 246
Hudutların Kanunu (The Law of the Border, 1966), 133
Huerta, V., 65, 67
Hughes, H., 25, 246–48, 253
Humanidad (Humanity, 1933), 73
Hurst, B. D., 164
Hutton, W., 162

I am the Rabbit, *see* Kaninchen bin ich
I Believe in God, *see* Creo en Dios
Ibro A Loko (Ibro in the Ally, 2007), 232
IFCA, 244–5
ilegítima, la (The Illegitimate, 1956), 71
IMF, 223
I'm No Angel (1933), 242
Impostor, el (1956), 73
Impoundage Act (Germany), 92
Indecent Representation of Women (Prohibition) Act (India), 194
Independent, the (newspaper), 159
Index of Banned Books, 54
India, 4, 5, 7, 173, 175, 178, 180, 184, 191–206, 224, 227–8, 238
Indian People's Party, *see* BJP
Indiscret aux bains de mer, l' (The Indescreet at the Seaside, 1897), 64
Infierno (Hell, 2010), 74
Informer, the (1935), 156
Inside Nazi Germany (1938), 181, 188
Interministerial Committee (Germany), *see* Amt für Verfassungsschutz
Internatinonal Monetary Fund, *see* IMF
International Catholic Film Office, 73

DAT

PRINTED IN U.S.A.

Printed in the United States of America